D1265627

Carol Mahler

Illustrated by Guy LaBree

Forewords by James Billie and Jacob Osceola

Afterword by Elgin Jumper

University Press of Florida

Gainesville · Tallahassee · Tampa · Boca Raton

Pensacola · Orlando · Miami · Jacksonville · Ft. Myers · Sarasota

Guy LaBree

UNIVERSITY PRESS OF FLORIDA

Florida A&M University, Tallahassee
Florida Atlantic University, Boca Raton
Florida Gulf Coast University, Ft. Myers
Florida International University, Miami
Florida State University, Tallahassee
New College of Florida, Sarasota
University of Central Florida, Orlando
University of Florida, Gainesville
University of North Florida, Jacksonville
University of South Florida, Tampa
University of West Florida, Pensacola

Guy LaBree

Barefoot Artist of the Florida Seminoles

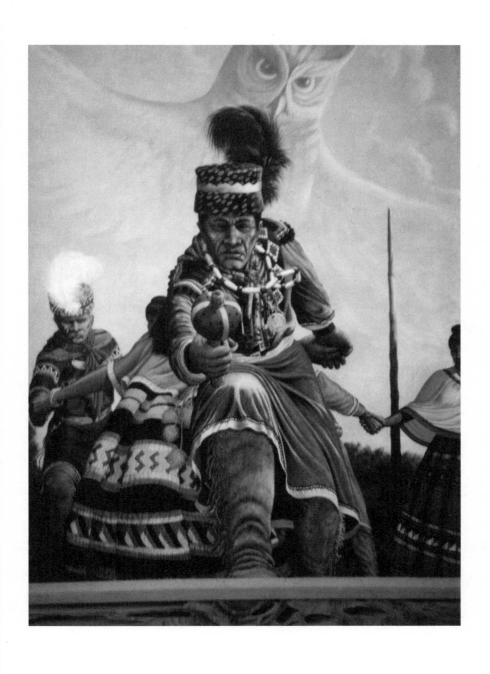

Copyright 2010 by Carol Mahler
Paintings copyright Guy LaBree
Printed in the United States of America on acid-free paper
All rights reserved

15 14 13 12 11 10 6 5 4 3 2 1

Library of Congress Cataloging-in-Publication Data
Mahler, Carol.
Guy LaBree : barefoot artist of the Florida Seminoles / Carol Mahler ; illustrated
by Guy LaBree ; forewords by James Billie and Jacob Osceola ; afterword by Elgin
Jumper.
p. cm.
Includes bibliographical references and index.
ISBN 978-0-8130-3430-0 (alk. paper)
1. LaBree, Guy, 1941—Themes, motives. 2. Indians in art. 3. Florida—In art.
4. Seminole Indians—Florida. I. LaBree, Guy, 1941– II. Title.
ND237.L193M35 2010
759.13—dc22 [B] 2009034634

The University Press of Florida is the scholarly publishing agency for the State
University System of Florida, comprising Florida A&M University, Florida Atlantic
University, Florida Gulf Coast University, Florida International University, Florida
State University, New College of Florida, University of Central Florida, University
of Florida, University of North Florida, University of South Florida, and University
of West Florida.

University Press of Florida
15 Northwest 15th Street
Gainesville, FL 32611-2079
http://www.upf.com

Contents

Foreword by James Billie vii

Foreword by Jacob Osceola ix

Introduction xi

Acknowledgments xxi

PROLOGUE: The Life of Guy LaBree 1

1. SEMINOLE LEGENDS 19

 Genesis and *Exodus* 20

 Bridge to Eternity 23

 Sons of Thunder 25

 Water Lily Lovers 27

 Vanishing Ceremony 28

 Time to Go Home 30

 Kissimmee River Legend 32

 When the Time Comes 34

2. SEMINOLE LIFE AND TRADITIONS 38

 The Storyteller/Sunset Recollection 40

 When I Grow Up 42

 "Oh, the Changes I've Seen" 47

 Breakfast Time 53

 Mikasuki Seamstress 54

 Homework 57

Hunter in the Grass 60
Dugout Apprentice 61
Travelog 65
A Visit to Big Cypress 68
Screech Owl Dance 70
Last to Leave 74

3. SEMINOLE HISTORY 77

End of Message 82
The Mocker 85
Withlacoochee Surprise 88
Battle of Okeechobee 91
Make It Count 94
Wild Cat, Red Warrior 96
Suspicion 99
Danger Zone 101
Deep Cypress Engagement 104
Survival 106
Suspect Foul Play 109
Plans of War 113
Intruder on the Land 116

4. FLORIDA WILDLIFE 119

Fire Peril 121
Almost Hog Heaven 122
Restful Shade 124
Jeopardy 126
Waiting for Mom 128
Sunup Turkey Feast 129
Snack Gar 131
Repeat Offender 132

Afterword by Elgin Jumper 135
Notes 137
Bibliography 155
Index 169

Foreword

JAMES BILLIE

Chairman of the Seminole Tribe of Florida, 1979–2002

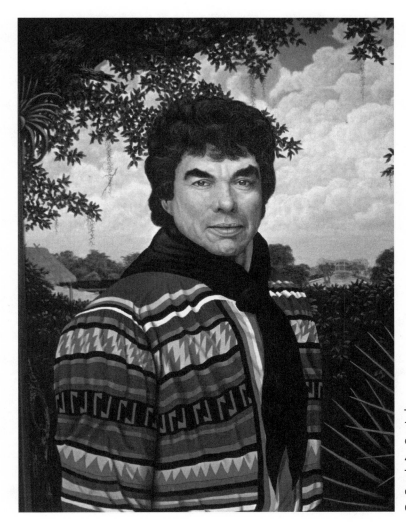

James E. Billie, 1999. Oil on canvas, 30" × 40". Seminole Tribe of Florida. Copyright Guy LaBree.

There are many well-known artists who have attempted to capture the culture, religion, histories, and day-to-day atmosphere of the Seminole Indians but have failed to do so.

Guy LaBree is a unique person in that he has lived with our people and had the rare privilege of exchanging intimate friendships with them. He has learned what it means to be an Indian in the twentieth century.

After hearing the story of *The Bridge to Eternity*, Guy captured the thoughts and feeling on canvas of what I believed would have been an impossibility for a non-Indian, but he did so with authenticity.

To this day, Guy far surpasses all well-known artists in painting the ways of the Seminole Indians.

Foreword

JACOB OSCEOLA

As James Billie and I were talking one day, he showed me a painting called *Bridge to Eternity*. I asked him, "How did you get a painting that details my vision of an Indian crossing over?" The painting was so profound in every detail that I had heard, I said, "I'd like to meet this gentleman." We were building chickees at that time, so on the way, we stopped at the artist's home, and I met Guy LaBree. We talked about Seminole culture and Seminole paintings. In 1982, I commissioned *Twins' Legend*, a painting about a decision that had to be made at one of the meetings: the tribal elders are sitting on logs listening to one person present the grievance. Since then, he's done other paintings for me.

This book will give readers a glimpse into Seminole culture. Each clan has basically the same stories, but sometimes an elder of the Panther Clan tells the tale a little differently. I am of the Panther Clan, and we have our ways of telling stories. Seven other stories could be told because there are eight clans. Guy paints the scene as the individual wants the story told, so those looking at the painting may say, "I didn't hear it quite this way." Yet the portrayal is valuable because each clan has its own way of telling the story.

The Seminole were not a warlike tribe to begin with, but they had to fight to protect what they thought was their area. In war times, sometimes they had to sacrifice their own children to keep their family alive. It was the only alternative, and Guy painted it in *Tragedy of War*, where the mother is drowning her baby. [For another painting treating this theme, see fig. 31, *Survival*.]

Some people may ask, "Why did an Indian mother do that?" Sometimes you had to sacrifice your own.

When I see some of these paintings, I can almost reminisce how a camp setting was and the day-by-day life. If someone is interested in the history of the Tribe, then reading this book will give them a sense of the daily Seminole life, especially in a camp: some of these paintings are good illustrations of how it was.

Introduction

On Thursday evenings, I sit in a circle of musicians, including Guy LaBree. He and others pick and strum guitars, but some play harmonica, fiddle, flute, bass acoustic guitar, travel harp, mandolin, hammered dulcimer, or other instruments. Each person leads a song, and then the one beside him or her takes a turn. Often newcomers do not realize that Guy is an artist whose images are on display in the Smithsonian National Museum of the American Indian. Once in a while, he'll sheepishly explain that his wife/business manager, Pat LaBree, told him to announce an upcoming art show. Although he is apologetic, we are happy for an opportunity to see his work.

A few years before I joined the group of musicians, I had admired Guy's paintings that illustrate a book of Seminole legends.[1] Then one night at the open jam in Gilchrist Park in Punta Gorda, Florida, a mutual friend introduced us. Guy modestly shook my hand as I gushed about how thrilled I was to meet him. Luckily, I was calm by the time I was ready to participate in the music. From the first, I admired the way Guy appreciated and encouraged each member of our circle.

As the hours advance on Thursday night, the music modulates into blues, bluegrass, Broadway show tunes, country and western, folk, gospel, jazz, rock 'n' roll, and traditional. The first night I sat in the circle, Guy sang "Mr. Bojangles" and "The Dutchman." After a few months, I realized that there was something of both those characters in him. Singer-songwriters are part of our circle, and we share our original tunes. Even Guy has written two ditties

that he sings one after the other—both with macabre endings. Death is no stranger to Guy. His heart was damaged in a heart attack in 1991, and it now functions at only a fraction of its normal capacity, so we allow him his black humor and grisly gossip. Applause follows each tune, with exclamations of admiration or cheer. A comment may blossom into a story, a joke, or a pun, and we banter with each other, but only for a minute. We're here for the music.

When we used to gather with other groups at Gilchrist Park, we joked that our circle was easy to find because so many of us wear hats. Guy has a great collection, including a beautiful chocolate brown, soft-felt fedora, the kind that he had always wanted and finally purchased when he lost another hat while traveling. As he talks, he gestures with his hands, and his thick silver rings, some with turquoise, click together. He wears his shirt—and even his jacket, on a cold evening—open at the collar to reveal an alligator-tooth necklace. Hooked to a belt loop of his blue jeans is a chain for a bunch of keys that he tucks into his right front pocket, and he wears comfortable slip-on shoes now that he can no longer walk barefoot.

During the years we made music in the park, often a musician stayed with us for just one song or one round; even now, some of those who regularly gather with us say "good night" after a couple of hours. Then, very late on Thursday night—and sometimes it's early Friday morning—someone calls "last round." No matter how many people have left and how many times we've cinched the circle, Guy LaBree is there for the last song. If he's leading, he'll play and sing a tune poignantly appropriate, like "Those Were the Days," "Puttin' on the Ritz," or "Help Me Make It through the Night."

During the socializing afterward, we share and laugh, and I've watched Guy pull out his pocketknife to pare a fingernail with the eight-inch blade because "it's rough." After all, he uses a thumb pick and his nails to "pick and pull" the strings of his guitar. His eclectic style—in music as in art—is self-taught. After he lost his coordination as the result of what was probably a ministroke in 1993, he had to find a new way to play guitar and to relearn songs he had known for years.

When we finally take our leave and drive home, most of us collapse into bed, but not Guy LaBree. Those wee hours are when he paints. I once asked him why, and he answered me with a story. He used to paint during the day, but one day, when his granddaughter was living with them, she ran to his side to tell him something. In her enthusiasm, she bumped his arm, and his careful brushstroke slid into a smear across the painting. It took him an entire day to cover it. So rather than lock the door or forbid her access, he began to paint while she was asleep.

Guidee Mallett, "Harry Mallett with Pat and Guy LaBree," 2000. Color photograph. Guy LaBree Collection. At the reunion of the art teacher and his student from the late 1950s from South Broward High School.

His studio is a room in his house, a double-wide mobile home on ten acres in rural DeSoto County. It is crowded with canvases and frames leaning in rows—his silent audience—against one wall. Near the window are his easel and a table for paints and brushes. Photographs and paintings cover the top of an antique wardrobe that holds Seminole clothing as well as other artifacts. The temperature is very cool, which may keep the scent of oil paint from becoming overpowering. I remember once, when he was working on a very large canvas, he told us that he had to bring it into the living room to finish it. Even then, he painted the lower edge of canvas upside down, so that he wouldn't have to cramp his lanky frame.

As he works, he plays old movies or listens to music. His acoustic guitar is nearby, and he'll often relax for a moment and play a tune. He also owns four electric guitars—one that he designed when he was a teenager and his father made by gluing together strips of different woods. Another is an acoustic-electric, one of several of a kind that his friend Alan Jumper was given to practice-smashing for the opening of the Seminole Hard Rock Hotel and Casino in Tampa; this one, though, he presented to Guy. He likes to play them, too, because they are easy on his fingers, but without an amp, because his wife, Pat, is asleep at the other end of the house.

His palette is the original one given to him by his high school art teacher, Harry Mallett. Originally one-eighth of an inch thick, it is now more than

five inches high, an accretion of every hue he has ever painted. He has completed more than one thousand canvases, and for the past twenty-five years, he has supported himself and his family solely by painting. Mallet wrote to him recently: "You have achieved an enviable status in the art world through much hard work and perseverance. May you continue using your God-given talent for many years. The world is a better, and more colorful world, thanks to you."

Guy's canvases illuminate the singular beauty of Florida, and they embody his distinctive respect for, remembrance of, and reflections about Florida. A third-generation Floridian, he has been an outdoorsman all his life—fishing, diving, gardening, alligator wrestling, working cattle, hunting—he even dated Pat by taking her on snake-hunting expeditions. All the time, his artist's eye observed, even as he watched the wilderness change with the rapid development of Florida in the last half of the twentieth century. He paints with a lifelong appreciation for, and an understanding of, the land as well as its flora and fauna.

In 1994, Henry Geldzahler (1935–1994), curator of Dia Art Foundation, New York; former curator of art for the Metropolitan Museum of Art; and champion of the careers of Andy Warhol and his contemporaries, selected Guy's paintings for Featuring Florida, a showcase of work by Florida artists, at the John and Mable Ringling Museum of Art in Sarasota, Florida.

Joanne Milani, a visual art critic, reviewed the show: "The wild card of the exhibition is Guy LaBree of Arcadia. His meticulously painted canvases show scenes of Florida wildlife and rigorously staged scenes of imagined Florida history. . . . At first glance, LaBree seems to be an innocent folk artist who depicts with craftsmanlike skill every curl of Spanish moss and every detail of every period costume. But his deadpan directness is unsettling—as if he is determined to put his own spin on the history and myth of early Florida."[2]

He likes to paint for himself, but many of his works are commissions. Unlike the stereotype of the ivory-tower artist of immutable vision, Guy often repaints in response to a patron's wishes or a friend's critique. Above all, Guy is an artist of accuracy. For instance, he'll read accounts of a historical incident in books. Then he'll ask his Seminole friends about the stories that have been handed down in their clans and families, and he always frames the scene from the Seminole perspective. He'll seek out experts—authors, archaeologists, anthropologists, historians, reenactors—to consult about details such as uniforms or weaponry. And he's quick to point out when he has erred, as, for example, in his painting *Battle of Okeechobee*. As we sat together in front of it, he said, "Researchers keep finding out more. That painting up there has a bunch of things wrong in it. At the time I did it, it was right on."

So I was surprised and pleased when Guy and Pat first invited me to collaborate with them on a book. I naively imagined it as a "collected works" until I discovered how many canvases he has painted. Invited to their home, I sat with Guy at their dining room table with the tape recorder between us. As I asked questions and scribbled notes, Pat, sitting in an armchair nearby, often reminded Guy of various details. We talked for two hours, and afterward, we planned a book that was primarily a collection of paintings accompanied by Guy's recounting of Seminole culture.

Later, at an art show, I was inspired to shift the focus of the book when I heard Guy talking about how he learned the Seminole creation myth for the pieces he painted about them. Self-conscious about his colloquial speech, he apologized to the audience for his inability to speak proper English. He makes this apology whenever he speaks to a group, although I enjoy listening to his "Cracker vernacular."

Afterward, I interviewed him again at his home, this time with Pat's participation, focusing on particular paintings. As we talked, he recalled how a historical incident, folktale, observation, color combination, or perspective had prompted him to choose a subject. Relying on his experiences to enliven the features, he related encounters with engaging characters and unusual adventures in the Florida wilderness. He also described how he researched and refined the details. This fascinating behind-the-scene view, much of which became the content of this book, imbues his art with another dimension.

Attempting to represent the wide range of his subjects and to include some of his most popular paintings, Pat selected the paintings presented here. Over four months, I did ten interviews with the LaBrees, focusing on from two to six paintings at a time. The three of us sat together in their living room with framed *giclées* and prints of his artwork on every available wall. (Friends and fans know that they can visit this informal gallery when they want to purchase a reproduction or see his latest work.) Sometimes the scene we were discussing hung within easy view; other works Guy brought from another room and propped against a chair. A few we discussed as we looked at the photographs that he snaps after he completes a painting; they are organized by subject in two large photo albums. Pat also keeps programs from art shows and events, news articles about Guy, and other memorabilia in a dozen scrapbooks.

As I wrote and rewrote the chapters of this book, I read about the history and culture of the Seminoles. I was continually amazed at how often historical accounts, archaeological discoveries, and anthropological reports—as well as those studies that analyze and synthesize such information—corroborate what Guy had told me. His lifelong friendships with Seminoles—some of whom he has known since he was in the first grade—combine with his un-

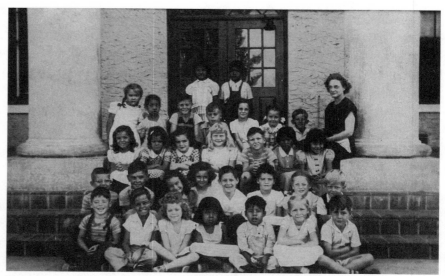

Helen LaBree, "First-Grade Class, Dania Elementary School," 1947. Black-and-white photograph. Guy LaBree Collection. *First row, fourth and fifth from left*, Judybill Osceola, Dan Bowers. *Fourth row, seventh and eighth from left*, Guy LaBree, Miss Wilson. *Standing behind, second from left*, Eugene "Tank" Bowers.

failing interest in their history and culture to give him rare insight into and regard for a people once known for their reticence and distrust of outsiders. I have integrated my studies only to clarify Guy's narratives or to augment his explanations. Unless otherwise indicated, this book is his memory of his own research and life experience.[3]

Growing up in Dania, Florida, Guy became friends with many of the Seminole children who first attended Dania Elementary School in the late 1940s.[4] He showed me a photograph of his first-grade class, naming the many children from the Dania—now known as the Hollywood—Reservation. He remained friends with two of the Seminole boys in that picture—Dan Bowers and Eugene "Tank" Bowers. Another classmate since the first grade, Judybill Osceola, became manager of the Seminole Arts and Crafts Enterprise Gift Shop at Seminole Okalee Indian Village on the Hollywood Reservation.[5] She asked the Tribal Council for permission for Guy to sell his art there, and he has the distinction of being the first non-Seminole artisan to be given this privilege.

Down the street from his parents' home in Dania lived Lois Shanley, an artist. Guy often visited to watch her sketch or paint. She offered him pencils and paper, which her husband brought home from the print shop where he worked. One day, when Guy was about ten, she asked if he wanted to paint.

He portrayed a cardinal that day, and after he completed several other scenes, she gave him her old paints, a palette knife, brushes, and other supplies. Whatever he painted, he asked for her critique so he could learn from his mistakes. He recalls, "She was very honest. So if I did something she thought was good, she'd say it. But I had to work for it."

In 1960, he graduated from South Broward High School and received an art medal during the senior awards ceremony. Lois Shanley arranged for a scholarship for him to attend Ringling Art School, but he didn't take advantage of it, entering the U.S. Navy instead. After a series of other jobs, Guy became a lithographer, and when he tired of the printing business, Alan Jumper suggested that he paint the Seminoles. Jumper thought that LaBree's paintings could create better communication between the generations. Through his art, Guy could interpret the oral history of the elders so that young people could learn about it.

Alan and Guy have been friends since childhood, when Guy visited the Jumper family camp.[6] There, Seminoles in colorful patchwork clothing lived in open-sided, palm frond–thatched chickees with no running water, limited electricity, and an open fire for cooking. Through the years, Guy was able to see "the old ways," as he calls them, slowly give way to a more modern lifestyle. Today, his friends in the Seminole Tribe live in luxurious homes and condominiums. The kind of camp where he visited and played as a child and teen is now constructed solely as a "living history" museum. James Billie has said of Guy: "He's just a couple of years older than I am which gave him the opportunity to see the last of the Seminoles in their original habitat and their lifestyles. He is probably one of the few fortunate white men today who has seen the ending of the older Seminole generations."[7]

When he was a young alligator wrestler—and two years before he was elected chairman of the Tribe in 1979—James Billie first bought a painting from Guy; during the five terms he served in office, he added many more to his collection. In 1980, he also sponsored Guy's first one-man art show at the "Native Village" on the Hollywood Reservation, where his paintings are now on permanent exhibit, as they are at the reservation's Tribal Offices. Some of the artwork was on loan in 2001 to Guy LaBree: Florida's Barefoot Artist, a retrospective (1977–2000) at the St. Petersburg Museum of History. For this occasion, the Seminole Tribune published a four-page supplement entitled "The Legend of Florida Artist Guy LaBree: Painter of the Seminole." The exhibit was an event of the annual Discover Native America festival that the Tribe, along with Eckerd College, had sponsored that year, and in which Guy had participated for ten years in various cities: Orlando, Jacksonville, and Fort

Lauderdale in Florida; Nashville, Tennessee, and others. Revived in 2007 in Tampa, the festival again featured a LaBree exhibit.

In addition, James Billie introduced Guy to the Tribe's elders, medicine men, and storytellers. In 1994, the storyteller Betty Mae Jumper requested that Guy paint the illustrations for her book of legends. The Ah-Tah-Thi-Ki Museum on the Big Cypress Reservation acquired the original paintings for the book (in addition to other LaBree canvases), and they were featured as the first show of 2007 in the new exhibit space in the museum's curatorial building. The Seminole Cultural Museum in Tampa featured a permanent exhibit of artwork by LaBree from 1983 until it closed in 2003. Also in 1994, the broadcasting division of the Gannett Company—publishers of *USA Today*—produced a thirteen-part documentary showcasing the history of eleven Native American nations, and Guy's paintings were used in the hour dedicated to the Seminole Tribe.

In 2002, the Tribe commissioned Guy to collaborate with Medicine Man Sonny Billie on images for the permanent Seminole exhibit in the Smithsonian; and in 2004, Guy was a guest of the Seminole Tribe during the opening ceremonies in Washington, D.C., including the "Parade of Natives." Another of Guy's paintings was included in *The Southeast*, volume 14 of the Smithsonian's encyclopedic *Handbook of North American Indians*, published in 2004.

Recognition of Guy's artistic talent and his dedication to authenticity have won him exhibitions in both art and historical museums throughout Florida. In 1988, Lisa Phillips, author and curator at the Whitney Museum of American Art in New York, chose his paintings for a juried show at the Boca Museum of Art in Boca Raton, Florida. He is one of the few living artists to have had a three-month exhibit at the Ringling Museum of Art in Sarasota; his art was exhibited three times at the Florida Capitol Building and most recently in the Heritage Gallery of the R. A. Gray Building of the Museum of Florida History, also in Tallahassee.

The fine arts critic Ellen Koven has written: "The rich culture and ancient ways of the Seminole Tribe spring to life under LaBree's careful brush strokes. . . . LaBree and his wife, Pat, research and cross-reference all the details in the finely tuned oils. It is this integrity that imbues the work with a sense of realism that deeply touches the viewer. . . . The visual impact of LaBree's work can't be overstated. . . . Since he began painting full-time in 1973, LaBree has created a body of work that will remain a testimony to a populace which made an indelible mark on Florida history. His work serves as a lasting tribute to them."[8]

Billy L. Cypress, the late director of the Ah-Tah-Thi-Ki Museum of the Seminole Tribe, said, "[James] Hutchinson is perhaps the best-known paint-

er who captured Seminole culture. He along with Guy LaBree are probably the two best painters alive today."

Hutchinson was a stranger to the Seminoles when he began painting those who lived on the Brighton Reservation in the early 1960s, after requesting permission from the "Seminole Indian Council." In the tradition of Remington and Catlin, he hoped to record the traditional life of the Seminoles even as it was changing.[9] In contrast, Guy has a half-century friendship with the Jumper family, and as a child, he was a familiar figure on the Dania Reservation. He paints Seminole culture, history, and people for the Seminoles themselves, rather than for some abstract notion of posterity. His goal is to inspire young Seminoles to ask their parents and relatives about the content of the paintings. Thus, his artwork transmits a living tradition rather than recording a past or passing culture.

Florida folksingers Ann and Frank Thomas have written a song about him titled "The Barefoot Artist—Guy LaBree," and two Seminoles have written poems about Guy that were published on May 25, 2001, in the *Seminole Tribune*: "The Man with No Shoes," by Moses Jumper Jr., and "Barefoot Man," by Ralph Billie. (The Seminoles gave Guy a nickname: *A Bosh Che—Will A Tee Chee*, or "The Barefoot Artist or Image Maker," because he used to do everything—including painting—in his bare feet. See the prologue for the origin of this nickname.)

Several dozen Tribal members own his paintings, and hundreds have purchased reproductions. Although he has lived near Arcadia since 1983, Guy remains a part of the Seminole community, and he is friends with individuals of the Tribe. He receives invitations to gatherings, both public and private. For example, he was the featured artist at the banquet celebrating the first Battle of Okeechobee Reenactment in 1987, and he attended a birthday party in 2003 for Alan Jumper's mother when she was more than one hundred years old, as well as the sixtieth birthday celebration of Seminole Tribal chairman Mitchell Cypress. When Guy was hospitalized in Naples with heart trouble in 2002, Council member David Cypress, representing the Tribe, offered to pay any needed medical expenses for the LaBree family. The Elett family, enthusiastic collectors of LaBree paintings, made the same offer and, in fact, settled up the medical accounts.

Our circle of musicians worried about Guy when he was in the hospital that time. For weeks, he had struggled with not having enough breath to sing. "I was dying," he said frankly. On that rainy Thursday evening, we were grateful when his daughter visited to give us the news about his surgery and expected recovery. When he was finally well enough to join us again, he proudly showed off the angry scar where a defibrillator had been inserted

under his skin. "It's really a box of cigarettes under my skin instead of in my shirt pocket," he joked. (Guy hasn't tucked cigarettes in his pocket since he quit smoking in 1983.) We all laughed with him—how could we not?

Guy LaBree is an artist of many talents, and he's a natural-born storyteller with the gift of humor. When painting, he renders the dramatic moment of conflict, keeping the observer in suspense as to the outcome. Yet he conceals whimsical features in the most serious of subjects. When reminiscing, he narrates using dialogue, pacing, and the surprise ending. He loves to horrify us with the truth—"I swear," he insists. This book is a collection of his stories—his images and his words about them.

Acknowledgments

Guy LaBree thanks the following members of the Seminole Tribe of Florida for talking with him about their tribe's history and culture: Judy Ann Baker, Bobbie Lou Bowers Billie, Henry John Billie, Ingraham Billie Jr., James Billie, Josie Billie, Noah Billie, Sonny Billie, Agnes Bowers, Dan Bowers, David Stephen Bowers, Eugene V. Bowers, Mary Bowers, Paul Bowers Sr., Richard Junior Bowers, Wanda Faye Bowers, Andy Buster, Paul Buster, Abraham Clay, Billy Cypress, Billy L. Cypress, Carol Frank Cypress, David Roger Cypress, Jeannette Cypress, Mitchell Cypress, Joe Frank, Joel M. Frank Sr., Larry Frank, Leslie Garcia, Henry J. Gopher, Louise Jones Gopher, Connie Gowen, Dale Evans Grasshopper, Marcella Green, Mable Johns Haught, Bobby Henry, Charles Billie Hiers Sr., John Wayne Huff Sr., Ronnie Jimmie, Archie Johns Sr., Billy Joe Johns, Cecil V. Johns, Joe L. Johns, Stanlo Johns, Willie Johns, Mary Johns, Betty Mae Jumper, Daniel Jumper, David Jumper, Delores Jumper, Elgin Gregory Jumper, Eva Jumper, Harley Jumper, Harry Jumper, James Jumper, Josiah Alan Jumper, Lucille Jumper, Moses "Big Shot" Jumper Jr., Sanford Jumper, Scarlet Marie Jumper, Tommie Jumper, Tina DeVito Lacey, Joanne Micco, Frankie Moore, Mary Osceola Moore, Nancy Motlow, Virgil Benny Motlow, Lawana Osceola Niles, Bill Osceola, Eloise Osceola, Frances Osceola, Jacob Osceola Sr., Jimmie O'Toole Osceola, Judybill Osceola, Marie Osceola, Mary Gay Osceola, Morton Osceola, Moses Bernard Osceola, O. B. Osceola Sr., O. B. Osceola Jr., Pete Osceola, Rudy Osceola, Tina Marie Osceola, "Wild" Bill Osceola, Priscilla Doctor

Sayen, Edna Bowers Sharp, Paul Simmons, Thomas McGowan Storm Sr., Buffalo Tiger, Dorothy Tommie, Minnie (Mittie) Tommie, Sally Rene Tommie, Samuel Tommie, Gordon Oliver Wareham, Jackie Willie Jr., Mary Jane Willie, Rita Michelle Youngman, Brian Manuel Zepeda, and Pedro Osceola Zepeda; from the Seminole Tribe of Oklahoma: Kelly Haney, Benny Harjo, and Stanley Smith; and from the Creek Tribe: Mark Madrid.

Carol Mahler thanks Margaret C. Blaker for her encouragement, suggestions, and criticism; others who read and critiqued these words: Lynn Harrell, Guy LaBree, Pat LaBree, Claire Ann Miller, Rachel Rebekah Renne, Luke Wilson, and Elise Zarli; those who provided critical reviews: Gary Monroe, Theodore Morris, and Patsy West; and those who assisted with research: Claire Ann Miller, Barbara Stringer, and the staff at the DeSoto County Library, including Cindy Beaudoin, Wendy Farris, Leigh Hornbake, Elizabeth Kenney, Anson Raymond, and Marsha York.

The Life of Guy LaBree

South of Stirling Road in Dania, Florida, out in the middle of u.s. 441 and flat on their backs, four boys looked up at the stars. All were dressed alike in dungarees, white T-shirts, and boots. Three of them, with straight black hair and rich bronze skin, were brothers: Alan, Jimmy, and David Jumper. The other, with light brown hair and light skin, was their friend, Guy LaBree.

Against their backs, the road pressed the last of the sun's heat. Across their faces and arms, the cool darkness tingled, and maybe an evening breeze, as light as laughter, tickled them. The crickets hummed a steady accompaniment as they joked, poking fun at each other.

When they turned their heads—so first one ear and then the other lay flat on the road—they gazed for miles to the north and south, seeing no car lights—even in the distance. "That many miles and nobody on it, and you could look up and look at the stars for ten minutes, fifteen minutes, and nothing, nothing would come by," Guy remembered. "Finally, you'd hear a rumbling in the road, and you could look and see way off these little headlights, and you knew it was a truck coming, and that was unusual."

When at last they pulled themselves up and sauntered from the road, sometimes they waited for the truck to grind by and then resumed their positions. Other nights, a passing vehicle was their signal to walk back to the Jumper family camp on the Dania Reservation.[1]

Growing up with two brothers and two sisters, Guy often escaped the busy household to play in the nearby woods or with his friends on the Reservation. He had been born in 1941 in Jacksonville Beach because his father, Edgar LaBree, worked as an electrician at the U.S. Naval Air Base there. When Guy was a baby, they returned to Dania. Until the end of World War II, his father was employed at the U.S. Naval Air Base in Fort Lauderdale, and later, he worked as the head of the maintenance department for the Broward County Courthouse.

Guy's mother, Helen Taylor LaBree, had health problems, so Guy learned to change the diapers of his younger brothers, wash clothes, and mow grass. When his mom was too sick to care for them, Guy and the other children stayed with his grandmother. When she worked "house-sitting" at a residence on the New River, Guy swam with manatees. He also helped her with gardening and other chores, and she fed him southern cooking and pickled watermelon rinds.

On trips to his father's uncle's ranch in Brooksville, Guy and his siblings jumped from the hayloft, hunted arrowheads in a dry sinkhole, and used the two-seater outhouse. Once, they watched their father kill a rattlesnake coiled in the trunk of his brother-in-law's car by snatching its tail and popping it like a whip. Another uncle also had a watermelon patch, and after it was harvested, the kids ate the hearts of the ones left in the field.

Guy is a third-generation Floridian in his father's family, and his wife, Pat, recounted the details. His great-grandparent James Holmes was one of the first settlers in Dunedin, Florida, arriving in 1875, with his future wife, Mary Pierce, and her family. The LaBree and Kirkland great-grandparents married in Fruitland, Florida, in 1884, and honeymooned aboard the steamboat *Chesapeake* on the St. Johns River. At the turn of the century, they moved to Miami, and then in 1908, to Dania.

At home in Dania, the LaBree family fished, went crabbing, and gathered oysters, too. Their house was part of an old-fashioned, working-class neighborhood, where the mothers stayed home and the children were Boy Scouts and Rainbow Girls. On some weekends, the adults partied in one home—dancing and drinking—while the children played hide-and-seek outside. On other weekends, Guy rode his bike to the Dania Reservation, or he hosted his Seminole pals at his house.

Guy felt welcomed from the very first time he visited the Jumpers: "When I was first going to the camps, there was always somebody there to help me out with everything. I mean there'd be somebody to tell me where somebody was

at, what you do here, where do you go to the bathroom, what do you do for this, what do you do for that, where could I put my stuff. . . . It made me feel welcome, just really big time. That went on for about six months, and then finally one time I went out there and nobody was around. They were all doing stuff. So I was asking, 'Where's Jimmy?'

"Someone said, 'He's back in there cutting some wood.'

"I was back in there for a while with him, and I said, 'What are they mad at me for?'

"He said, 'What do you mean?'

"'Nobody paid any attention to me. They just waved and smiled and stayed away.'

"'Yeah?'"

"'Well, they never did that before. There was always somebody right there all the time.'

"'They trust you now. . . . Before they didn't trust you. They were seeing what you were going to be like.'"

"My dad, on the other hand, didn't trust them. And I didn't know it . . . because my dad was a great guy, and I didn't think he would ever do anything like that—I guess—so I never looked. But they told me when they were grown that he was right on their case, really on their case, close.

"They would come to my house a lot. They loved my house. They'd come to my house more than I'd come out there. When they came, he'd always watched them, because he came from the age when whites stayed with whites, and blacks stayed with blacks, Indians stayed with Indians. He had nothing against them personally. It was just the way he was raised."

But as the situation changed for Guy, so it changed for his friends, too. He said: "About nearly a year later, Jimmy walked up to the door, knocked on the door. My dad looked out and said, 'Hi, Jimmy. Come on in. He's upstairs.'" Jimmy told Guy that when he walked in the house, Guy's father never glanced up from reading the newspaper. That's when Jimmy knew that Mr. LaBree finally trusted him.

Guy's father had built their home of materials recycled after World War II from the U.S. Naval Air Base in Fort Lauderdale. It was very different from the chickees his Seminole friends lived in, because it had window screens to keep out the bugs, electric lights for every room, and fans.

"We had a shower—that was the main thing," Guy said. "We had a shower and iced tea in the refrigerator that they could just go take and help themselves. My mother made sure there was always plenty of iced tea in there. Jimmy thought my mother was nuts because she put sugar in the tea and then lemon. He couldn't figure out why she wanted to make it sweet and then sour.

I told him, 'Give it a try, and see what you think.' From then on, that's the way he made his tea.

"But they'd take a shower when they'd get there," he said. "If they had come walking in from the Reservation in the morning, on a Saturday—it was a five- or eight-mile walk—and the first thing they asked was 'Could we take a shower?' . . . and it wasn't that they were dirty people. They were clean people. They just couldn't get to a shower. Everything was that hand pump or jump into a canal." His friends wanted to take another shower maybe at lunch, or before dinner or before bed. "They'd take showers constantly and that was all right. . . . That's one of the things that endeared them to my dad, I think. They took more showers than we did. He had to make us take a shower."

Besides attending Dania Elementary School together, Seminole and white children shared a special Cowboy and Indian All-Kid Rodeo. It was organized by Andy Carrady, who had a leather and silver shop on the Dania Reservation. Guy said, "Andy would give away big old silver belt buckles—which was darned nice of him—but he lived right there on the Reservation, and that's one thing he did to keep in good standing."

The arena was west of Highway 441 in Dania, where the original bingo hall is located. Often a crowd enjoyed the rodeo because people driving by saw the lights and stopped to see what was happening. Guy explained how it worked: "If you were under eighteen, you could be in it. They used calves. They didn't use any full-grown cows. But, hey—a yearling could hurt you good. They're pretty heavy. We learned how to bulldog them; we learned how to lasso them, to ride them and not ride them."

Guy and Stanlo Johns, a few years older than Guy, helped at that rodeo. He said that Stanlo Johns was "the all-around, number-one Indian cowboy in the U.S.A., not just in the state of Florida." Although Guy had not seen him since then, they met again at an event on the Big Cypress Reservation in 2008.

Guy also recalled riding a bull in the Davie rodeo. He said, "I couldn't tell you the year or which rodeo it was, but I got talked into trying it, and paid my ten bucks. . . . You get on the bull, and about the time you're getting confident and getting done trembling, they open the chute, and you go flying out the door, flying through air, and then lying down in the sand that looked so soft, but you find out how hard it is."

Many people talk about racism and social problems of that time, but Guy recalled a different experience. "I used to take them to the beach, the Seminole kids, and the whole family sometimes, we'd work them into the car and

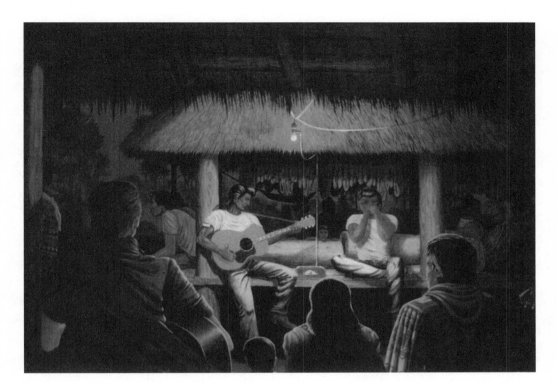

drive down to the beach—Dania Beach." Although he remembered a crowd of both tourists and local residents, no one ever bothered his family or the Jumpers.

The first alligator wrestler that Guy ever saw performed at Chimpanzee Farm, a tourist attraction owned by his parents' friends. He thought he could learn how to do it by watching, so he spent hours there, observing the shows and animals as well as cleaning cages. At home, he collected caymans, crocodiles, and alligators that he kept in pits that he built in his backyard. Then he discovered that Alan Jumper was working as an alligator wrestler, and Alan offered to teach him the techniques. Guy wrestled alligators and helped Alan clean out the alligator pits at Aqua Fair and at Aqua Glades. Sometimes Guy hitchhiked to where Alan was performing, so that he could watch the show.

Alan's brother Jimmy taught Guy to play the guitar, a skill Guy's father also shared with him. Jimmy had learned some on his own, and from Slim Summerville, a disc jockey in Hollywood, who had been a country singer. In remembrance of those days, Guy's painting *Fifties Fun* is a unique self-portrait. Wearing a purple shirt and holding a guitar, he stands to the left in the foreground with his back to the viewer watching the Seminole musicians.

Fifties Fun, 2001. Oil on canvas, 24" × 30". Dale Grasshopper Collection. Copyright Guy LaBree.

A neighbor who was an engineer instructed Guy how to skin-dive. He and his friends often went spearfishing, gathering spiny lobsters, or catching tropical fish that they sold. Later, he was a diver for the volunteer fire department. To learn to shoot guns, he joined the National Rifle Association, and one of his hobbies was shooting land crabs because they were pests: their claws could puncture tires, and they burrowed in people's lawns and the East Dania Marsh, making treacherous holes. Because his friends signed up for the Civil Air Patrol, he became a member until his first trip in a helicopter, when he realized that flying terrified him.

At Dania Beach, he climbed the palms to pick coconuts, splitting them on a machete half-buried in the sand, to sell to tourists. He also earned money by delivering newspapers, as well as by making shell lamps, knives, and gaff hooks for fishermen. He worked only one day as a helper on a fishing boat because he discovered his seasickness. He painted murals in clubs, and once, in a swimming pool. He tried plastering and working as a cowboy, but he didn't care for those jobs.

Watching wild animals fascinated him, so he spent many hours observing them in nearby hammocks, where trees grow on higher ground surrounded by marsh or swamp. He camped on the beach and in the swamps east of Dania, sleeping in a U.S. Army surplus hammock. When he had a car, he drove from Dania to the Everglades to hunt snakes, which he also marketed. On one expedition, he met Buffalo Tiger, who later served as Chairman of the Miccosukee Tribe. He warned Guy that rattlesnakes were dangerous.

Once an Indian told Guy that if a snake came into a Seminole camp, the people would watch it and keep everyone away from it. If it didn't leave after a few hours, a man would kill it with a club or some other weapon. "Then they'd take a stick and split it and hold the end open, and just slide it under the snake and clamp it, so it would snap shut . . . and then they'd pick him up and keep him out there," he said, pointing away from his body, "because a dead snake can still hurt you." They laid the snake by a lightning-struck tree, and if they couldn't find one, they'd lay him down by an old dead stump. Using a coal from the fire, they'd mark the stump so that it seemed lightning-struck.

The reason the Seminoles do this is that if another snake discovers the dead one, it would think the one had been killed by lightning and not seek revenge by returning to kill one of the people.[2] Even though Guy understands the biology and behavior of snakes, he couldn't tell the man who told him this story that it wasn't true. Guy said, "He had seen it work every day of his

life. So who's right and who's wrong? You can't laugh at somebody else's ideas. Some of that sounds like it's so childish, and yet it's not. It works."

Guy said, "I used to catch snakes and sell them to Frank Weed—rattlesnakes and cottonmouths and things like that—he would sell them to a place called 'Wild Cargo,' a place over in west Hollywood." (For more about Frank Weed, see *Restful Shade*, chap. 4.)

"We used to go out on dates hunting snakes," Pat offered.

"She used to hunt snakes with me and everything until the day we got married," he said, "and then it stopped immediately, strangely."

"We'd go out off State Road 27," she prompted.

"The bombing range out there, west Fort Lauderdale. We'd go in the Everglades, of course, and down the Tamiami Trail. One time we went home to her house, and her father was a big old guy. He was not so tall—"

"He was six foot," Pat interjected.

"—but he was mammoth. Big bones, a big German, and she walked in with a king snake—that was about four feet long—draped around her neck, and he went out that back door like a rocket. That was the funniest sight I ever saw—a man that big running, and boy, he was out; he was gone. And she goes out the back door, and he was in the front yard all of a sudden."

"And I chased him around the house," she said.

"Yeah, she was having a ball with chasing him all around the house . . . and her mother's screeching like a cat."

"She's Italian." Pat shrugged her shoulders. "What can I tell you?"

After they stopped laughing, Pat continued: "The first brochure I wrote, I put in there that Guy's hobby was snake hunting barefoot. Then every reporter that wrote a story about him wrote that in."

Guy said, "Frank Thomas wrote a song about me, and he put that in—'He used to catch rattlesnakes in a gunny sack'—and all that, which is true, but I guess it was more fascinating to them than it was to me. I mean, I really enjoyed doing it. I liked the thrill and the danger of it. . . . And I had people ask, 'Did you go barefooted?' Yes, I did, many times. Sometimes I didn't. It depended on the type of ground. If it was a lot of thorns and rocks, I would go with boots. If it was in swamp and water, I'd go barefoot."

When he graduated from high school, Guy enlisted in the U.S. Navy and attended boot camp in Chicago. After two months, he was honorably dis-

charged for sleepwalking. On returning home, Guy found that his father was dying of cancer, so he worked to support his family. Broward County employed him, first in air-conditioning and then as a rod man for a surveyor. A few months after his father's death, Guy married Patricia Dittmer, and by the end of that year, 1961, their first child, Cynthia, was born. In 1962, they named their second child William Alan, to honor Pat's father and Alan Jumper. As newlyweds, they lived in a travel trailer. A year later, they bought a small home in Hollywood. Guy landscaped the large yard, and to decorate it, he carved a palm log into a South Pacific Island–style statue. Their son Guy Thomas, nicknamed Shorty, was born in 1964.

As a married man, Guy worked for MacArthur Dairy, unloading trucks and then delivering milk—sometimes to a nudist camp. He supplemented his income by giving guitar lessons to teens and painting signs. With help from a school friend's father, he became a lithographer's apprentice. (Later, this man also offered the LaBrees advice on marketing and sidewalk art shows.) Of the few paintings that Guy completed each year, he sold some to friends and gave others to his family.

Because he worked nights, he liked to take his three preschool children to the beach during the day. They explored, searching for sea creatures in the shells and seaweed, and for lunch, he cooked hotdogs over a fire. Remembering his own childhood experiences, he camped overnight with them in the East Dania Marsh and taught them to swim and snorkel in rock pits, a friend's pool, and the Atlantic Ocean. At every opportunity, he explained the habits of the birds, snakes, and other wildlife that they encountered.

His friends Jimmy and Alan Jumper also married, and with their children, visited the LaBrees. They attended Alana Jumper's first birthday party and the opening of the Seminole Okalee Indian Village on the Dania Reservation, when Billy Bowlegs III was honored.[3]

Guy said, "Billy Bowlegs III came to Dania three times in his lifetime, and I have seen him three times. I happened to be there each time, apparently. I only read that in a book that he'd been there three times in his life, and I figured, well, I was in on something historic and didn't know it.... He didn't like to talk to white people, unless he knew them. He could speak English ... but mostly he would act like he didn't understand English. A lot of the older people did that."

Guy remembered seeing Billy Bowlegs III wearing Levi's, an Indian shirt, and a cowboy hat, and that's how he portrayed him in a painting. However, at the opening of the Seminole Okalee Indian Village in 1956, Guy photo-

Guy LaBree: Barefoot Artist of the Florida Seminoles

graphed Billy Bowlegs III, dressed in a turban and traditional Seminole clothing, with the Reverend Billy Osceola. Guy also snapped a picture of Reverend Osceola with a man dressed in a Scottish Highlander costume, who played the bagpipes. His presence recalls the early history of the Seminoles, when Indian traders and early settlers were Scotsmen.[4] He was brought to the ceremony from a ship at Port Everglades.

Moses Jumper Sr. was also there because he had done an alligator-wrestling show.

When the man began to play the bagpipes, Guy said, "It was louder than hell, and I was walking away. I got behind this building. Next thing, I saw Moses come around the side of the building, and he says, 'Whee,' like that." Guy winced and covered his ears to show Moses's pained expression. Walking behind him was a woman reporter, and Guy narrated their conversation.

"She said, 'What's the matter?'"

Guy demonstrated how Moses Jumper plugged his ears with his fingers. "Moses said, 'Boy, is that loud. Why does he have to play it so loud?'

"She said, 'That's just the way it comes out.'

"He said, 'Man, that's terrible.'

"She said, 'Don't you realize that more men have gone to war to the sound of bagpipes than any other instrument?'

"He said, 'Lady, I can understand that.'"

When Guy's laughter subsided, he mentioned another photograph that he had—of Alana Jumper at her first birthday party. Guy noted how well behaved she was: "She's in her high chair, and the cake's right here." He reached his hands in front of him as if he were placing a cake on a table in front of himself. "We walked back, and we were standing with a camera waiting, and she sat there looking around because she knew she's not supposed to touch the cake. So, her parents said, 'Go ahead, you can have a piece of cake.' I think even her mother, Eva, put some on her finger and put it in her mouth." However, Alana didn't attack the cake, so they all hid in the closet and emerged a few minutes later. He said, "She had it all over her face, but I think she was about ready to cry, too, because she thought she was in trouble."

Discontented with hippies, anti-America rioting, and the mistreatment of returning Vietnam soldiers by the media and antiwar factions, the LaBrees decided to migrate to Australia. In 1970, after selling their home in Florida, they endured the thirty-hour flight there with their children, ages five, seven, and eight years. They bought a house, and Guy rode a train and a ferry to work. Although he upgraded the lithography trade in Brisbane, he received

very minimal pay for his efforts; some weekends, he couldn't even afford a fifty-cent quart of beer. He made friends with his "workmates" and neighbors. (Some eventually visited the LaBrees in the United States, and they also hosted the LaBrees, with their daughter and granddaughter, for a return visit to Queensland, Australia, in 1987.)

Guy tried diving on the southern end of the Great Barrier Reef but was seasick aboard the dive vessel. Some weekends, for fun, the LaBrees bought fish and chips and fresh pineapple and went to the beach or to farm houses to pick bags of macadamia nuts. (The houses had been abandoned because a dam was under construction to create a reservoir.) They swam in ponds located a few blocks from their house. In cages in the garage, Guy kept a ten-foot carpet python and poisonous snakes. He and his sons also made pets out of frilly and blue-tongued lizards. At a mall in Queensland, he participated, for the first time, in an art show, and he sold one of his three paintings on display.

Selling their home in 1973, they returned to the United States, and Guy found a job as a lithographer, although he no longer enjoyed the work. In the 1980s, his boss allowed Guy to work his forty hours in three days, so he could have the weekends free to paint and attend art shows. At the suggestion of Alan Jumper, Guy began to paint Seminole life and history instead of the other themes he had offered unsuccessfully at sidewalk art shows around the state. He geared the prices of his canvases to the 1970s low income of the Seminoles, which earned him about fifty cents an hour to paint them.

The LaBrees camped with their three children at different places around the state, and unhappy with noisy campgrounds, they bought ten acres of pines, palmettos, and oaks in DeSoto County near Arcadia, Florida. In the mid-1970s, the LaBrees were camping on their acreage, where their home is now. Then, the land had not been cleared or improved, and only a path could be seen from the road. They heard a horn beep, and their children ran to investigate. They found Alan Jumper and his family.

Guy said, "I had told him how to get here one time, but he'd never been here. And that son of a gun remembered, and since they were in the area, they figured they'd swing on over, so they did. . . . They had a big bag of oranges, and we were eating barbecue or something, and we all just put it together and had a good time for the afternoon."

Perhaps it was that day when the LaBrees offered an invitation to Alan's wife, Eva. Guy narrated their exchange:

"'Why don't you all come camping with us?' I asked.

"And she just shook her head no.

"I asked her, 'Why not?'

"And she said, 'I've been camping since the day I was born. . . . I got a house, now, and I'm going to live in that.'"

Another time, Alan was visiting at the LaBree home, sitting on the couch admiring the coffee table, which was made of plastic with a marble top. Guy narrated their conversation:

"He said, 'That's nice. How much did that cost?'

"I told him, 'Not much. . . . Why?'

"He thought it was wood because it looked like wood. . . . He's tapping it, and then he says, 'I wish I could have something like this.'

"I said, 'You can afford something like that.'

"And he said, 'Yeah, but one of my older relatives would come in, sit on it, and break it.'

"I said, 'Well, tell them not to.'

"And he said, 'You can't tell them not to, 'cause they wouldn't understand what it's there for if you can't use it.'"

Guy laughed for a moment, and then he added, "Also telling them not to is disrespectful."

In 1976, the LaBrees tried living in California. Although they enjoyed the house they rented—with apricot trees in the yard and surrounded by friendly neighbors—as well as camping at Yosemite National Park, they soon returned to southeast Florida. In 1977, their daughter married, and in 1979, she presented them with their first grandchild.

A Sebring couple who owned a gallery saw Guy's paintings at a local outdoor show, and they hosted a one-man show for him. The LaBrees helped by preparing the food, the invitations, and buying pecky-cypress frames for Guy's paintings. The art show was a success, and a realtor who bought a canvas later began hosting one-man shows for Guy.

The LaBrees met the Florida folksingers Ann and Frank Thomas. They became friends, and the Thomases invited the LaBrees to the 1982 Florida Folk Festival in White Springs, where they introduced Guy to the festival's director. The director invited Guy to be the featured artist the following year, and over the years, he has been featured at other heritage festivals, including, most recently, the Largo Folk Festival in 2006. Another folksinger that the LaBrees met, Dennis Devine, sang ten years later (with his group) at Pat's college graduation, and twelve years after that, he bought the Guy LaBree domain name and set up a Web site for the LaBrees: www.guylabree.com.

In 1982, an entrepreneur became interested in Guy's art, and he offered Guy a salary in exchange for ownership of whatever he painted. With the promise of steady income, the LaBrees felt comfortable with Guy quitting his lithographer's job and painting full time. In 1983, after their youngest son's graduation from high school, they moved to Arcadia. When the entrepreneur would not sign a contract, Pat suspected that he was a fraud, and his actions soon confirmed it. One positive result of this bad business deal was an introduction to Brad Cooley, a sculptor, just starting out in north Florida. Since then, Guy has introduced Cooley to the Seminoles, and the two artists have participated in many two-man shows on the reservations and at other locations.

By pursuing commissions they had refused during the five months they were trading paintings for a steady income, the LaBrees restarted Guy's art career. Since then, his paintings have been exhibited at museums and colleges as well as regional wildlife art shows, and he has won numerous awards. (A partial list of exhibitions follows.) In addition, he presented seminars for the DeSoto Campus of Florida Southern College, the Fort Lauderdale Historical Society, the Florida Center for Teachers, and for the University of South Florida in St. Petersburg.

His paintings appear on the covers of *Guns of the Palmetto Plains*, a "Cracker western," by Rick Tonyan; the second edition of *The Story of Florida's Seminole Indians*, by Wilfred Neill; *The Battle of Okeechobee*, by Willard Steele; and a reprint edition of *Light a Distant Fire*, by Lucia St. Clair Robson. Regional magazines and newspapers across the state have published feature and news articles about Guy, and his paintings have been published on their covers. His art has also been featured in programs and other printed pieces for Seminole-sponsored events and information as well as appearing regularly in the pages of the the *Seminole Tribune*, the official newspaper of the Seminole Tribe of Florida for more than twenty-five years.

In the summer of 1993, Guy painted a mural, *Lake Istokpoga Village*, on the corner of North Main Street and West Bellview Street, in Lake Placid, Florida, for the Lake Placid Mural Society. Sponsored by the Noon Rotary Club, the mural is thirty-two feet wide by thirteen feet high.

Guy recalled that he had just started to paint the bottom areas of the mural when some schoolchildren passed by:

"They're looking and they're talking, laughing and joking around, so I'm thinking to myself that I'm going to be fixing graffiti here every day." So he asked which one of them was good at art, and one boy pointed to another.

"I asked him, 'You want to help me with this over here?'

"He said, 'Sure,' so I gave him a brush and let him fill in an area.

"The other kid said, 'Well, I can do that,' and I gave him a brush, and this other kid a brush, and I had all these kids helping, so I never had trouble with graffiti.

"I told them while we were painting there, I said, 'I just hate it when somebody's going to come up here and mess this up just because they got nothing better to do.'

"And they said, 'Nobody will mess with it,' and they didn't. . . . It was part of their handiwork."

As Chief of the Seminole Tribe of Florida, James Billie became a full-time art patron. For twenty years, he commissioned or bought five dozen paintings for his home, his office, and as gifts for others. In 1981, he arranged an exhibit in the secretary of state's office in Florida's Capitol Building in Tallahassee (where Guy's paintings were again displayed in 1984 and 1985), and the Tribe sponsored Guy as an exhibitor at Seminole gatherings around the state, including festivals, grand openings, museum exhibits, and reenactments. In 1982, James Billie hosted a one-man show for Guy at the Native Village, a privately owned tourist attraction on the Hollywood Reservation. Government officials and important tribal members attended the opening reception, and Guy's friend Jimmy Jumper introduced him. James Billie invited the LaBrees to his wedding with his second wife and their wedding reception at Disney World, and for a second reception at the Big Cypress Reservation, he commissioned Guy to paint a humorous image for the invitation.

In 1986, James Billie asked Guy to exhibit his paintings at a powwow honoring Cory Osceola at the Naples Depot Museum. While there, Guy met a new art patron, Bill Elett, who now owns a considerable collection of LaBree originals. The Eletts enjoy taking the LaBrees out to dinner, inviting them to parties, and lavishing gifts on them and their four grandchildren. They included the two youngest girls on an annual summer vacation in Orlando with trips to Disney World. In return, Guy arranged trips to Billies Swamp Safari for the Elett family to be photographed with alligators and to tour the Big Cypress Swamp.

Guy said, "We were sitting around Native Village, the way I recall, with James Billie, Richard Bowers, Dan Bowers . . . I think, I'm not sure who all was there. They'd been working around the place and were taking a break, and we got

talking about going camping . . . the old ways, the old days—get your matches and your knife and go camping and make it out of whatever was out there. Then I said that now it was new to me—we'd just started going camping with a family—we got kids and all that—tents and tables and chairs and all kind of stuff to bring along.

"James said, 'You ain't alone. I gotta a whole dad-gummed RV to get used to with stuff in it like a house.'

"I said, 'Yeah, you sit out there watching TV in your travel machine, and I'm in a tent.'

"He said, 'Isn't that weird how things have changed around over the years. Now I'm wearing shoes, and you're not' ('cause I wasn't wearing shoes at the time). Then he said, 'Barefoot Artist, Guy LaBree.' Or it might have been Richard Bowers that said that—I'm not sure which one. James was the one that said, '*A Bosh Che—Will A Tee Chee*,' and explained what it meant— 'mocker without shoes'—because they don't have a word for artist, so they use the word 'mocker' and describe with their hand [Guy gestured with his hand as if painting with a brush] so they know what kind of mocker. However, when translated into English, the name is rendered 'barefoot artist' or 'barefoot image-maker.'"

Later, at the opening of "The Seminole Village" in Tampa, where the Seminole Hard Rock Hotel and Casino is today, James Billie was announcing on the stage. Guy remembered "a huge crowd was listening when James Billie said, 'And there's Guy LaBree back there, the barefoot artist. Guy—show them your feet.' Of course, I was wearing shoes. . . . Patti had wanted me to dress up and wear my boots. So after that, James came over and chewed me out. He said, 'When you come to these things, you come barefooted.' That was all right with me. I liked being barefooted."

Another time at a festival in Tampa, Seminole Medicine Man Bobby Henry made it rain.[5] The LaBrees were displaying paintings beneath one of the chickees. Guy recalled, "Bobby had been saying for several weeks that he was going to make it rain the last day of this festival he was having—in the afternoon. It had been hazy like this, but it never rained. So we went over to watch him do it, and he had these women that were with him helping him by hitting this chickee pole with their dresses. He had a turtle shell he was working with, a bucket of water, his rattles, and his knife. It was very quiet. It wasn't the dancing-around, yahoo-type thing that you think about. It was very quiet. He would shake a rattle and talk to himself, kind of quietly, praying.

"I'm looking up at the sky, and all of a sudden . . . the sky's just turning black

and rumbly." He could see clouds racing across the sky even though he felt no wind. When Bobby finished, he announced that if it didn't rain within an hour, he would not take credit for it. By the time the LaBrees walked back to Guy's display of paintings, the rain was pouring. When Bobby joined them, he asked them if they believed. Full of mirth, Guy remembers that his wife said, "You could have waited till we loaded our stuff up."

In the 1990s, Guy's health began to deteriorate from past decades of smoking, weekend drinking, and indulging in fatty foods, especially his favorite—donuts. He started on medicine to control his high blood pressure, but he hated the reactions his body had to it. He informed the doctor he would not take the medication while he was on vacation. The LaBrees, with their granddaughter Melissa, drove to see Guy's brother's in South Carolina and then visited his mountain cabin in North Carolina. From there, they traveled to Albany, New York, to another relative, then to a bed and breakfast inn in Bath, Maine, near where the LaBree ancestors had lived in the 1700s. After exploring Maine—seeing Stephen King's house and touring Acadia National Park—they journeyed to the nation's capital and then returned to Florida.

As Guy became increasingly short of breath, they didn't recognize that he was suffering from congestive heart failure. Four months later, he suffered a ministroke and a silent heart attack, but he refused to go to the doctor. By Christmas, he had regained his normal speech, but he was short-winded constantly. Finally, in early 1992, he caught the flu, which aggravated the symptoms of his congestive heart failure, and he agreed to take medicine for his high blood pressure again. Tests showed that the damage to his heart was so extensive that surgery was not an option; he was given two years to live if he did not change his diet. Along with eating healthy foods, he began chelated vitamin therapy. A man who officiated at his son's, and later his granddaughter's, wedding introduced Guy to a psychic healer in Ft. Lauderdale, and although Guy was skeptical, one session with the healer improved his energy.

But Guy's health difficulties increased, and in 2002, a defibrillator with pacemaker was surgically implanted in his chest. Two years later, when the defibrillator/pacemaker was recalled by the manufacturer, a surgeon replaced it, pro bono. In appreciation, Guy painted a portrait of the surgeon's son as a gift.

When visiting at the LaBree home before Guy received his first defibrillator, Medicine Man Sonny Billie learned of Guy's damaged heart. He made a spe-

cial medicine for Guy and instructed him how to use it outside. Even though it was winter, Guy did as he was told. "And by then you're so damn cold, that you either catch pneumonia or you're cured," he said with a laugh. "But I did feel better later. I have to say that. Every time I used it, I felt better."

Sonny Billie also claimed that he knew when Guy would die, but he wouldn't tell them. "He said I had a ways to go yet," Guy said.

Pat said, "Here's a little background information about Sonny. He was from a family of medicine people. And they kept a certain line going. They knew he would grow up to be one of them. He didn't, and he sort of rebelled against it for a long time, I guess, when he was a teen."

Guy added, "He thought all people who were older could do medicine because all his family could do medicine, and he said that once he was at some kind of a show—a big crowd of white people, and somebody passed out. He's looking at this older guy he was with who wasn't in his family, and he kept asking, 'Aren't you gonna help him?'

"And the guy said, 'I don't know how to help him.'

"He said, 'You got to know how to help him.'

"The guy said, 'I don't know. You're into medicine. You do it.'

"Sonny didn't know what to do at the time, so he started working on it. That's when his family started explaining it to him. And he learned from seven different medicine men—"

"—and women," Pat continued, "so his information was passed on from previous generations."

Most days, Guy spends at his easel. Otherwise, he gardens, and flowers bloom throughout the year around the LaBree home. In 2004, it was spared by Hurricane Charley, the fifth hurricane that Guy has survived. However, the storm broke and killed more than one hundred pines and oaks on their ten acres. Vines bury the dead ones and new branches sprout on the living trees, and they continue to provide a haven for wildlife, including panthers, bobcats, foxes, quail, owls, hawks, snakes, and many others.

At other times, Guy and Pat drive thousands of miles to deliver art and to call on friends and family. During the summer of his sixty-fifth birthday, he and Pat treated the two youngest teen granddaughters to their first car trip outside of Florida. At home, he enjoys visits with his grandchildren and great-grandchildren.

Members of the Tribe frequently invite Guy and Pat to judge contests on both the Hollywood and Brighton Reservations, and, honored, they always accept. Two of Guy's paintings were reproduced and he received "special

thanks" in the commemorative anniversary book *Seminole Tribe of Florida Celebrating 50 Years, 1957–2007, of the Signing of Our Constitution and Corporate Charter.*[6] At the grand openings of the Seminole Hard Rock Hotel and Casino in Tampa and Hollywood, Guy was the one fine artist to display and sell work amidst the Seminole craftswomen. Pat and Guy spent a few days at the hotel suite as guests of the Tribe, and while they were at the big Seminole party around the Hard Rock pool, Councilman David Cypress showed his appreciation for his large collection of LaBree paintings by sending an electric guitar, as a gift, to their room.

As a teen, Guy had a "garage rock band," and during the past decade, he has started playing guitar again and attending a weekly gathering of musicians. They sing tunes written and performed by a range of artists, including Guy's favorites: Johnny Cash, Hank Williams, Willie Nelson, as well as Florida folksingers Frank Thomas, Gamble Rogers, Will McLean, and Don Grooms. Now, Guy shares these stars with his friends under the same stars that he, Alan, Jimmy, and David Jumper once watched in the night sky above U.S. 441 in Dania, Florida.

The following is a partial list of exhibitions of paintings by Guy LaBree not otherwise mentioned in this book:

MUSEUMS

Pioneer Florida Museum in Dade City (1979, 1981, 1982)
Lake Wales Museum and Cultural Center (1984, 1992)
Missouri Jefferson Barracks Museum (1987)
Boca Museum of Art (1988)
Tampa Museum of Art (1988)
Fort Lauderdale Historical Museum (1990)
Dade City History Museum (1991)
Loxahatchee Historical Museum (1991)
Collier County Museum (1987–1995)
Tallahassee Museum of History and Natural Sciences (1995)
Florida History Center and Museum (1998)

COLLEGES AND UNIVERSITIES

University of Tampa (1982)
University of Florida School of Forestry (1986)

Brevard Community College (1988)

Rollins College (1989)

South Florida Community College (1989, 1993, 2007)

Florida Southern College, DeSoto Campus (1990–1992)

Manatee Community College (1995)

Eckerd College (1999, 2000, 2001)

University of South Florida in St. Petersburg (2000)

WILDLIFE SHOWS

Southeastern Wildlife Exposition, in Charleston, South Carolina (1989, 1990, 1991)

Florida Wildlife Exhibition in Orlando (1994, 1995)

Seminole Legends

Many artists excel at portraying the likeness of a particular person, animal, object, or landscape, but they shy away from depicting imaginary worlds. However, in these canvases based on legends told by his Seminole friends and patrons, Guy LaBree exhibits a talent for painting fantasy as fact. A tribute to his skill is the collection of his paintings that illustrate *Legends of the Seminoles*, as told by Betty Mae Jumper.

Until Jumper wrote her book, few legends of the Seminole oral tradition had been published, and the amateurs as well as professional ethnologists and anthropologists who recorded them usually did so outside the traditional storytelling context. However, in the Seminole family that Guy visited, when it was bedtime for the children, everyone—even the older folks—gathered: "Somebody—either an old man or an old woman usually, or even a younger one if they were practicing the stories—would tell one of these stories, or two stories, to the kids to give them something to think about while they're drifting off." He recalled how some storytellers prolonged their tales by weaving their friends and relatives into the plot.

Participating in the custom of the oral tradition, he learned the creation story depicted in *Genesis* and *Exodus* from Medicine Man Sonny Billie. Guy repainted some details as requested by Sonny Billie and other Seminoles to ensure the authenticity of the portrayals. Also commissioned to paint *Bridge to Eternity*, Guy changed the original picture according to the patron's wishes, and two decades later, he repainted the damaged canvas to "repair" it as well as to create a more faithful version of this afterlife legend.

Guy often praises a narrative by saying, "It makes pictures in my mind," and his own interests may guide his choice of what to paint. In the thunderstorm tale, for example, the flying snakes appealed to him so he focused on them in *Sons of Thunder*. In addition, he uses his own observations of the natural world, as in *Water Lily Lovers*, to a create a supernatural scene inspired by the origin of the water lily.

In addition to his extensive knowledge of Seminole history and culture, he consulted with Seminole friends about the story of "invisible people" to envision the scene in *Vanishing Ceremony*. When his sources were silent on some aspects of the legend of the "little people," as in *Time to Go Home*, he conjured the details within the guidelines given to him.

Kissimmee River Legend is based on a complex story, and Guy learned the meanders of the tale from a series of storytellers. Other stories are more personal: *When the Time Comes* is the embodiment of one man's dream, yet this portrait of a cattleman evokes a Seminole and Florida heritage.

Guy can only paint the essence of each legend, and as a natural storyteller, he feels frustrated by having to tell the tale in a single scene. However, such freeze frames fit his goal for painting the Seminoles because the viewer of an intriguing scene may seek others to tell the rest of the story.

Genesis and *Exodus*

When he was asked to portray the Seminole creation myth for the Smithsonian National Museum of the American Indian, Guy first painted three prototypes based on what was told to him by Seminole Medicine Man Sonny Billie. After consultations with Sonny Billie and other Seminole traditionalists, he painted two final canvases that his wife, Pat, named *Genesis* and *Exodus* (see figs. 1 and 2). The reproductions of them that now hang in the National Museum present an authoritative representation of the Seminole creation legend.

During a 1999 event at the Ah-Tah-Thi-Ki Museum on the Big Cypress Reservation, Director Billy L. Cypress introduced Guy to Sonny Billie. When Sonny Billie first told Guy about the project in 2000, he did not immediately understand that the request came from the Smithsonian. They were on the Big Cypress Reservation at the Kissimmee Slough Reenactment, an annual staging of a battle from the Second Seminole War.

Guy said, "Sonny Billie called it Smith's, Smith's Museum, and I'm thinking, well, there's a million museums around. He said that Smith's wanted to know about the beginning of people, and nobody else even knew the story, or

knew all the story. That's the way he put it. He said he did, so he would tell them the story. They said they wanted an artist to do the painting, and they'd get an artist to do it if he'd tell them the story, but he said, 'I don't want *any* artist. I want Guy LaBree.'"

Pat said that Sonny Billie had seen a collection of Guy's art at the home of James Billie when he was chairman of the Seminole Tribe.

Billy L. Cypress negotiated with the Smithsonian. When he explained that the Smithsonian's budget did not include enough funds to pay for the commissions, Guy heard that James Billie responded, "The Tribe will pay for it, but they're not getting the originals. We'll send them copies." So the Tribe sent digital reproductions, *giclées,* to the Smithsonian, and the original oil paintings are now on display in the Tribal offices on the Big Cypress Reservation.

Sonny Billie visited the LaBree home several times so that Guy could learn the creation story. Rather than taking notes, Guy tried to learn the legend in the oral tradition.[1]

Guy said, "So I was just trying to be polite and listen to him. He told the story lots of times, and then . . . he'd say, 'Don't you know it?'

"I'd say, 'Yeah, but I just heard you. But let me make sure I got it right, okay?' And then he'd correct me, and so every time after that, he'd make sure I would tell him back."

Pat said that the legend is about the beginning of all people, and that, although the Indians come into the world first, the other races follow. Over the years, other origin myths have been recorded.[2] However, they are outlines at best, lacking the rich details that the LaBrees learned from Sonny Billie and that Guy worked diligently to realistically portray. He said, "The only thing in these paintings that is mine is the waterfall. I couldn't figure out how else the water would get there."

First, Guy painted three large prototypes in acrylic, a quicker and easier medium than oil paint. When they were finished, the Seminole Tribe arranged a gathering at the Big Cypress Reservation, inviting those of the Tribe who were involved in the medicine tradition. Until they attended the dinner, Guy and Pat had not realized how many of their friends were knowledgeable in these matters. During the meal, each one, in turn, looked at the paintings by himself or herself. At the end of the meal, Sonny Billie talked with each one because he wanted to make sure he had not missed anything. Guy remembered, "There were five mistakes, and every one of them found those five."

One canvas showed a tree with its roots growing around a cave. Eventually, the roots would crack it open and release the people. He painted the cave as a

cross-section so the people inside can be seen. One of those was a black man crouching beside the other three men standing in a reddish oval. Each of the three has the symbol of his clan over his head.

However, according to Sonny Billie, the men in the cave were all Indians, so Guy corrected the image. After the men emerged from the cave, they all washed in the river. The fourth man, Guy said, "washed last, and the water was muddy, so his hair got all black and kinky, and his skin was all black from the mud."

Sonny Billie also asked Guy to indicate that the men appeared first and the women later, so Guy added ghostly images of women's faces inside the cave.

Another prototype canvas shows a mountain of jumbled boulders with a body of water at the base. On the level ground between the water and the scree slope, a ghostly hand plants small trees. Sonny Billie told Guy that the mountain is "the backbone of the world." Moving his hands as if sculpting the circumference of a sphere, he described how the mountains once encircled the globe, with the ocean on either side. Later on, the mountains split, but pieces of the "backbone of the world" form all the mountain ranges in the world, including those in the United States, Tibet, and Africa.

When Sonny Billie first saw how Guy had painted the mountains, he thought that they looked like an alligator with its mouth open. He asked Guy to repaint the "backbone of the world" in profile. Sonny Billie also wanted another change, actually an addition. According to the legend, during the time that the trees grew around the caves, dinosaurs and other creatures lived on earth, but before people emerged, the Creator destroyed those animals that would harm humans. So Guy painted a tyrannosaur and a pterodactyl in the background of *Genesis*.

In another of the prototypes, Guy had depicted small figures who had emerged from the caves, but Sonny Billie wanted them to be larger. In addition, he requested that the cross-section of the cave be incorporated into this scene, now called *Exodus*, so that the story would be told in two paintings instead of three.

The distinctions among the members of each clan are important to the scene in *Exodus*. Sonny Billie told Guy that a heavy mist covered the land. The man of the Panther Clan asked the man of the Bird Clan to dispel the fog, but he was so mesmerized by the new world that he did nothing. So the man of the Panther Clan asked the man of the Wind Clan to blow away the clouds, and he did so. Guy pictured a mound of earth, with the man of the Wind Clan standing on top with his hand raised. The mist is thick above— and cleared away below—his hand.

When Sonny Billie saw the final painting, he complained that there wasn't enough mist. Guy explained, "I had to cut back on the amount of mist, or you wouldn't be able to see anything."

Sadly, both Billy L. Cypress—whom Guy had known since elementary school—and Sonny Billie died before the Smithsonian National Museum of the American Indian opened. However, Sonny Billie's telling of the Seminole creation myth and his critiques of their representation give authenticity to the paintings *Genesis* and *Exodus*.

Bridge to Eternity

When James Billie first saw this painting that he had commissioned, he asked Guy to repaint the night sky because the stars weren't accurate (see fig. 3). Guy said that he had positioned the stars at random. His wife, Pat, reminded him that James knows celestial navigation, and she remembered that he particularly wanted Guy to portray the North Star. He recalled, "So I'd sit out there at night when I was living in Hollywood, when it was really, really dark, and there wasn't many clouds," to paint the stars glittering in the western Everglades sky.

James Billie had told Guy that after a man dies, he travels at night to heaven, not the traditional Judeo-Christian concept, but rather a place where the spirits will have "a good way to live." That place appears in the painting as the light blue sky in the distance at the horizon.

The warrior glows with a special light as he walks through the darkness.[3] Guy said, "When they were alive, they had scarred their arms in different ceremonies. After their death, the scars would light up like beacons and help them see the bridge so they didn't step off."

The Seminoles believe that this journey is perilous: a person must cross the sky on a narrow bridge over a bottomless pit inhabited by evil spirits and terrible creatures. Guy painted the sides of the pit as rock walls writhing with the faces of evil spirits. As James Billie told Guy, such spirit-creatures vary according to the person's clan, with natural animal enemies opposing each other. For example, if the man on the bridge belongs to the Bird Clan, then the beings below may be snakes because they eat birds. If a man of the Snake Clan crosses the bridge, he "might have giant birds down there because birds eat snakes."

The warrior wears a traditional "long shirt," leather leggings, and moccasins, which are made from one piece of leather that is sewn up the front.[4] Using a pair of authentic Seminole moccasins, Guy demonstrated how it can

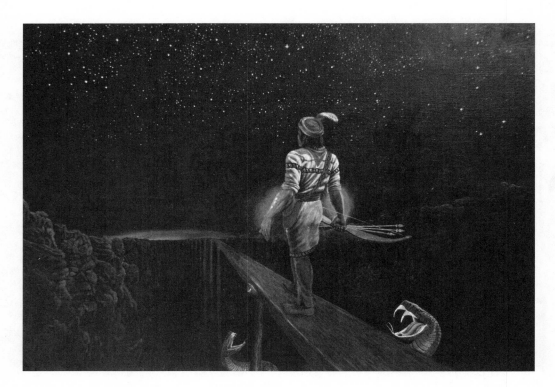

Bridge to Eternity, original, 1982. Oil on canvas, 24" × 30". James Billie Collection. Copyright Guy LaBree.

be tied low on the ankle like shoes or high on the leg like boots. The deerskin ones he owns were made and signed by Jimmy O'Toole Osceola. Besides moccasins, Osceola also fashioned clothing and other traditional Seminole items. "He invented the short-sleeve Seminole jacket," Guy said, describing a shirt with short sleeves and a short waist, designed to be in keeping with the traditional long-sleeved, long-waisted jacket.

William C. Sturtevant summarizes the distinctions in the "shirts" worn by the Seminole men: "Thus the four man's garments are uniquely defined by combinations of a few features: the coat or 'long shirt' has a full front opening, cape, and ruffles, and is long; the modern 'shirt' is uniquely short, always has several bands of patchwork designs, is always worn with trousers, and usually has a full front opening; the 'big shirt' is long, has a chest opening only, may have patchwork designs (almost always does now), and is unique in its constricted waist with skirt below; the 'straight shirt' hangs straight without waist band, has a chest opening only, and never has patchwork designs."[5]

Almost twenty years after Guy finished *Bridge to Eternity*, he repainted it. James Billie had displayed the original canvas in his Native Village, a tourist attraction on the Hollywood Reservation. In the art building built near a pond, the artwork hung on a wall beside sliding glass doors that were usually open. Humidity caused mildew to grow on it. Cockroaches were eating the paint, and they had laid eggs all over the back of it.

After cleaning it, Guy said, "I painted the whole back of the canvas—mainly to support it—in case it was going to start cracking. Normally, they don't go bad like that in just twenty years, but they're not normally kept in that kind of environment." He added a resin to the paint to keep it from buckling again before repainting every feature of the painting except the stars. "I redid all the black around every star," he explained, because cracks in the black paint showed the white canvas beneath.

When Billie asked Guy to repair the canvas, he also told Guy that he wanted him to change the content. James Billie had talked with some older Seminoles, who had told him that the "narrow bridge" is the ribbon of stars across the night sky known as the Milky Way.[6]

So Guy painted a path of stars to conceal the original narrow wood bridge. That change meant that other details had to be altered as well, including a snake that had been coiled around a support pole for the bridge.

"I touched all this up," Guy said, waving his hand over the canvas as if he were a magician rather than a painstaking artist. "That's why it's brighter."

Sons of Thunder

Guy was intrigued when his Seminole friend Jake Osceola told him a story about storms. In late spring and early summer, storms full of lightning and thunder blow across the state from the west. They are the "sons of thunder," young men riding on flying snakes. Out over the Atlantic Ocean, they mature and return to Florida as hurricanes.[7]

Guy said, "I just liked the idea of them riding the snakes."

Most people think of a thunderstorm as layers of gray clouds, but he painted sky, too. "Blue and gray and purple—a little blue showing through. If you don't have something showing through, you can't make clouds. You got to have something to bounce colors off of. . . . You know how the clouds light up when the lightning's flashing? That's what I did—made it lighter than I would've had it."

Although Jake Osceola's narrative did not specify how many sons of thunder rode in each storm, Guy portrayed two (see fig. 4). One shoots lightning bolts as if they were arrows, and the other throws them as if they were spears. The wings on the snakes are modeled after those of the flying fox, which is a fruit-eating bat not native to Florida, but the snakes do not resemble any species that live in Florida or elsewhere. Instead, he used people's misconceptions about snakes to create these. He said, "I don't, but people think of them as evil. . . . People think of snakes as being green, which they're not, and slimy, which they're not, and eating dust, which they don't, and all of them

have fangs, which they don't." Laughing, he conceded, "Fanglike teeth they do have."

Often Guy relies on their distinctive clothing to identify Seminoles in his paintings. However, in this composition, the young men are naked, so he created another way to specify the scene. He used the lightning to outline several symbols, which he pointed to as he named them: a Seminole woman with her distinctive coiffure, ball sticks and a ball, a man poling a canoe, and a chickee. He noted that the shapes are "rough and crude," but he didn't want the forms calling too much attention to themselves. "They're just made out of that little fine crackly lightning—spider lightning, some people call it."

In 1979, when Guy was still living in Hollywood, James Billie was building his Native Village. Guy often visited, assisting with the construction and listening to James tell stories. His tales often inspired Guy to paint.

When Hurricane David threatened the coast, meteorologists predicted a landfall near Miami, with a projected path through Broward County. On September 3, the eye was thirty-five miles east of Fort Lauderdale.[8] After Guy secured his own house, he went to the Native Village to help James, but he wasn't there. Guy found him at his home talking with Henry John Billie, a member of the Wind Clan. "I told James that I had come to help him board up the place, if he wanted, so it didn't blow away, and he said, 'It ain't going to hit here. Don't worry about it.'

"I said, 'It's hitting Miami right now. It's just starting.'

"He said, 'No. It ain't going to hit here. This man here [indicating Henry John Billie]—he knows how to turn them.'"

Guy remembered how this statement shocked him, and he thought it was a joke at first. Then James told him how Henry John Billie had chanted as he placed an ax that will "cut the wind and make it turn" in a tree.

"I told him I'd be back to help him clean up the wreckage, and I left." On his way home, Guy saw the ax tied in the branches of an oak, as James had described.

Strangely enough, after skirting the Miami area, Hurricane David pushed back into the Atlantic and made landfall at Melbourne, farther north on Florida's east coast.[9]

"If people out there that heard what he did didn't believe in it before, I bet you they do now." Guy chuckled. "Because I sure as heck did. That was amazing."

According to this legend, a hurricane is the "sons of thunder" returning from the Atlantic. Guy said, "I don't know what the rest of the story is on that, other than coming back and tearing things up. Now, there must have been a reason for that, too, but I didn't hear that part of it. . . . Sometimes you can

hear a story, and then you find out later you only heard a piece of it, and you think you heard the whole thing."

Water Lily Lovers

A legend about the origin of water lilies inspired this painting, and Guy noted that stories like this one are used by the Seminoles to teach their people how to live (see fig. 5). He compared them to Aesop's Fables because they often have morals. This one is a tradeoff. "They had to sacrifice the woman to get the shade for the fish," Guy said. "The fish were complaining that there's nowhere for them to get out of the sun. It was hurting their eyes because they don't have eyelids."

His keen observations of nature provide the details that transform this supernatural occurrence into a natural scene. For instance, he pointed out the fish in the painting: "A big catfish, a bass, bream, a garfish up near the top—just regular Florida fish." He mentioned that many ponds in Florida have water that's tinted brown with tannic acid leached from fallen leaves, but he painted this water green because he imagined this pond as fed by a freshwater spring. Even though the woman is underwater, her dress hangs naturally because she's been submerged long enough for the air bubbles to rise from it. The view is a dual perspective, revealing the woman below and the man above the water. From years of swimming and diving in Florida waters, Guy knows both points of view.

He also appreciates this story because he raises water lilies. "My first ones, that I got started with, I had taken out of the wild. They're just the regular wild Florida water lilies [*Nymphaea odorata*] that are white with the yellow centers." That lily is the model for the one in this painting. He also grows purple, yellow, and blue water lilies. "I have a pink one out there I'm real proud of, and I'd like to get a red one sooner or later. And once you get them, if you take care of them, they do proliferate. They do it two ways. They send out a rhizome under the ground, like grass, and . . . at the base of the lily pad inside, there's always a little plant growing."

He has three ponds for growing water lilies, but one is unusual. "It was a satellite dish, which is now doing a much better job as a lily pond," he noted with his characteristic humor. "We call it the dish pond." Such a transformation seems as picturesque as the one he portrayed on this canvas.

The setting for the legend is the time of creation, when the animals talked and the world is in process. Two young lovers were meeting every day by this pond, so when the woman arrived first, the Creator snatched her up and dunked her into the water.

Guy said, "She grew to the bottom of the pond. Her face became the flower of the water lily, and her hands became the lily pads." Unable to talk, she cried. Her tears formed dew droplets on the flower, and her breath was its fragrance. Her lover searched for her, calling her name as he walked around the pond. "He could never see her," Guy said, "and she's right there. But the fish had their shade from then on."

Vanishing Ceremony

For many years, Guy wondered about a story he had heard about invisible people. On moonless nights, when an overcast sky obscures even the lights of Miami, a person looking out over the Everglades may see "a glow over the top of one of the hammocks, and that's supposed to be the glow from their fires."

Eventually he asked a Seminole friend, Scarlet Jumper Young, if she could tell him about the invisible people. Although she had heard of them, she felt she needed to know more. After talking with several other Seminoles, she told him that toward the end of the Second Seminole War, many people had wearied of the conflict. They wanted to be left alone, to live in peace, without being forced to move or assimilate. They participated in a ceremony that made them invisible so they could live wherever they wanted without anyone harassing them.

Rather than painting that mysterious glow in the nighttime Everglades, Guy imagined the ceremony, though the details of it have vanished as completely as the people who participated in it (see fig. 6). A Seminole friend suggested certain elements to include and other details to omit because he thought that they should not be shared with those outside the Seminole religion. Guy said, "Between him and me, we got it together. It's just like a figment of our imaginations." He laughed at the obvious cliché.

For the setting, he chose a shell mound that may have been built by the indigenous inhabitants of Florida. The one in the painting is so ancient that huge trees grow on it. "The shells that they're using to drink out of would have come from this mound. They just used what was there—that's in my mind."[10]

Two medicine men knew how to perform the vanishing ceremony: a Choctaw[11] and a Seminole. They let it be known that the ceremony would be performed for the last time because they were the only ones who knew how to do it. Designs in their clothing distinguish them: on the mound, the Choctaw boils a concoction, and on the ground, the Seminole sings as he walks around a circle of "medicine colors" (red, black, yellow, and white).

Such songs or chants are integral to the Seminole religion. Guy once asked Stanley Smith of the Seminole Tribe of Oklahoma about the importance of chants, and Smith told him, "With a glass of ice water . . . I can cure common diarrhea in about fifteen minutes with a chant."

Those participating in the ceremony wear historically accurate, early nineteenth-century clothing, as do the witnesses gathered in the left foreground. Also, the Seminole medicine man shakes a rattle made from a box turtle shell. It has an attached handle and is filled with seeds.

Guy modeled it on a rattle made for him by his Seminole friend Jimmy O'Toole Osceola. He decorated it with beads and feathers, although traditionally it would not have had them. Guy commented, "I had to wait on these for, like, six months, and the reason why was because those seeds inside come from a water plant that they call pond flag [*Canna flaccida*], and they weren't in season yet.

"And I said, 'Why didn't you just put some black beans in there or something?'

"He said, 'You want it to be the real thing and sound like it.'

"So we waited," Guy said.

The drum is a hollow log with a slot in the top,[12] and Guy has seen similar instruments depicted in some sources he has read.

The structure through which the people walk as they are vanishing resembles the "Big House," a feature of the site used during the Green Corn Dance, or annual festival (see more details in *Screech Owl Dance*, chap. 2). Sometimes referred to as an arbor because of its "palmetto- and brush-covered roof," the "Big House" is where the men rest or eat or watch when they are not dancing during the multiday ceremony.[13]

Showing the people gradually disappearing challenged Guy's artistic abilities, and he created a special technique to portray this process. First he painted all of the background details, and then he painted the people becoming progressively transparent as they pass through the structure. His technique— sometimes called glazing—required him to add more and more Liquin to the paint to thin its consistency and ability to mask what is beneath it.

"So there's two or three people and then suddenly, there's nobody . . . the people are see-through, really see-through, and then you barely can make them out." After a moment of reflection, he added, "If the Seminoles could have just found a way to kill the soldiers while they were invisible, they'd have won that war. Unfortunately, it didn't work that way."

When he finished the canvas, he displayed it during a three-day powwow in Collier County. He was surprised that no one talked to him about it. Then, on the last day of the show, he was approached by some older Indian women

whom he had never met. They told him they lived on the Tamiami Trail Reservation.

"And they said, 'We think you ought to know how it really happened.'

"And I said, 'Well, hey, I'm not going to say that it didn't.'

"They said, 'Well it did, but not like that. They drank poison. And that was all.'

"And I said, 'I wasn't trying to get into something like that.'

"They said, 'No, it's all right, because we can tell our kids the story by looking at that painting. Tell them the one story, and then the other part of it.'"

Guy was grateful for the insight that these Seminoles shared with him, and their approval of the scene he had imagined. At first, he believed he had failed in his quest for accuracy, yet he felt better when he realized that the women had said his painting provides an opportunity for Seminoles to talk about their history. After all, to inspire dialogue between the generations was one reason he began to paint the lives and legends of the Seminoles.

Time to Go Home

Guy remembers hearing about the little people when he was a boy visiting the reservation. He was told that lightning bugs were little people out hunting. Riding on flying insects, they carry torches to light their way. He said, "That was to make you go catch one and see what it was." That memory inspired another canvas, called *Fireflies*, in which an old man tells this tale to a boy as the winged insects—bearing little people with torches aloft—parade past their faces.

Thinking about such stories as an adult, he wondered if his Seminole friends were teasing him. So he talked with Medicine Man Bobby Henry, and the following exchange took place. Guy asked:

"Well, what do they look like?"

"What do you think they look like?" In other words, he wasn't gonna tell me what they look like

"I don't know. Maybe little, bitty people. . . . How big are they?"

"How big do you think they are?"

"What do they wear?"

"What do you think they wear?"

The conversation continued in the same way.

Finally, Guy said, "I'll just make little bitty ones, and I won't put clothes on them. That'll just save me a lot of time. So that's why all the ones I do are the ones I just made up. . . . I don't even know if it's even close to what they call little people. But I call them that because that's what they are."

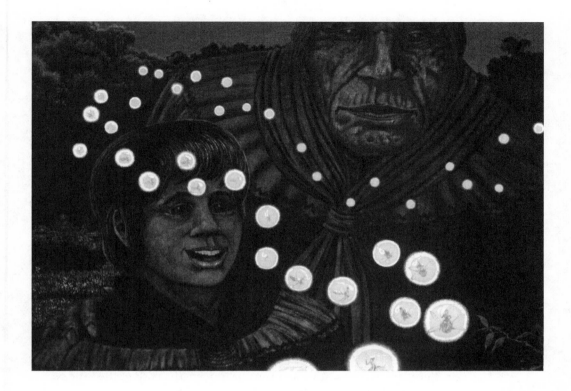

Although *Time to Go Home* features the little people as its subject, he includes at least one in almost every picture (see fig. 7). He calls it a gimmick, something like a joke: "I like to put jokes in paintings—when I can—that somebody will find years later, maybe." He included a "joke" in an early painting of a Seminole woman sitting on a blanket, wearing a plain bracelet around her arm. "When I got all done with it, on the inside of that ring, there in one spot, I put in little bitty letters—it took me a while to do it, even—'made in Japan.'" About two years later, the owner of the painting telephoned Guy. He had just discovered the miniscule lettering, and he was astounded. Guy's delight is evident in his laughter even before he acknowledges how much he enjoyed it. Often he hides other items, especially in a Florida wildlife scene: part of a Coke bottle or a rusty can hidden in the grass or sand. "I don't do it a lot, but once in a while, I . . . throw something crazy like that in there."

Similarly, the first time he included a little person in a painting—"in the saw grass, a little old bitty guy, in this poling scene"—somebody spotted it as soon as he showed the painting. "So then, somebody else wanted to know if they were in all of them, and then I got thinking, 'Well, maybe I ought to start throwing in a little guy or little lady—some here and there—for fun.' And now, it's kind of like I'm trapped into it. The only ones I haven't done them in—since 1990—are the two for the Smithsonian because that was very

Fireflies, 1990. Oil on canvas, 16" × 20". William Elett Family Collection. Copyright Guy LaBree.

serious stuff from Sonny Billie." Guy is referring to the two paintings titled *Genesis* and *Exodus*.

Alan Jumper told the story portrayed in *Time to Go Home*: Seminole children are instructed to come home before dark, because the "little people" may keep them, and the youngsters might never see home again. "They say little people and babies play with each other during the daytime," Guy said. "Little kids see them all the time." So he imagined this scene of a four-year-old girl gazing at the little people. Her bemused expression suggests that she's so entranced that she may not reach for the next flower that the little people offer. In the background, mist gathers as it does in the evening, the time when she should return home.

Another part of the legend is that each tree has its own tribe of little people. When a child falls out of a tree, the adults say that the little people shoved the youngster because they needed a rest: "They pushed you out, and give them a week or so, and then they'll let you climb there again." He reasons that the waiting period gives the child time to heal. Another sign that the little people inhabit a particular tree is a lightning strike. Because the little people mock storms, lightning chases them, trying to kill them. A scar on a tree is the evidence, the shape twisting and turning, tracing the path of the little people dodging the strike. Guy illustrated such a tree in *Legends of the Seminoles*.[14]

Bobby Henry told him that everyone—whether or not they are Seminoles—can see the little people. "If you're daydreaming or sitting there just relaxing on a stump or on a chair . . . or you're just staring ahead of yourself, and suddenly something is seen out of the corner of your eyes—'cause they're real fast—that's them. When they catch your eye, it's just for a split second—that's why . . . you see them, but you never see their faces."

Some have wondered if the little people are related to leprechauns, fairies, or other tiny, mischievous humanlike, imaginary beings. Guy said that the Seminoles he has asked have assured him that the little people are uniquely their own.[15]

Once when Guy and Sam Tommie were talking about the little people, Sam's mother, Mittie, was nearby. "She told me the word was *ya: topóski*," Guy said. "She said it in Indian with other Indian words, and I didn't quite understand what she was saying.

"Sam said, 'She's telling you what they call the little people.'"

Kissimmee River Legend

Alan or Jimmy Jumper first told Guy this legend, which explains the origin of the Kissimmee River, but he has learned more details and episodes from so

many other Seminoles that he cannot remember them all. It begins with two brothers hunting far from home. After an unsuccessful day, they make camp. As they sit around the campfire, they hear noises. One brother investigates and finds a large fish, alive, inside a hollow log. The other brother reminds him that they have been taught not to eat "things that aren't in the right place." The first brother is overwhelmed by his hunger, so he cleans and cooks the fish. He eats it, but his brother abides by the old teachings.

Guy said, "During the night, the one fellow [who ate the fish] couldn't sleep. He was itchy all over and scratching. When he looked at his legs, they were getting scales on them, and they had already grown together into one long point. By morning, he was this huge snake, maybe fifteen, twenty feet long. And the brother woke up and saw him, and it scared him." Although Guy knows the fine distinctions between three kinds of Florida water snakes, he did not use any of them as a model. He wanted to create a believable water snake, yet one that looked supernatural.

The snake asks his brother not to run away without giving him something to eat. The brother replies that because they found nothing to hunt in the area yesterday, he will go home and bring back some food. With some other hunters, he returns with a cow, which the snake swallows and then grows bigger. They bring a deer and then an alligator. Each time the snake eats, he increases in size, and then, in his hunger and impatience, he devours one of the people.

Pausing for moment, Guy tried to find the words to explain why the Indians don't kill the giant snake. It seems that the Seminoles consider the snake as a human being in animal form, so they don't want to kill him. Guy compared it to someone who acts improperly because of mental illness.[16]

Continuing the story, Guy said, "So a wise old man told the snake, 'The "snake side" is getting the better of you, so it'd be better if you went and lived by yourself in a place that has a lot of things to eat. I know of a big lake south of here, and if you just cut through this big swamp, you'll end up there. It's huge and big enough for you, no matter how big you grow.'"

As the snake crawls through the swamp, he topples some trees and uproots others, his body gouging the sand because of his size and weight, forming the channel of the Kissimmee River. Eventually, the snake arrives at Lake Okeechobee. Before he swims into the lake, he looks back at his brother, who is in a tree watching the snake. Guy captured that moment in a painting based on Betty Mae Jumper's version of the story called "Two Hunters."[17] Nancy Motlow, a friend of the LaBrees' who is a vendor at Seminole events, also shared the moral of this part of the story: "You shouldn't fool with things that are out of place, things that don't look right."

About a year later, the mother of the two brothers wants to find her son who has been gone for so long, and his brother and some friends travel with her to protect her. After watching for a while at the edge of Lake Okeechobee, they see movement in the water. The mother climbs on a log so the snake will see her. When he starts swimming toward her, the friends flee to the forest, afraid because they know the snake has eaten a person. They hide among the trees that once grew on the lake's north shore where the Kissimmee River enters. Guy described how saw grass marshes once encircled Lake Okeechobee except where hurricane winds had pushed the sand north, creating a habitat for the cypress trees.

Watching over his mother, the brother stands behind her. When the snake arrives, he lays his head—that has grown horns[18]—in her lap. Eloise Osceola, who died a few years ago, commissioned this painting (see fig. 8). She explained the moral in the scene: "A mother loves her son no matter what he does."

When James Billie saw the finished canvas, he told Guy that the brother hung the brother-turned-snake's gun and ammunition pouch on the snake's horns, "in case he needed them for something—which he didn't," Guy said.

Then another person told the LaBrees a continuation of the story. After years, the snake becomes lonesome. One day on the other side of the lake, he discovers a trail made by a large female snake[19] with horns. Although Guy didn't recall that the two snakes produced offspring, his wife, Pat, said that she did.

Bobby Henry shared the grand finale with the LaBrees. The earth starts to catch on fire, and the snakes hide in the water. Eventually, it evaporates, leaving them in the mud. The male stretches and wings pop out. The female does the same, and they fly off into space searching for another place to live.

The fame and popularity of this legend throughout south Florida is evident in its influence on the folktale "The Sea Serpent of Cape Sable," collected by the Florida Writers' Project in the 1930s.[20] However, the variations, morals, and nuances that the Seminoles have shared with the LaBrees—which have engendered more than one canvas—create a legend that is as long and meandering as the Kissimmee River itself.

When the Time Comes

Some years ago, Mitchell Cypress, the present chairman of the Seminole Tribe of Florida, commissioned a painting of a dream he had while he was napping in a pasture one afternoon, taking a break from his work (see fig. 9).

His wife had died some years before, and she appeared to him mounted on a pinto horse, waiting for him in the distant sky. From his dream, he understood that when an eagle brings him his hat, he will know to join her, and then he will follow her into the heavens, riding an appaloosa horse.

In the scene, a coffeepot simmers over a small fire, and his empty cup rests within easy reach. Propped on the saddle and blanket that he has removed from his horse, his head leans against a cypress tree. Across from him, his quarter horse grazes. As is customary for most Florida cowmen, a dog helps him manage the herd, and he asked Guy to include it. As the cows amble in the background, they stir a flock of cattle egrets.

Guy said, "A year at least, after that, his daughter passed, and he called and wanted to know if I could put her waiting up there, too," riding a buckskin horse. He said that he couldn't remember the distinctive characteristics of that breed, but his neighbors, Bill and Carrie Bowers, who are experts on horses, described a buff brown horse with a black mane, tail, and forelegs. So Guy added Mitchell's daughter astride a buckskin to the already finished canvas.

Cattle have lived in Florida since the Spanish first imported them to start a colony in 1521. Later in the sixteenth and into the seventeenth centuries, the Spanish introduced ranching in north Florida, where they established missions for Timucua and Apalachee Indians. The ranches kept free-ranging stock, so feral animals were possible even before the demise of the missions at the start of the eighteenth century. Several decades later, the Indians moving into Florida—who would become the Seminoles—began herding these feral cattle. Although many lost their herds because of the Seminole Wars and their migration to south Florida, some Seminoles owned cattle into the twentieth century.[21]

In the 1930s, the federal government initiated a livestock program on the Brighton Reservation, and in 1941, in response to a petition from ten of those living there, on the Big Cypress Reservation. The government's initial expenses were repaid as the operation proved successful, and today the Seminole Tribe's cattle program is ranked twelfth nationally.[22]

Guy said, "In the Big Cypress, where Mitchell keeps his cows, there's these little hammocks around, now that they've dried the land down. The Seminoles didn't dry it down. SFWMD [South Florida Water Management District] did. But that made the Seminoles happy because they were up to their knees in water all the time out there."

He listed the cowman's chores: "taking a head count, or checking how many calves he's got out there running loose, 'cause they got these huge stretches

of pasture out there, and the cows scatter all through these hammocks." He described how the dogs flush the cattle from the brush so that cowmen can "make sure they're healthy."

Guy knows about working with cattle from his own experience. As a young man, he helped his uncle, Buster Hill, who was a cattleman. Guy remembered two tasks in particular: branding calves and castrating bull calves. His uncle did the castrating, but Guy assisted with the branding, pressing the white-hot iron on the calf's flesh for three or four seconds to create a scar. He recalled that when the iron first sears the cow, it "hollers for a moment." When released, it stands, kicks, runs a few yards, and then walks away.

A couple of years ago, Guy asked Seminole cattleman Paul Bowers if he and his friend Andrew Murray could watch Bowers and other Seminoles work their cattle on the Big Cypress Reservation. So one weekend, Guy and Andrew stayed in a camper that belonged to Paul, a cousin of Eugene Bowers, who attended Dania Elementary School with Guy, and brother to Dan, another classmate, and Richard, current president of the Seminole Tribe. Although he was there to observe, Andrew—a lifelong cattleman—helped the crew, but because of his heart condition, Guy only watched and photographed the action.

He said, "I wanted to see what the Indians were doing now, in case I'm doing any cattle scenes about them. . . . I wanted to see how they dress now, what they do. Everything changes over the years, and I was surprised." Although some wore T-shirts, jeans, and boots, most wore large sneakers, oversized t-shirts, and baseball caps on backwards or sideways. "They looked like punk rockers . . . like somebody out of New York City." Yet they were comfortable in such clothes and able to do their jobs.

During that weekend, amidst the musty smell of oak leaf mold and the pungent odor of cow manure, Guy framed a memorable sight. He stood outside a corral under some large oak trees, so the scene was dark except at the edge of the trees, where the sunlight highlighted the leaves and streamers of Spanish moss. So many cows were penned in the corral that he could hear them lowing and bumping against the wood. What caught his attention was that he couldn't see much besides their horns because of the height of the fence and the way the light was shining.

He described his friend Andrew as a short, stocky man with plenty of muscles, and that day, he wore a white felt cowboy hat. When Andrew jumped into the corral, all Guy could see was the dark forms of the cows, the glinting horns, and the white hat. "That was one of the neatest-looking pictures." He regrets that he didn't have his camera at that moment, but he said, "I got it in my mind. . . . One day, I'll maybe get to paint it."

His comment recognizes the business of working as an artist: many of his paintings are commissioned and must be completed by a deadline and to the customer's satisfaction. Some clients specify a particular content; others allow—or even welcome—Guy's imagination to supply details that complement the subject. In the limited time between commissions, he also paints "for himself," and like this engaging depiction of one man's dream, Guy's personal visions sell, too. Popular because of their subject, style, and artistic merit, his compositions are invitations to discover more about Seminole life, history, and legend.

Chapter 2

Seminole Life and Traditions

When Guy LaBree first began visiting his school friends on the Dania Reservation, he experienced Seminole life that was similar to the way Seminoles had lived since the end of the Seminole Wars. They adapted their customs and traditions to the Everglades, an environment popularly characterized at the time as a "wasteland," and other wilderness areas. They shunned contact with other Floridians, except for traders and their families, yet even this minimal contact initiated some changes in their conventions.[1]

With dreams of transforming "the great swamp" into farmland, white men began dredging and draining the Everglades in the late nineteenth and early twentieth centuries. As the birds and animals that had flourished on the flooded lands began to disappear, life for the Seminoles changed again. Some worked in Florida's growing tourism economy or as seasonal farm laborers. For example, James Billie was born at Chimpanzee Farm, a popular tourist attraction in Dania, and the parents of Guy's friends, the Jumpers, met in an orange grove. Seminole families did not take up residence on the reservations—land the state began to acquire at the request of concerned citizens—until the New Deal offered work relief and other programs to those who lived there. Others remained independent from any kind of government assistance.[2]

In 1957, while Guy was finishing high school, the Seminole Tribe organized and gained federal recognition; later, they gained access to funds for political and entrepreneurial development. In the following decades, even those Semi-

noles most remote from white civilization began to adopt some aspects of a "modern" lifestyle, and those who lived the traditional ways became fewer.[3]

Instead of elegizing or enshrining this lost way of life, Guy's paintings celebrate it as a living tradition, as in the painting *The Storyteller/Sunset Recollection*. Because of his lifelong friendship with individual Seminoles, Guy understands their customs and traditions in a way that few outsiders do. Yet he does not depict his own adventures; rather, he uses that knowledge to create an authentic portrait, as in the painting *When I Grow Up*.

As a child, he became familiar with Seminole culture thanks to his friendship with the Jumper family, and his love and respect for Tommie Jumper, the matriarch of the family, is evident in his portrait of her, *"Oh, the Changes I've Seen."* He also transforms his experiences into a scene that recalls his overnight visits in her camp, as in *Breakfast Time*. Similarly, in the portrait *Mikasuki Seamstress*, authentic details compose an imagined, yet true-to-life, scene.

Guy's continued friendships with many Seminoles gives him an incredible range of observations from which to compose a painting such as *Homework*. His interest in the natural environment also provides realistic details, yet he willingly transformed them into a patron's vision in *Hunter in the Grass*. Ever eager to consult the experts, Guy seeks out the fine distinctions that characterize his paintings, as in *Dugout Apprentice*.

Instead of making generalizations or assumptions, he recognizes the individuality of each Seminole. He knows that there's more than one process to accomplish any task, and he doesn't want his representation interpreted as the only means. For example, he explained that in the past, when an observer saw an Indian board a canoe on the left side, he or she wrote conclusively that every Indian did the same. However, Guy has watched Indians step into a canoe from any direction as well as poling from the bow, stern, or middle. He has painted many "poling" scenes, such as *Travelog* or *A Visit to Big Cypress*, yet he composes each with a flair for color and perspective—plus an implied story—that makes them as unique as a moment in the river of time.

Although considered an authority on Seminole culture, Guy is modest about his extensive knowledge and ready to learn from written accounts and experts—especially the Seminoles. When a Seminole friend or acquaintance points out an error in his portrayal, he is grateful for the chance to increase his understanding of aspects of Seminole culture, such as the annual festival portrayed in *Screech Owl Dance* or a Seminole funeral depicted in *Last to Leave*. Guy respectfully paints subjects usually unavailable to outsiders, and he also honors the wishes of those who have asked him to refrain from depicting arcane matters or special beliefs.

An anthropologist who wrote of his fieldwork among the Seminoles in 1953 noted that any researcher who wanted to study the culture had to first "break down" the natural reticence of the Seminoles and overcome the distrust they have for curious strangers. Of course, the researcher understood that these feelings resulted from the history of war with and discrimination against the Seminoles. He also suggested that the audience influenced a speaker's choice of subject matter.[4] In contrast, in the 1950s Guy was a teenager who had already gained the Seminole's confidence, and he continues to be highly regarded among them today both for his artwork and for his appreciation of their customs and traditions.

The Storyteller/Sunset Recollection

When Guy first displayed his paintings of the Seminole at the arts and crafts shop at the Seminole Okalee Indian Village, a tourist attraction on the Dania Reservation,[5] a young alligator wrestler at the village, James Billie, critiqued each one even though Guy was not there to hear. When Guy visited the shop, Manager Judybill Osceola, Guy's childhood friend, repeated the critique, and Guy repainted canvases accordingly. After about a year of trying to learn from these comments, Guy painted this scene.

The storyteller in this painting may be a grandfather or an uncle of the children (see fig. 10). Finished with his work for the day, he's occupying the children until supper is ready. As he tells them tales from the Second Seminole War, they envision a battle that Guy represented in the late afternoon clouds. One boy sits on the ground, but the younger one nestles against the storyteller's leg. Guy commented about young children: "They'll use you like a sofa. When they get a little older, they're a little more polite, but little kids don't think about that."

When he finished this canvas, Guy drove to the village and found James Billie. "I asked him to come out to the car and have a look, so he did. And he said, 'What do you want me to tell you?' I said, 'Tell me what's wrong with it.' He stood there looking and looking and looking. And finally, he said, 'How much you want for it?' And he started buying paintings."

That was 1977, the year James Billie first became a patron of Guy's art. In addition, he introduced Guy to other Seminoles—some he had never met and some he didn't remember he had known as a child. Their stories inspired paintings and helped him to refine the images that he wanted to paint. Sometimes in the middle of a work, when he needed information or clarification, he telephoned them to ask what a particular item was called or how a specific task was performed.

Guy offered an example: "It's like if you had never had a pair of shoes on, and somebody handed them to you—would you know what to do with them?" Those with whom he spoke were kind and generous in answering his many questions. He laughed a moment before he added, "They could have had a ball with me, but only a few times did they pull some jokes, and I don't mind that. We're all jokers."

In addition to what the Seminoles have shared with him, Guy remembered his own experiences on the reservation. When Guy listened to stories told in Mikasuki by Jimmy Jumper's mother, Jimmy or one of his brothers would translate. Once Guy asked Jimmy what he thought before he knew English, when he heard white people speak. Jimmy told him that "it sounded like a bunch of dogs, going 'ar, ar, ar, ar'" because the Mikasuki language has no "R" sound. Years later at a dedication for one of Guy's murals in Lake Placid, Dan Bowers noted that while English has twenty-six letters of the alphabet, Mikasuki uses only nineteen.

Mikasuki is a dialect of the Hitchiti language, and Miccosukee is the name of the tribe that gained federal recognition in 1962, seven years after the Seminole Tribe was recognized. Two-thirds of the Seminoles and Miccosukees in Florida speak Mikasuki, a language related to but mutually intelligible from Muskogee, also known as Creek. Some Seminoles speak only Muskogee, and other Seminoles and Miccosukees speak both languages, and until the 1950s, Muskogee was used by both groups for communicating with outsiders.[6]

Guy said, "There are certain words that the Seminoles just don't know what they mean anymore because they don't use them." For example, he remembered the word *hinata* in the book *Seminole Music* by Frances Densmore: "The 'hinata' was said to be a mythical animal resembling a lizard or an alligator, but very large. It lived in the water like an alligator, had a long tail, and killed people. Its abode was 'farther north.'"[7]

Inquiring among his Seminole friends, Guy has not yet found anyone who knows about this creature. He said "It was some kind of monster, out of the water, but the name should say what kind," because it's either "the sound it makes or what it does." Pat said, "We were told that the name was probably from their ancient language." That language may be referred to as "the old language" by Seminoles, whether they speak Muskogee, Mikasuki, or both. Just as English evolved from Old English, so Muskogee may have descended from a more archaic language or a dialect no longer in use.[8]

Guy doesn't remember Harry Jumper, Jimmy's father, telling stories. He worked making chickees, and he also constructed them around pools and by hotels on the beach for non-Seminoles. Once Guy and his friends were building some for cabanas on the beach in Pompano. Mr. Jumper stood away

from the structure so he could align it in reference to the horizon rather than to a carpenter's level or plumb.

When they were almost finished roofing the last chickee, Mr. Jumper called the young men to go home. On the twenty-five-mile drive home, Guy asked, "Mr. Jumper, why are we going back now? In an hour, we could've had that finished."

Harry Jumper replied, "Why die tired?"

He also gave Guy his childhood nickname: "The kid with the knife." Unlike his friends, Guy kept a knife in a sheath on his belt. He said, "I wore it all around wherever I was at—at home, everywhere—'cause I lived right next to woods, and I was always out in those woods—a place called Rattlesnake Ridge in Dania. Today, they should call it 'House Ridge.'" Then he spoke with derision. "Not even a ridge—they flattened it all out."

Unfortunately, this painting suffered a similar transformation. When he asked to borrow it from James Billie, Guy found it at the Native Village under cinder blocks, pieces of wood, and other debris. "The stretching was gone. It was like—really messed up, scored up and scratched up, and filthy, and covered with a thick layer of dust . . . like fur, almost, on it. So I had to take it home, try to restretch it. It did no good 'cause it was too old. You couldn't stretch it any further 'cause it would rip. So I cleaned it all off with soap and water, and more or less repainted it."

His laughter belies his hard work. "I tried to mix all the colors again and tried to get them as close as possible and repaint it 'cause we had a show coming up." That exhibit was a retrospective of Guy's work, 1977–2000, at the St. Petersburg Museum of History. Years later, he continues to work the way he did then—basing his images on what he knows and what he has learned from the Seminoles.

When I Grow Up

Guy has a photograph of himself as a skinny fourteen-year-old, holding a cayman. At one time, he had twenty-two of them. He collected them on a golf course where the tourists who had bought them as "baby alligators" had released them before they returned north. Pointing to the painting, he said, "That's a baby alligator, and the boy's dreaming of being a big-time alligator wrestler. . . . He's got a Band-Aid on his finger where he got bit. As for that wood box, you put the gators in whatever you got" (see fig. 11).

No one believed that Guy had caught two crocodiles in the East Dania Marsh until his father also saw a large crocodile there. Guy cared for five alligators ranging in size from two to almost five feet. In his backyard, he had a

Helen LaBree, "Guy LaBree Holding Cayman," 1955. Black-and-white photograph. Guy LaBree Collection. Backyard of LaBree family home in Dania, Florida.

cement pool with sand around the edge. He built wood sides about four feet high, with a foot of wood buried underground to block the reptiles from digging underneath to escape.

He had discovered alligator wrestling by watching Bill McClellan, a non-Seminole, wrestle alligators at the Chimpanzee Farm in Dania. "To me it was amazing just to watch a man walk up to one and start grabbing ahold of it by the mouth. And even watching him do it three or four times, it took a while before I could figure out what in the heck he was doing. That's the number-one trick—to hang on to that mouth."

In contrast, Alan Jumper was taught to wrestle alligators by his father and uncle. Guy met Alan when he sat behind Guy in second grade. "I used to draw a lot instead of doing my lessons," Guy recalled, "and so he would sit there and look over my shoulder and so would a bunch of other guys." Afterward, Alan attended school elsewhere for eight or nine years.

Guy was closer in age and in friendship with Alan's brother Jimmy, who was a year younger than Guy. Jimmy died of a heart attack a few years ago. Guy remembers that Jimmy wrote eloquent poems, and when his teachers encouraged him to write more, he was embarrassed. The children in Guy's

Dania neighborhood often asked Jimmy to read aloud his verses about Elvis, James Dean, the pollution of the world, and other poems about nature.

One day, Guy and Jimmy were talking about gator wrestling. "Jimmy didn't care for it because he had to do it sometimes, and he didn't really like it because he had to do it for a buck, for the family." When Jimmy told Guy that his brother Alan was wrestling alligators, Guy wanted to talk with him. A week or so later, Alan and Jimmy drove to the LaBree home in Dania. Jimmy proudly presented Alan. "He had a whole bunch of photographs of his wrestling styles that they had made into postcards," Guy said, "and he gave me one of each of them—like a fan club thing—and we became good friends."

Guy had tried to learn how to wrestle alligators simply by watching McClellan and others. Seeing how Guy handled the alligators, Alan warned him that he would get hurt. When Guy admitted that he already had been, Alan showed him safer techniques. After that, Guy was bitten only a few times. Guy recalled when he wrestled alligators at the Chimpanzee Farm: "I did it for a crowd a lot of times, but it was not like Alan did it. He did it all day long. . . . Whenever there was nobody there to do the show and when they had enough people, I'd go sneak in there and do the show. . . . Bill McClellan had no idea I was sneaking in there doing that."

Guy respects and admires Alan for his skill at alligator wrestling. "With me, it was the excitement. With him, it was a business." From about age twelve, Alan performed seven shows a day, working at different locations, including for the *Jungle Queen*.[9] "You got paid in tips back then. Now they pay them money up front, but they couldn't afford it back then."

Henry Coppinger, owner of another tourist attraction, is "the one that invented alligator wrestling," Guy said. Alan Jumper told how Coppinger wanted to display alligators for the tourists that visited his Tropical Gardens attraction, so he asked the Seminoles to catch some for him. He was impressed that the Seminoles could deliver the reptiles without being bitten, and he used their techniques to create a show.

Alan described how Coppinger tied an alligator to a log sunken in the middle of the river before the tourists arrived. Standing in a boat, he told the audience that he would bring up an alligator he could see in the river. "He'd dive down there and untie him and grab this gator and pull him up to the top. And he'd wrestle around a while, and bring him up on the bank and open his mouth and turn him on his back. And then, a lot of the other tricks just went from there." After that, the Seminoles started wrestling alligators, and Guy maintained, "They do it better than anybody." He recalled meeting Henry Coppinger Jr., who also wrestled alligators.[10]

According to Guy, alligators for wrestling are kept in a walled sand pit with a pool. The wrestler needs a different alligator for each show, so usually fifteen or more alligators live in the pit. He has to make sure that he doesn't choose the same one each time because an alligator that is continually handled will stop eating and eventually die. Also, the reptiles become so accustomed to the show that they don't hiss, growl, and snap their jaws. Such behavior makes the show more exciting, and the audience will be more likely to give a generous gratuity in appreciation.

The wrestler wades into the pool and selects a gator. Grasping either the tail or the jaws, he pulls the animal from the water. Then he straddles its back and holds the jaws open so the crowd can see the teeth. After that, the wrestler shuts its mouth, and performs a trick called "bulldogging," where he presses the closed mouth between his chin and chest as he extends both arms out to either side of his body.

In a photograph Guy snapped in 1962 on the Brighton Reservation, Alan is bulldogging the alligator from the front. In this dangerous stunt, the reptile has an opportunity to twist free by thrashing its powerful tail. Guy has never seen anyone do it since that day.

The third trick is flipping the reptile on its back, which causes it to lose consciousness, although the wrestler tells the crowd that the alligator is asleep. Guy said, "If there's a lot of people there, you may want to do some extra tricks—like open his mouth with one hand, and put his top jaw under your chin and pull it open with your other hand and keep one hand out to the side. My friend Alan's done it a bunch of times, but he doesn't do it all the time either. It's only when there's a big crowd."

Another trick is for the wrestler to place his head in the alligator's mouth. Guy admitted that he had done it "twice, never again." He continued, "It's stupid. Once your head's in there, you think, 'What am I doing here?' Suddenly I'm in there, and before I realize, 'What am I doing this for,' I get my head crushed."

Guy regards Alan as probably the best alligator wrestler that he has ever known. When he was a young man, Alan won a contest sponsored by Animal Land, a tourist attraction near Lake George, New York. Wrestlers were judged on the drama and danger in their shows. Guy explained that many wrestlers look so strong that the audience doesn't worry about their safety. However, Alan was different, both brawny and a showman. One trick that he did was to pass his hand—holding a pinch of sand—through the alligator's open mouth. Releasing the sand, he quickly pulled his hand away because as soon as the sand touched the alligator's tongue, it slammed its jaws.

Sharon Taylor, "Guy LaBree Wrestling an Alligator," 1998. Color photograph. Guy LaBree collection. Performed at Seminole Billie's Swamp Safari on Big Cypress Reservation.

Remembering his friend Alan, Guy said, "He could make the alligators jump, charge, and do different things. He wouldn't feed his gators a whole lot. He'd feed them about an average amount that they'd get in the swamp, so they were always moving around." Guy noted that other wrestlers fed their alligators so much that they were docile: "I'd rather have had the big slobs, because they don't bite your hand off when they get it."

Although Animal Land no longer exists, a photograph of Alan wrestling there is included in *Echoes in the Wind: Seminole Indian Poetry of Moses Jumper, Jr.*,[11] and several years ago, Guy and Pat saw its location when they were visiting her aunt in New York. Guy recalled a photograph of the entrance.

Guy LaBree: Barefoot Artist of the Florida Seminoles

The sign was an image about twenty feet high of Alan up to his waist in water, surrounded by alligators: "Tall, tough, and terrific—see him in action." Alan performed shows all summer long.

Indians don't wrestle alligators anymore, Guy commented, except for a few young men. The Tribe now hires non-Seminole men to perform with the reptiles. When his younger son, Shorty, in his early thirties, asked Guy to teach him how to wrestle alligators, Guy worried that the young man was considering that job. However, his son wanted to learn how because Guy had done it.

"Patti reminded me that I hadn't done it for thirty-five years, and might tell him something wrong or leave something out, and get him hurt. So we asked my friend Tommy Taylor, who was running the Billie Swamp Safari on the Big Cypress Reservation." There, Guy's son wrestled an eight-foot alligator, with Tommy watching over him "like a mother hen." Guy captured it with his video camera, proud that his son had done such a good job.

On the way home, Guy realized that he didn't have his own performance on tape, so they returned. "Patti was sure I was going to die, but she lived through it, and I made it through all right. I was gasping for air because I was in the throes of heart failure at the time, but it was fun. And I got my pictures, and they turned out to look like a crotchety old man—which is about the way it is."

Guy has painted many scenes of alligator wrestling, including a series showing different tricks. Commissioned by James Billie, the paintings are displayed at the Native Village on the Hollywood Reservation. He also painted a portrait of James wrestling an alligator. However, Guy said that the boy in *When I Grow Up* "is me and my buddies, Indian friends and white friends . . . we'd all dream about being alligator wrestlers."

"Oh, the Changes I've Seen"

This portrait is Tommie Jumper, the mother of the family with whom Guy stayed whenever he spent a night on the reservation (see fig. 12). He says that when he visits the reservations these days, he doesn't usually see people in such old-fashioned outfits. "All of a sudden, you'll see one of the old, old people walking out dressed like that, and you'll think, 'I wonder if they're off to some festival,' but that's just the way they are. That's just the way they dress—they always have."

Guy described how her cape hangs from her shoulders to her hips, hiding her arms and the waistband of her floor-length skirt. As a child, he saw her in clothing that was similar, but more for everyday wear than for special oc-

casions. He said, "She'd have her older clothes on because they were always working around there in the woods. It was in the woods; it wasn't in a park, like they show it now. I mean, they show chickees in parks, with sidewalks and grass, and all, but there was no grass. It was all sand, which they would keep raked smooth and cleaned out because it would keep scorpions out."

Mrs. Jumper's hair is traditionally styled, combed over a piece of cardboard to shape it and held in place with a net. Guy notes that the size and shape of the cardboard varies, but it usually forms a kind of hat brim over the face. Seminole women have been styling their hair this way since the early twentieth century.[12] He said, "The first ones were a lot like white women's bonnets. They came down on each side, and you couldn't see the face, almost, from the side."

About a Seminole woman's beads, he said, "I never have understood . . . but she had a bunch. Some people say the women had so many they would encircle their necks all the way up under their chins, but she never wore that many that I saw." Pointing to her portrait, he said, "That's about the most that I ever saw her wear . . . and she had more. . . . As she got older, she only wore a few strings—like about six or seven."[13]

Mrs. Jumper first saw her portrait at her birthday party. Guy said, "They just called it her one hundredth birthday because they hadn't had one for her. . . . At that time, she was about 103, really. . . . We showed her the painting, and she didn't say much, but she put her hand up to her mouth." He imitated her gesture and facial expression, indicating attention and appreciation. He remembers that eventually she said, "'Oh, I still have that cape,' . . . and then she said, 'You even got the colors of the beads right.'"

The idea for this portrait came from her son Alan. He suggested three scenes from her life as a background, and Guy painted them in brown tones to suggest old sepia photographs. In the upper left corner, a young girl sits with her mother. Buildings rise through the trees because her mother is telling about the times when she had visited Miami. Her daughter Tommie had never seen the city, a place very different from the south Florida wilderness where they lived in chickees, traditional Seminole homes.

Guy noted that the word *chickee* means "house," but the houses that the Seminoles lived in before the wars were cabins. Once he met Abraham Clay, one of the Seminole guides for the Tamiami Trail Blazers, a group that crossed the Everglades in 1923 to create publicity and public support for completing the Tamiami Trail.[14] Somehow Guy and Abraham started talking about these cabins, and Guy was surprised when "Abraham started showing me how they made them. They had little doors, low doors, for the same rea-

Guy LaBree: Barefoot Artist of the Florida Seminoles

son, I guess, as the Eskimos did in an igloo, so when people are coming in, they're down and at your mercy if they're not your friend." Holding his hands up, with thumbs extended to frame an opening, he said the windows were small. Smacking the palm of one hand against the side of his other hand, still serving as the window's edge, he demonstrated how easily such openings could be blocked with one board.

After the war, the Seminoles living in the Everglades created a dwelling more suitable to their new environment. Guy described chickees, which are built of cypress poles with steeply pitched palm-thatched roofs. They have a platform—which serves as a floor—built about three feet above the ground. The chickees are open-sided, although two or three "walls" are constructed of thatch in the same fashion as the roof. These "sides" are stored and taken out only during intense storms. The side is tucked up under the roof and then lashed to the rafters, side poles, and flooring to protect those inside from blowing rain.

However, Guy noted that chickees offer no protection from mosquitoes, so mosquito bars—nets of very fine screen—were suspended from the rafters to protect sleepers. Because these mosquito nets were expensive, regular bed sheets were also used. Guy related how the sheet was arranged, showing with his hands how to make a kind of tent over a mattress. "At night when you're going to go to bed, they put a pillow and a blanket in there, and you crawl up under there and kill any mosquitoes that come in with you. Then, in there, you tuck the edges of that bed sheet all around, and you're mosquito-free for the rest of the night unless you roll against the edge of it."

The family used many blankets to keep warm during south Florida's occasional cold nights, and Guy saw how blankets, clothes, and other possessions were stored in cardboard boxes under the roof on boards that spanned the rafters. One electrical line entered each camp and powered "a light and a radio or a sewing machine and a light"—only two appliances at a time.

Pat said that Tommie Jumper "had a preference for chickees." Guy agreed, saying that she lived in a chickee until she was nearly eighty years old. "She had a heart attack or two because the temperature out there in the Everglades drops dramatically in the winter, and then in the summer it gets super hot and humid out there, and as you get older you can't handle that as easy as you can when you were younger."

In the upper right is another scene from Tommie Jumper's childhood. Pointing to the wagon, he said, "She's up here with her mom and their belongings." Alongside the ox, her father is walking and carrying a stick, to guide the ox instead of reins or a lead rope. Ox cart was the preferred method of

transportation through the dry areas of southwest Florida, even as late as the 1930s.[15] However, Guy said that by the time he was on the reservation, the Seminoles were driving old cars.

When Alan Jumper was invited to wrestle alligators in New York, he bought a fairly new truck to haul the alligators. One evening about two months before he left, he drove to Guy's house, and Guy and the other neighborhood teens and children went for a ride. Guy said, "He took off and went up Stirling Road and out off 46 . . . at that time, just an old dirt road with pastures on each side—now it's called Emerald Hills. Anyway, somebody was parking and sparking back off this other dirt road, and the car came out, right at a curve, . . . with no lights on, right slap in front of us." Alan turned the wheel sharply to avoid a collision. The other car sped away, but the truck turned over and children were thrown from the truck bed. (Guy was inside the cab.) "It was a violent accident for going thirty miles an hour," Guy said.

One girl said she was hurt, so Alan walked to the Dania Reservation for help, and soon police officers and an ambulance arrived. Alan was arrested and taken to jail. Guy remembers the scene in front of the judge, when the prosecutor asked Alan if he had killed a pedestrian. Sitting beside Guy, his friend Curtis Hall "stood up and said, 'Your Honor, this man is railroading Alan. Ask him what a pedestrian is.'" The judge discovered that Alan didn't know the word *pedestrian* and that he had been in an accident involving another vehicle that had driven away.

Guy said, "Then he was all kind of heartbroken because he wasn't going to get to go to New York. Alan and his brother Jimmy had been around our neighborhood a lot—everybody liked them—so Mrs. Hall, my mother, and all the neighborhood women got together and started having bake sales and raffles and all kinds of fund-raisers and got enough money to buy him a brand-new truck . . . and he was on his way to New York."

The third scene in the portrait dates from the late 1940s and early 1950s, when Mrs. Jumper was a young woman and mother encouraging her children to ride the school bus. Guy said, "Alan told me that she was known in the family for making sure the kids got to school. That'd be her out there, making sure that they got on the bus because the kids would play hooky if they could. . . . She figured if they didn't assimilate some, they were going to be left behind in the world."

The Jumper family lived among palmettos and oaks on the Dania Reservation, about a block to the east of u.s. 441, also known as State Road 7. Parallel to 441 and about a mile away was another blacktop single lane. Nearby was a rock pit—a place where coral rock had been dug—and a canal. "That was where they used to wash or swim," Guy said.

In the center of the cluster of chickees was a clearing. "There was a pump, a pitcher pump on a well, and that's where they all went to get water," but it wasn't always that way. Guy recalled that Judybill Osceola had told him that at first, they only had a hole dug in the ground, and they covered it with palmetto leaves to try to keep debris from falling in the water. What Guy experienced when he stayed overnight was that he and his friends gathered in the sand and sand spurs around the well, pumping cold water to wash their faces and hands as well as brush their teeth. He commented, "It's a hard way to get ready to go to school."

The Seminole children didn't like school because they were treated differently from the other students. Guy knows "stories about Betty Mae Jumper that said that she'd come around and if she found somebody home from school, she'd grab them and take them to school." In particular, he recalled when "Jim Billie threw his shoes away one time, so he didn't have to go to school. She marched him downtown and bought him a new pair of shoes and made him go."[16]

Tommie Jumper did not attend public school, nor did she learn English, although she could understand more than she spoke. Guy said, "She preferred to speak her own language because she thought in her own language, just like Alan does. She never had the need to speak English. I don't think I ever heard her talk English but once or twice, one or two words."

Guy had a difficult time describing her voice. To him, it sounded high-pitched, with a "singsong" quality, which in part is a characteristic of the Mikasuki language.[17] His friends—Alan, Jimmy, or David Jumper—as well as their father, Harry Jumper, would translate for him. He said, "Sometimes she would just come over and hand me a cup of coffee, and I knew what she's talking about—it's time to have a cup of coffee."

In the painting is a panther, the symbol of Tommie Jumper's clan, as well as the clan of her children. Her husband belonged to the Bear Clan, but membership was passed on to the next generation through his sisters. Guy explained that all the children—boys or girls—belong to the mother's clan. The clan relationship determines many aspects of daily life, including education, hospitality obligations, retribution for crimes, and leadership roles.[18]

"I think Mrs. Jumper had thirteen kids," he said. "I forget how many of them died, but the Florida Seminoles had a high mortality rate because they were living out in the woods. . . . One or two of them might have been born in the hospital; I'm not sure." Some of the children were born in a special chickee in the woods.[19] Guy said, "I know my friend Alan was."

The first two meals that Guy ate at the Jumper Camp were the same, a kind of flat white bread cooked in a pan and browned on both sides. A stew

of meat and vegetables was ladled onto the bread. He ate the stew first and then rolled up the bread, savoring the gravy it had absorbed. A young child, he was impressed that the Seminoles did not use plates or forks. He thought they always ate that way, so he told everyone before he found out differently. "It just so happened it was two meals I had in a row. It's just one way of eating."

The Seminoles make another kind of bread that for many people is their only experience of Seminole culture. "The fry bread is thicker. It rises. They deep-fry the fry bread—it's bad for you, and that's why it's so good!" Guy said. Fry bread and pumpkin fry bread are sold at powwows or other special occasions and festivals.

Another fried treat that Mrs. Jumper prepared was swamp cabbage. Known to some as "hearts of palm," it is the terminal bud on the cabbage palm (*Sabal palmetto*), the state tree of Florida. Guy recounts her method. First, she sliced the swamp cabbage into pieces shaped like half-moons. Sizzling on the fire was a pan of bacon fat or some other kind of grease. She dropped the pieces into the pan and spread them out. When they browned on one side, she flipped them. When the other side was crispy, she lifted out the slices with a little screen that may have been made with the kind of wire used for plastering. She shook the oil off, laid out the slices on newspaper, and then used a sifter to sprinkle them with powdered sugar.

"And then she's making more, and pretty soon, there's a pile of that stuff sitting there, and the kids are coming over," Guy said, noting that she was speaking Mikasuki. "I couldn't understand a word, but I knew what she meant. She's saying, 'Tell everybody to come get some.' Man, that stuff was gone in a heartbeat. Boy, was that delicious." He realized that making this treat for the children was one of the ways that she showed her love for them. "She's not one of these kinds of mothers that's grabbing the kids and loving them up. But she was fairly strict . . . and she did love them."

He described her as smart, hardworking, and elegant—especially in the way she moved. He remembers her tending the fire and cooking over it—time-consuming tasks—and washing clothes and hanging them out to dry on the fronds of palmettos or the branches of wax myrtle that grew near the camp. She also sewed clothes, made beaded jewelry to sell, and taught the children how to do chores. Her way of life was as traditional as her clothes. Guy said, "She was quite something."

In the LaBrees' collection is an article with the same title as Guy's painting. Published in the July 1, 2005, issue of the *Seminole Tribune*, it includes the following remarks by Chairman of the Tribe Mitchell Cypress: "In recognizing Tommie, you give special recognition to all of our mothers, who are the roots

of our culture. She is representative of the strong willed, determined, self-sacrificing women who have kept the Seminole Tribe alive during the hard times."

Breakfast Time

The items and customs in the painting *Breakfast Time* are authentic, yet Guy imagined this scene based on details remembered from when he was a boy visiting the Jumper family (see fig. 13). He remembered that when he spent the night with his friends, Mrs. Jumper was the first to wake up, and so he envisioned the woman in the painting.

He described the fire, which is a focal point of the composition. Arranged like the spokes of a wheel, the logs are ten or twelve feet, so long that the ends sometimes protrude from beneath the thatched roof that provides protection for the cooking and the fire, especially from the frequent Florida rains.[20] Unlike the others, the cooking chickee does not have a raised platform, so the fire burns on the ground. However, Guy noted that because the Jumpers had a large family and only two chickees, someone also slept on a partial platform at one end of the cooking chickee.

As they cooked, the Seminole women used the unburned portions of the logs as both kitchen stool and countertop. After the logs burned away on one end, the woman shoved a stick into the ground at the other end. It served as a lever to push the log forward. Then she fanned the coals, using—in this instance—a bird's wing. When the fire was burning again, the woman cooked on a grate placed over it.

Guy said, "After the fires get going for a while, they hardly look smoky at all, unless it's real wet wood." The smoke is visible "just for a short distance. Then it disappears." Inside the chickee, the smoke from the fire ascends, and depending on the direction of the wind, it escapes out one side or the other—or both. "What I couldn't show here, but really happened, was the inside would get darker and darker toward the top, because of the soot going up."

He listed the items that were either hung on the posts or placed up off the ground on benches: hand-carved sofkee spoons, pots, pans, porcelain cups, knives, spatulas, a basket full of eggs, coffee, oatmeal, grits, and flour. The cooking chickee serves as both kitchen and pantry, yet the chicken in the painting is realistic as the structure has no walls to keep out the animals that roamed the camp.

The fire burned continuously, and the logs might take a few days or even as long as a week to burn completely, even though the fire smoldered all night. He imagined that sometimes the fire was completely extinguished, although

he never observed that. He said, "It's easier to keep it going than it is to start a new one. I mean, it's a lot of work living outside, so that's kind of like a modern convenience to keep it going all the time." He laughed. "They'd leave the ashes around there, real close—until they got too many—because that would keep the fire from spreading."

Although the Seminoles cleared a site to build their chickees to protect them from falling branches that could damage the thatched roofs, pines and palmettos as well as oaks surrounded the area so "firewood" was brought from other sites. Guy said, "When they were getting the logs for making chickees, a lot of times they would take an extra log or two for the fire, or a tree that was kind of twisted up that wouldn't be any good for use in building."

O. B. Osceola and his wife told Guy that when they lived near the Tamiami Trail, they built their homes in a hammock—a natural rise of ground surrounded by swamp. They didn't want to cut all the trees from around their chickees, so they went out in their canoes to search for firewood. Sometimes they found a tree root or a fallen branch that they sawed or split to fit into the canoe. Guy said, "It looked kind of crazy to see a canoe coming down the waterway with this great big snag of wood. That's what I mean about they didn't always do the same thing. . . . It was whatever's necessary. They had their ways, but they would adjust."

He noted that the little girl in this painting is "hanging on her mama's knee waiting" for her breakfast, and the mother is boiling a pot of water to make coffee. Some Seminole families owned standard coffeepots, he said, but others measured the coffee grounds into a big pan of water. After it boiled, they either strained it or carefully poured it out so as not to disturb the grounds, which settled at the bottom. Guy remembers this detail and others from when he was a child visiting the reservation, and he uses his knowledge to illuminate a morning as faithful to Seminole tradition as the sun's first rays.

Mikasuki Seamstress

One of the most distinctive arts of the Seminoles is their brightly colored patchwork clothing, which is the focus of this painting (see fig. 14). A number of origins have been suggested for this unique art, yet the influence of the sewing machine is indisputable.[21] Around 1900, traders offered machines for sale and instructions on how to use them. Ivy Stranahan in Fort Lauderdale and Jane Brown of Brown's Boat Landing, east of Immokalee, taught both men and women how to sew on the machines offered for sale in their husbands' stores. Perhaps others did as well. Subsequently, storekeepers like

James D. Girtman in Miami offered ready-made items such as bias tape and rickrack that contributed to the decorative Seminole clothing.[22]

A traditional seamstress, Susie Billie showed a sewing machine of that period to the LaBrees when they were visiting James Billie. "She had a couple of her old sewing machines that she had had since back at that time," Guy recalled. "She was really old, and she was showing me how they worked . . . explaining it all out in Mikasuki, which I did not understand. So I kind of got the gist of what she was saying, and I thanked her very much for showing me." He noticed that the sewing machines looked like new, without any rust or other signs of wear. One was hand-operated, and one was electric.

Guy painted this hand-crank sewing machine from memory rather than copying a particular photograph or model. He portrayed the seamstress in a wrist-length cape, a clothing style that dates the scene to the 1920s or 1930s, as does her coiffure. He said, "She had a lot of hair . . . a big old bun up there." His careful brushstrokes create a hair net holding her topknot in place.

The chickee platform serves as a work table for the seamstress although it was considered the floor of the dwelling. Resting on it is a knife, which Guy identified as an "Old Hickory," made by the Ontario Knife Company. That was the kind of knife he saw on the reservation when he was a child. However, Mrs. Jumper used a knife that a member of her family had made. Her son Alan told Guy that "they took a deer horn, and they'd drill it out, and they put the tang of the knife down in there and then fill it with lead and let it harden." By the time Guy met Mrs. Jumper, the deer horn had broken off, yet she continued to use the blade.

Although a woman used scissors or a knife, much of the time when she wanted to cut fabric, she ripped it. Guy said, "Like the patchwork—nearly all of that is ripped . . . and if you look at the inside of a jacket or a skirt, you'll see that. It looks like—almost like—fur."

Pat added to the discussion by showing a pamphlet, published by the Seminole Indian Agency in 1948, from the LaBree reference library. She read aloud one fact from it: "Skirts may consist of as many as 5,000 separate pieces."[23]

So-called patchwork is made by sewing together strips of cloth and then "cutting them into geometric sections." The shapes are then resewn to create a design that repeats horizontally.[24] Bands of patchwork are usually made in long strips that are rolled up for easy storage and use. Such a roll can be seen in the right foreground of the painting. One seamstress may create the colorful bands, and another may sew them together into clothing, alternating the long, narrow bands with other fabric as well as rickrack braid.

The LaBree's reference collection also includes the 1990 publication *Patch-*

work and Palmettos: Seminole-Miccosukee Folk Art since 1820: An Exhibition Sponsored by the Fort Lauderdale Historical Society. Guy said, "It's written by a friend of mine named Dave Blackard. He was the director of the Ah-Tah-Thi-Ki Museum for the Seminole Tribe. He's gone on to other things now, but . . . he really is knowledgeable—I'd say expert—on the Seminole clothes. Only somebody in the Tribe could be more expert than him. . . . I use his book like a Bible whenever I have any kind of a question about when something was used and when it wasn't."

Within reach of the seamstress is her sewing kit, which here is a cardboard shoebox. A cigar box or other container also may have been used to store needles, thread, and other supplies. Colorful skirts hang above the woman's head.

The painting shows the components of a chickee. The corner supports are cypress logs, as are the rafters and the carriers for the thatching. The roof is thatched with the fronds of the cabbage or sabal palm; the Seminole refer to them as leaves. In the painting, the smaller sticks between the carriers are the stems of the fronds. In the background, the viewer can see chickees with logs placed on top of the thatching. Called "weights," they are not nailed, but they secure the fronds and keep them from warping.[25]

Because the wood is untreated and exposed to the weather, the chickees start to rot about eight years after they are made, so they are constantly renewed. Guy recalled that when he visited the reservation, the men brought in a cypress log and skinned the bark, filling the air with the sweet-sharp scent of cypress resin. Then the pole was seasoned—dried out—and used to replace the rotting poles.

Periodically, chickees needed to be rethatched, and when a new pile of leaves from the cabbage tree was brought in, everyone knew that they would soon be working. Sitting beside the pile, the children and older adults hammered a nail into the stems and handed them up to a man balanced on the rafters.

Guy said, "You start at the bottom, just like shingling a roof, and you lay down one end, and you get it folded over, and you lay the first one down and nail it up. Then you put the next one on, fold it over and lay it here and nail it up." Guy gestured to show the pattern. "So now you got four layers in one spot. . . . It takes a heck of a lot of them, but when you're done at the end of the day, that'll last you for a year or two or three depending on the weather." He described the roof as "pretty close to waterproof" and so welcome in the summer heat because it retains the moisture and provides a cool shade.

The chickee where the woman works is part of a camp or village. Chickens, pigs, and dogs run loose. "Sometimes they had a pit with alligators if it

was a village where tourists could visit 'cause they knew that people liked to see them." As he considered the painting, he reflected that he may have been thinking of a village built for tourists, one with chickees "lined up off in the distance like a straight road," as at Musa Isle in Miami. Other mid-twentieth-century tourist attractions with Seminole villages included Tropical Gardens, owned by Henry Coppinger, and the Chimpanzee Farm in Dania.

In 1983, when the LaBrees moved from Hollywood to Arcadia, James Billie and his family gave Guy a Seminole patchwork jacket. The LaBrees commissioned another one: two women created the patchwork, and a third sewed the strips into a jacket. In 2001, the Seminole Tribe gave Guy a third one as an honorarium for judging the Seminole Princess Contest. Guy often wears a patchwork jacket to Seminole-sponsored events, the artist of the Seminole dressing in Seminole art.

Homework

In the painting, two women are pounding corn (see fig. 15). The crushed corn is boiled in water to make what the Seminoles call sofkee. Guy compared it to "hasty pudding," a cornmeal mush known in early America. Sofkee has a thinner consistency, more like a soup. He said, "If they were going to make a pot that's maybe a gallon's worth, they crush all the corn and put it in the water and get it boiling, until it boiled down . . . a little bit thicker than molasses, but a little bit runnier 'cause it's made with water. And then you have it in a cup and sip it like coffee or something. But if you get it down too thick, then you need a spoon. And that's when they usually add a little more water to it."

When Guy visited the Jumper family in the 1950s, he was a teenager with an inextinguishable appetite, and sofkee was always available. "You could go get yourself a dipper, and get you a cupful to keep the fire of hunger away until dinner." He noted that the most traditional recipe uses corn, although grits, rice, or other grain may be cooked. Sometimes bits of meat were stirred in. Guy recalled, "The best-tasting one to me was the crushed corn, though . . . I always added salt and pepper, and they didn't like that. They kept saying, 'You're ruining it,' but it was perfect for me."

To prepare the corn for sofkee, the women used a mortar and pestle. The mortar, or bowl-shaped vessel in which the corn is crushed, is a hollowed-out, knee-high oak or hickory log set on its end. The log varied widely in size and shape.

Guy related how the mortar was made. The men "take some hot coals that they keep going in a little fire beside them, and then they pick them up and put them on top, right in the center, and burn it for a while. They blow on

it with a blow pipe, and then they'll take those coals and put them back in the fire. Then they take their knife or a chisel and hammer or an awl . . . and they chip out the burnt part." The worker repeats this process until the cavity is about eighteen inches deep. He recalled that Mary Johns of the Brighton Reservation remembered that her father had used this technique, and Guy watched Bobby Henry of the Seminole Village in Tampa carve a mortar this way.

The pestle grinds the corn in the mortar. It is also made of a hard wood, like live oak, but Guy has also seen some made of cypress. It has a thinner handle in the middle with a heavier top and bottom. Most mortars, such as the apothecary's symbol, have only one pestle, but this mortar takes two.

Instead of pushing or grinding the pestles into the mortar, the two women allow gravity to smash the corn: "They just kind of pick the pestle up and let it drop, pick it up. One will drop and then the other, and then one, then the other. So two women will crush a lot of corn in no time. And then they just scoop it out and put it in another pan. And then put some fresh corn in and do it again until it's mashed flat. It doesn't seem to crumble up . . . and if you felt the bottom of one of those mortars, it's smooth like it's been shellacked. Just as smooth as it could be."

In the nineteenth century, the U.S. government waged three wars against the Seminoles to "relocate" them to Indian Territory, now the state of Oklahoma. Those remaining in Florida used such mortars and pestles, and those who moved also brought this custom with them, even though the land was as foreign to them as they were to it. The LaBrees once met a chief of the Seminole Tribe of Oklahoma who remembered the mortars and pestles: "Each house in Oklahoma on the reservation, he said, had one beside the door outside . . . and he liked this painting because it reminded him of when he was a kid."

In *Homework*, the mortar stands away from the rest of the village, perhaps so that the women could talk freely as they worked. In 1962, when Guy visited the Brighton Reservation with the Jumper family, he recalled watching such a scene. A distance from the camp, two women were "pounding corn and talking and joking and laughing. . . . After they were done with theirs, a couple other women would go out and use the same one."

On one side of the canvas, a dog sleeps beneath a chickee. Hounds lived in the camps, and the Seminoles appreciated them because of their keen sense of hearing and smell. When the canines are young, they are treated as pets, but when they are older, their job is to guard the camp. Guy said, "They'd lay there sleeping and all, and get in the way," but the dogs alerted their owners

long before they noticed a visitor. The dogs warned sleepers, but "it might be too late" if they slept on the ground. So the raised platforms in the chickees serve as dry places to sleep, even when it floods, safe from any animals—such as snakes and alligators—that may wander during the night.

He remembered such an intrusion when he slept in a chickee on that 1962 visit to the Brighton Reservation. "During the night, a herd of hogs came through." He laughed at the recollection. "That was neat. The dogs went nuts. They were chasing the hogs all over the place. But nobody cared. They just slept right through it. I was the one that cared. My eyes were that big around." He formed a circle with his index finger and thumb.

In this scene, the women work on ground that is slightly raised. Guy has seen such elevated areas on property in the Everglades owned by Jack Fry, whose land abutted the Big Cypress Seminole Reservation. Fry called them "garden mounds." About two feet higher than the surrounding area, the man-made areas are formed of rocks and filled with sand. Guy supposed that they were made by the "ancient Indians," but they may have been created by Seminoles.[26] In his painting, banana trees flourish near the mound. Guy said that the Seminoles grew whatever fruit was best suited to where they lived—guavas and papayas, among others.[27]

The women pounding corn are so involved in their conversation and work that they don't see the "little people" stealing from the bowl near their feet. "One of them is taking kernels of corn out of the pan there and then handing them to somebody else, and then the other one is running across, handing them to somebody else, who is taking them way up in the tree." He explained that the little people are mischievous, so when people lose a pocketknife, or misplace their glasses, or can't find the toilet paper in the outhouse, they can blame the little people (see the discussion of the legend of the little people in *Time to Go Home*, chap. 1).

Guy included no men in this daytime scene. Sometimes old men stayed in the camp during the day because they could no longer lift heavy items or do strenuous work. "When they get my age, they sit around bothering the ladies with their chatter." He chuckled before he recounted the activities of the younger men absent from the camp: hunting, trading, fishing, working on a canoe, or cutting down logs. In the foreground is a rack for cypress poles where the men will scrape the bark from the limbs before they season. The draw knife, used for skinning the bark, rests on the ground, ready for someone to begin work again.

The background of this scene shows women involved in typical activities: an elderly woman may be lost in reflection while a young mother swings a

baby in a hammock. Another woman sews, and a third is teaching the children by telling them stories. "But you can't see the real work over in the cooking chickee," Guy said. That's where the women are making sofkee.

Hunter in the Grass

Guy remembers this painting "very well, because I worked on it a lot, for a simple painting" (see fig. 16). At first, he portrayed a panther stalking some deer in the distance, with mist hovering near the ground just before sunrise. "Then I didn't like the sky I had . . . so I redid the sky to make it more of a morning sky." When he finished the canvas, Guy hung it in his living room. He usually displays his newly completed work among the *giclées* that also crowd the walls.

"My friend Jake Osceola came over and had dinner with us. And he kept looking at it, and he said, 'Is that for sale?' I said, 'Sure, it's for sale. That's what I do for a living.' He looked at it for another hour or so, while we were talking, and then he said, 'If you put a man in that panther, I'll buy it.' So I said, 'Okay. . . . How do you want him in the panther? . . . A hand hanging out of his mouth—or what?'"

Laughing, Guy nodded toward the painting. "He wanted it like that—like a phantom built into the cat, so you can see both. . . . The scariest thing of all was putting a man in the cat. I had to do it with glazes, so the cat still showed, and the man showed, so it had to be just enough glaze."

Jake also asked him to depict the man holding a knife, because he has to have some way to kill as he moves along in the same position as the panther. His knife is the equivalent of the cat's claws and teeth. Jake belongs to the Panther Clan, and when members of that clan are children, they are told to watch the panthers, to learn from observation how and what to hunt. "So he thinks of them as being hunters together. And he's quite the hunter himself, anyway, from what I understand. I know he's a real expert with a pistol."

About a month after Guy had delivered the painting to Jake, they were talking on the phone, and Jake asked Guy to repaint some details. "He had some changes, but Jake usually does. Jake'll get a painting and change it to what he wants." Jake requested that Guy include some water, so he created a pond in the background near the deer. "He also wanted medicine colors in there. I didn't know how I was going to do that, and he said, 'Make a silver arm band, and put these tassels on it in medicine colors.'" Guy doesn't know about the significance of the medicine colors—yellow, red, black, and white—but he notes that they are used on the Seminole flag, and that medicine men often favor those colors for their clothing.

Guy remembers the first time he saw a panther when he was six years old, at the U.S. Naval Air Base, now known as the Fort Lauderdale–Hollywood International Airport. As a civilian, his father supervised the electrical department—for the base and the airplanes—as well as the runway lights and the fire department.

After a rainstorm or other disturbance, Guy's father had to check that the runway lights were operational. Even though World War II had ended, U.S. Navy pilots were still flying in damaged planes at any time. One evening, he accompanied his father as they drove through the back entrance, "right by the Dania Cutoff Canal on Ravenswood Road. There was a little road that turned back up to the east."

Inside the eight-foot-high chain link fence, they turned onto a one-lane road that circumnavigated the base. Some bushes grew at the end of the runway, and Guy remembered how dark it was when their headlights shone on something. "I wasn't even looking, and my dad said, 'There's a panther.' . . . And there was this cat kind of crouched beside the road on the runway side." His father stopped the car, but the panther ran. "In two moves, it was gone. . . . It jumped across that lane to the other side, and the next jump went straight up over that fence. He never even touched the top of that fence." In his memory, the panther seemed to bound away in slow motion.

As he narrated the freeze-frame of the canvas, Guy empathized with the panther hunting in his painting: "He's got one more chance, he figures, to catch something before daylight, before the deer can see him too easy. So he's kind of skulking around. . . . If he can get through this grass and around to that brush," he said, pointing to it, "then he can probably jump on one—because they may go into that brush to sit out the heat of the day—if he's lucky. If not, he's hungry."

Dugout Apprentice

Once Guy asked a Forestry Division worker if the trees he was selling were pond or bald cypress. The worker said that as far as he knew, there was only one kind of cypress, but Guy disagreed.

Guy said, "Many years—like maybe twenty years—later, I went to another one of those tree sales, and I asked the guy there, 'These pond cypress or bald cypress?' And he said that they were pond cypress.

"'But you know, it's a funny thing,' [the Forestry Division worker] said. 'Years ago, a guy came to me and was mentioning that there might be a difference.' The forestry worker had researched the question and discovered that two kinds of cypress trees grow in Florida: 'Bald cypress are much bigger, and

they have a different color bark . . . and they live by running water more, or on big lakes, and the pond cypress can live on big lakes but mostly in swamps, and they grow very fast.'

"And, I said, 'Yeah, that was me.'" Guy snickered. "So we had a little reunion there for a few minutes, and I learned something for sure—that there are two kinds."

Knowing the difference between a pond cypress, *Taxodium ascendens*, and a bald cypress, *Taxodium distichum*, is essential for understanding not only the Florida landscape but also the process that the Seminoles use to craft canoes.

According to Guy, to make a big canoe, one large enough for a family, a man searched for a bald cypress of just the right size and shape. Then he felled a smaller pond cypress and sawed it into logs that he arranged in a row beneath the bald cypress. Then he chopped down the bald cypress so that it landed on those logs. That allowed him to turn it over and roll it as he shaped it with an ax.

This painting focuses on the next step: the boy peels the bark as his father sculpts the top (see fig. 17). Guy remarked that the man seems to be in a strange position, at an odd angle, but he's trying to gauge the cut of the ax so that the canoe is shaped correctly. Guy has watched his Seminole friends expertly wield an ax, including Alan Jumper and Alan's brother Joe. "He could make two-by-sixes or two-by-eights or whatever you want out of a regular pole with an ax. He would chip it out, and you would swear it was sawed. He was an expert with an ax." Guy gave this same praise to Henry John Billie, and once Guy watched him carve a canoe.

To continue the process, the man making the canoe drills a hole in the center of the tree, about halfway along its length, and fits a small log into it. This becomes a lever so that he can turn the tree over to work on the bottom of it. The center piece or pieces may also have prevented the vessel from warping as it dried.[28]

Sometimes in the finished canoe, the maker kept the original center hole by not removing the wood around it so he could rig the canoe as a sailboat. According to Guy, a limb with several branches, serving as a mast, was placed into the hole, and a large sheet or other fabric was tied onto it. When sailing the canoe, the Seminole used a push pole as a tiller.

Another style was the "sailing rig"—mast, gaff, and boom—that the Seminoles probably adapted from the whites. Most photographs of such craft date from the late nineteenth and early twentieth centuries, but white men observed Seminoles sailing canoes when Florida was a British colony (1763–83),

after Florida became a U.S. territory in 1821, and during the Second Seminole War.[29]

To hollow the canoe, the man worked on a small section at a time, first in the front—Guy skimmed his finger over the log in the painting—and then in the back, continuing until the thickness of the sides and the bottom was from three to five inches. In older canoes, Guy has found evidence of how the craftsmen checked the dimension. "Sometimes they would have to drill a hole or cut a hole in the bottom or the side to see if the thickness was right. Then they cut a piece of wood to fit and then hammered it in there again, and once they put it in there, it would only leak for a very short time 'cause that plug would swell up."

Each canoe was as individual as its maker.[30] Guy said, "You might see one style for as long as that canoe lasted and then never see that style again if it didn't work well."

On display along with several older canoes at the Ah-Tah-Thi-Ki Museum of the Big Cypress Reservation is one made in recent years by James Billie. "He did his out of a big cypress tree, and he used routers, chain saws, I forget— every modern tool there is, and when asked why, he just said, 'Well, if the old people had had all this, they would have used it, too.'" Guy wholeheartedly agreed. "James's ancestors weren't doing that so there'd be something historical for us to find . . . they were doing it because that's the only way they could do it."

James Billie was also instrumental in saving some ancient canoes revealed on the bottom of Newnan's Lake, near Gainesville, Florida, during the drought of June 2000. Interestingly, Newnan's Lake was formerly known as Lake Pithlachucco, meaning "canoe place" or "place of long boats." Information posted on the Web site for the Cultural and Historical Programs of the State of Florida states that 70 percent of the Newnan Lake canoes date between 3,000 and 5,000 years old. Archaeologists have speculated on the reasons for the quantity of canoes—maybe a hundred or more.[31]

According to an article in the October 20, 2000, issue of the *Seminole Tribune*, the archaeologists who discovered the canoes notified the government ten days before a state-permitted deadhead logging operation began at the site. "Seminole Chairman Billie, upset that state officials had not notified the Tribe of the find, flew to the lake site, to see the canoes—damaged and undamaged—first hand. . . . [He] was credited by Secretary of State [Katherine] Harris for fast-tracking the radiocarbon dating after his visit."[32]

The LaBrees heard about this archaeological discovery from their friend, folksinger Dale Crider, who lives on the lake. Although Crider wasn't home

at the time, Guy and Pat visited his property to view the situation. Guy called the site "a factory for making canoes." He said, "One tribe or two tribes were getting together and making them and selling them to other tribes. . . . Most of them were made of pine. That was the neat part, and some were pieces of split pine trees, where they did one-half of the canoe and then the other, and then put them together lengthwise with tar in the middle."

However, the lake in this painting is modeled on one east of Lake Placid and southeast of Sebring in Highlands County, a lake that he also featured in a mural painted for the Lake Placid Mural Society in 1993. "The Seminoles used to live right on Lake Istokpoga. In fact, some of my friends' families lived over there—Dan Bowers and others. Their families worked for some of the people that lived over there."

Pat said, "Dan Bowers came to the dedication of the mural."

"And he talked about it," Guy said, "how his family used to work over there for some people growing beans on the shore of Lake Istokpoga."

The cypress tree on the right edge of the canvas has a wound. Guy noted that the branch probably broke when the bald cypress tree was felled. He pointed to the canoe-in-progress and then to a stump beside it, gliding his finger upward to where the tree had stood and then tracing the arc of its fall. "You've got to think of those things, sometimes," he interrupted himself to laugh at what seemed so obvious, "when you're doing a picture."

He admits that he usually paints with a specific plot in his mind: "I try to tell that story—as much as possible—with one picture—which is impossible." As he thinks, he transforms the narration into moving images as if in a full-color, three-dimensional movie, because he never knows what part of the sequence he may want to paint. In this scene, he said that he could have portrayed the man holding the ax in another position, and he demonstrated by extending his arms with both hands clasped as if they were holding the handle and swinging through the motions.

Then he described how he portrays trees. "Oak leaves are easier than cypress needles." He chuckled at the comparison. "You can get a brush of the size you need, usually, and—this takes a little experimenting, but now I've been doing it so many years, it's not so bad. . . . You can make all these different-shaped leaves with one kind of brush going in all different directions. And then you come back and take certain numbers of them, where you want your light coming through, and you highlight them, and then where you really want the light to come through, you highlight those again, just a hair. . . . It's a lot more work, I'll say—but it looks better to me. It looks closer to the real thing."

To paint cypress needles, he uses a different technique. He chooses a "little bitty brush with a real chisel edge, and I touch it head-on just like putting a razor blade against the canvas like I'm trying to cut it . . . and it wears the brush out real quick because the bristles start to spread." Paint brushes are numbered according to size, so the very smallest sizes are multiple zeroes. "Some of them are four aught, and below that, I generally just make my own brush . . . out of a moose hair and a stick and a dab of superglue."

His source for moose hair is Orville Treibwasser, who had a taxidermy business not far from the LaBree home. Orville knew that Guy experimented with making brushes using his own hair. Orville offered hairs from elephants, lions, panthers, and many others, but the one Guy liked the best was from a moose.

Guy explained, "It's a deer hair, which holds the paint, but it's heavier than a regular deer hair. Hog hair ain't worth a darn. That's like using a piece of dad-gummed nylon filament. . . . It makes a big bubble of paint on the side, and it smears all over." He excused himself and disappeared into his studio, returning with a chunk of moose hide, his "lifetime supply." The difference in the texture between moose and deer hair is as important to Guy—and his finely detailed canvases—as the distinction between a pond and a bald cypress.

Travelog

When Guy began talking about this painting, he called it a "scenery picture" (see fig. 18). He wanted to use some "pretty colors, without going too bright," so in this late-afternoon scene, the rain has already stopped before the Seminoles pass in their canoe. He imagined the location as somewhere near Corkscrew Swamp.

Guy said, "People think it was always like that and that the Seminoles had to find these pools of water, but it used to be all under water. In fact, that whole area out there where the roads and everything are, used to look like the Corkscrew Swamp looks now." He spoke the last words through suppressed laughter. "I used to go out, and I could wade for all day long, and I'd be just wading in water up to my knees . . . and no end to it, it seemed like."

Speaking from his experiences hunting snakes, camping, and enjoying nature, he recalled that when he visited the Everglades, the process of drying it out—begun in the late nineteenth century and accelerated in the 1920s—was not as advanced as it is today. As evidence of the change, he now finds wax

myrtle trees growing in the saw grass and pines growing among the cypress because the land is dry for more months of the year than it is wet.

Guy's wife names all of his paintings, and she delights in puns. *Travelogue* literally means a lecture illustrated with travel slides or a film, yet the word sounds like—and can be alternately spelled—*travelog*. A dugout canoe is—in essence—a log for travel, and in this vehicle, the Seminoles return home from trading. Boxes and barrels of trade goods, such as flour, sugar, coffee, and salt, fill the canoe. A canvas covers everything so that as they pass through a hammock, the food won't be contaminated by cypress needles, twigs, or other debris dropping from the trees. In addition, Guy said, "A snake or something that might fall in, would just slide off."

The Seminoles bought their groceries by trading deer or alligator hides or selling them for money to a dealer. Harry Jumper, Alan's father, knew enough English that he worked "when he was younger as a go-between for the trappers . . . and he had the connections to sell the hides, so the hunters would bring them to him," Guy said. "He would buy the hides from them and sell them for more."

"In the late thirties," Pat said. "Alan had to be born in the late 1930s."

Guy said, "Alan is six years older than me."

"Alan remembers it," Pat said. "That's when they lived on the west coast of Florida, near Marco Island."

"He could tell you how the hunters . . . came in with alligator hides . . . rolled up and stuck in big cans, and all different things like that, to protect them," Guy said.

Guy used to go snake hunting not far from the trading post and store of C. S. "Ted" Smallwood on Chokoloskee Bay in the Ten Thousand Islands. Although Smallwood probably preferred to be paid in money, he accepted whatever the Seminoles brought in because they were the majority of his customers. At that time, Chokoloskee was accessible only by boat—or canoe. In addition to hides, Seminoles traded pelts of other animals and the plumes of the snowy or American egret, which were fashionable decorations for ladies' hats. Other trade goods included produce—such as huckleberries, bananas, melons, and sweet potatoes, starch from the coontie root as well as venison and wild turkey.[33]

The man in the canoe uses a pole that has a spike on the top of it. Guy has seen such push poles in old photographs. "The old-timers had a spike in the end of the pole, tied on." His friend Brian Zepeda, who works at the Ah-Tah-Thi-Ki Museum, talked with some older Seminoles who told him "the best thing that they used to get for that was not a piece of re-bar," referring to the

steel bars used in reinforced concrete. "They did use that, but if they could find somebody that had an old pitchfork, they would take one of the tines and work it back and forth and break it off and sharpen the end and then tie it down to the end of the pole." They used it to spear fish or turtles. Since it had no barb, the tine was pushed forward to stab the fish or reptile and then lifted into the canoe, where the "catch" slid off.

Once a newly made dugout canoe is launched, it stays in the water. Algae and other aquatic plants grow on the underside. Guy said, "The bottom will get slippery with moss. The older Indians—I was told—used to like that better than a new canoe because when you had to pole along and go over a log or something, a new canoe would stick on it, and the old ones would just slide right over. And if you were going through the saw grass, it would just slide through it so much easier with the slime on it."

When the Seminoles reached their destination or home, a single rope secured the canoe, looping through a notch or hole drilled in the stern. Where a village fronted the water, the Seminoles left a few trees or bushes at the water's edge to secure their canoes. Guy noted that the canoes are heavy, unlikely to be moved by wind or wave. Also, if a canoe is pushed into the grass and weeds growing thick in the shallow water near shore, it will probably stay there.

Wind may blow before or during a squall but afterward is calm, as evidenced by the Spanish moss that hangs straight down in the painting. Although the water seems a perfect mirror, Guy explained that it is not: "The water's a black water or coffee-colored water, so your reflections are all very dark. Although when you're there at the time, a lot of the time, they will look like they're the same color as what's above it, but they're not. And people'll swear, 'Yes, they're the same.' But if you take a photo of a landscape reflected in the water and fold it over to compare the two parts, you'll see the two halves are a good 20 to 30 percent different in the color."

Guy enjoyed playing with color variations when he painted the clouds. He explained that the colors look brighter than the actual paint because their hues bounce off the shadows. Shadows in clouds must be subtle, so that they don't seem heavy enough to fall on the ground. "But then any kind of color you put in the sky, you just put it real pale, and it looks like it's really bright. I don't know why. It's just because your eye tells you the clouds should be that way." He stifled a laugh before he tried to dismiss the special effects he has created: "It's mainly scenery, and I'm trying to get some pretty colors in there."

A Visit to Big Cypress

As an artist who makes a living in part from commissions, Guy sometimes has very little time in which to paint his own compositions, such as *A Visit to Big Cypress* (see fig. 19). He said, "I didn't have a whole lot of time, if I recall, I had a week or so that I could work on it."

A stand of cypress trees seems to loom over the scene because the perspective is so unusual. Guy imagined that the viewer is about the same height as the woman sitting in the canoe, perhaps in an adjacent canoe. The inspiration for this point of view is another of his paintings, in which a Seminole man poles a canoe and behind him, the sun highlights a cloud as an eagle soars in the sky. It serves as the cover for the *Florida Seminole Heritage Map* published by the Ah-Tah-Thi-Ki Museum. The viewer of that scene seems to be waist-deep in the water, looking up at the front of the canoe. Here, Guy wanted to paint a similar perspective with more colors.

However, *A Visit to Big Cypress* also suggests a story, one in which the young couple in the canoe are all dressed up to go visiting. Their destination is a village visible in the background. Although the scene is beautiful, it is also tense because a thunderhead builds in the distance. The couple wants to arrive at the village before the storm. Guy figures that they only have to travel about a quarter mile.

The man poles the canoe through the saw grass, *Cladium jamaicense*. Its common name comes from its serrated leaf blades. Actually a sedge, saw grass can grow as tall as nine feet, forming thickets and spreading by underground stems. This plant pervades the Everglades. "On the Taylor War Map, 1839, the name of the Everglades is recorded as *Pay-hai-o-kee* or *Grass Water*."[34]

Comparing the canoe trails to those made by an airboat, Guy said, "If you use a trail long enough, it keeps it open—pushes the grass down." Although continual passage maintains the trail, as soon as it is abandoned, it will grow up again in one season and be indistinguishable from its surroundings. Such a path can be seen in the painting alongside water lilies growing in open water. He said that most people think that water lilies flourish around the edge of a slough or pond. However, "water lilies will grow in deeper water than you think they will, if the water's clear, and most of that water is clear out there in the middle of the saw grass."

He noted that a variety of water lilies grows in Florida, and one is called a spatter-dock or cowlily—*Nuphar luteum*. He said, "It gets a little round, yellow flower that never opens up . . . and grows in ten- or twelve-foot-deep water." Other water lilies grow in half as much water, but prefer a depth of

three to four feet. Seminole children are taught to identify these plants so they will know how deep the water is in which they grow.

A bucket in the front of the canoe may be filled with food that the young couple is bringing to share. Guy compared it to the custom of bringing a covered dish for a "potluck" meal. One person may bring some garfish that can be roasted on the grill over the fire. Another may contribute birds to be eaten or the ingredients for pumpkin bread. Someone may offer wild peas, corn, rice, or small morsels of meat to stir into the sofkee.

"If they're going somewhere for a party, they'd all bring something. If they were just stopping by to say 'hi' for an hour or two, or maybe it was getting too late to get to their home, they'd stop by and stay overnight. . . . The people in the village would let them camp there, and then they'd feed them without worrying about it."

The extended family camp was the heart of Seminole society, economy, and residence. A camp was both the site and the people who lived there. "All Seminoles followed the practice of matrilocal marriage, in which a married woman and her family took up residence in the camp of her mother. Thus each camp had a matrilineal core of women all belonging to the same clan. Unattached males of the family also resided in the camp of their mother." Seminole hospitality is offered to clan members. When a couple travels together, they stay overnight at a camp where the women belong to the same clan as the wife. If the man is by himself, he stays overnight at a camp where the women belong to his clan.[35]

In the canoe, the woman cradles an infant. "Maybe she's bringing the baby to the uncle, so that he can see him," Guy wondered aloud, although usually the uncle travels to see his nephew at his mother's or sister's camp. Guy reminded Pat of the time they were visiting James Billie, and Alan Jumper stopped by to see his great-nephew, James's son Micco, for the first time.

Pat said, "Uncles are supposed to take an interest in their nephews, and still to this day, some families are upset that an uncle hasn't shown the ways to his nephews."

Because children are born into their mother's clan, her brothers are responsible for educating her children in the way of their clan. For instance, he may lecture or punish disobedient nieces and nephews, and if they are ill, he may ensure that they receive medical treatment. If he is unmarried and living in his mother's camp, he may take an active role in raising his sister's children. However, if he is married and living in a camp distant from his mother's, he may not be as attentive to his duties as uncle.[36]

Guy added that an uncle teaches his nephew "how you should be, and

how you should act, and what manners are, and how they are used—and the traditions, so when he grows up, he'll be proud. He'll be a real grown-up man, living the right way."

Whatever the reason for the journey depicted in *A Visit to Big Cypress*, the canvas expresses Guy's love of color and a unique point of view.

Screech Owl Dance

Seminoles perform the Screech Owl Dance as one of many rituals during the annual Green Corn Dance celebration, the Seminole busk (from a Creek word meaning "to fast"), or annual festival:

> It marks the beginning of Seminole new year and provides for the general health and well-being of the people, especially the men and boys, during the following months. The function perhaps most frequently mentioned is to permit the males to eat the new crop of maize without becoming sick; hence the English name "green corn dance." Another important purpose is the annual re-examination of the medicine bundle, to ensure its continued potency and power for good. The political activities of the council on the third day are also essential. This is the time for trying serious crimes, discussing important matters affecting the tribe, and maintaining the informal political connections with the other Seminole bands. The membership of the several bands is defined by regular attendance at the appropriate busks. The busk further is the chief social affair of the Seminole year, the time when the people gather from their scattered camps and associate with old friends, renew old acquaintanceships, and learn the news and gossip of the past year.[37]

Although he has been invited more than once, Guy has never attended the Green Corn Dance. "If I have nobody to tell me what's going on, I'm just wasting their time and interfering with their religion and their traditions. Like Sonny Billie told me once, 'I don't come to watch you pray. Why do you want to come watch me pray?'" Guy laughed. "And unless I'm learning something from it, I don't really want to." Guy pointed out that those Seminoles who have invited him have also participated in the ceremonies, so they would not be available to explain what was happening as he observed.

For the Green Corn Dance, a special village is constructed, and many different clans gather for the festivities. Guy explained that certain areas are reserved for members of the tribe, and other locations are for visitors. Guests

are not allowed to tour the entire complex. Once, Guy saw the village from the air: "You cannot see it unless you're in a plane or know where it is."

Guy read a description of the Screech Owl Dance in Frances Densmore's book *Seminole Music* that inspired this painting (see fig. 20). The movement in the dance suggests the flight of the bird for which it is named. "Both men and women take part in the dance, but only the men sing the songs. This is similar to the custom in the Snake Dance. The dancers are in a long line, alternating men and women, and moving in a circle, contraclockwise, around the fire. The leader of the line has a coconut-shell rattle in his right hand and extends his left arm backward, holding the right hand of the woman behind him. This is continued throughout the line. During the first and second songs the dancers stand still and during the third and fourth songs they move forward."[38]

The shaking of a coconut shell rattle accompanies the dancers as does the chanting of the medicine man. Guy identified another sound—the turtle-shell shakers that the women wear on their legs under their dresses. They are made like the hand-held turtle shell rattles, but with smaller shells, filled with seeds. Six or more shells are attached to a leather strap, and the strap is tied on to the leg, often with hide thongs.[39]

Guy said, "When they're doing the stomp dance, it sounds like they're taking two steps; each time they would stomp their foot, it would *chick-chick*." He compared the sound to the passing of a steam locomotive. During tribal fairs and powwows, he has observed traditional Seminole dancers. "Some of the dances may not go on quite as long as they would otherwise, but it's the same. It's the real thing. I've asked the Seminoles, and they say, 'Yes, this is the real dance. . . . Why make one up? Nobody knows what it is anyway.'"

In this painting, the medicine man leading the dancers wears a medal, one similar to those that Guy has seen worn in nineteenth-century portraits of Seminoles, such as those in the Indian Gallery, the collection reproduced in *The Indian Tribes of North America*. For example, in an 1825 portrait by Charles Bird King, Tukose Emathla wears a medal featuring John Quincy Adams.[40] Guy suggested that the medal in his painting may have a likeness of a president on it, and the man may have inherited it from his father or grandfather.

One of the dancers wears crescent-shaped gorgets, hung from his neck, in a graduated series from smallest to largest. Guy said that he may have inherited this adornment, although it could have been of more recent manufacture. The form originated from "aboriginal shell and copper gorgets (usually cir-

cular)," and it is also borrowed from the British indication of military rank that formerly had been a piece of European armor protecting the neck between the helmet and breastplate. The British awarded gorgets to the Indians during their two decades of Florida rule, and the United States continued the practice after the American Revolution. In addition, some Seminoles have made their own.[41]

A silver band and ostrich feathers decorate the medicine man's turban. Guy noted the popularity of ostrich plumes during the Second Seminole War, when the Seminoles could obtain them through trade. One scholar has suggested that the fullness of ostrich plumes made them preferable to those from native egrets. Another has suggested that the Indians imitated their use in the bonnets of the Scottish Highlanders, who settled southern Georgia and northern Florida; some became Indian traders.[42]

The medicine man also wears a sash that dates from the late nineteenth or early twentieth century.[43] Guy said, "They'd tie it across their chests, and it'd have all these tassels hanging down, with these big, like pompoms, almost, on them. That's what these orange things are, there, hanging off his belt." He pointed first to the medicine man and then to a man in the background to the left, who wears a similar sash.

In the painting, the form of a screech owl emerges from the clouds. Guy painted the image from memory, as he often sees screech owls in the woods that surround his home in DeSoto County. When approached, the owls try to evade capture by remaining motionless. Only when the observer nears do they zoom off. He compared them in size to a two-pound bag of sugar, but he observed that they don't weigh even a pound, perhaps only a few ounces.

The owl in the sky symbolizes the dance. Guy said, "I like to do symbolism. . . . A lot of times you can tell a whole lot of a story with just a symbol in there as long as somebody knows what the symbol means." He laughed. "Once you explain that, then they can know what's going on. And many times, a symbol in there just allows somebody to make their own story up, if they want. Some people don't want to know the real one."

He recalled a painting that he did of some Seminoles with phantom wolves. He didn't mean to imply that the wolves were actually there or that at some time the Seminoles hunted with wolves, because they never did. The animals were a symbol that the Seminoles in the portrait belonged to the Wolf Clan, which has since died out. Similarly, he has portrayed panthers and other animals representing different clans. Many Seminoles who commission a painting request that he include a representation of their clan.

Guy has found that the easiest location for such a symbol is in the clouds because it is less noticeable and doesn't detract from the picture, and the members of the clan will identify and understand it. Recently, he finished a canvas commissioned by a member of the Snake Clan, who requested such a representation. "So I painted it in a tree, and I made it transparent, but it still looked like it was climbing a tree." When Guy showed the painting, the man who commissioned it asked him where he would paint "the invisible snake." In response, Guy pointed it out. Guy said, "And he said, 'Oh, I thought that was a real one.' And I said, 'Look—the tree is showing through it.'"

Even though Guy strives for accuracy in his paintings, sometimes he makes a mistake. One such error in this painting strikes some Seminoles who view it because they have participated in or watched the Screech Owl Dance. They point out the ball pole in the background. The pole serves as the goal post for another activity of the Green Corn Dance—the stick ball game. Near the top of the pole, the bark is skinned off, and to score a point, the ball must strike above that area.[44]

"You heard of lacrosse?" Guy asked. "Very much the same thing." He explained that, in the past, the team members were all male, and that in other areas, they may be of either gender. However, during the Seminole Wars, the men started to play against the women. He said, "The women get to use their hands. The men don't. They have to use the stick ball sticks." He described the stick as about two feet long and made of a single piece of wood that is carved thin at the end and warped in a circle, forming a loop at the end of the stick. Narrow strips of leather are tied across the loop to form a kind of basket for catching the ball.[45]

"They use two of those to catch the ball," he said. "The men have to use those to touch the ball. . . . I've played it a little bit, but only for a few minutes. It's very hard. . . . I found the best way is to throw the ball backwards." He gestured as if both hands held the sticks to toss the ball over his shoulder at the goal. In contrast, "the women can use anything and any tactics they want, and they do, from what I understand," he said. "It's rough. People lose teeth and get scarred up."

Mary Johns from the Brighton Reservation told him that she recognized his error because of the angle of the sun on the pole indicated the wrong time of day. Guy said, "Other people have told me it was wrong, but they didn't say why . . . and I didn't think to ask, how could they tell? . . . Also, when they were saying it, I didn't have much time with them. We were talking about other things. But when Mary Johns said it, we were at her house, and we had a lot

of time to sit around and talk. And so I asked her, 'How do you know? What is it that makes it wrong?' That's when she explained it. And I thanked her very kindly. It's good to know those things." His amusement is evident in his laughter, but this is his business: he keeps adding to his knowledge and experience, so he can accurately portray such Seminole traditions as the Screech Owl Dance.

Last to Leave

"I did this painting from talk that I've heard and from things I've read. I've never actually been to a Seminole funeral," Guy said. "In fact, I don't go to funerals anyway." So in this scene, he imagined that an old man has died, and his wife is walking away from his burial (see fig. 21). He showed the canvas to Jake Osceola, who liked it, but he told Guy that the woman's hair should be loose. Guy had forgotten that the Seminole custom is for widows to wear "disheveled" hair as a sign of mourning.

Perched above the structure is an owl spreading its wings. Seminoles believe that the spirit of the deceased person takes the form of an owl until night, when the spirit travels west across the "bridge to eternity" (for the legend, see chapter 1). Guy depicted another spirit as an owl in his painting *Osceola's Deathbed*, which belongs to the Ah-Tah-Thi-Ki Museum. The portrait is the head and shoulders of the dead warrior, and a huge owl with spread wings—his spirit—rises behind him.

Pat said that another Seminole belief is that the spirit of the possessions must be released. Tools, pots and pans, even weapons were broken, and clothes ripped. They also believed that the Seminole would need some of his or her most prized possessions on the journey in the afterlife, so those were buried with the corpse.[46]

In the first quarter of the twentieth century, some Seminoles were buried in cemeteries, but before that, they were laid to rest in an above-ground structure in the wilderness. The construction details were recorded by observers in the late nineteenth century. Two cabbage palm logs were split and placed on their sides to form an oblong box, lengthwise from west to east. In this box, a floor was laid and a blanket spread over the floor. Wrapped in a blanket, the body was placed on the floor, head to the west, and covered with cabbage palm leaves and then logs. The roof was supported by sticks driven into the ground, across the box, to form an X, and then connected with a pole. This roof was then thatched.[47]

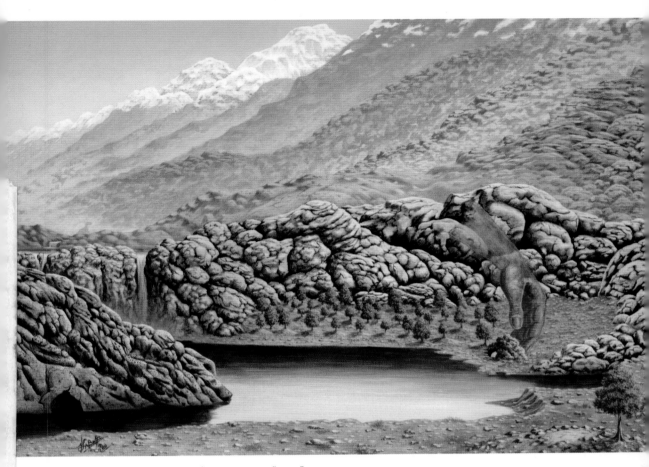

Figure 1. *Genesis*, 2000. Oil on canvas, 24" × 36".
Seminole Tribe Office, Hollywood, Florida. Repro-
duction. Smithsonian National Museum of the
American Indian, Washington, D.C. Copyright
Guy LaBree.

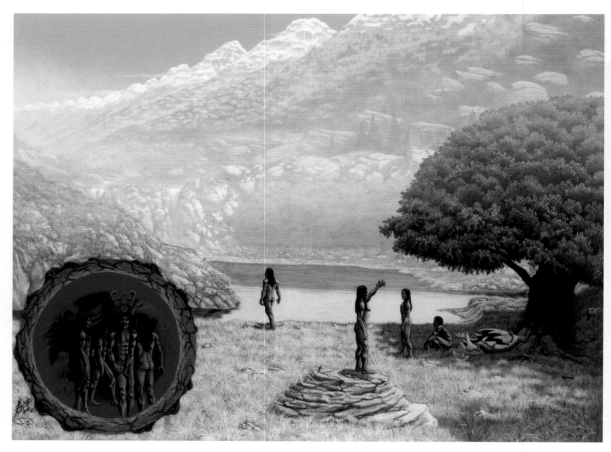

Figure 2. *Exodus*, 2000. Oil on canvas, 30" × 40".
Seminole Tribe Office, Hollywood, Florida. Repro-
duction. Smithsonian National Museum of the
American Indian, Washington, D.C. Copyright
Guy LaBree.

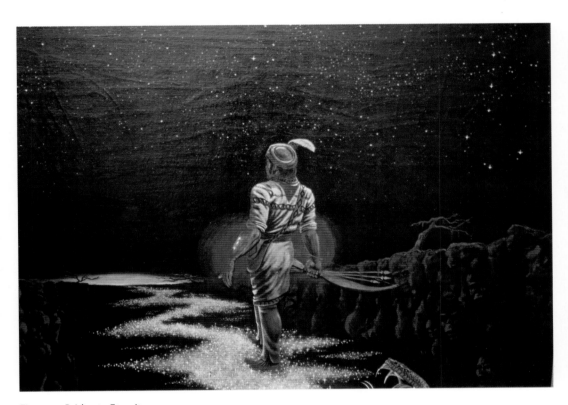

Figure 3. *Bridge to Eternity, revised*, ca. 1993. Oil on canvas, 40" × 30". James Billie Collection. Copyright Guy LaBree.

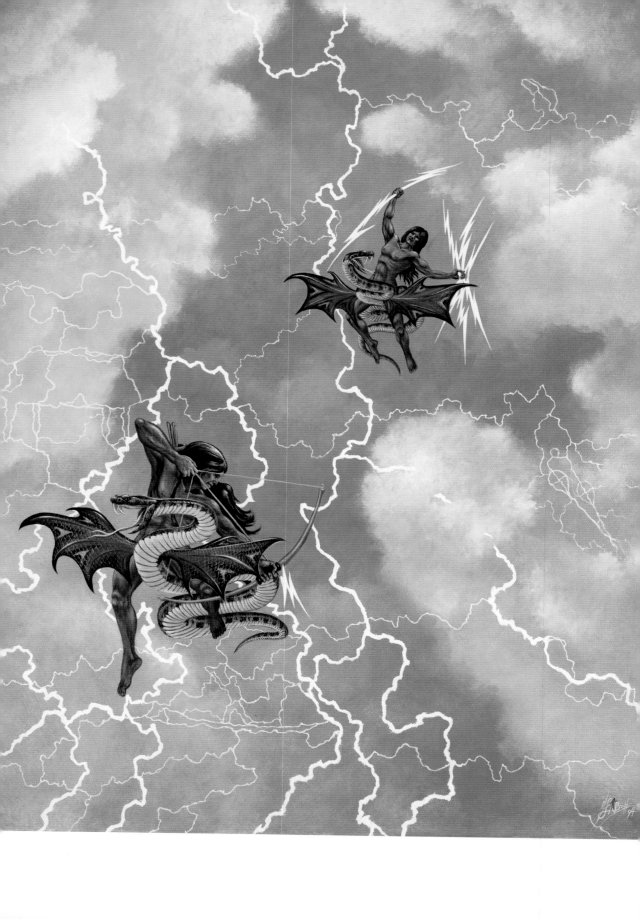

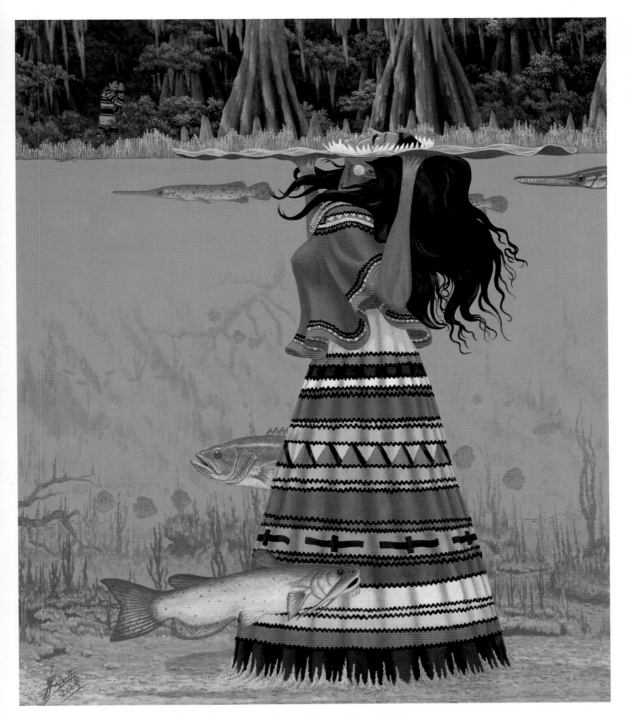

Left: Figure 4. *Sons of Thunder*, 1994. Oil on canvas, 24" × 30". William Elett Family Collection. Copyright Guy LaBree.

Above: Figure 5. *Water Lily Lovers*, 2003. Oil on canvas, 20" × 24". Sally Tommie Collection. Copyright Guy LaBree.

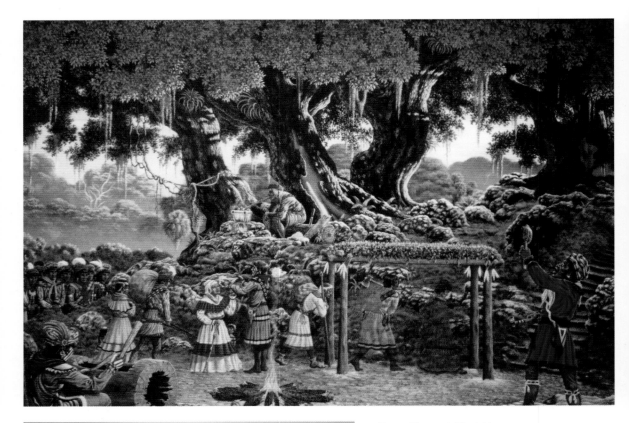

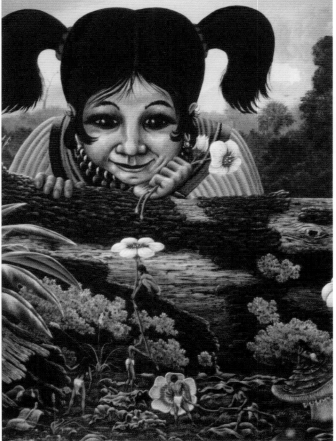

Above: Figure 6. *Vanishing Ceremony*, 1993. Oil on canvas, 30" × 40". William Elett Family Collection. Copyright Guy LaBree.

Left: Figure 7. *Time to Go Home*, 1993. Oil on canvas, 24" × 30". William Elett Family Collection. Copyright Guy LaBree.

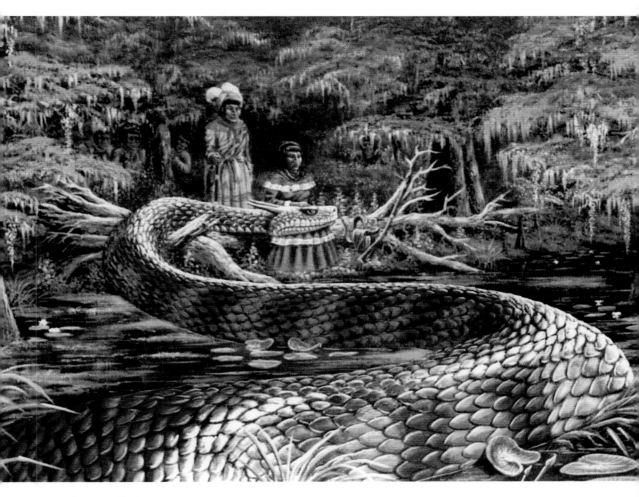

Figure 8. *Kissimmee River Legend*, 1982. Oil on canvas, 16" × 20". Eloise Osceola Collection. Copyright Guy LaBree.

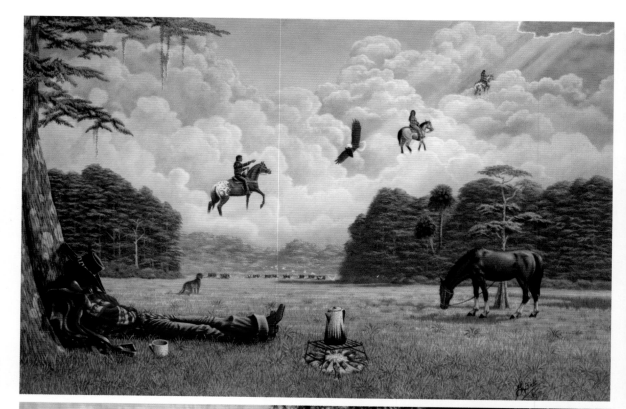

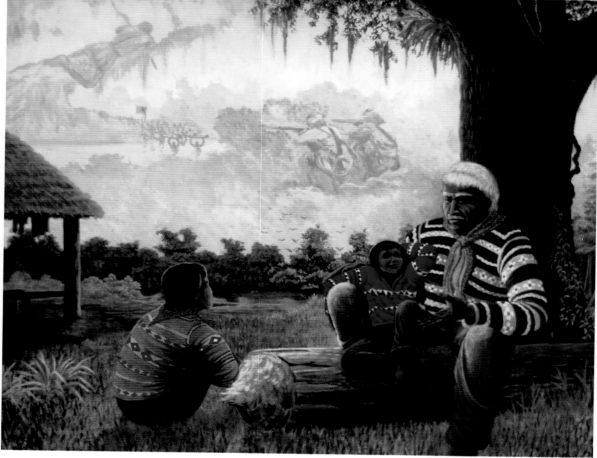

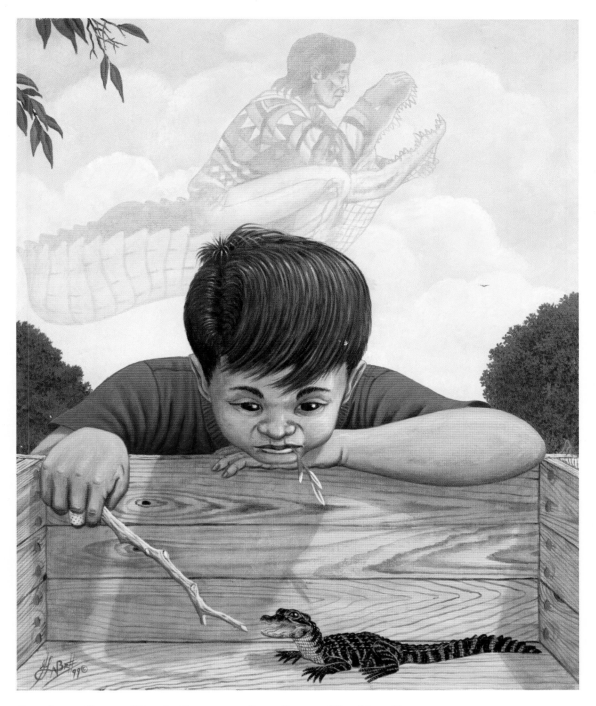

Opposite, top: Figure 9. *When the Time Comes*, 1996. Oil on canvas, 24" × 36". Mitchell Cypress Collection. Copyright Guy LaBree.

Above: Figure 11. *When I Grow Up*, 1999. Oil on canvas, 16" × 20". Tina Lacey Collection. Copyright Guy LaBree.

Opposite, bottom: Figure 10. *The Story-teller/Sunset Recollection*, 1977. Oil on canvas, 16" × 20". James Billie Collection. Copyright Guy LaBree.

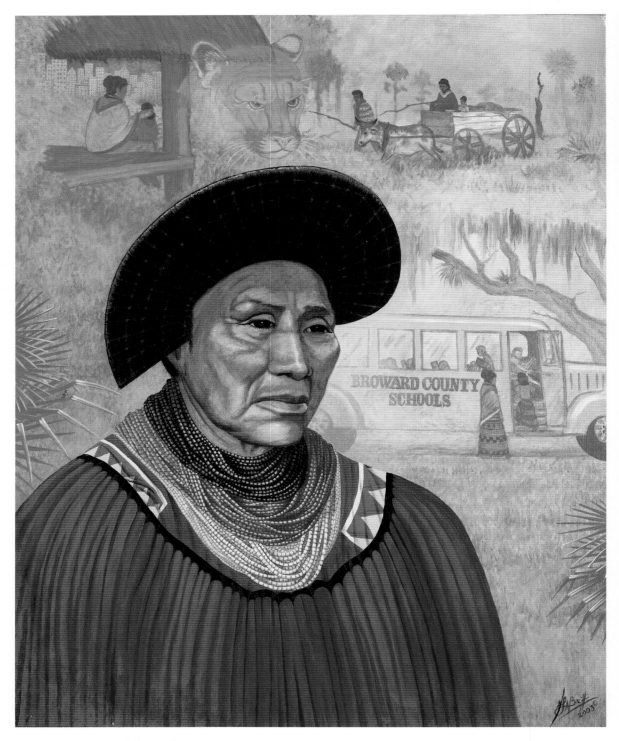

Figure 12. *"Oh, the Changes I've Seen,"* 2003. Oil on canvas, 24" × 30". Patricia LaBree Collection. Copyright Guy LaBree.

Figure 13. *Breakfast Time*,
2000. Oil on canvas, 12" × 16".
Patricia LaBree Collection.
Copyright Guy LaBree.

Above: Figure 14. *Mikasuki Seamstress*, 1995. Oil on canvas, 16" × 20". William Elett Family Collection. Copyright Guy LaBree.

Opposite, top: Figure 15. *Homework*, 1997. Oil on canvas, 20" × 24". William Elett Family Collection. Copyright Guy LaBree.

Opposite, bottom: Figure 16. *Hunter in the Grass*, 1993. Oil on canvas, 24" × 36". Jacob Osceola Collection. Copyright Guy LaBree.

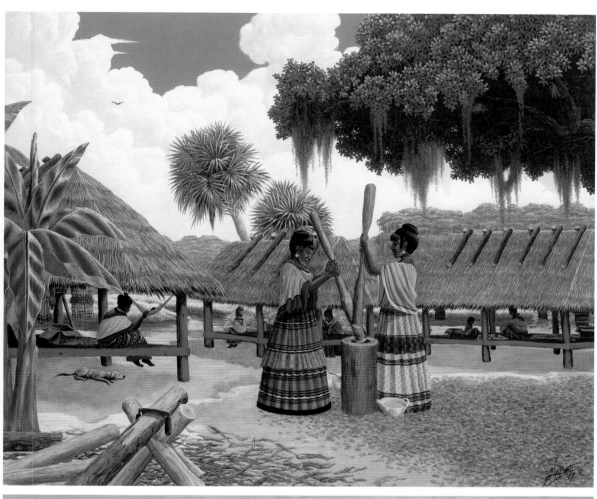

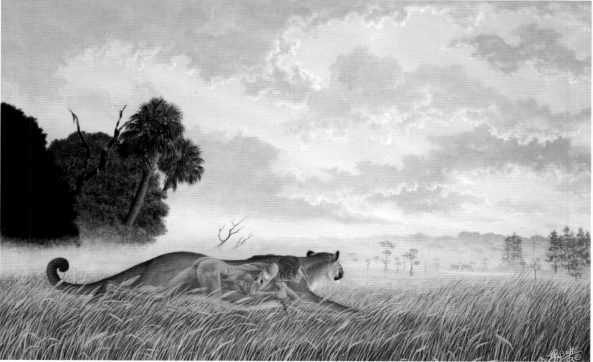

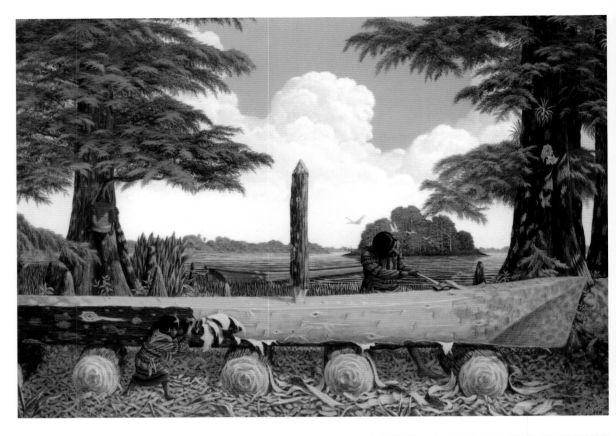

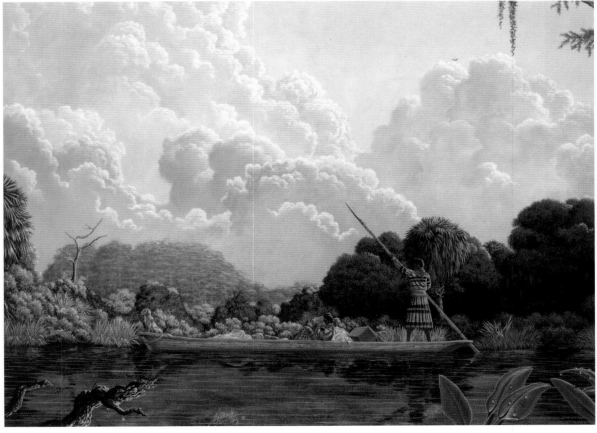

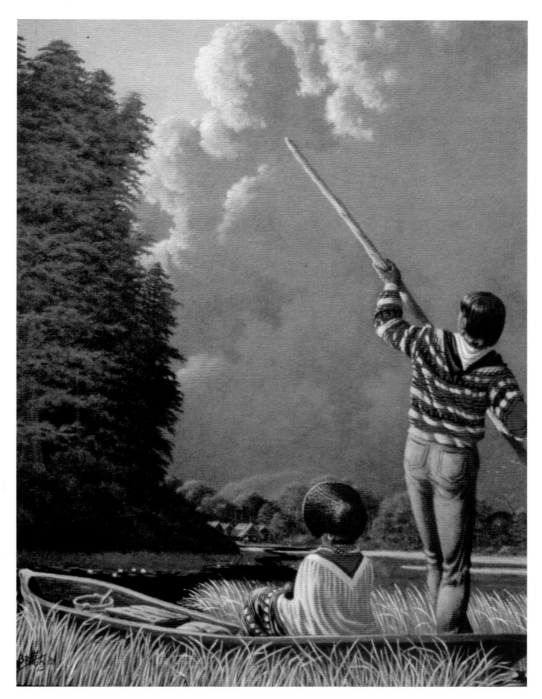

Opposite, top: Figure 17. *Dugout Apprentice*, 1995. Oil on canvas, 24" × 30". William Elett Family Collection. Copyright Guy LaBree.

Opposite, bottom: Figure 18. *Travelog*, 1993. Oil on canvas, 18" × 24". William Elett Family Collection. Copyright Guy LaBree.

Above: Figure 19. *A Visit to Big Cypress*, 1992. Oil on canvas, 16" × 20". William Elett Family Collection. Copyright Guy LaBree.

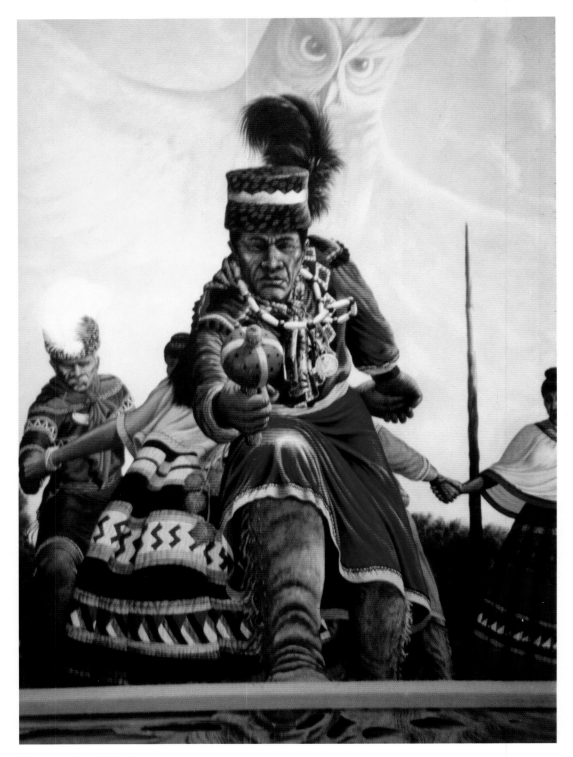

Figure 20. *Screech Owl Dance*,
1985. Oil on canvas, 24" × 30".
James Billie Collection. Copy-
right Guy LaBree.

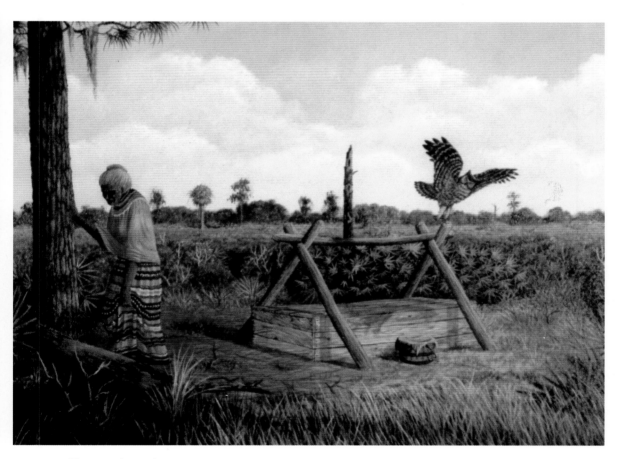

Figure 21. *Last to Leave*,
1981. Oil on canvas, 16"
× 20". Seminole Tribe
Collection. Copyright
Guy LaBree.

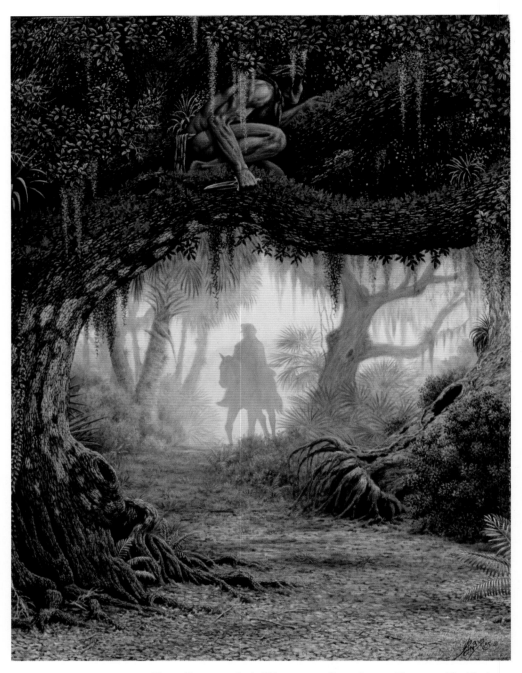

Above: Figure 22. *End of Message*, 1985. Oil on canvas, 24" × 30". William Elett Family Collection. Copyright Guy LaBree.

Opposite, top: Figure 23. *The Mocker*, 1989. Oil on canvas, 24" × 36". James Billie Collection. Copyright Guy LaBree.

Opposite, bottom: Figure 24. *Withlacoochee Surprise*, 2000. Oil on canvas, 30" × 40". James Billie Collection. Copyright Guy LaBree.

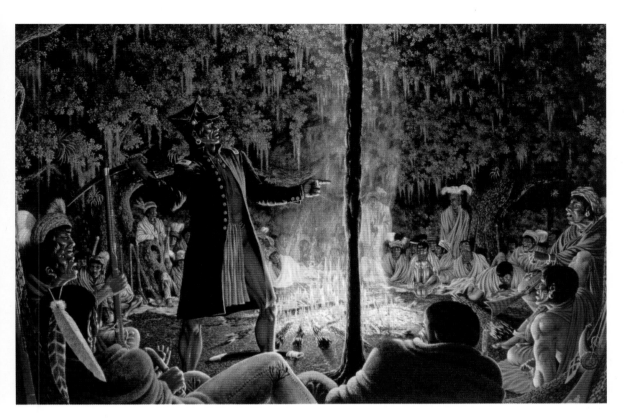

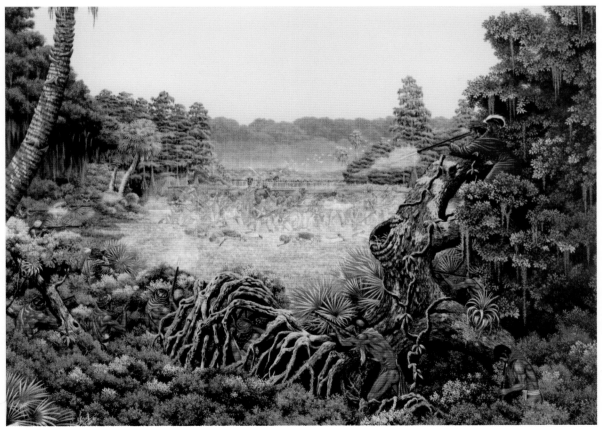

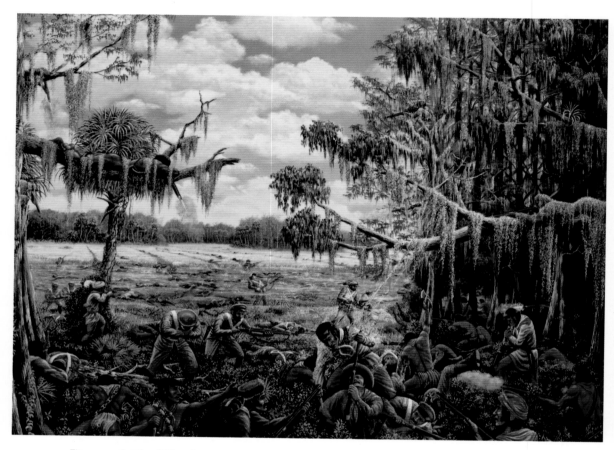

Figure 25. *Battle of Okeecho-bee*, 1983. Oil on canvas, 30"
× 40". Gary Frazier Collec-
tion. Copyright Guy LaBree.

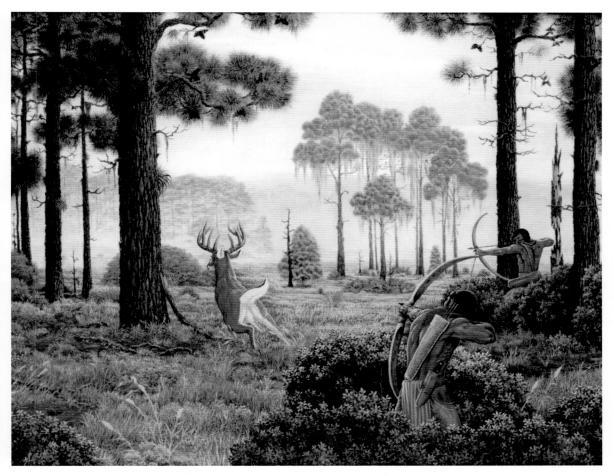

Figure 26. *Make It Count*, 1990.
Oil on canvas, 16" × 20". Wil-
liam Elett Family Collection.
Copyright Guy LaBree.

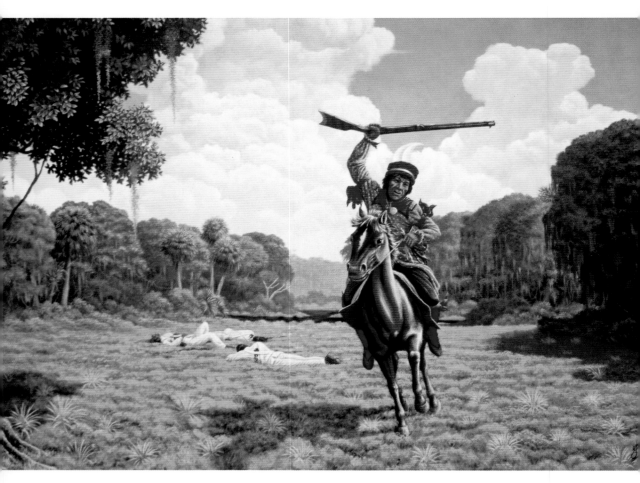

Figure 27. *Wild Cat, Red Warrior*,
1997. Oil on canvas, 24" × 36".
William Elett Family Collection.
Copyright Guy LaBree.

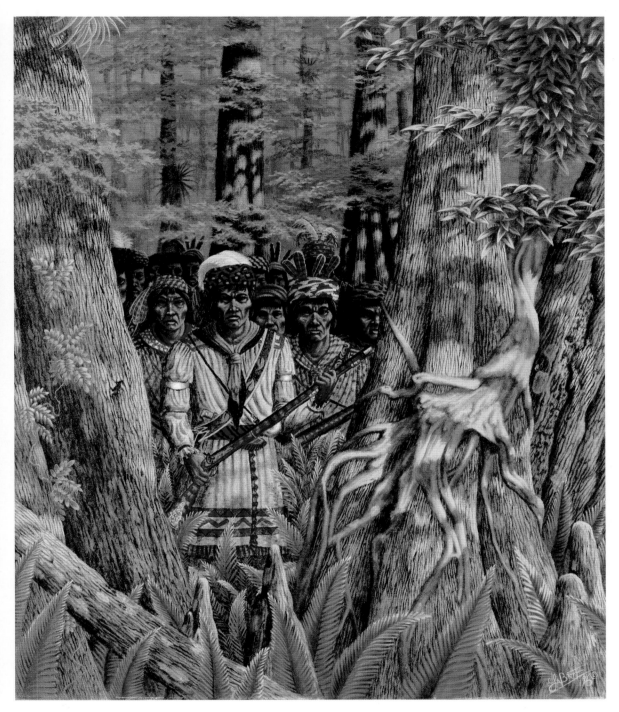

Figure 28. *Suspicion*, 1996. Oil on canvas, 20" × 24". William Elett Family Collection. Copyright Guy LaBree.

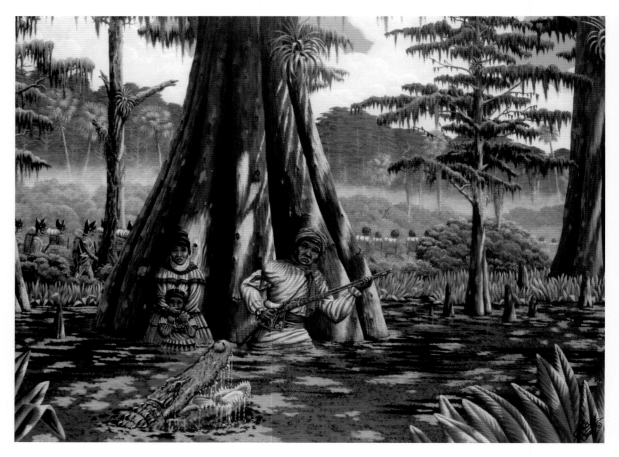

Above: Figure 29. *Danger Zone*, 2001. Oil on canvas, 24" × 30". John Wayne Huff Collection. Copyright Guy LaBree.

Opposite, top: Figure 30. *Deep Cypress Engagement*, 1983. Oil on canvas, 24" × 36". Unknown. Copyright Guy LaBree.

Opposite, bottom: Figure 31. *Survival*, 1983. Oil on canvas, 24" × 36". William Elett Family Collection. Copyright Guy LaBree.

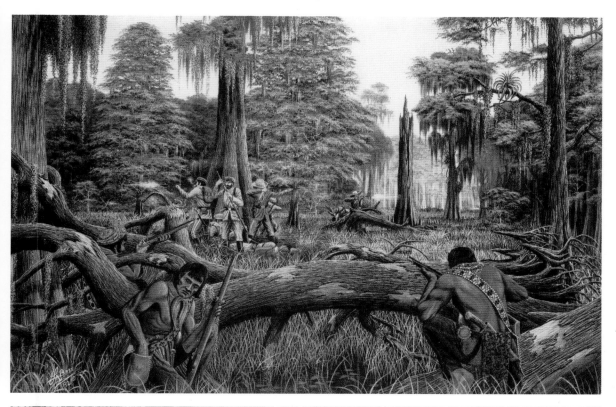

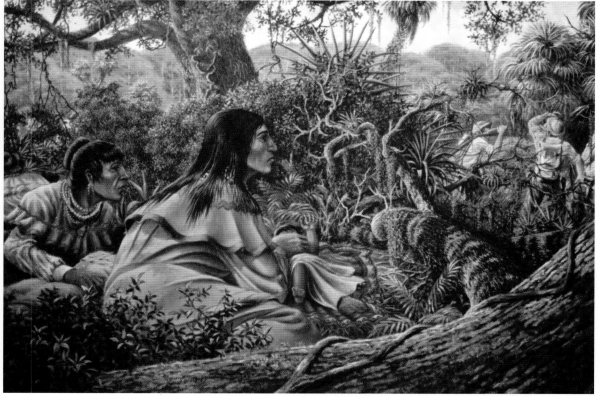

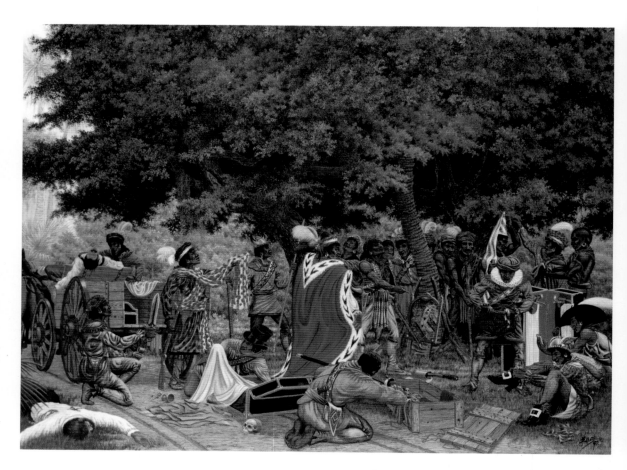

Above: Figure 32. *Suspect Foul Play*, 1992. Oil on canvas, 24" × 36". William Elett Family Collection. Copyright Guy LaBree.

Opposite, top: Figure 33. *Plans of War*, 1986. Oil on canvas, 24" × 30". James Billie Collection. Copyright Guy LaBree.

Opposite, bottom: Figure 34. *Intruder on the Land*, 1992. Oil on canvas, 20" × 24". William Elett Family Collection. Copyright Guy LaBree.

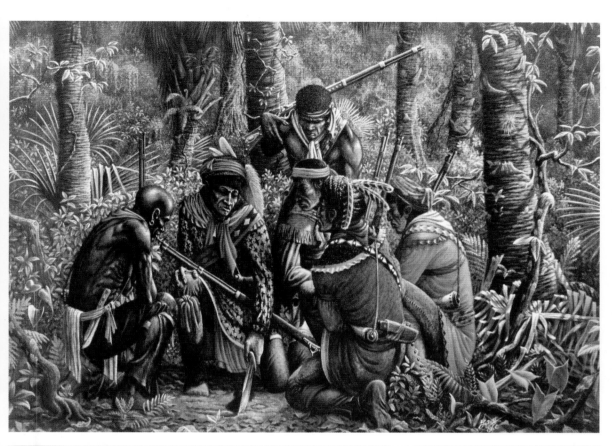

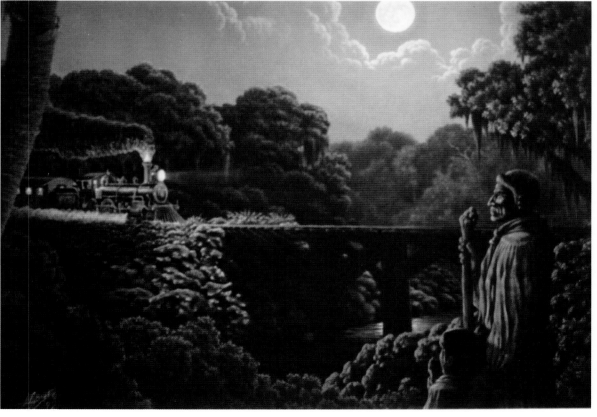

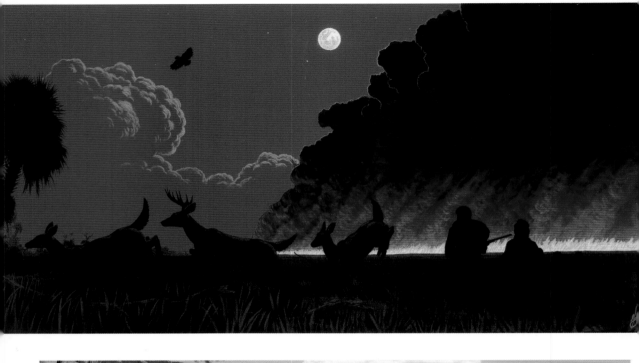

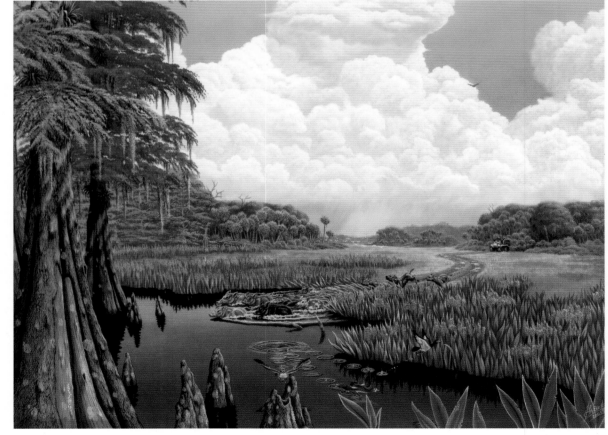

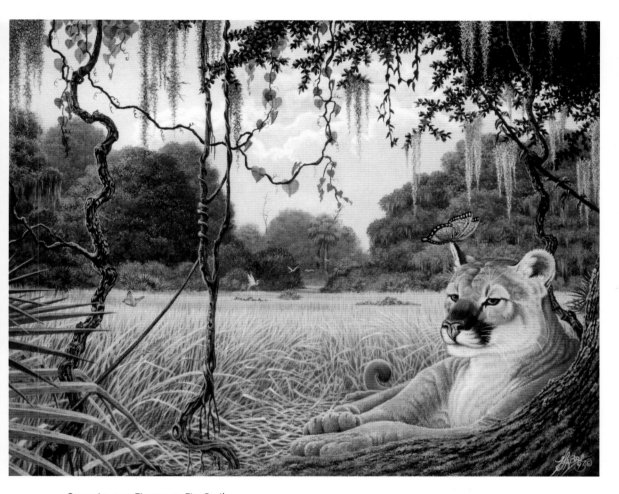

Opposite, top: Figure 35. *Fire Peril*, 2003. Oil on canvas, 12" × 24". David Cypress Collection. Copyright Guy LaBree.

Opposite, bottom: Figure 36. *Almost Hog Heaven*, 2003. Oil on canvas, 24" × 30". David Cypress Collection. Copyright Guy LaBree.

Above: Figure 37. *Restful Shade*, 1993. Oil on canvas, 16" × 20". William Elett Family Collection. Copyright Guy LaBree.

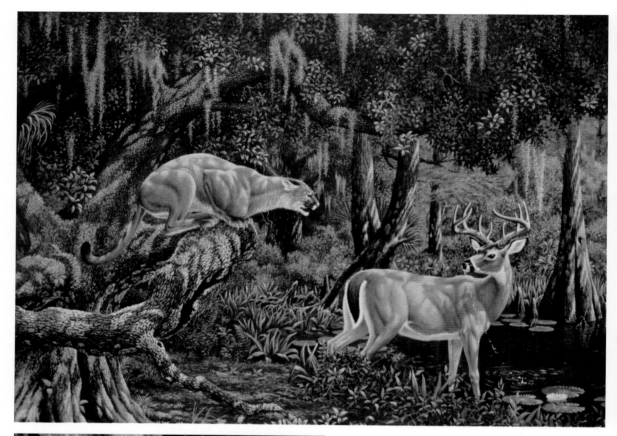

Above: Figure 38. *Jeopardy,*
1986. Oil on canvas, 22" × 26".
William Elett Family collection.
Copyright Guy LaBree.

Left: Figure 39. *Waiting for Mom,*
1990. Oil on canvas, 16" × 20".
William Elett Family Collection.
Copyright Guy LaBree.

Figure 40. *Sunup Turkey Feast*, 1988. Oil on canvas, 24" × 30". John LaBree Collection. Copyright Guy LaBree.

Left: Figure 41. *Snack Gar*, 1996. Oil on canvas, 16" × 20". William Elett Family Collection. Copyright Guy LaBree.

Below: Figure 42. *Repeat Offender*, 1989. Oil on canvas, 20" × 24". William Elett Family Collection. Copyright Guy LaBree.

In 1961, when Guy was nineteen years old, he saw and photographed the remains of such a burial in the Everglades, behind Monroe Station, a way-stop at the intersection of Loop Road and the Tamiami Trail in the Big Cypress National Preserve and Wildlife Management Area. At that time, water stood on the ground except on mounds where the palmettos grew, and even the sand there was damp.

After Guy and a friend from school had spent a morning hunting snakes, they climbed onto such a mound to eat lunch. They were sitting down before they noticed what was on the ground. His friend pointed to some bones that looked like a skeleton. Guy remembered: "This face looking out of the sand." They also discovered the framework and coffin, although parts of it had rotted away. In the corners of the box, he observed a few nails that had dissolved into rust. He wondered if perhaps someone else had robbed nails or other items from this gravesite. He said, "I didn't. I was afraid to be disrespectful."

Guy guessed that the Seminole had probably died thirty or forty years before he saw the burial. Years later, he met a relative of the dead man, and he apologized. The relative told Guy that he was not offended because Guy was only looking. "I showed him the pictures I took, and he thought that was neat. And he said, 'Yeah, I'll tell you right where this is,' and he drew me a little scratch in the sand, and he put a pinpoint right where it would have been. He said, 'That was my grandfather.'" Guy laughed, remembering how surprised he had been. "That's who I learned it from. He said it would just go back to nature, just rot away."

Guy mentioned that he had read about a Seminole who had been buried inside a canoe that had been cut in two, and he may be remembering "Captain" Tom Tiger. In 1906, Tiger died before he had finished making a canoe for his family, so they cleaved it in half, placing his corpse inside and his belongings on top. Tom Tiger's granddaughter, Betty Mae Tiger Jumper, also includes this incident in her autobiography as well as a photograph, dated June 29, 1906, from the National Anthropological Archives, which shows "the deserted village of Tom Tiger's followers."[48]

Guy noted that it was an old custom to move from a village after someone died: "They'd go build another place to live, and then they'd move, and they wouldn't go back there, except . . . maybe . . . to show a kid where they used to live or something." He didn't feel confident that the parents actually guided the children to the former village, but he knew the reason for moving: at night, the spirits of the dead may visit. The Seminoles believe that "when you're sleeping, you're out of your body" and the dead ones may "take you on with them," he said. "There's a lot more to that, but I'll just leave it at that."[49]

When Guy started to paint as a career, a fellow artist, Fred Kirsch, gave him some tips. He told Guy not to use white or black paint unless they're mixed with other colors and not to portray scary subjects—such as snakes or spiders—or anything about death or dying.

"Well, I use pure white, and I use pure black, and I do a lot of pictures about death and dying and spooky things—to other people, it's spooky.... The stories I use it for, it's a necessity, and people don't seem to mind it, when it's authentic." Adding that he does "the opposite" of Fred's advice, Guy said, "But I didn't start out doing that. I worked my way to that, somehow . . . like doing this picture—*Last to Leave.*"

Seminole History

The original native inhabitants of Florida were decimated by diseases introduced from Europeans, enslavement, and relocation to Cuba. Some survived in south Florida and as employees of the coastal Spanish fishing industry; other remnants or refugees from Spanish missions may have been assimilated by the "Lower Creeks" from Georgia and Alabama, the Indians that migrated to Florida in the early eighteenth century. Members of other Indian tribes also moved to Florida and were integrated with the Creeks. Then, in the early nineteenth century, a large group of "Upper Creeks" moved to Florida. By then, the word *Seminole* in English referred to the descendants of the Creek people who lived in Florida. Jerald Milanich writes, "Scholars agree the name *Seminole* was originally derived from the Spanish word *cimarrone*, a word long in use by the Spaniards to refer to Indians living apart from missions or other Spanish-Indian settlements."[1]

After the Seminole Wars that killed or caused the removal of a large population to Oklahoma, those remaining in Florida—perhaps as few as two hundred—lived in the isolation of the Everglades and Big Cypress Swamp. For about twenty years, they insulated themselves from the few non-Indians in south Florida. When the Indians were discovered anew, settlers referred to any Florida Indians as Seminoles. However, the Indians themselves rejected this name when translated into English as "runaway", "renegade", or "outlaw." According to William C. Sturtevant, "in Florida, these [Mikasuki and Muskogee] terms mean simply 'wild' and are used to refer to naturally wild animals and plants in contrast to tame or domesticated ones." In the 1950s,

the Indians knew "the derivation of the English word 'Seminole' from these Indian words" and scorned it. In their own languages, they called themselves "Indians", "meaning literally 'red person' and paralleling terms meaning 'white person' and 'black person' applied to whites and Negroes."[2]

In 2000, Guy spoke as a guest lecturer for anthropologist Dr. Patricia Waterman, an associate professor of anthropology at the University of South Florida. He said, "I get real nervous when I have to give these talks, so I just told them right out: 'The first thing I'm going to say is that when I call them as a group or whatever, I say "Indians," I don't say "Native Americans." They don't either.' And a whole bunch of people clapped. That was nice, and it made me feel more relaxed."

Pat LaBree added, "At the opening of the Ah-Tah-Thi-Ki Museum, Tribal Elder Laura Mae Osceola said, 'We have always called ourselves Indians.'"

Of the name "Seminole," Guy said, "The white men like to write down that it means 'runaway,' but the Indians say that it does mean 'runaway,' but it is also used in another context which means 'pioneer' or 'explorer.'" He says that the Seminoles are proud of their name. As an example, he recalled the controversy about the Florida State University football team using a Seminole for a mascot. He said, "When Jim Billie was in office, a reporter called him up while he was working and asked him what he thought about being a mascot for a football team. James thought about it for a second, and he said, 'Look, I'm out here building an alligator pit. To me that's more important than answering your questions. Does that tell you what I care about being a mascot?'" Later, in a 1991 letter to the FSU Alumni Association, James Billie endorsed the use of the Seminole name for the team, and in 2005, the Seminole Tribe voted to reaffirm FSU's right to use the Seminole name.[3]

Until well into the twentieth century, most outsiders thought Muskogee was the Seminole language. Speakers of Muskogee use that name to refer to the language and all of the people of their culture—whether they speak Muskogee or another language. However, anthropologists distinguish between Muskogee, the language, and Creek, a cultural group that includes those who speak Muskogee as well as other related languages. (For the difference between Mikasuki, the language, and Miccosukee, the tribe, see *The Storyteller/Sunset Recollection*, chap. 2.) Although many historical and contemporary writers refer to the Creek Confederacy, this political organization may not have been as important to those who were said to belong to it. Instead, they were members of a town, and English-speakers often named groups of Indians for their town or location. For example, the name "Creek" was shortened from "Ochese Creek Indians," referring to those who lived on Ochese Creek, the designation for the upper Ocmulgee River in Georgia.[4]

Many years later, this practice of naming groups of Indians according to where they lived continued in Florida. For example, Pat said that some people assume that the "Cow Creek" Seminoles, who mostly live on the Brighton Reservation, were so named because of their participation in the cattle program that originated there in the 1940s. However, she had recently read the true derivation of the name, which referred to their location on the banks of Cow Creek, which flows into Lake Okeechobee.[5]

Where the Seminoles live today is a result of the three Seminole wars, which some historians consider to be different phases of one conflict lasting more than forty years. For centuries, Spanish Florida had served as a refuge for runaway slaves and Indians in flight from British and American settlers, yet many considered the peninsula destined to become part of the United States. A few researchers include the so-called Patriot War, or East Florida Annexation Plot of 1812; the destruction of Seminole towns near Payne's Prairie by Tennessee militia and U.S. troops in 1813; and the British, Indian, and Negro occupation of Pensacola in 1814 as part of the First Seminole War. However, most historians focus on the destruction of the "Negro Fort" in 1816 and Andrew Jackson's military campaigns in Spanish Florida that drove Indians and blacks from the border with the United States. Joshua Giddings interpreted the United States' aggression in 1817–18 against the Seminoles living in Florida as an effort to recover the runaway slaves who lived among them. Giddings writes of the campaign's conclusion: "The army was therefore withdrawn from Florida, without any treaty whatever." The ultimate outcome of the First Seminole War was the acquisition of Florida in 1821 by the United States.[6]

The Indian Removal Act of 1830, passed by the United States Congress and signed into law by its advocate, President Andrew Jackson, precipitated the Second Seminole War, 1835–42. At issue were both land and escaped slaves, who lived in settlements as "vassals" of the Seminoles. (For details, see *Plans of War*, chap. 3.) Long before the war, settlers feared a slave revolt, and Larry Rivers has suggested that the liberation and arming of the slaves from the sugar plantations along the St. Johns River at the outset of the conflict in 1835 is "the largest slave rebellion in United States history." In the First Seminole War, much of the violence was aimed at black Floridians, and this situation continued. Brevet Major General Thomas Sidney Jesup called the conflict a "Negro war," and by the time he relinquished his command of the forces in Florida in 1838, nearly all of the Seminole Maroons had been captured or had surrendered for emigration to Indian Territory because they had been promised their freedom. The Indians fought five more years to preserve their way of life and their land, and some remained in Florida at the war's

conclusion. On August 14, 1842, Colonel William Jenkins Worth's General Order 28 announced that "hostilities with the Indians within this Territory have ceased."[7]

After seven years of relative peace, several incidents of violence roused the government to renew negotiations for removal of the Florida Seminoles. The Third Seminole War began in 1855 with an Indian attack, and throughout the conflict, the Seminoles and the runaway slaves living with them employed only "hit-and-run tactics." The Florida Volunteers captured some; others surrendered; and the two groups embarked on ships for the Indian Territory. Then, "On May 8, 1858, Colonel Gustavus Loomis declared the Third Seminole War officially ended and ordered the dispersal of military supplies and units." As some Seminoles remained in Florida, and none of the three wars was ever concluded with a peace treaty, the Seminole Tribe claims to be "unconquered." In addition, historians single out the Florida Seminoles as giving "the fiercest opposition" to the "national policy of Indian removal."[8]

Many of Guy's historical canvases depict scenes from the Second Seminole War, the conflict most remembered by the Seminoles. Brent Weisman has called it "the cultural watershed from which much of the contemporary Seminole culture and personality has sprung." In the nineteenth century, it was called the "Florida War." At a cost of $30 to $40 million and seven years in length, it is cited as "the longest, most costly, and deadliest war ever fought between the United States and Native Americans," with a 14 percent death rate in the regular army and a comparable rate for the volunteers.[9]

The Second Seminole War profoundly changed Florida and those who fought in it. Only three years after the war, as a result of the Armed Occupation Act of 1842, the Florida territory gained enough population for statehood, and many of its cities and towns retain the names of the forts around which they were established. In addition, veterans of the Florida War gained "invaluable field experience" and learned the strategies of "guerrilla, or partisan-style, warfare" as well as "riverine warfare." They fought in the Mexican War (1846–48) and on both sides of the Civil War. For example, William T. Sherman employed the tactics he learned during the Second Seminole War in the infamous "march to the sea."[10]

Historical paintings may be compared to historical fiction, which is defined by fictional characters acting in a bygone setting that is true to the particulars of surviving records. So Guy's paintings are wrought from a wealth of authentic details and characters from historical accounts, yet he composes those facts according to his imagination. He carefully frames each one from the Seminole point of view, a perspective usually lacking in the chronicles.

For more than thirty years, Guy and Pat have read books and articles,

Guy LaBree: Barefoot Artist of the Florida Seminoles

listened to scholars and other experts, and—most importantly—talked with the Seminoles. For example, his conversation with his Indian friends contrasting the behavior of the troops and the warriors inspired the painting *End of Message*. Similarly, his friends supplied the details for another composition, *The Mocker*. It focuses on how the Indians celebrated their victory after the Dade Battle. The incident—from a Seminole perspective—is recorded by Brevet Captain John T. Sprague, as told to him by a warrior after his capture.

Sometimes the Seminole oral tradition corroborates the chronicles, and other times it contradicts the historical record. Guy said, "One of the ways they hand down their history is by telling. . . . The history is put into stories, but it's very accurate, usually. Ninety percent of the time, I'd say, more accurate than ours, in the books. How they do that, I don't know."

An avid reader of history and historical documents, he incorporated details from published accounts to paint *Withlacoochee Surprise*, relying on his own observations of nature to complete the scene. His canvas *Battle of Okeechobee* is a good example of how he researches information—consulting historians, reenactors, archaeologists, and his Seminole friends.

Some paintings do not reflect particular historical incidents, but rather the truth of everyday life for those at war. For these paintings, he relies on his knowledge of Seminole culture and history as well as the Florida wilderness. In *Make It Count*, he captures two warriors hunting with bows and arrows, because during the final years of the Second Seminole War, the Seminoles were often without ammunition for their guns, or even if they had black powder, they needed to hunt silently so as not to reveal their position to the enemy.

Reacting against an image of the defeated Native American, he created the vision of a triumphant warrior in *Wild Cat, Red Warrior*. Although the incident is surmise, this portrait of Coacoochee is based on historical descriptions of him. *Suspicion* pictures another imagined encounter: thinking about how much he enjoys walking in the woods and about his lifelong friendship with Alan Jumper, Guy envisioned surprising a detachment of warriors.

He also frames the plight of Seminole families caught between human and natural predators in *Danger Zone*. A brief skirmish is the subject of *Deep Cypress Engagement*, but as Guy explains, it was a special Seminole tactic designed to "demoralize the enemy." Charles H. Fairbanks poetically called it "raiding and then fading into the forest or swamp."[11]

When Guy happens across tantalizing references that seem the perfect subject for a painting, he searches for more information. When he heard and read about a controversial matter—infanticide—he asked his Seminole

friends about it. Enough corroborated the practice, so he painted *Survival* to elegize a desperate situation: when on the defensive and to elude capture, the Seminoles sometimes sacrificed their own children. In another case, he found mention of a Seminole attack on a theatrical troupe, so Pat requested and received a copy of a newspaper article about the event from the St. Augustine Historical Society. To the facts contained therein, Guy added his knowledge of costumes and props gleaned from watching films and studying Shakespeare in high school for the canvas *Suspect Foul Play*.

After an acquaintance related an episode from the Third Seminole War, when Seminoles attacked a homestead within fifty miles of the LaBree home in DeSoto County, Guy chose to focus on the preparation rather than the action itself in *Plans of War*. Even after the wars, the Seminoles continued to confront the growing population of Florida and the changing landscape, as symbolized by the locomotive in *Intruder on the Land*.

Guy noted that the Seminoles never fought "the English, the Spanish, the French—nobody. They only fought with Americans." His historical paintings, based on information gathered from many sources, offer the truth of portrait rather than photograph. Whether they are named battles or unrecorded incidents, they offer a unique perspective—imaginative and informed—of the Seminole's past and Florida's history.

End of Message

In a conversation with Jacob Osceola and other friends, Guy remembered they had said that, during the Florida War, the Seminoles usually knew the movements of the army because they could hear them. "The soldiers had their family dogs with them," barking and chasing rabbits and other prey through the surrounding wilderness. Soldiers talked as they marched, "cracking and snapping twigs," accompanied by the "squeaky old wheels on caissons" or other vehicles and the jingling of harnesses for horses and draft animals.

In contrast to the noisy troops, solitary, silent Seminoles hid in the grass, bushes, or trees, undetected by the army, to learn about their locations and numbers. Guy said, "So this is one of those guys, but he's about to get rid of a messenger who's coming through a hammock from out in the fog, and that's why it's called *End of Message*" (see fig. 22).

The Seminoles often intercepted and killed messengers of the U.S. Army. In December 1835, messengers sent from Fort King, near present-day Ocala, bringing the news of the Indian attack there never arrived at Fort Brooke, at Tampa Bay. Nor did messengers from Tampa, charged with reporting the fate of the reinforcements expected under Major Francis L. Dade, ever reach Fort

King. According to a letter written by Lieutenant Joseph W. Harris to General George Gibson: "Two expresses, soldiers, were dispatched upon fresh horses on the evening of this horrid tragedy with tidings of it to General Clinch; but, from our not hearing from him or them, we are apprehensive that they were cut off. We are also exceedingly anxious for the fate of the two companies which had been ordered up from Fort Brooke, and which should have been so a week ago, of whom we can learn nothing. Our communication with Tampa is cut off."[12]

Pointing to the painting, Guy said, "There's some cabbage trees [*Sabal palmetto*], and there's some palmettos [*Serenoa repens*]. Usually you don't see a whole lot of cabbage trees and palmettos growing together, but there's always that one certain height of the ground where cabbage trees will grow and palmettos will grow. If you get down too low, palmettos don't want to grow there 'cause it's too wet. But cabbage trees will." He explained that although the passage in the painting looks like a path, it was considered a road.

During the Second Seminole War, General Zachary Taylor reported that his soldiers had constructed 848 miles of "wagon-road" as well as 3,648 feet of "causeways and bridges." Guy mentioned one in particular, built before the start of the conflict. Called at first the "Military Highway," and then the "Fort King Road," it connected Fort Brooke on Tampa Bay to Fort King near present-day Ocala, continuing to Micanopy, near Gainesville. It more or less followed an established Indian trail from Tampa Bay to Alachua.[13]

Guy called the soldier in his painting "dead man walking" before he corrected himself: "The horse is walking. It's a silhouette of a guy on a horse. He's probably wearing a slicker or something. He's got the army cap on, carrying his rifle across his horse there, so the barrel's sticking out to the left side—his left—and there's like a pack in back of his saddle there, kind of showing."

For the artist, this canvas has a special mystery. He said, "It looks like I put shadows on the man and the horse and all—and I didn't do that." He was trying to focus on a phenomenon that he has observed—the gradual way that images emerge from the fog. His finger pointed to the features as he spoke. "It looks like there's a highlight on this horse's neck here. I don't remember putting that in." Indicating where the man's face is dark, and where it seems lighter on the side, he tried to explain what could have happened. First, he outlined the silhouette, and he said, "Maybe when I was putting the paint on, as I was filling it all in, it came in that way, but it was all supposed to be the same color."

Poised to ambush the soldier below, the warrior holds his weapon ready. Guy said, "It's not the kind of a knife that the Seminoles made 'cause they didn't make them. They would get them from the army or somebody that

they had killed." He added that the warriors made sheaths for many blades that were simple kitchen knives, reflecting that a kitchen knife is "a whole lot harder than—and easier to sharpen than—stone."

Always scouting for information about the Seminoles, he discovered an important source at an art show in Dade City. Bill Dayton, an attorney and Florida historian, bought a painting. When the LaBrees visited his home, he showed them a diary that may have been written by Dr. Ellis Hughes.[14] In it, Guy found information about Sam Jones, also known as Abiaka, a Seminole medicine man.[15] Guy remembered that the diary belonged to Dayton's friend: "A diary of his great-great grandfather . . . he had seen Sam Jones at some meeting years before, and he gave a description and even had a little sketch of him in a diary. It's kind of a crude sketch . . . but it told a lot about Sam Jones, and I did a painting of him later from his descriptions."

Besides diaries, he discovered additional primary source material in the annual *Congressional Record*, printed in 1840 for the first session of the Twenty-sixth Congress, a copy of which is part of the LaBree library. Included is a series of reports from the U.S. Army commanders of the Second Seminole War. Guy said, "It's great because they write like it's matter-of-fact, and when you put yourself in their position, these guys are heroes."

One event that Guy read about occurred in July 1836, when the Seminoles attacked the Cape Florida Light on Key Biscayne. Although the lighthouse was burning and the Indians who torched it may have been in the vicinity, the U.S. schooner *Motto* landed a rescue party.[16]

Guy said, "A big, big black man was working with the white lighthouse keeper, and he had climbed way up into the tower when they set it on fire. Up at the very top rafters, there was a steel beam or something up there, and he was laying on it." The Seminoles shot the black man, so the lighthouse keeper crawled onto his corpse, and this "saved him from being burned to death or shot." The lighthouse keeper was rescued, "which took a good while because the stairs were all burned. They got him down, and they were saying how he was 'quite a guy,' and I'm thinking these guys that got him down are the heroes, because the Indians were right around there somewhere."

Not only did these letters describe various battles, skirmishes, and other incidents, but they also supported the commanders' requests for additional appropriations for the war effort. Another one that Guy remembered related the adventures of a patrol near Bushnell. The soldiers heard their reinforcements in the distance. "As they come over this rise on horses, they stop and look down below them, as the hill went down toward where the road was, and there was about fifty or sixty Indians there waiting to ambush the reinforcements," Guy said. "Here's where the letter gets snide, because the commander

of the patrol was asking for more equipment and more men—'it's all we could do to hold back our seven men from attacking those fifty Indians'—he was trying to show the odds they were against."

Yet as the war continued, the soldiers deployed in Florida far outnumbered the warriors, perhaps even the entire Seminole population. At least one officer wrote with empathy of the Seminole, especially a warrior like the one pictured in *End of Message*: "We are prone to denounce the Indian as cowardly and treacherous because his mode of warfare differs from ours and is based on stratagem.... The noblest and bravest warrior esteems it no disgrace to lurk in silence and take every advantage of his foe; *his* greatest triumph is in the superior craft and sagacity which he displays in decoying, surprising and destroying his enemies; for the first and most *natural* principle in war is, to inflict the greatest injury on our enemy without giving him the chance to injure us, and this can be effected by stratagem only."[17]

The Mocker

Guy calls one of the first incidents of the Second Seminole War the Dade Battle instead of by its well-known name, the Dade Massacre. He explained: "Alan Jumper always said, 'How come it's a massacre when we won, but when you won, it was a battle?'" Guy laughed. "It's a good question, huh?"

In December 1835, General Duncan Lamont Clinch had ordered Captain George Washington Gardiner to march his artillery company and another from Fort Brooke to reinforce the troops under Clinch's command at Fort King. When Major Francis L. Dade discovered that Gardiner's wife was among the sick at Fort Brooke and the comfort of her husband might positively affect her recovery, he offered to take charge. Later that day, with his wife embarked on a ship bound to better medical facilities—and her family— in Key West, Gardiner joined the march, bringing with him a team of horses to haul the cannon. It had been abandoned by the column because the oxen— more accustomed to farmwork—could not haul it. Although Dade offered to relinquish the command to him, Gardiner demurred, asking only to lead his artillery company. On the sixth day of the march, the Seminoles attacked; the first volley killed half the men.[18]

Considering Gardiner's situation, Guy said, "He wasn't used to being in charge of a battle necessarily, but the others had been killed, including Major Dade . . . out on a little dirt road, and the Indians in the grass right next to the road, not twenty feet away from him. And the men were scattering in all directions, and it had been drizzling rain, and their guns had been under this tarpaulin, or canvas, that was laying on the back of this wagon to keep

them dry." (When wet, black-powder firearms can be used only as bayonets or clubs.)

Under steady fire from the Seminoles, the men dodged from pine to pine to shield them as they retraced their steps. The horses, already wounded, dragged the cannon toward them from its place at the rear of the column. When the horses finally fell, the cannon was near the pond, and Lieutenant William Elon Basinger and his crew began firing—solid shot, grape, and canister—and eventually the Seminoles retreated. During that lull, Gardiner ordered the men to fell trees and build a barricade.[19]

Continuing the story, Guy said, "Gardiner pulled his sword and started walking back and forth down the road, and he was a very fat man. They said he was as wide as he was tall, and he started yelling at the men to get the cannon working. Then he saw some logs, and he said, 'Get those logs and make a breastwork and get behind them.' And he's just telling them what to do, and they still weren't quite doing it 'cause the Indians were still picking them off, and he got really upset and started cussing. And he's yelling, 'Get that goddam cannon working,' and 'Get behind them goddam logs.'"

Guy said that the Seminoles thought Gardiner "was really something, because they couldn't seem to hit him, and he was so big, and he was right there in front of them, right close to them." He appeared almost magical. "He seemingly wasn't afraid. I'm sure he was probably so mad that he wasn't thinking about it." When someone finally shot him, Alligator,[20] a Seminole leader, took Gardiner's coat, hat, and sword as trophies.[21]

That night, the warriors gathered in the Wahoo Swamp, east of the Withlacoochee River, northwest of modern-day Dade City. They sat around fires, drinking rum, "which I don't hold against them," Guy said, "because all our soldiers drank rum as a regular ration. And the warriors were kind of feeling down, because they were not killers." Their aim was to stop the U.S. Army from relocating them to the Indian territory in present-day Oklahoma.

Then Seminole Warrior Osceola[22] arrived from Fort King—near Ocala— where he had killed the Indian agent General Wiley Thompson, his companion, and four others. He and his fellow warriors had scalped the slain, including Thompson. Guy said, "You can't have a war without having happy soldiers, so Osceola took these scalps and cut them into small pieces." The medicine man "hung them on a small sapling that they call a glory pole. He thorn-pinned them to the pole, so that there was enough for each person to have a scalp, these little pieces of it." First, Osceola told how he had killed Thompson. Guy said, "It was kind of quiet for a minute, and then Alligator jumped up, put on the hat and coat, and he picked up the sword of Captain Gardiner and started talking about their exploits with Captain Gardiner, and

how they thought he was kind of mystical because they couldn't really hit him for so long. And he's walking around the campfire waving the sword, yelling 'goddam, goddam,' because they remembered those words because he said them so many times."

Guy acknowledged that some of the details in the painting he gleaned from conversations with his Seminole friends: James Billie, Alan Jumper, and Jimmy O'Toole Osceola (see fig. 23). The "glory pole" is one. Guy said, "Jimmy O'Toole said that it probably was a sapling that they just trimmed all the limbs off of, and they didn't have to pin it in the ground." Another example is the temporary nature of the camp, which meant that the warriors didn't build lean-tos or hang tarps. They sat around the fire, wrapped in their blankets, Guy explained, "because it was winter time, it would have been mighty cold, when the mists settled in."

The circle of Seminoles includes some in the foreground, with their backs to the audience, giving the illusion that the viewer joins them around the fire. Pointing to it, he commented, "The hardest thing about it, too—but what I liked doing—was fooling with the light. The light source is just that fire, and it comes out like a dome in all directions from the center coming right at you, coming straight up, and off to each side, and off in the distance. And, of course, fire light doesn't travel too far, unless the fire's a big one." From his years of experience around campfires, he has observed that "colors change a bit. Reds brighten up, and yellows brighten up. But then your darker colors get darker, and blue colors mute down to kind of a brown, almost sometimes. I tried to put the colors in and mute them when I had to, and then the highlighting is . . . where I used the firelight."

When the painting was on display at the Collier County Museum, he gave a formal presentation. Some of his Seminole friends were making fun of him, "trying to get my goat, trying to embarrass me. So they come in and say, 'Aw, he don't know nothing,' and stuff like that, in the background, and they're Seminole, so the white people are thinking, 'What's with this guy?' Anyway, when it was all over, James Billie asked about the painting, and I told him about it, and he said, 'Well, I want it.'" The canvas became a part of the James Billie Collection.

Having previously portrayed the Dade Battle, which James Billie also purchased, Guy focused on its less well-known aftermath in this painting. "I thought the best moment would have been when Alligator jumped up and started waving that sword around with that outfit on, walking around, describing how Gardiner did. Because they all thought very much of Gardiner. They thought he was quite a brave son-of-a-gun. That's why they think of him when they think of that battle."

Withlacoochee Surprise

"The Withlacoochee is a river running through the Green Swamp, and Osceola—during the Second Seminole War—used to have a camp back in the Green Swamp, and they had a hell of a time trying to find it," Guy said. "They never did really find it until just recently,[23] and the war's been over a long time."

Withlacoochee, meaning "little river," names two streams. One flows through southern Georgia and merges into the Suwannee River in Madison County, Florida. This painting features the other, which the *Handbook of Florida*, published in 1892, characterizes as a "swift stream with rocky bottom, and high, wooded, picturesque banks." Originating in the Green Swamp, the river flows north and west for one hundred miles to the Gulf of Mexico. Much of it now passes through government-owned land, "protected by conservation and recreation agencies" in Polk, Pasco, Sumter, Hernando, Citrus, Marion, and Levy counties. Where it curves around Lake Tsala Apopka—actually a group of small lakes—it forms the Cove of the Withlacoochee.[24]

The U.S. Army planned to attack the Cove of the Withlacoochee, a known Seminole stronghold, for the advantage gained by forcing Osceola and his warriors into a battle rather than retaliating against their usual "hit-and-run" tactics. The offensive was timed to make use of the 560 mounted territorial volunteers before they were released from service on January 1, 1836. They had arrived at Fort Drane, near modern-day Williston, on December 24, 1835, under the command of Richard Keith Call. On December 29, General Clinch led the volunteers plus 250 army regulars. After a three-day, thirty-five-mile march, they reached the river. Relying on their Indian guides, the troops bypassed the usual ford on the Withlacoochee River without realizing that the Seminoles waited there in ambush. When the troops proceeded past them, the warriors shifted their forces.[25]

"When they said Osceola was a genius at strategy, that shows you," Guy said. "The river was high and running—they'd had a wet year—and so [the soldiers] couldn't just wade across, and it was a deep river anyway at that point. The Indians had taken all the canoes way upstream. One old canoe—they'd knocked a hole in the bottom, so it leaked a little bit, and they'd left it on the other side."

Only six or eight men at one time could cross in the canoe. Continuous bailing and a swift current hampered the operation. To speed the operation, some soldiers as well as volunteers on their mounts swam the river, with their clothes and gear ferried by the canoe or on rafts that Call had ordered his men to make.[26]

Lieutenant Colonel Alexander Fanning directed the troops that had crossed to the south side of the river. Guy said, "He had one arm; I am not sure which arm. I have never been able to find anything or anybody that could tell me which arm he had left. In this painting, I'm guessing it was his left because most people are right-handed, but that doesn't matter" (see fig. 24).

Once they crossed the river, Fanning ordered his regulars into a form for battle in an open, grassy area surrounded on three sides by the dense growth of hammock and swamp. Posted sentries guarded the main body of soldiers that Fanning allowed to rest on the ground, maintaining their positions; by some accounts, they had stacked their arms.[27]

"The Indians were all around them, and they didn't know it," Guy said. When the Seminoles shot at the soldiers, Call—on the other side of the river—couldn't order his troops to return fire. "He was afraid he'd hit his men because he couldn't see them," as smoke from the black-powder weapons obscured the battle across the river. Comparing this battle scene to another he portrayed, Guy said, "I—once again—couldn't show all the smoke. I had to thin it down quite a bit."

For his painting of the Dade Battle, he visited the site; however, for this scene, he relied on the descriptions he found in historical accounts. "Kind of a horseshoe-shaped opening, they said, on the one side, so I did that, and they talked about a tree that was knocked over." He placed Osceola up in the branches of a tree that is still alive but has been partially uprooted. "He's wearing a blue greatcoat that he had taken from a dead soldier, and the first time he had been wounded was in this battle—he got shot in the arm." (After Osceola's capture, the Seminole leader Alligator said that the wounding of Osceola caused the Seminoles to retreat.)[28]

When Osceola was a prisoner in Fort Moultrie, George Catlin and Robert John Curtis both painted his portrait. Guy said, "People who knew Osceola at the time saw Curtis's painting and said that it looked like him, not Catlin's. Curtis makes him look a lot bigger, but that doesn't mean that he was. Of course, we've seen the death mask and it's a little old thing." He held his hands in front of him to show the size.[29]

Physically, Osceola was "middle-sized or below common height, well proportioned but of slight build . . . with hands and feet effeminately small," yet his athletic ability is remarked by many witnesses. Another described him as having "a spare frame," with "a structure well-knit and sinewy." Most commentators recognized in his countenance a look of intelligence, often characterized as shrewdness or cunning.[30]

The written accounts of this offensive on the Withlacoochee River do not mention the other warriors, so Guy imagined their positions: "Everybody's

looking for a good spot. I'm sure some of them would have been down in the roots [of the fallen tree]. I mean, it makes no sense for them not to be in places where they could shoot and then hide while they load. . . . In the painting, I show how they used to load their guns in a war. . . . They'd take a mouth full of bullets—a lot of them—and they just hit the neck of that gun with their powder horn. . . . Sometimes a great amount of powder went in—they didn't know it—and sometimes hardly any. . . . Then they would spit a ball down there and put a little powder in the touch plate, and set it off. So it was much faster than having to use a ramrod all the time."

The effect of this technique was uneven. "There were all kinds of reports of balls bouncing off of guys' chests and arms and leaving bruises, maybe, and other ones going through two and three people and maybe tearing a limb off a tree. . . . It must have really hurt to shoot—it must have been a kick like a mule with that much powder in there. But it was definitely an innovative way to fight a war," Guy laughed.

During the seven-year war, the U.S. Army also tried various battle strategies. "During the Second Seminole War, they used every weapon known to man at that time, trying to beat the Indians. And it was the first time they asked for an air force. The army asked for balloons so they could try to locate the Seminole camps at night[31] . . . but the army couldn't get the balloons until the Civil War, so that's when they first got their air force. That I learned reading history books." He chuckled before he mentioned that he read two different books about the war. "There's probably several more that have the same things, because most of them are taken from the guys that lived through it, usually from the white side. I painted it from the Indian side because I can make that side up. It's as accurate as I can get it from the information I got, but the information would have come from a soldier, probably, that was wounded or lived through it."

He compared his method to that of the historian. "I have a hard time with this because I'll read a book, and I'll find a story, and I'll find all the things in that story that make the picture I want to do. Then I'll read another book and find the same things, and if I find something different, then I have to try to look that up and find out what's what. So I end up going to the Indians, usually, to find out what really happened, because they handed it down [in the oral tradition]. Now, they're also starting to write it down, finally. . . . I get what I need for that one scene, and I really research that one scene. So the kind of researching I do is a little different than the kind a historian does."

In addition, his own experience and observations color the landscape: "The trees that are all brown are the cypress trees . . . under a plain gray sky 'cause that happens a lot in the winter." He painted the other trees with some green,

growing above yellow grass, commenting, "Our Florida wintertime doesn't look as bleak as it does up north."

In the background is a rookery. "The birds are taking off, and there's a whole load of them, and that's when all the shooting started. . . . I figured the noise would have chased the birds, so I just threw that in there. I don't know if there was a bunch of birds there. I imagine there was. . . . They had millions of them in Florida at that time—billions." His supposition is a realistic detail of Florida in the nineteenth century, and in this scene, the Seminoles surprised both the birds and the soldiers on the banks of the Withlacoochee River.

Battle of Okeechobee

"This was not a commission—I just did it," Guy said. Surprised by the lack of information about the Battle of Okeechobee, fought on Christmas Day in 1837, he remarked, "It was the biggest battle fought—I think it was three and one-half hours." He painted this scene in 1983, four years before the publication of Willard "Bill" Steele's definitive account of the conflict, *The Battle of Okeechobee*. Guy's painting is the cover art for Steele's book (see fig. 25).

Guy described Steele, who serves as the historic preservation officer for the Seminole Tribe: "While I'm going fishing—he's going through manuscripts. While I'm going hunting—he loves going through old bills of lading. . . . His mind is like an encyclopedia." One time, the two met at the Battle of Okeechobee Reenactment. Guy was asking Bill some questions about the so-called Negro Fort, or Fort Blount, on the Apalachicola River.[32] Guy said, "Bill goes to his car and opens his trunk, and there's drawers, and he pulls them out. He's got whole layouts of this fort I was asking him about, how it was designed and built from the old days—amazing—and it's in his car. The guy knows so much."

Another source of information for paintings is Robert "Bob" Carr, an archaeologist, who introduced Bill Steele to the LaBrees. Carr is the cofounder and executive director of the Archaeological and Historical Conservancy, the organization that published Steele's book. Guy said, "Bob has been very great about that. If he finds out something he thinks I'm interested in or can learn something from, he'll give us a call, and many times, we took off and drove a hundred miles just to see what he has."

The LaBrees also consulted J. Floyd Monk, who had written an unpublished manuscript about the battle.[33] Guy remembered that Monk's manuscript was about five inches thick. "We went down and talked to him—he's a real old man—and he was proud to tell me anything he had learned. He loaned me a copy of his book for a while." Monk's research clarifies many

discrepancies in previously published accounts. Guy noted that although the facts in Monk's manuscript were true to the scholarship of the time, some have since been disproved as archaeologists and historians continue to research the battle. In that regard, Guy commented that his painting is similar. Recent discoveries have changed historians' understanding of the battle, but when he painted the canvas, it reflected the current scholarship.

Another expert was Dr. Ray Giron, a reenactor who lived in McIntosh, Florida. Guy acknowledged that a good reenactor may often be as knowledgeable—or even more so about certain historical details—as a professor of history. From him, Guy learned the details of the army uniforms and equipment, and Pat noted that movie companies buy costumes made by Giron because of their accuracy.

Guy said, "I also found out I was one of the few people who ever put gun flashes in paintings." He narrated his conversation with Giron.

"He said, 'You didn't put any gun flashes in your picture.'

"I said, 'Yeah, I did.'

"He said, 'That's not done. Most war scenes have smoke coming out of the guns like they've just been fired, but you rarely, rarely ever see flashes.'

"I said, 'If you have a thousand guys shooting guns, you're going to see a few flashes going off all at the same time. So I put them in.'"

Pat added, "The artistic license was when you were picturing the smoke."

Guy said, "The one thing in the second painting I did of that and in the original *Battle of Okeechobee*, I put in less gun smoke than there would have been because if I'd put what there would have been, you wouldn't have been able to see the battle. That black smoke was like a cloud."

Guy's Seminole friends and Giron agreed that most of the Seminoles had guns of a smaller caliber than the ones the army used. For centuries, Cubans had fished the coast of southwest Florida, especially Charlotte Harbor, and they traded with the Indians. From this trade, the Indians stockpiled lead and gunpowder in readiness for war.[34]

Guy said, "So Cubans would trade them these small-bore hunting rifles, which were real accurate, but small. And so many times, they would only wound guys. And after a battle, the army says only six guys were killed and four hundred wounded, and maybe in a day or two, they had a bunch more dead."

Accounts of the 1837 battle have been handed down in Seminole families and clans. These stories contradicted a statement that Guy had read in many books—that the Indians all wore white muslin. Alan Jumper told him that it wasn't true, and Alan talked with his mother to confirm that detail. Guy said, "Some warriors had been woken up in the middle of the night by the army

and run off from their camps, and they didn't have anything on. . . . They got muslin and made themselves these long shirts real quick." Other warriors, from camps undisturbed by the soldiers, wore their traditional clothes.

"Other guys had medicine put on them that would move bullets around them. They believed that a bullet wouldn't go through them. Other ones would have no clothes except for their weapons. They'd just be buck-naked because they had invisibility medicine put on them the night before this battle by the medicine man. They believed they were invisible. They probably were up in those trees," camouflaged by Spanish moss.

In his book, Steele also acknowledges the memory of a Seminole in identifying the battlefield's location. Although he had not visited the site in many years, Billy Bowlegs III identified a pasture that his mother had told him had been the saw grass slough where the battle was fought. Subsequent archaeological discoveries confirmed his recollection.[35]

Guy said, "To paint the battle, I had to try to come up with something that would tell the main story . . . so I remembered reading that the Seminoles had made it an ambush. They had a little village across the swamp from the edge of the lake, a rise . . . maybe five miles over from Taylor Creek to the east and in between a big saw grass slough . . . so when you're walking through that, you're about up to your waist in water and mud." The saw grass grows taller than an average man stands.

He said, "The warriors had gotten places cleared out up in the trees, notches for their guns to sit and everything, and then all the brush from the bottom of the trees, right on down and into the water and out into the saw grass for about fifty feet out . . . they had cut it down to water level. So when the soldiers suddenly appeared out in the open, they still had all this grass floating in water and mud to slog through, plus they're in the wide open, and the Seminoles are up in these trees, over there, just sitting and picking them off. And 90 percent of the men who were killed were killed right there in the water—either shot dead or drowned from their wounds."

The Seminoles ensured that the troops would fight them on the battleground they had chosen by sending out a warrior to be captured. Colonel Richard Gentry, who led the Missouri Volunteers, asked Colonel Zachary Taylor of the U.S. Army, who commanded the campaign, why he trusted this warrior who had surrendered. Guy noted that they didn't even have to torture him to learn the whereabouts of the Seminole encampment, yet Taylor replied that he didn't care how he received information about the enemy—only that he received it.

After the officers surveyed the area, Taylor suggested that the soldiers march in two lines through the slough, with the volunteers in the lead. Guy

said, "Gentry asked Taylor, 'Why don't you send some men around the sides of this area and find out why these trails are there?—It could be an ambush.'

"Taylor said to him, 'Sir, are you afraid of facing your enemy head on?'"

In response, Gentry agreed to follow Taylor's plan if it was an order, and Taylor assured him that it was. So Gentry led his volunteers into the ambush and may have sustained the first wound. Later that night, as he lay dying from a second wound, he requested a promise from Taylor that in his official report, he would commend Gentry and the Missourians for their bravery and conduct in following his orders.[36]

For directing this battle, Taylor won a promotion as well as the notoriety that ultimately gained him the presidency. However, Taylor's dislike for the volunteer troops may have influenced his report, which so denigrated the actions of the Missouri volunteers that outraged Missouri citizens called for an investigation, which resulted in the recognition of the courageous deeds of the volunteers.[37]

Colonel Zachary Taylor claimed victory in this assault against a Seminole defensive position because, in the end, the Seminoles retreated. Many historians agree, including Bill Steele, who claims in his book that the Seminoles never recovered from this defeat. However, in many ways—especially comparing the number of casualties reported—26 killed and 112 wounded soldiers versus 12 killed and 9 wounded warriors—the outcome of the Battle of Okeechobee was as Guy pictured it: a Seminole triumph.[38]

Indeed, citing Taylor's claim that he had "gallantly beaten the enemy," Willie Johns wrote: "Certainly, that's an overstatement. We, the Seminoles, the descendants of the 'enemy,' still call Florida home, heirs to the courage and sacrifice made by those 'beaten' warriors. . . . The virtue they displayed, the resolution they practiced, on this hallowed ground against overwhelming odds, continues to motivate and inspire us in our present day challenges and pursuits, and serves as a noble inspiration to all who love freedom."[39]

Make It Count

Describing this scene as a "typical Florida pine barrens," Guy noted, "I always see a lot of dead trees out in the pines" (see fig. 26). The details include a rabbit, which he pointed out, perfectly blended into the buff and brown grass. It jumps, as startled as the deer by the sudden appearance of the hunters. "It's early in the morning, and the hunters have been sitting up all night waiting. The deer shows up just before sunrise. It's all misty, and they're just standing up."

The hunters are wearing leather leggings and loincloths because they need protection from the wax myrtle bushes in which they are hiding rather than from mosquitoes. Those insects plague the hot, rainy months, but Guy imagined this scene in the dry fall or winter season during the Second Seminole War. In the early years of that conflict, the army planned offensives for the dry season to lessen the health risk to the troops, such as contracting malaria or yellow fever or suffering fatigue from the high heat and humidity.[40]

For this scene, he imagined that soldiers were patrolling the area, so the Seminoles want to be as quiet as possible. A few days earlier, the hunters had asked the medicine man to place some medicine on the corn.[41] The hunters leave the special corn as bait, and they watch for the "tracks of a deer coming 'round to eat it regularly." Hidden in the myrtle bushes, the two hunters wait for the deer to nibble the corn.

Not sure at first how they signaled each other, Guy then remembered his own experiences. "You can get a thing going, almost like telepathy, but not really, more like a feeling, a rhythm going." So both hunters stand and shoot at the same time. He said, "Bow and arrow is not much good as far as a big animal like that goes, unless you have a real powerful bow." That was why two hunters were more assured of a kill. He modeled the bows on the toys that Seminole wood carvers make and sell to the public. He reasoned that the toy canoes are like the full-size ones, so the bows should be scaled-down versions of the authentic items.

In addition, he recalled a time when he talked with Brian and Pedro Zepeda and their uncle, Ingraham Billie Jr. "He was an old man, older than me," Guy said with a laugh. "He was the one who said, 'I remember that they used to send us out when we were young to cut the mulberries to make bows.'" It was a chore that the boys did each season as the bow would eventually lose its spring. Guy explained that the red mulberry (*Morus rubra*) is a soft but flexible wood, and they cut large, sturdy pieces to make bows.

Guy has read in books that Seminole points were made of silver, copper, or brass. "They were made out of coins, which they smashed thin and then turned . . . into little cones and [stuck] . . . on the end of the arrow with a glue," he said. "But I've also been told that they used splinters of bones—anything sharp, even broken glass if they could get a long splinter of it. And they would use fat pinewood heart—splinters of that. . . . Mostly it was small animals they were after, something like a raccoon. . . . The shafts were usually made of maidencane or river cane [*Panicum hemitomon*], which grows near the water. They'd straighten it out and dry it." He noted that an arrow doesn't have to be a lasting artifact, but it does need to kill the animal.

Pointing out the deer, he said. "It's a buck, and he's a good one. Hey, you don't spend time painting a dad-gummed deer that don't have a big rack of horns." He couldn't remember if it was for this painting or for another one, but at one point, "I was trying to find out what the back of a deer's leg looked like—I had just forgotten." He usually paints such details from memory, but this time he had to do some research. None of the pictures that he could find focused the deer in the right position.

He telephoned Tom Goodhue, a friend with the Florida Fish and Wildlife Conservation Commission, and asked if he had any pictures. Goodhue introduced him to Horace King, the gamekeeper for a private hunting preserve in northwestern DeSoto County. In his truck, King drove into the preserve with Guy, and he told Guy to stay near the vehicle. Because King allows no one to shoot from a truck, the deer only flee from those on foot.

"He threw out some corn, and about forty deer came out. I took a lot of pictures," Guy remembered. He still has those pictures, and one of them may have provided the accurate details for this moment he imagined from history.

Wild Cat, Red Warrior

Guy has never liked the image of the defeated Indian known as *The End of the Trail*, originally a statue sculpted by James Earle Fraser in 1915.[42] "This beat-up, tired-ass, whipped, old, starving horse and this guy on his back, all hunched over and wore out. . . . He's got nowhere to go except down from there, and so they call it *End of the Trail*. It's been copied over and over and over by a million people, but I didn't like it because it's not characteristic of the Indians I've met."

He noted that the Seminoles have never signed a peace treaty with the United States, so technically, they are still at war. In the nineteenth century, the U.S. Army defeated the Seminoles with overwhelming numbers and advanced technology, but, he said, the Indians are "very proud and on their way back to beating us now." With the Seminole's strength in wealth, they participate in the global economy. "They are buying back their land instead of taking it over with guns," he said gleefully. "They're using our own laws against us, and I think more power to them."

In fact, Willie Johns, a member of the Seminole Tribe, has written: "But our heritage of determination and persistence, bequeathed to us by our warriors, sustained us. New weapons were found; formal education, diplomatic

skills, and business savvy now combine with our rich heritage to lead us into the future."[43]

Diametrically opposed to Fraser's image is the triumphant warrior known as Wild Cat in Guy's painting (see fig. 27). He said, "Everybody says, in English *Có-a-coó-chee*, but the Indians say *Co-wok'-oo-cheé*. . . . He was known as quite a fighter, and one of the books I read—here, again, I don't know which one it was—talks about him going into a hut or chickee and coming out dressed with all these red bandanas all over him and getting on his horse and taking off to go to a battle somewhere or to a meeting. I don't know which it was. He was known, by different people, as the Red Warrior after that, because he wore a lot of red sashes and stuff."[44]

Guy portrayed Coacoochee wearing a hunting tunic, breechcloth, and red leggings. The leggings may have been dyed leather, or they may have been made of cloth. He noted that Osceola often wore cloth leggings, and that leggings made from trade cloth, especially woolen broadcloth, were often saved for "dressier or more formal occasions."

Portraits of Osceola completed while he was a prisoner at Fort Moultrie, South Carolina, show him wearing "tightly fitted" cloth leggings. One of these was painted by George Catlin, who also portrayed other Seminole leaders, including Micanopy,[45] awaiting their "transfer" to Indian Territory. The commander of the post allowed Catlin to use a large room in the officers' quarters. Micanopy enjoyed watching the others model for Catlin but refused to be painted.[46]

Ever the storyteller, Guy narrated this incident: "Catlin said, 'Well, I'm not here to paint you, . . . I'm here to paint your nice red leggings.' So if you see that painting he did or that drawing of Micanopy, he's sitting like this." Guy bent one leg, raising it to rest his ankle on the knee of his other leg. "Catlin drew in detail this part," Guy rubbed his hands along his pant legs, "and sketched the rest in lightly . . . and then, he'd go back in his room and do Micanopy from memory."

Catlin also painted Coacoochee's father, King Phillip, but he never portrayed Coacoochee. However, John C. Casey, a U.S. Army officer and amateur artist, did, and the portrait was reproduced in *Red Patriots*, using late-nineteenth-century technologies, from an original that may have been damaged. Before using it as the frontispiece of her book about Coacoochee, describing it as "the only credible image" of him, Susan A. Miller, a member of the Seminole Tribe of Oklahoma, had the portrait "restored."[47]

As Guy recalled the story, Coacoochee "thought Casey was arrogant, so he wanted to be arrogant, too, and when Casey was painting his picture, Coa-

coochee pooched his lips out like a kiss." Guy pursed his lips and drew in his breath with a squeak. "If you look at the picture, that's just what he's doing, and it makes him look kind of strange, and you think, how could this guy be a nice-looking guy?"

Having read about Coacoochee, Guy knew his reputation: "He was supposed to be very handsome." Indeed, those who met him noted his attractiveness. In 1837, an army surgeon wrote that he "has the countenance of a white man—a perfect Apollo in his figure—dresses very gaudily, and has more than the vanity of a woman." In 1841, an officer described him after his capture: "about thirty-two years of age, five feet eight inches in height, well proportioned, with limbs of the most perfect symmetry. His eye is dark, full, and expressive, and his countenance extremely youthful and pleasing."[48]

The warrior's physique may be true to life, but the scene is Guy's imagination. "I just got the picture in my head and started. I wanted to do it. Sometimes, you just get an idea, and everything's there. At least, for me, it is. I don't know. Some artists are like that, and some aren't. . . . I found out some people don't think in color, and some people don't think in pictures. Some do, and some think without color, but they do see the pictures." He admitted that his thoughts are "in color and in colored pictures—Technicolor—whatever." For this painting, he visualized the layout, but he had to work to create the details.

Pat reminded him of one of those features—the little people. (For the legend of the little people, see *Time to Go Home*, chap. 1.)

"Oh, yeah, they're getting run over by his horse. I just threw that in for fun—getting trampled to death." He chuckled at their plight. "They're running in all directions. . . . They're underneath the horse's hooves and ahead of the horse, running through the grass as best as they can—about to get crushed. Just a little grisly humor."

One of Guy's favorite stories about Coacoochee also appeals to his sense of humor. Coacoochee, Osceola, and others had been captured and confined in the Castillo de San Marcos, renamed Fort Marion by the U.S. Army, in St. Augustine. As special guests, Coacoochee and other Seminoles attended a dance, as did U.S. Army surgeon Samuel Forry.[49]

Guy remembered the incident from his reading: "All the women thought he was very handsome, and they were always wanting to dance, and they're giggling and snickering. He would say things—he could speak some English, but he mostly spoke Indian. He would talk to them in Indian, very smoothly, and they would be all flattered, but the other Indians were laughing" because "what he was saying was, 'You're going to be a real pig in a few more years,' things like that, or 'Boy, you're getting fat.'" He laughed.

Coacoochee and others escaped from Fort Marion in 1837. Some historians agree with General Jesup's claim that the escape of Coacoochee prolonged the war three more years. One contemporary characterized him as "the Napoleon of the Seminoles," another as more militant than Osceola, a third as "by far the most dangerous chieftain in the field," and a fourth as "a military genius," attributing the change from a seasonal to a year-round American military campaign to Coacoochee's resistance. He was captured again in 1841, and, under coercion from army officers, induced other Seminoles to join him in leaving Florida.[50]

In this painting, Guy portrays that charismatic Coacoochee as a young man in Florida. In contrast to the brilliantly colorful Seminole, the dead soldiers sprawled on the ground wear white uniforms. He explained: "I had to have summer uniforms because of all the green trees. Plus they didn't always get their winter uniforms in time when they were in Florida. A lot of people didn't want to come down here because of malaria problems. And Daniel Boone could only stand it for a while."

In the autumn of 1765, Boone visited the British colony of Florida with a hunting party from Virginia, but he returned home to North Carolina by Christmas Day. Unlike Boone, Coacoochee was born and raised in Florida, as were his parents. Aboard the ship that began his journey to the Indian Territory, Coacoochee is reported to have said "that as he was now leaving Florida for ever, he could say that he had never done anything to disgrace it. 'It was my home'; said he, 'I loved it; and to leave it now, is like burying my wife and child.'"[51]

Suspicion

Guy shares a half century of friendship with Alan Jumper, yet they have talked about how they would have been "deadly enemies" if they had met during the Second Seminole War. "I'm much happier to know him now," Guy said through his laughter.

As he enjoys walking through the natural areas of Florida, he wondered what would have happened if he were "going through the woods, and it was back in the 1830s or 1840s, and suddenly you push some bushes open and there's these guys—four or five guys in a hunting party . . . you're their enemy, so what would happen? . . . You get that feeling like it may be your last day—or maybe not. They may be in a good mood, and let you go."

In this scene, the Seminoles wear ostrich, turkey, and egret feathers in their turbans. (For a discussion of ostrich plumes, see *Screech Owl Dance*, chap. 2.) He indicated that such adornment was not customary for a hunting party, so

these men may have been visiting or on another formal errand. They wear long shirts made of calico with appliqué designs rather than the well-known patchwork, which is a late-nineteenth- or early-twentieth-century innovation (see fig. 28).

"The cuffs would be loose, and they would tie them off with little bandanas to keep the bugs and all from getting up in there and to keep them blousy, and that makes it harder for mosquitoes to chew on them," he said. The shirts seem to be a kind of calico cloth, but "a lot of the time, they would just get muslin 'cause it was cheaper, but sometimes they would get the print, and then they would make the shirts and things out of that. Things that they used to make out of leather . . . they started making out of cloth, like the bandolier bags. [Warriors carried their ammunition in these bags, also called shoulder pouches.][52] The leather ones were the best ones 'cause they lasted the longest and could take the most weight."

The warriors stand bare-legged and barefooted in a cypress swamp. It's difficult to think of people walking such terrain without shoes or boots, but the Barefoot Artist of the Seminoles[53] speaks from his own experience. "I used to walk on the boiling hot pavement and be standing there talking to somebody, and they'd say, 'How can you do that?' I didn't even know what they were talking about. But sandspurs were always sharp enough to go right through my calluses and nail me good."

He has met others who have lived without shoes, including a man about ninety years old living on the Big Cypress Reservation. "He'd been barefoot all his life, and he had calluses that went around and up onto the top of his feet. You could see where they stopped about an inch into the top of his feet all the way around. . . . He's one of the few people that I've ever met that could walk through a bunch of the real stiff sandspurs. It didn't bother him."

In the painting, the man at the front of the group dominates the scene with his unusual weapon. "He's got a cap-and-ball rifle with a tigerwood design. That tigerwood maple was much sought after." Guy pointed out that extra patches—a kind of wadding—were stored in a section cut into the butt of the rifle. "I've seen those rifles before in stores, and I have one here that's in the other room. That's why we got it, so I would learn how to use it, so I would know what I was doing was right when I was showing them loading in a painting."

His rifle is a replica, so he recommended visiting the Ah-Tah-Thi-Ki Museum on the Big Cypress Reservation to see authentic weapons and other artifacts from the Second Seminole War. One item is a shoulder sash that belonged to Osceola. He said, "It's pretty neat to go in and look at those things and see they're 150 or 160 years old."

Many personal possessions, such as earrings, shoulder pouches, or clothing, were not handed down in Seminole families. For example, a burial excavation in Hialeah revealed objects—including a gun, clay pipe, and mirror—deliberately destroyed. Other personal items were buried with the corpse, as seen in artifacts unearthed at the Fort Brooke cemetery.[54]

Pat also suggested that, during the 1940s and 1950s, many Seminoles may have sold such heirlooms as curios to supplement meager incomes. Guy remembered when he was a teenager that he saw a man selling such items on the reservation. "This guy had two different tomahawk heads. One was brass. One was steel." He noted that the Seminoles did not make such metal objects. "They had traded for them some time way back, or their parents or somebody had."

Even though the artifacts in *Suspicion* are distinctly Seminole, the body language is universal, and the outcome of this situation is left up to the viewer. "I would hope I could make friends, but looking at their faces, I don't think I'd have made friends. I think I'd have probably been killed on the spot." Guy laughed as he spoke his own death sentence.

"You've got to remember: they had a lot of really bad memories. At that time, they were a lot fresher." He explained that some people he has met say "they hate Indians 'cause their grandfather was killed by Indians." Some Seminoles share a similar feeling. "They had their whole families wiped out, a lot of times, by white people, so they still remember that."

Danger Zone

In February 1842, toward the end of the Second Seminole War, Lieutenant George Archibald McCall wrote of the Seminoles he had pursued: "They have become wilder and more vigilant than the beasts of the forest, and show more caution and sagacity in moving and concealing their wives and children than does the wild deer towards her fawn."[55] In a time when capture for the Seminoles meant either death or deportation, concealment often saved them.

This painting is a scene of desperation (see fig. 29). "This man and his wife and daughter are walking. They're on their way somewhere down a trail, and they hear the army coming. So they kind of slip into the water and get back behind a great big, giant cypress tree, but a big alligator happens to live there, and he's come up, and he's kind of telling them to get lost. So they don't want to shoot the gator and bring the soldiers now walking by them. . . . So they're like between a rock and a hard place, in the *Danger Zone*." Guy spoke the painting's title with a smile, as if it were the punch line of a joke.

The bald cypress tree that hides the Seminoles seems uncommonly large when compared to those growing today because many such trees were logged in the late nineteenth and early twentieth centuries. "I saw a picture of one," he said. "They had an old wagon and a set of mules on the stump, and there was still stump on either side of the wagon and the mules. They had them even way bigger than that. There were some that were humongous, almost like the small redwoods." Because the scene is during the winter, the bald cypress trees are turning red and orange. "It's the only pine tree in Florida that loses its leaves in the winter," he said. "They turn brown and hang there for a long time. Near the end of winter, they finally fall off, and then you get that real barren, gray look."

He described the growth cycle of the cypress, illustrating with his hands. As he held his fingers up, he told how the green needles first sprout skyward. Then as they mature, they grow horizontally, and he extended his fingers to demonstrate. As they complete their growth, he curved his fingers to the ground, showing how the green needles mature, hanging down, until they finally turn brown.

Growing in the water is duckweed, *Lemna minor*, "the smallest lily pad in the world. If you look at them—take some in your hand—there's a little mass of roots with little lily pads. And they even get flowers at certain times." Another plant, called pond flag, *Canna flaccida*, also grows in the shallow water. In the background, cabbage palms indicate higher ground where the soldiers walk. He pointed out the mist. "It would be in the foreground, too, but it would be so thin, you wouldn't see it there because it's in the daytime. But off in the distance, it's so humid back in there, even in the winter, many times, you'll see a mist even in the daytime, because it stays cool from the night being so cold and wet."

In a December 14, 1841, letter, McCall writes of his campaign in the Big Cypress Swamp, and "the difficulty of penetrating the country by any route but the old Indian trail." A subsequent letter, written on Christmas Day, noted: "Five days' rations of hard bread and meat, with sixty rounds of ball-cartridges, blanket, &c., &c., is as much as a soldier can move comfortably with on good roads. We, however, took seven days [rations], not knowing how far we might be led."[56]

Threatening the Seminole family's safety, the soldiers march in authentic uniforms on such a trail. Strapped to their backs are a bedroll and a big leather pack. They also carry a bullet pouch, a canteen painted red, and their rifles. Their caps seem unusual. Guy said, "Those are called forage caps, and that's what they wore back then. That's what I should have had in the Battle of Okeechobee, because that's what they were wearing at that time." The forage

cap folded flat, he explained, holding his hands palm up and then smacking them together. "They could take it and fold it together, and then the brim would fold up in the front, and then they could just stick them in their pants, carry them around if they didn't want to wear a hat."

The other danger in this scene is the alligator. Although only its head emerges from the water, Guy explained how the size of the head indicates its full length. "You figure from the nose to the back of his ear, which is that square block behind his eyes . . . that same distance is the length of his neck, and then there's two—two of those measures, I think—is the length of his belly to where his tail starts." Most of the time, the tail will be half the animal's length; however, "every animal has a different one—sometimes . . . one with a longer tail, sometimes shorter—but mostly, within inches, it will be the same length as the body to the nose. From the back legs to the nose, the tail is about the same length."

He estimated that the alligator he painted has a two-foot head, and so, by the formula, is sixteen feet from nose to tail. "That's a whopper. He's a big one. He's one that's big enough to eat you, anyway, but many times alligators wouldn't, just because back then they didn't know too much about people, and they were more leery of them. . . .

"That water's clear enough to where he can see the top—he can see what's above him—and you don't see him, because of his coloring and all, he'll come up, and it's so sudden, it's like—*whoosh!*—up he comes. It's designed to scare you off. And if you don't go, he's liable to get menacing a little more to get you out of there; but if you just stand real still, sometimes he'll leave you alone. He'll relax to see that you're not attacking him."

In the painting, the mother holds her hands over her daughter's mouth because when the girl first sees the alligator, she cries out. Guy demonstrated by making a strangled, surprised sound and then clapping his hands over his mouth. The mother's gesture tells the girl quickly and quietly not to make a sound, because any noise may have alerted the soldiers.

The woman stands in a long-sleeved, full-length dress. From her shoulders, across the upper part of her sleeves, and over her chest is a ruffle that eventually evolved, in the early twentieth century, into the sleeve-length cape that, with a long skirt, is a present-day traditional regalia for Seminole women.

The man wears a sash around his waist. Like the neckerchief, it may have served him by carrying items that he tucked into it. On his head is a small turban, typical for the time. Later, in the 1930s, Seminole men wore large turbans. Guy recalled, "Dr. Harry Kersey of Florida Atlantic University said that some of those were actual blankets, and that if they were out on a road somewhere, they could undo that, make a camp, and sleep in that blanket—

wrapped up. And then the next day, roll it back up and make a turban." Those turbans were wrapped higher or wider than the one in this painting.[57]

The man is well-dressed, including ribbons or sashes tied around his sleeves at the biceps. "He may have been going to a meeting somewhere or something with his Sunday-go-to-meeting clothes on, so to speak." Guy laughed at his choice of words, but he turned somber when he reflected on the situation of the family in the painting. Their one chance of survival is to remain hidden, a strategy that protected the Seminoles many times. Ultimately, it allowed a remnant to live in Florida after so many were removed. As Elgin Jumper notes in the afterword of this volume, many Seminoles today revere the Everglades for secluding them.

Deep Cypress Engagement

Although modern places are the namesakes of some forts established during the Seminole Wars, little evidence of their military history survives. Soldiers burned wood structures so that the Indians could not use them, or the Indians burned them to forestall the troops' return. At least one was booby-trapped by departing soldiers and destroyed when the Indians arrived. Some were designed to be temporary; others were dismantled so that early settlers could reuse scarce building supplies. Palm-log or pine palisades decayed, and breastworks—felled trees or mounded sand—degraded. In addition, artifacts that characterize the location of the forts—such as square nails, horseshoes, or brass uniform buttons—were often redistributed by agricultural use of the land or scavenged by souvenir hunters.[58]

Many of these forts were built or repaired in 1838 when General Zachary Taylor commanded the Second Seminole War. He divided "the territory into military districts of twenty miles square. In the center of each, or at the most eligible point, a post was to be established, and occupied by twenty or thirty men." A detail of men were to patrol the area daily.[59]

Guy described how the patrols walked "a perimeter around their fort, maybe ten miles out, and they'd do that regularly, but they'd always use the most open areas." Often, Seminole warriors surrounded such open areas, hiding in the brush. When the soldiers ambled into their midst, the warriors shot them. "They'd kill one or two, wound one or two, and just scatter." The Seminoles never tried to kill everyone because "it made it better that the survivors took the message back to the fort and told them what happened, so that the next group would be even more afraid the whole time they were walking. It would demoralize them."

The soldiers faced other dangers, too, he said. "Back then, there were a lot more snakes than there are now . . . and some big alligators, because they didn't have alligator hunting that much down here, so it was not a good place to go running through the swamps chasing the Seminoles." In addition, the soldiers never knew when a warrior would pause behind a tree to turn and shoot at them.

In this scene, the warriors are "stripped down for fighting. . . . They have the leggings on because they're going through saw grass and stuff, and they could cut their legs up, but normally they didn't wear leggings in water." He depicted them as wearing breechcloths, though he didn't believe that they always wore them into battle (see fig. 30).

Because they wore leggings instead of pants, the warriors did not have pockets, so they "carried things tied in the neckerchief, just like a mother sending the kid to school with lunch money tied in his handkerchief," he said. In addition to money, a Seminole may have also used his neckerchief to carry a pipe, tobacco, and "medicine." This last may have been for general protection, a hunting charm, or a root said to be an antidote for snakebite.[60] The warriors also wore a pouch for bullets, a powder horn, and carried a cap-and-ball or flintlock rifle.

This skirmish occurs somewhere in the Big Cypress National Preserve in the Everglades. "They have hammocks of cypress with little openings in between with short saw grass. Some have rivers, and some have just creeks, and some are just water standing everywhere. The whole place is a river." He smiled at his allusion to *The Everglades: River of Grass*, written by Marjory Stoneman Douglas, originally published in 1947.[61]

As he continued to describe the painting, Guy indicated its features. "There's a tree knocked over, probably from a hurricane some time before or something, and another dead one back there, just a stump sticking up." Backed up against a living cypress tree, the soldiers struggle to reload their guns "in the center of the circle, but the center, of course, is not the center of the painting because that would be really lousy composition."

He paused for a moment, considering how to explain. "I had placed the trees and the moss hanging down and different things so that it would keep your focus coming back into the picture instead of going off out of the picture." He pointed out an example. "The log goes off to the right, past the men, but I have a man there, shooting back to the left, so that kind of brings your eye back in. And if you drift up above him, in the distance, there's some Indians way out there, shooting back into the painting."

Although the scene does not represent a specific historical battle, Guy learned how the Seminoles fought such skirmishes by talking with Seminole

friends and reading historical accounts. Frank Laumer is one author that he read. "He wrote a book called *Massacre!* about the Dade Battle.[62] He talked about their ways of fighting, and he had researched it, too, for a long time, so I relied a bit on him, plus what my Seminole friends told me."

The Seminoles fought guerilla style, a strategy that he compared to the way that the colonial militia fought the British regulars in the Revolutionary War. The Seminoles did not build fortifications—or even large encampments—because they did not have the numbers needed to defend such installations. Throughout the Second and Third Seminole Wars, they were grossly outnumbered by soldiers in the field, and their smaller forces—often acting independently of each other—did not require the complicated logistics necessary to direct, provision, and house the U.S. Army.

One U.S. Army surgeon who served in 1836–38 described the Seminole tactics: "The enemy had an espionage over the whole country, and knowing all our movements, was met or not, at his own convenience; that they always fought from their own positions, and never took any from which they could not secure a safe retreat; that this position was always on the edge of some hammock, whence every Indian, posted behind some covert, made his deliberate shot;—the fact of his being near not known until the crack of his rifle and savage yells were heard, and our men were seen falling; and when charged upon, they precipately retreated. Thus it was in every engagement with these Indians; nothing but a succession of running fights from hammock to hammock, and swamp to swamp."[63]

Survival

As he read about the Second Seminole War and talked with his Seminole friends, Guy heard about infanticide. "The first one, I think, that ever told me that story was Judybill Osceola." He heard similar accounts from the Jumpers and from Paul and Richard Bowers and their family. "Everybody has pretty much the same version, where somebody was trapped—usually women or old people that were unarmed." Often when the army surprised the Seminoles, hiding was their only means of escape. He said that, sometimes, those concealed in the thick and tangled growth nearby also included warriors when they were greatly outnumbered by the soldiers.

Concealment was survival, but a frightened infant sometimes couldn't be silenced, so that the mother, he said, "had to hold its mouth shut and hold its nose and all—or hold it under water—or any one of various ways of keeping it quiet, and hopefully the soldiers would move on and the baby would survive. . . . Sometimes the soldiers hung around too long, and the baby died.

So that happened. . . . I know it had to be the last thing—the last-ditch effort that they would use—because the Seminoles are crazy about their kids. They love them."

He gestured toward the canvas (see fig. 31). "So that picture tells the story, with a lady holding her baby's nose and mouth shut." The mother's sadness is evoked by the tear on her face. "And then there's another woman there with a little bit older girl, and she can be quiet. . . . The soldiers are out there on foot, stomping around the bushes, trying to see what's there."

Because the soldiers often had to struggle through tangled undergrowth, they favored more open areas. In contrast, the Seminoles sought the thickets that the soldiers avoided. "So the Seminoles would dive into the heavy vines and weeds and whatever's there . . . and hope they're not landing on a rattlesnake nest or something. I imagine *that* would be a painting, wouldn't it?" His glee is evident in his expression. "Somebody sitting there holding their leg and having a rattlesnake there looking at them for the next bite and soldiers out there."

His wife, Pat, reminded him that he did portray such a moment, but he corrected her. "That was a white man, though. He was going to shoot an Indian guy, and his pant leg is pulled up, and he's laying down like this." He leaned forward with his elbows bent and out to either side of his face as if he were lying on his belly to steady a gun. "There's a rattlesnake down there by his leg. I don't have a painting of that. I had a drawing. . . . In pen and ink, yeah. I wanted to do an oil painting of it eventually, but you don't get time for all of those."

After he brought out the sketch he had described, he explained that he was trying to create a scene that would show a special kind of Seminole medicine. "If you use it, something will change things to protect you." He pointed to a Seminole in the sights of the white man's gun. "Like this Indian must have been wearing protective magic; so therefore, this guy was going to shoot him, but the protective magic makes some other force—the rattlesnake—take the white man out of the picture."

During war times, Seminoles often posted sentinels to warn them of approaching soldiers, and many times they could hear the troops moving long before they arrived, yet sometimes they were surprised in their camps. Commenting on the unstyled hair of the woman in his painting, he said, "She could have been having her hair done by one of the other women, or be trying to comb it and put it up into a bun, and didn't have time." She may also have been caring for her baby.

He tries to portray the Seminoles without stereotyping them: "Many times, I'll have them in clothes that are ornamental, or at least a little bit

ornamental, just to show that they're Seminole, and some of the people have said, . . . 'Why don't you ever show us in our old clothes? 'Cause we don't go out and do this work in our new clothes.'"

Reflecting on Seminole apparel, he remarked that he has found little information about the clothing styles of the Indians who first migrated to Florida.[64] "I know they went from being seminaked, for the summertime, anyway, into all those clothes that looked like they were from Scotland . . . around the time of the First Seminole War. . . . I don't know if that was a sudden thing, or it took many years. I haven't been able to find out."

When he hears or reads an account like the one illustrated on this canvas, he often seeks corroborating information. "Sometimes you'll hear a story about one thing, and you bring it up to somebody else, and they'll tell you another story like that one. Sometimes I ask, 'Did you ever hear of this happening?' and they'll say, 'Oh, yeah, this happened to my grandpa, or something like that. . . . Well, a lot of times people will say that, and it isn't true, and I imagine Indians are just like anybody else—I've found them to be so, but at the same time, if three or four different people from different families say the same story, chances are that happened."

A few written records of Seminoles killing their children during the Second Seminole War exist. For example, when a group of Seminoles with inadequate clothes surrendered at the end of the Second Seminole War, Major-General Ethan Allen Hitchcock tried to encourage a sad-faced Seminole woman holding a baby by saying that now she could raise her children in peace. Her reaction was to cry. He wrote in his memoirs: "There is a story current that at one period the members of this band put their children to death to avoid the chance of their exposing the hiding-places by their cries, and also to make flight easier. It is remarked that there is no child among them from four years old to about fourteen."[65]

Reports of infanticide may seem unlikely because of the love that the Seminoles have for their children. Several nineteenth-century observers noted the devoted feelings that Seminoles have for their children. One wrote, "Yet no people are more fond of their children, and none so indulgent," and another, "The care they take of their children, is beyond expression. . . . They may justly be reproached with that manner of bringing up their children—they know not what it is to chastise them."[66]

The Seminoles that Guy has met have much the same feeling toward their children: "The children have the run of the world—unless they burn down a chickee, they don't get punished. The parents are really, really loose with them, as far as that goes, but they're very respectful kids, but the parents love them, and to say that they did kill children, some people—even some of their

people—don't believe it. I believe it because there are enough people who told me about it."

Suspect Foul Play

As Guy read about the Second Seminole War, he noticed one incident often mentioned: Coacoochee's attack on a theatrical troupe. He said, "We spent a good half year trying to track down the story. We'd get a little out of one book, a little out of another book, and it was never the whole thing, and what there was would be different from the first book. So Patti got the idea, I think, to write to the Historical Society in St. Augustine—they're the closest to where the incident occurred—and by golly, that was where we got the newspaper report—they sent us a direct copy of it—even the misspellings and everything in it."

The article, entitled "Indian Murders," was published in the May 29, 1840, issue of *Florida Herald and Southern Democrat*. The incident occurred on the road, now State Road 208, from Picolata on the St. Johns River to St. Augustine, about twenty miles away. The LaBrees have visited the site, which is commemorated by a historic marker. A military supply depot, Picolata was also the landing for steamships, such as *The Florida*, that may have transported the actors from Savannah. According to the article, they rode in a coach belonging to Colonel Hanson, although they had no military escort.[67]

Guy noted that the troupe had performed *Hamlet* for the soldiers at Picolata the night before. He said, "A group of actors, which back then were called comedians (which they should call them nowadays)," were traveling. "Picolata is not very far from St. Augustine . . . but, back then, that was a good long way because Indians were prowling around, and it was all woods." Coacoochee and John Horse, with their warriors, "together, as one big army, saw these two wagons, and they couldn't read . . . what was printed on them. One of them had the Forbes Acting Company written on the side. They thought it was U.S. Army supplies, so they thought they were going to get into a bunch of guns and powder. They attacked them, and, of course, the actors ran like crazy (much like they do nowadays)."

The Seminoles killed several, but "they were fairly happy with what they found—all these strange clothes, costumes, and makeup colors, and all things like that that they never had before." Guy imagined the scene. "I know that the Seminoles are not very stoic people that stand around, never smiling and all that. I know that they're always cutting the fool and playing jokes on each other and all, so I got them all trying on—which they would have done—this different stuff, and looking in this old gun-shot mirror, and laughing at

each other at how they look . . . and enjoying the moment as far as what they found—not necessarily that they killed somebody. . . . Later on, one Seminole was captured—I think they said dressed in an outfit that reminded everybody very much of a character from Shakespeare's plays."

Almost a half year after this incident, Coacoochee arrived at Fort Cummings dressed in a costume that the soldiers recognized as befitting the character of Hamlet, another with him as Horatio, and a third as King Richard III. "Others were ornamented with spangles, crimson vests, and feathers, according to fancy." So many costumes and props had been lost that the Forbes company did not stage *Richard III* or *Hamlet* in St. Augustine. Instead, the first play offered was *The Honey Moon*, "a popular romantic comedy."[68]

When Guy was a junior at South Broward High School, Dr. Trubey taught a class about Shakespeare. "First we had to study Shakespeare—his life and what the words meant—for about two weeks before we went into studying his plays and poems, which made them a whole lot more interesting. Actually, it was a smart thing to do. At least we understood what Shakespeare was saying." As part of the class, he also watched a movie of the same time period as Shakespeare: "One of my favorites, anyway, and that was *Cyrano de Bergerac.*" To create the costumes and props in this painting, he remembered details from that film and another he saw later—*Fire over England.*[69]

Enumerating the items in the painting, Guy said, "The skull on the ground—that's Yorick" (referring to the famous graveyard scene in *Hamlet*), "old battle-axes and things that the Seminoles didn't have, and big heavy-duty swords." He added all kinds of costumes, such as "an old beaver-skin top hat," or "neck rings the Spanish used to wear" and "great big pantaloons—real big bloomers—and buckles on the shoes." In addition to a Viking helmet, he portrayed "a hat like a Cyrano would've worn" and an English woman's hat "that one of these black guys has on; of course, they wouldn't have known if it was supposed to have been for a man or a woman. So they're all laughing and having a good time with each other. That's what I was after—a grisly scene that wasn't necessarily a real bloody scene—kind of grim humor" (see fig. 32).

Although the Seminoles may have worn the clothing out of necessity, especially after the troops had discovered and destroyed many villages, Robyn O. Warren speculates that Seminoles were probably attracted to the costumes "because they were similar to their native dress." The attire may have resembled the costumes worn in "portraits of nineteenth-century actors: tunics, great coats, and cloaks made of bright, intricately patterned cloth." Adorning these outfits are "medallions, medals, and decorative belts, sashes, or straps," which also appealed to the Seminoles, who wore comparable accessories. Dis-

playing their plunder was also a symbol of their success in war, good for their morale, and detrimental to the enemy's self-confidence.[70]

At Fort Cummings, one officer observed Coacoochee and those who accompanied him: "Parts of the wardrobe plundered from the theatrical party the year previous were wrapped about their persons in the most ludicrous and grotesque style. The nodding plumes of the haughty Dane, as personated in the sock and buskin, boasting of his ancestry and revenge, now decorated the brow of the unyielding savage, whose revenge had desolated the country by blood, and whose ancestors had bequeathed the soil, now consecrated by their ashes, which he had defended with unwavering fidelity. . . . His youth, his manly bearing, his intelligent face, the calm subdued intonations of his voice, his fluent speech, and graceful gestures, won the sympathy of those around, and commanded the respect and attention of all."[71]

In contrast to the natural refinement of Coacoochee's manner of speaking, Guy studied public speaking with Dr. Trubey. He said, "She tried and failed to get me to talk right. So what happened was, eventually, she gave me an A in the class. And I said, 'How can this be?'

"And she said, 'Because you have a way of getting your point across, and people understand what you're saying.' She said, 'That's the whole idea of speech.'"

Whenever someone has requested him to speak about his paintings to a group, he has relied on the guidelines he learned in her class—"tips on what not to do and what to do." One was that "if you use hand expressions, keep them above your elbows." Another suggestion was what to do when you can't think of the right word. "If you're pretty sure you got the wrong word, accent it. Make it really wrong. And that gets everybody laughing, and you go on from there, 'cause then it makes it seem like you did it on purpose." Another hint she offered was for him to "play with" his southern drawl, which was more pronounced when he was younger. His teacher admitted that English has rules, but "under certain circumstances"—laughter mingled with his words—"like mine, you just break the rules as long as it works."

He also remembered a particular incident from her class. The students had to give a speech on whatever subject they wanted. "I knew all about alligators, so I went to where Alan Jumper was wrestling alligators, and he gave me this one about two feet long. I took it—'cause I didn't have any at the time—to school in a box. My time comes to tell a story, and I say, 'I'm gonna talk about alligators.'"

He was standing in front of the first row, where the girls sat, as he began his speech: "'Now, they're not as vicious as you think, and this, that, and the

other,' and I reach in there, and the alligator started banging around. 'Not-As-Vicious-As-You-Think' is trying to bite me, so anyway, finally, I got it behind the neck and pulled it out, and all the women go, 'Aaaaaaa,' and when they did, he pissed." The LaBrees cannot suppress their laughter, even as Guy continued the story. He tried to pull the alligator away, but as he moved it across in front of him, the alligator sprayed each girl. He commented, "The teacher just died. She was in the back of the room just laughing her guts out. I got an A for that one."

He told an amusing incident—involving another of Florida's unique reptiles—about one of the leaders of the attack on the actors—John Horse. In the painting, Guy pictured him in a red turban and neckerchief, holding a rifle at rest, watching the others. Guy said, "If you read about him at all, in the history books, you'll find another guy called Gopher John, and they'll show the same drawing that they use for John Horse, and it's actually the same guy." He received his nickname as a teenager at Fort Brooke, selling gopher tortoises, now protected as an endangered species, but then considered an epicurean delight.[72] Although the details differ as to how he managed to do so, "he kept reselling . . . some of the same gophers over and over, and they thought that was a riot, and so everybody started calling him Gopher John after that. But originally his name was John Horse."

After serving as an interpreter and guide for the U.S. Army through the end of the Second Seminole War, John Horse eventually joined Coacoochee on the reservation in Indian Territory, now present-day Oklahoma, but Guy noted that they stayed only a short time. In 1849, they began a journey to Mexico, which had outlawed slavery, bringing with them their followers and allies as well as a band from the Kickapoo Tribe. In 1848, the Mexican government hoped to secure its new borders by encouraging the establishment of military colonies. So, in 1850, it welcomed Coacoochee's band because, in exchange for a land grant, they agreed to fight against slave hunters from the United States as well as marauding Comanche and Apache Indians. After three months, the government revoked the first grant of land, between the San Antonio and Rodrigo rivers, and gave them property at La Navaja, on the Rodrigo River, a tributary of the Rio Grande. It soon proved too near the U.S. border to be secure from slave hunters, so in 1852, the Mexican government—thankful for the group's considerable military assistance—granted them real estate in Nacimiento, "the birth," or headwaters, of the Sabine River, another area of unrest that would benefit from a military colony.[73]

Guy noted that after Coacoochee died of smallpox in Mexico, John Horse returned to the United States. "He was kind of a lost soul all by himself there.

That would have been a neat guy to meet while he was alive, after all that—he'd really got some stories."

As a leader of Seminole Maroons, a military commander, and a free black man during a time of slavery, John Horse survived incredible adventures. In 1870, he traveled from Mexico to the United States with other Seminole Maroons, some of whom enlisted in the U.S. Army as the Seminole Negro Indian Scouts, and many of their descendants still live in Texas. He finally returned to Nacimiento, where Seminole Maroons (and Kickapoos) live to this day. In 1882, he died on a journey to Mexico City to appeal a supposed sale of that land.[74]

His compatriot Coacoochee is the subject of a book by Susan Miller, a member of the Seminole Tribe of Oklahoma. Miller finds that although "Coacoochee's place in the Seminole historical consciousness has been much diminished . . . Seminoles remember him with reverence and name sons for him." She praises his "military genius" as well as his skill in diplomacy and politics.[75]

Guy remembered that he was also the son of a king.[76] Appropriately, he has pictured him as the center of the viewer's attention, clothed in a purple robe. Even though it is the white man's symbol of royalty, those unaware of Coacoochee's heritage will recognize his princely stature in this painting.

Plans of War

At an art show, Guy met Barney Whitman, a Kentucky colonel who lived in Wauchula, Florida, who told him about a local Indian attack on the Russell homestead during the Third Seminole War, 1855–58. The residents were refugees from their own partially constructed dwellings: Willoughby Tillis, his wife and seven children, and Thomas Underhill, his wife and three children. Bolting themselves in the house, the families exchanged shots with the Seminoles. Outside Fort Meade, two boys heard the shooting and informed the militia. Seven mounted men arrived and fought the enemy. One survivor alerted the forces at Fort Fraser, near Bartow, and the next day, seventeen men tracked and battled the Indians. The five citizen-soldiers who died in this series of engagements are buried in a common grave in Fort Meade.[77]

Guy imagined this incident from the Seminole perspective. "It got me thinking about what the Indians had done ahead of time, and, of course, I started with a much smaller group than he was talking about. His story had about twenty in it, so I got four Indians and two black men, escaped slaves or

whatever they want to call them. They wouldn't have been slaves for nobody because they came right from Africa, and they were already grown warriors."

Because of Florida's unique history as a colony of Spain, Great Britain, and Spain again before it became a U.S. territory, African Americans lived in three distinct situations. Some were slaves to whites, especially on the sugar plantations along the St. Johns River. Others were free citizens, either by birth or by having gained their liberty under Spanish rule and choosing to maintain their residence in the St. Augustine area and to trust the United States government to protect their freedom. The other group lived with the Seminoles and were called "Seminole Negroes" or "Indian Negroes" in the nineteenth century, but other names, including "Black Seminoles" have been used throughout the succeeding century. However, the most accurate description of this people is "Seminole Maroons," which is an "etymological doublet."[78]

The Seminoles welcomed runaway slaves, but they also purchased them as status items or received them as gifts. In addition, free blacks sometimes chose to ally themselves with the Seminoles, especially after the Florida Territory passed an act in 1836 that decreed that free African Americans who incited slaves to join the Seminoles could be seized and sold into slavery as punishment.[79] These circumstances seemed to invite slave dealers to capture free blacks, destroy any papers that guaranteed their freedom, and sell them. Guy said, "They just got tired of being treated that way, and so they went in with the Seminoles because they had a big group of warriors." He compared the situation to the battle of one soldier versus an entire army.

So these Seminole Maroons dwelt in adjacent but separate towns from the Seminoles, and they were not treated the same as slaves in Florida or throughout the South. Guy explained that they cared for the cattle and helped with building. They also raised crops, and in exchange for protection from those who wanted to enslave them, they paid a "tribute," or part of the harvest, to the Seminoles. They were allowed to be armed, so they could hunt for their food, Guy noted, and in battles, they fought alongside the Indians rather than under their command. Seminole Maroons participated in at least ten major battles from 1835 through 1838.[80]

During negotiations with the United States, blacks served as interpreters, he said. "They learned the white man's language, a few of them did, and they were very important. You've heard of Abraham[81]—surely everybody's heard of him—and there's [Luis] Pacheco,[82] and some other guys. I think the war went the way they wanted it to, and I think when it could have stopped, they made it go longer, because they made sure they were free."

When *Plans of War* was displayed at an art show on the Big Cypress Reservation, Guy met John Griffith, a Seminole War reenactor. "He was so inter-

ested in this one painting because, to him, everything he had been studying about his past and all was right there, and so he was telling me things that he had learned, and I was telling him things that I had learned, and we sat there talking about blacks and whites in a language—not so much slang use, but just in a way in which most blacks and whites don't talk about things like that."

They discussed the color Guy chose to paint the Seminole Maroons (see fig. 33). "John was interested that I have them a blue-black almost, and he says, 'You know, that's just the way they used to be when they came from Africa . . . no whites mixed in at all, and so they were very, very, very dark.'" Guy remembered from his childhood, "a man who used to come around and cut our side lot with a swing blade. He'd spend the whole day and cut all of that grass down from about waist high, and he was like that. When he'd get sweating, he'd be so shiny, he'd be blue looking."

Griffith remarked of the Seminole Maroons in the painting, "It's apparent that they're slaves by the way they're dressed and all. They're not as fancy as the Indians are. . . . Yet it's not insulting. . . . There they are strong, and they got guns and everything, and they're interested in what's going on, and they're going to be part of it. They're not on the outside."

The Seminoles wear breechcloths and leather leggings, which are similar to chaps. They have a loop at the top, on each side, that's threaded through the sash that secures the breechcloth. Guy commented that they were the most difficult part to paint. "Leather has a different look from regular cloth. It gets creases in it and has scars on it from when the animal was hurt and rehabilitated, and of course, when they made leggings, they had these great big giant stitches in them."

In addition, the leggings are tied at the knee. "Now sometimes, when they get into a wet situation, like all this humidity—even though they may not be walking through water—that leather starts to drag them and pull down, and all that's holding it is that one loop, so they pull it up here." He demonstrated by grabbing both hands around his pant leg just below the knee. "They put like a neckerchief, and tie it real tight around their legs." He pointed to another warrior in the scene. "He's got a leather strap around his. They used to do it around their arms, sometimes." He used one hand to grasp his shirt sleeve around his biceps, adding that sometimes the Seminoles traded for bands made out of silver that fitted around their arms. Ties and garters were often fingerwoven yarn with beads forming intricate designs.[83]

In the painting, the warriors huddle in an incomplete circle, but one remains standing. "He'd be kind of a lookout while they're doing this. Every now and then, he'd look down and see what's going on, and he'd be looking

around, and then go down and look what they're doing again, so he knows what's going on." The lookout helped to prevent a surprise attack.

This composition makes the viewer feel as if he or she participates in the war council. "I guess that's what I think of it when I'm doing it," Guy said. "Like, that'd be where I'd be at"—he gestured at the canvas—"I'd be right here, probably, if I was one of them."

Intruder on the Land

"I was thinking about what the Indian people might have seen a long time ago that kind of affected them a lot. I know they have talked about trains quite a bit." So Guy chose that subject for this painting (see fig. 34). "I have an older Seminole man, like a grandfather, and his grandson, watching a railroad crossing at night, a trestle over a little creek or something, and one of the old steam engines coming across."

In the 1830s, the earliest railroads were chartered and built in Florida, and before the companies could afford to purchase steam locomotives, mules pulled the cars along these short lines. He imagined this scene in north Florida, so perhaps the railway is the Florida Railroad, which extended 160 miles from Fernandina to Cedar Key, the longest line completed before the Civil War. Even as late as 1880, Clay MacCauley wrote about a Seminole visiting him in Orlando: "He is the only Florida Seminole, I believe, who had at that time seen a railway."[84]

Guy used an old photograph of a steam engine as a model. "I just brightened it up, showed the steam and all that, and from a different angle." However, he knows about steam engines from personal experience, and he used his memories to dramatize this scene. "When I was little kid, it was all steam engines. 'Choo-choo trains,' they called them." He remembers watching them near his childhood home in Dania, Florida. "At night when they were really going hot and heavy, really racing—and back in through a woods like that, the engineer wouldn't be slowing down 'cause there's nobody to slow him down—it'd be throwing ash and fire out the top, right out the smokestack. He would really burn it up."

He compared it to the ballad "Texas 1947," written by Guy Clark, about the debut of a diesel-electric "streamline" engine in that state. Guy LaBree learned the song from listening to Johnny Cash, and it remains in LaBree's repertoire. He summarized the incident. When the first diesel-electric engines arrived in Texas, people "lined the tracks to see it because no one could believe it could be as powerful as a steam engine, and the thing was bigger and

more powerful. We had the same thing in Dania in the 1940s. A big old first streamliner . . . as they called it then, a big red one, and we all lined up along the tracks out there."

Although the first "streamline" lightweight trains powered by diesel-electric engines arrived in Florida in 1939, Guy probably remembers the debut in 1946 of the Florida Special, a streamline locomotive, which had not been in service during World War II.[85] He was impressed by the height of the diesel engine, "about twice the size from the tracks to the top of the steam engine stack—just the old engine itself. It was a monstrous thing." Its noise was also distinctive from the steam-powered trains. "A real, real loud whining sound. You didn't have all the steam and black smoke and all that, which we used to get three times a day before that."

Guy has another memory of trains that is personally unique from about 1951 when he was about ten years old. He could walk from his home, through the woods, to the tracks about a tenth of a mile away, and he often played in that area. One day, he and a friend decided "to cause a train wreck" with the materials at hand. "If you walk along the tracks—at least then, I don't know if it's so much now—I haven't done it since I was kid, but if you do, you'll find things like railroad spikes and these clamps that they also drive into the cross-ties as well, they're kind of bent like a question mark, and they're heavy-duty. They're big old things. So we started collecting those, and then we started putting them on the tracks. We laid them down for about four blocks, and then we went home. We figured we were going to see this crash later that night when the evening train came through about six o'clock.

"So I got home, and I was thinking about that all day long. That's 'cause it's not in my nature to cause train wrecks." At this point, he and Pat could not restrain their laughter. "It wasn't something I got a thrill out of. I was thinking I would, but I didn't." He tried to describe his anxiety. "I was getting the feeling like, 'What if somebody gets hurt?' and 'What if they find out who did it?' Then my dad will have to pay for all that." By the time he finished eating supper, about 5:30 p.m., he ran through the woods to the tracks. "The sun was just about gone down. It was in the wintertime. And I started picking up the things and throwing them off the tracks—spikes and all; I heard some noise and looked down the ways, and there's my friend Bobby. He's picking up and throwing them off, too."

His laughter didn't allow him to speak for a moment. "Scared him to death, too. We got the spikes and clamps all but about two" before they heard the train. Abandoning their efforts to clear the tracks, the boys "hid in the bushes to watch" the approaching train. When the wheels hit the debris, sparks erupt-

ed. The engine "skidded for a second, and then it just threw them off, and it sounded like a bullet ricocheting—puh-twang! That old train just didn't even slow down. It didn't look like it anyway. It just went right on through."

He paused for a moment. "I guess it sounds better now than it was. It was scary at the time. I remember both of our hearts were beating, and our eyes were big around as dinner plates waiting for something terrible to happen." They were also "wondering how long our butts were going to be burning after that," when one of their fathers discovered what they had done, and probably both fathers would have punished them. "I never told my dad. I don't think he did, either. I never told nobody till I was older."

In the painting, the boy's face is turned away from the viewer, and the man's face is a stoic profile. Even as Guy was painting them, he wondered about their thoughts. "Would they be glad to see it? Because the Seminoles are very adaptable people, but at the same time, they did not like the way their culture was being changed, to have to assimilate to the white man's culture just because it was there."

Guy believes that Seminole attitude continues today. As an example, he explained that even though the Seminole Hard Rock Hotel and Casinos in Hollywood and Tampa focus on "rock 'n' roll," there are stores selling Seminole products. The one in Hollywood has a Seminole museum near the casino and an alligator-wrestling exhibition. Also, "Hard Rock Live" hosts the annual Tribal Fair in February. He said, "They're going to put their culture in anyway, and that's good.

"But I was kind of just wondering if that old man is happy that the trains are coming because he can get different things that he couldn't get before just from a little trading, or is he not happy? That kid would be kind of in awe, I think, because of the thing screaming through there making all that racket, and smoke, and probably looking like a dragon to him." Admitting that his comparison may be exaggerated, he continues the narrative he has imagined: "The old man brings the boy to watch the train, and the old man says: 'See? Do you like it or not? 'Cause you got to live with it.'"

Chapter 4

Florida Wildlife

The Florida environment varies dramatically. A few inches of elevation can change salt marsh to mangrove forest, hardwood hammock to hardwood swamp, pine flatwoods to prairie marsh, cypress swamp to cypress dome. Although other artists may prefer painting this variety of scenery, Guy insists that a landscape isn't a still life. For years, he has walked, waded, and ridden through the diverse habitats of Florida, and no matter where or how he traveled, he has observed creatures animating the scenes. In essence, he focuses on Florida's unique ecology.

Preserving Florida's distinctive nature began early in the twentieth century with federal designation of lands that eventually became national wildlife refuges. Within the decade, Florida established its first state park. Others were purchased with private and state funds, and some were developed by a federal program during the Great Depression.[1]

In addition, Everglades National Park was authorized by a 1934 congressional act that included a clause to protect Indians' rights. However, the Indians feared they would be forced from their villages secluded in the Everglades, and when asked, they wanted "just to be left alone." Land acquisition for the park involved trading property held in reserve for the Seminoles for acreage adjacent to the park's boundaries, now the Big Cypress Reservation. Although several historians have written that establishing the park did not affect the Seminoles, they view it differently.[2]

The Everglades National Park project was suspended until after World War II, and in 1947, when Guy was in first grade, it was dedicated as the first federal park to honor a wetland. Since 1960, Florida has continued this tradition of acquiring its natural lands through a series of programs.[3]

Yet, Florida's wilderness has diminished to accommodate a population—as well as the agribusiness, tourism, and other industries to sustain it—that has grown exponentially since the advent of affordable air-conditioning. This growing population contours the land to suit its needs—draining wetlands, building mounds, excavating lakes, and "dredging and filling" to create more waterfront lots.[4] In addition, exotic plants and creatures of all kinds—by accident and by design—have invaded, so that little remains of the pristine "Land of Flowers" first seen by the Spanish more than five centuries ago.

Guy's canvases convey the natural beauty of Florida and imply that it is a treasure worth saving. He has portrayed particular incidents as if they had occurred in the real world rather than in his imagination. For example, *Fire Peril* conveys the truth of the Everglades fires that he witnessed in his childhood.

His lifelong observations provide the details that authenticate these canvases, and he has participated in enough hog hunts to paint the reality of the situation in *Almost Hog Heaven*, or he can transform the many views he has had of panthers napping in a cage into one relaxing in the wild in *Restful Shade*.

He has learned to balance a composition, such as *Jeopardy*, that involves predator and prey so that the situation will appeal to the viewer and will sell. In addition, his appreciation of and respect for nature illuminate these paintings, and they are sought after by naturalists, hunters, and conservation organizations. For example, his paintings of wood ducks, like *Waiting for Mom*, have won him acclaim from chapters of Ducks Unlimited.

His paintings of Florida wildlife bring the natural world into focus, and sometimes the birds that he photographs outside his home provide the focal point for a painting, such as *Sunup Turkey Feast*. Or, in another painting, like *Snack Gar*, he may concentrate on one aspect of a larger landscape he has already portrayed. Even when his artistic sense of color inspires a subject, he may have to expand his knowledge of the natural world by consulting an expert, such as an entomologist, as he did for *Repeat Offender*.

In 1989 on the Big Cypress Reservation, Guy slept in a chickee at a camp constructed to display the traditional Seminole ways. The mosquito netting he brought was smaller than usual, only about a foot away from his face. That night, he thought he was the sole inhabitant of the camp. He said, "For some reason, it got real quiet, and the moon was kind of over and shining under the side of the chickee and inside on me." Even though he wasn't sleeping very soundly, he's not sure what woke him—maybe the odor of breath or the sound of panting. He opened his eyes and saw a silhouette with big ears. His realization that the animal was a bobcat startled him—and the cat—before it darted away.

This encounter is only one in a lifetime of adventure and exploration in the wilderness, and as long as he is able, Guy will continue that journey. His experiences will enrich his nature portraits, and they will enhance his audience's appreciation of natural Florida.

Fire Peril

"You've heard of Everglades fires?" Guy asked. "Well, I've seen quite a few of them in my lifetime. At night is when they are the most spectacular. We used to go to State Road 27, if there was one close enough to see." He climbed the levee that begins south of Lake Okeechobee and parallels the road to Miami. "I could stand up on that levee, which—I guess—was about twenty feet high, at least, and look out over the Glades and see this line of fire and smoke and how it was going up into the sky."

During the rainy season, lightning forks over the Everglades, and in the painting, a thunderhead looms in the sky behind the clouds of smoke (see fig. 35). He imagined that a lightning strike kindled this fire: "It burns down to the water real fast. There was water everywhere out there, but the top of the grass was dry, and it burned forward. Behind it, there wasn't much smoldering for very long, because it was just grass. It would burn up quick."

He explained that fires in the Big Cypress Swamp look much different because the big trees flare like torches on the horizon. "Now, since they drained the Everglades, there's a lot more hammocks than there used to be, and a lot more myrtles and stuff like that out there in the saw grass." Without enough moisture to nourish the saw grass, the muck—six to ten feet of decayed vegetation—can catch fire and burn uncontrollably for weeks.

Portraying an Everglades fire gave him the opportunity to accurately depict a natural phenomenon, and a challenge "to paint something with two light sources." Remarking on a recent luminous full moon, he said, "You could hunt snakes out there on a night like that." However, in this scene, the flames overwhelm the brilliance of the moon.

"One year, I remember they had a really big fire. It was burning down from Okeechobee." When it reached Andytown,[5] at the intersection of State Road 27 and State Road 84, which now parallels Alligator Alley (Interstate 75), Guy joined a friend and his father "camping out there on the levee, eating hotdogs and drinking Cokes and watching. And in the distance—it's so far away, you could see this little, fine, bright line—it looked like a worm moving across there. The next morning, there was so much smoke around, but you could look down in there and see all the deer standing around, where they were running ahead of the fire. . . . They didn't seem to run constantly. They'd run for a ways, and then they'd hang around for a day or two, and the

fire would catch up to them, and they'd run again. That's the way it looked to me."

The Seminoles have told him about the fires in the Everglades, so he knows how they have survived. One described how they dug a trench around a village to keep a fire out, and how they guarded against sparks falling on anything that would burn. In his painting, a Seminole family hastens away from their home because, without modern-day fire-fighting equipment, even plowing a fire line can't save them.

Guy recognizes that natural disasters often change the dynamics of everyday life. "Facing a big fire like that . . . there's no higher and lower animal—they're all the same—animals trying to get away from the fire . . . people mixed with deer, with birds, with everything." Their desire to escape—as well as Guy's composition and vibrant colors—unite them against this Everglades fire.

Almost Hog Heaven

"You can tell it's kind of the rainy season, because of the puddles in the little roadway or pathway," Guy said, pointing to the canvas (see fig. 36). "I have a bit of rain—a storm way off—coming out of a thunderhead." Such clues identify the season as summer, as other details define the habitat. "It's a lot of cabbage trees and cypress trees, and then over here on the right, there's cabbage trees and oaks." On either side of the scene are the purple blooms of pickerel weed (*Pontederia cordata*) and saw grass. "It's kind of a pasture, but I have no fences showing. Some places out there, it's a long way between fences."

After seeing this painting, a Seminole friend told Guy that he "should have put a fence running along the back between that buggy and the dogs, and have it pushed down like it's been run over a whole bunch of times . . . because that's what the white guys do. They come out there and just drive right through the fence on the reservation, knock it down, and go in there poaching, because they have more animals on the reservation" than elsewhere. Guy assured his friend, "Well, I'll stay out of that controversy."

Birds often fly through the backgrounds of his scenes—egrets in this composition as well as a hawk soaring overhead. In addition, three Florida mallards take wing in the foreground. He said, "When they take off, they take off like a plane. They run on the top of the water, lift up and flap their wings." He indicated this movement in the painting. "Their feet make little splashes until they finally just take off, and then you get a drop or two that falls off of their feet and no more after that."

The slough surrounds what Guy calls a "cypress head," or dome, where trees

grow in a circular formation, taller at the center and progressively shorter to the edges.[6] Although only an edge of the cypress head appears in the painting, it exists in its entirety in his imagination.

The focus of the scene is six hogs bounding toward the water, their chance to escape, because dogs can outrun wild hogs. He said, "If the hogs can get the dogs into that water, then they're pretty safe, because they can swim better than the dogs."

According to Stetson Kennedy, who visited the LaBree home in 2007 and admired Guy's paintings, wild hogs in Florida are descended from domesticated pigs imported by the Spanish and other pioneers. A wide-ranging forager, this omnivorous animal finds food even in lean times or on barren country, giving rise to the expression, "Root, hog, or die!" Many settlers depended on these animals to feed their families. Although panthers, bears, and alligators will prey on them, hogs are formidable enemies, and they once destroyed more crops than the free-range cattle. The Seminoles also raised hogs to sell and for their own consumption.[7]

When Guy was a teenager, he hunted hogs with his uncle. "He'd have his swamp buggy, and we'd go out with the dogs." Although one dog, named Jiggers, was a bird dog, she was very good at hunting hogs. She "bayed" the hog by running around it in circles, barking until the hunters arrived. "We drive up, and generally my uncle would just get out and shoot the hog 'cause he used a pistol, and *bang!* that was it."

Another way of hunting hogs is to catch and cage them, so they can be fattened on corn before they are killed. This method removes the "wild taste" from the meat. The first time that Guy ever participated in that kind of hunt was about ten years ago on a ranch near Lake Okeechobee.

He narrated the process as if telling someone how to capture hogs: "You run up and grab them, and then when you got them by the hind legs, if you lift them up, they fall over." The hunter can't be bitten because the muscular hogs can't reach around with their heads. "So you just hold their legs, and they kick and scream. You think you're killing them."

Grasping a hog's hind legs, the foreman called for help. Guy had to cross a ditch, "and I liked to drown because I hit a soft spot and went completely under. But I got over there, and I got hold of the hog. He was about 150 pounds—wasn't no giant, but he was big, with big old tusks on him."

Together, Guy and the foreman dragged the hog across the ditch. "I went underwater again, and we dragged him up the other side—which was a lot when you're going up the side of a canal that's just been freshly dug, and it's soft sand." The effort winded Guy. "I was gasping for air, hanging on to this one leg, and he was hanging on to the other leg, and he's half my age, and he

was gasping for air, so I didn't really think I was in that much trouble as I was. My heart was giving out, and I didn't know it.

"We had a Yankee friend with us," and when he asked how he could help, Guy said, "Come over and grab this leg. I might not be able to hang on much longer." He did.

The foreman said, "Here hold this one."

Guy's friend said, "What'll I do?"

The foreman said, "Just whatever you do, don't let go."

"So while we went over and sat down by the buggy, catching our breath," Guy said, "this poor fellow's out there, and man, when we get back, he'd just about cut the circulation off" because he clasped the legs so tightly. Guy noted that his friend had claimed to be "quite the hunter, but when he got out of there, he told me that he'd never go do that again. He said that was the most dangerous thing he had ever done."

The foreman and Guy wrestled the hog into the cage, although Guy was suffering a heart attack. "I was having one later after that, too. I was feeling really bad." Because he didn't experience any sharp chest pains, he didn't realize what was happening to him.

Boar skulls decorate the stumps and rocks around Guy's home, and he explained why: "I'm too poor to have them taxidermied." He laughed. "The skulls are falling apart. I just wanted them to show how big the teeth was in them son-of-a-guns." He used his hands to show the size that is usually found on hogs versus the ones on his skulls. Continuing to gesture, he described some monstrous and tortured tusks. "I've seen them where they come out and go around and come up through their jaw. And I seen them come out like this [he gestured with the index fingers of both hands]—over the top of their nose, which most of them do."

Guy said that some viewers have criticized another of his paintings, *Cornered*, because they believe the size and shape of the tusks on the wild hog he has portrayed can't be correct. Yet others, who have seen similar animals, praise the accuracy of his image. The hogs that Guy paints may not be portraits of specific individuals, but he captures them—teeth and hide—in true-to-life detail.

Restful Shade

"I've been in the woods most of my life. Only three times have I seen a panther. That's out of sixty years—not even for a minute each time—in the wild. I've seen a lot of them in cages, of course. . . . And then I had a friend that used to raise them named Frank Weed. I got to see his panthers a lot, and I

learned a lot from Frank. He knew more about wild animals than anyone I *ever* met in my life. He had a TV show on Miami's Channel Four back when I was a kid, called *Tumble Weed*."

Guy recalled visiting Weed's ranch of five acres, where he kept panthers and other wildlife in cages. He said, "So that's where I got the idea for the panther lying under a tree because they did a lot of that during the daytime, lying in a tree or under a tree, cooling off when it's real hot like that. And the butterfly sitting on his ear just added a little bit of color. People ask what kind that is, and it's just made up" (see fig. 37).

The setting is also in his imagination, "in the Glades, somewhere, a higher area, probably with a little place there in the middle where it's normally wet, but it's dry now because the grass is all brown." He pointed to the center of the canvas. "When it rains, it will turn green again." He went on to explain that he doesn't copy his scenery from photographs, nor does he try to duplicate a particular place. From the images he has seen over the years, he selects particular elements to balance his composition.

"I used to be able to see a picture before I painted it. . . . Every detail would be there, the colors and everything. And then if I was painting it, I wouldn't necessarily start the way I do now—trying to block these big areas in. I would do a little bit of the sky, do a little bit of the neck, work over here a while, work over there for a while. When I needed each piece, I would just focus—take that original idea and go in on that corner, or go in the middle, go on the bottom corner, whatever I needed, and it would be there."

Pat said, "He could have that picture in his head, and say, 'I don't like the colors,' and change it in his head."

"See this is all one color scheme," he said, pointing to this canvas. "If I wanted it brighter, I could—bang—do it like that, or I could do it nighttime, like this." He gestured toward another painting. "Whatever I wanted."

"He could keep a quarter of the picture in his head and get rid of three-quarters," she said.

"Yeah," he said. "I'd do a little piece at a time. . . . Life was easier." He regretted that he can't work that way anymore. "I don't know. I just got old."

"That isn't true," she said. "It stopped when you got off of salt, sugar, and caffeine. . . . You gave them up all at once. The pictures disappeared. . . . It was just like a writer's block. It was an artist's block. . . . So I said, 'Why don't you do something you know, like snakes?' And it's slow, because you have to do the scales."

So Guy began to paint again, but his ability to "visualize a picture" has never fully returned.

Although he was once advised not to paint scary subjects, like snakes or

spiders, he has done those paintings, and they sell, especially to collectors. "I like to do coral snakes because they have a lot of color." He pointed to a painting of two snakes. "See it's always black, yellow, black—that's a coral snake. The others start with red on the end. Some have red, black; some have black with just a touch of a red, but that never happens on a coral snake."

Panthers seem more elusive than snakes. Since he and his family have moved to ten acres in rural DeSoto County, he has found panther tracks. Gene Schuler of the Wild Animal Retirement Village in Waldo, northeast of Gainesville, and Frank Weed both confirmed Guy's assessment when he showed them plaster-of-Paris casts of the tracks. Another time he spied the "tail-end of one" digging and thought it was probably trying to catch an armadillo. He ran back to the house to get the camera and his wife, but when they returned, the cat had disappeared. The hole was large enough for Guy to crawl inside.

As he paints at night, he may take a break. "When I get a headache or start to get eye strain too bad . . . sometimes I'll get up and go for a walk in the woods for a little while . . . especially in the wintertime, when it's cooler." He carries a flashlight that he switches on when he hears something else moving. This strategy has allowed him to observe more animals than he would encounter during the day. He has seen bobcats at night, but never a panther, although he's heard one moving. Once, he walked backward all the way to the house to be sure that the panther wasn't following him. The animal was so close, Guy heard it purring as loud as a machine, and the next day, he found its unmistakable tracks.

He has enjoyed watching foxes, possums, alligators, and many other creatures, and none of them has ever bothered him. But he's cautious of large animals, like the panther. "What he's doing is hunting for dinner. . . . I figure I might be next on the menu, so I get out of there. . . . Even though they don't usually attack people, when I'm out there amongst them . . . it makes me feel mighty insecure."

Jeopardy

Guy painted *Jeopardy* in response to people's reactions to a similar painting entitled *The Buck Stops Here.* He said, "I had done a picture of a panther about to take a deer, and the deer was drinking or looking away, or something. Not too many people actually enjoyed looking at it, and so I tried a different approach."

In this scene, he made sure that the deer has "a split-second chance to get out of the way. That seemed to make people happier. It sold faster" (see fig.

38). His laughter acknowledged the reality of the art business. He recognized that most people will create a story for the painting. "If they want to see the panther eat, they can say, 'Ah—that panther's got him.' But if they don't want to, they say, 'Ah, that deer will get away.'"

He noted that panthers don't always hunt deer because "a big deer like that with a rack on him is a very dangerous animal." He read a study of panthers conducted by the Florida Fish and Wildlife Conservation Commission that analyzed the stomach contents of those animals struck and killed by vehicles. "Armadillo is the number-one thing they've been eating. Easy to catch—they're everywhere. There's a lot of meat on them, a lot of calcium 'cause they have to eat the bones with them, I guess."

Of course, the panthers also kill deer. "If they can get one of them, that's a lot of protein, and will last them for a week or so," unless buzzards and other scavengers discover the carcass. "I really don't know if a panther stops and hangs around their kill until they're done with it."

Although deer and panther are enemies, their colors are comparable. Then he remembered an exception: "The deer that live over between here and Howard Solomon's Castle[8]—they're regular old white-tail deer, but they got a black saddle on their back." He estimated that the herd contained about thirty animals. "I never have painted them because they're so unusual. Maybe one day, I'll do that—just to say I did."

Although he has observed a lifetime of Florida landscapes, he said that the setting of this painting resembles part of the land that he and his wife own in rural DeSoto County—at least how it looked before Hurricane Charley swept through on August 13, 2004. "It'd be in a woods, like an oak hammock . . . very much like where my hammock was in the back there. . . . It used to be a lot more open under there and all. Now there's no shade, so we got a million vines all over the place."

The most time-consuming aspect to paint was the lighting. He enjoys creating the shadows and highlights, but "that's when my wife is saying, 'You should've had that done by now.' But it takes time, and you got to keep figuring that same angle." Pointing to the sunbeams, his fingers danced like dappled light across the canvas as he spoke: "The sun's way over ninety-six million miles away . . . so when you get one ray, you got to get them all the same. So, on the deer as well as on the cat, and I guess that was the most fun—and trying to get the reflections as close as possible for that dirty, little stream."

His depiction of the landscape seems as real as the deer's chance of escape, a glint in the shadows of this dramatic scene.

"I was learning a little bit about the wood duck, which to me is the prettiest duck of the wild, natural ducks in Florida," Guy said. As with most bird species, the male is the most colorful, with "iridescent back and head plumage, red eye and base of bill, tan sides, white throat, and white-spotted maroon chest. Both sexes exhibit head crests." Although the wood duck (*Aix sponsa*) is not common now in southeast Florida[9] where Guy grew up, he observed them numerous times when he camped in the swamps there.

"They live in the swamp, and they'll have a hole in a tree" where they nest. "When the babies are born, they stay in the tree." Although the hole can be as high as forty feet from the ground, usually it's fifteen or twenty feet. "But when the mom calls them, they just jump out." They land on cypress knees, branches, "or whatever happens to be there." However, they are not hurt because "there's so much of that down on them that they just bounce like little balls." The down also keeps them from sinking in the water, "so they learn to swim real fast, like having their own little water wings" or flotation device.

Guy once observed wood ducks when he visited with his friend sculptor Brad Cooley. "I was up at his house in Lamont, and he lives right on the Aucilla River."[10] The two sat beside the river talking for several hours before the wood ducks arrived. Brad had described how the duck would fly straight into a hole in a tree trunk that was about eighteen inches in diameter. "I didn't believe they could do it that fast 'cause they were really moving. It's like if you took a bird by his legs, and slung him as hard as you could at that tree, and he went right into the hole—that's the way they go, just right in, zip—even with the babies in there." He demonstrated by bending his arm, pulling it back behind his head, and sliding his hand forward and down, extending it flat as he did so. "Brad thinks they might go in and dive downward and do a circle, like a somersault real quick, so they tumble and land with their feet."

Although he has always been intrigued by birds and other creatures, Guy didn't paint wood ducks until he learned about Ducks Unlimited. Founded in 1937 by a group of sportsmen who wanted to save waterfowl dying because of the Dust Bowl drought, Ducks Unlimited—as it is known today—describes itself as "the world's largest and most effective private waterfowl and wetlands conservation organization."[11]

Guy said, "If it wasn't for Ducks Unlimited, you wouldn't have half the wood ducks, or any of the other ducks . . . because they bought up huge tracts of marshland and saved them, so that the ducks traveling south would have a flyway where they could stop and rest and eat." He noted that the organi-

zation also purchased wildfowl habitat in Florida. Members are allowed to hunt, but "they take very few birds compared to how many there are."

Pat said, "We first heard about Ducks Unlimited from a Tampa artist who introduced us to someone who belonged to the Ducks Unlimited Tampa chapter . . . and he came to the Seminole Village over in Tampa to meet us and to look at some of Guy's paintings of wildlife, and he ended up buying four." The canvases focused on ducks as well as other waterfowl. They were auctioned at a banquet to which the LaBrees were invited and at which they displayed Guy's artwork. (The Florida chapters of Ducks Unlimited host annual banquets, with an art exhibit and auction, as fund-raising events.) In 1984 and 1985, he was the featured artist for the Tampa chapter, in 1984 for the newly formed East Hillsborough County chapter, and in 1990 for the Palm Beach County chapter.

In this scene, along the edge of the nest cavity, grow "what we call Jesus Christ ferns," Guy said, or resurrection fern (*Pleopeltis polypodioides*) (see fig. 39). In dry seasons, its leaves turn brown and shrivel, but after a rain, they become vibrant and green, seemingly resurrected—hence their name. Some Spanish moss (*Tillandsia usneoides*) and another air plant belonging to the bromeliad family flourish nearby. Resurrection fern, Spanish moss, and the bromeliad are epiphytes, or air plants, taking their nutrients from the air rather than from their hosts as do parasitic plants.[12]

In the background, the swamp changes with the spring season. Guy said, "That gives me a chance to put a little more color." He mentioned the browns and golds in particular because "the trees are starting to get their color back."

The view into the nest is one that few people ever see, including Guy. Even when he had the opportunity, he avoided climbing up to look into the nest, having been taught as a child that leaving his scent near the nest may cause the mother to abandon the chicks. His respect for wildlife and his unique perspective blend together in his paintings of waterfowl like *Waiting for Mom*.

Sunup Turkey Feast

Guy had painted many wild Florida turkeys, and the canvases sold before he had a chance to reproduce the images as lithographs or *giclées*. Because of the popularity of the originals and because of the length of time it takes for him to complete a canvas, he and Pat thought that prints of a turkey painting would sell well. At about the same time, he managed to videotape a flock of turkeys near his home in DeSoto County. "There was about twenty-five of them right here in this one spot." He pointed through the sliding glass doors

of the living room. "I was on my hands and knees, right over there, lying down on the ground."

These turkeys were not the first that he has observed. "We used to have them come up here all the time, but I never really got to sit and watch them for any length of time" because the birds startle and fly off when they spy a person. "The neighborhood around here now—everybody and their brother's got sixteen dogs" that chase away the wildlife. "I did see a bobcat the other day—a nice big old dude—nice to see for a change."

The painting began as a landscape—a pasture without fences along the shores of a river like Peace River,[13] not far from his home in DeSoto County (see fig. 40). Dissatisfied with the static scene, he added the turkeys. In this early morning scene, one deer drinks as the other keeps watch in the background. "These turkeys have just jumped down out of this oak tree, kind of, and they're going over and finding blackberries. I got some blackberry thorn bushes around here and there, and an old dead tree laying there that they're growing over, a few cabbage trees in there, cypresses, oaks." His hand skimmed across the painting as he described each feature.

"The water in the river—I had fun with that—with the different kinds of highlighting on the shadows and reflections." He noted that the sand under the water is clear in one area. "You wouldn't see that everywhere—just certain spots." In the distance are some dead trees, with "a hawk sitting up in it—by the shape—and then I got one up here flying." He pointed to the bird. "Either a buzzard or a hawk—it's hard to say. . . . And the rest is pretty much up to your imagination," he continued through his laughter, "whatever's lurking back in there."

The scene focuses on the "Osceola turkeys—which are the original Florida turkeys.[14] They're a little smaller than the ones they brought in from North Carolina, which are about a third bigger than that, but they're way more colorful." He pointed out that Florida turkeys have "pinkish legs" and "very metallic colors," compared to the "white legs" and "mostly black" shading of North Carolina turkeys. He explained that, at one time, the state government "thought all our turkeys were about extinct, and so they brought the other ones in 'cause turkeys are a natural part of Florida. . . . One of the few times that it was hunters that took them out, but . . . they started coming back on their own."

The Osceola turkeys in this painting "are all jakes. They're at the age I call them 'red necks' 'cause they all got that red neck showing most of the time—the young ones—maybe two years old, or three." In contrast, the females are duller in color. "Once in a while, a female gets a little red under her neck—not much—it's just like a little pouch there that turns red, but that's all, so she can

spend her time raising the babies and not looking over her shoulders all the time." Her lack of color makes her less noticeable to predators.

Guy mentioned his friend Harriet Shepard, who lives in Lake Suzy, in southwest DeSoto County. An excellent photographer, she also videotapes wildlife. She told him how she filmed a bobcat sneaking up on a group of about twelve turkeys feeding one evening. When the birds saw the cat, "they all turned around and spread their wings out to the sides—not their tails— their wings—and each wing was one in front of the other, so they looked like this great huge long black animal. And then they started shaking them and walking toward the bobcat, and the bobcat turned tail and ran."

He admitted that he hasn't seen the footage yet, but when he does, it may inspire him to paint another extraordinary scene like *Sunup Turkey Feast*.

Snack Gar

South Florida has a wet and a dry season, and as the standing water evaporates, fish are often trapped in small ponds. Guy pictured such a moment on a large canvas entitled *The Plunderer*. Two fish hawks, or ospreys, in the foreground, have raided fish from the pond, but a Florida black bear has also discovered the fishing hole, and he emerges from the water with his plunder—a garfish in his mouth. "So I figured that would make a neat picture just by itself, just with the bear alone, so that's where this painting came from."

In *Snack Gar*, the background is a mixture of cattails (*Typha latifolia*) and saw grass (see fig. 41). "The cattails come in wherever you get a lot of nitrates in the water." He remembers when only a few cattails grew in the Everglades, but he knows that "the best way to clean that water is to give it about a hundred acres or so of cattails" because they absorb waterborne pollution such as fertilizer runoff. "The saw grass does that, too, but it doesn't do it as quick as a cattail."

Water lilies grow across the top of the pond, and as he surfaces, the bear catches a lily pad on his head. "Alligators do that, too, and otters'll do it. Turtles will do that. They'll come up under a bunch of greenery, and they'll just look like a bunch of greenery." He laughed. "Just sitting there, it'll be all over them."

The bear holds a garfish in his mouth. "I've caught garfish all my life. . . . If you live in Florida, you catch garfish whenever they're around." He realizes that many people won't eat them. "They say they're trash, but they're not. There's a lot of meat on them, and they're very tasty. They taste a lot like a bass when they're fresh. But they are prehistoric—here's the bad part—and

they go bad quick, quicker than a bass." He recommends that they be kept in water after they are caught.

"And then when you take them out, cut their head off, gut them, and throw them in the fire. You don't even need to cut the head off, actually, just gut them and throw them in the fire, cook each side of them real good for about fifteen minutes depending on how big they are. It's a good white meat. It's very good-smelling, very good eating. It has that bass-sandy taste. . . . You ever get a mouthful of white sand by accident from digging a hole, and you try to breathe, and you get that in your throat and get that taste that's in the air? That's what I mean. It's a fresh taste."

He has never seen a bear eating a garfish, but he knows that they do. "Bears are funny. I was talking to Pete Caron, who used to run Octagon Wildlife[15] before he died, and I asked Pete about how come you hear that one minute they're eating berries, one minute they're eating honey, one minute they're eating fish, one minute they're eating deer?"

He gave Pete's answer: "They don't hibernate; they semihibernate. They have a lazy, cold time, when they get up and run around, but very little. They mostly lay there and sleep, and in the spring, they've lost a tremendous amount of weight, so the first thing they'll do is look for a honey tree . . . and eat every bit of honey in there and the bees with it. . . . Then after that, they need a lot of protein, so they start hitting the fish." Bears eat berries all summer, plus "a deer or hog or something like that, and they'll eat a little of everything from that point on"—including a snack gar.

Repeat Offender

Although Guy's art has won some prestigious awards, he rarely enters competitions. "Contests are nice, but they don't put meat on the table. . . . I'd rather sell a painting, and I know this sounds very crass, commercialism and all that garbage, and it is, but when you do it for a living, you need to sell the things. If they don't sell, you're not going to eat."

The LaBrees agreed that in some art contests, political concerns may triumph over talent. "I pick the shows to enter," Pat said, "and usually it turns out to be the right thing."

Pat chose to enter *Repeat Offender* in an art contest judged by a professor of modern art from New York who had just accepted a teaching position at Ringling Art School. Guy said, "The judge gave me first place, and I couldn't believe it. And they had a lot of modern art there, and that's her thing, so I asked her, 'Why in the heck did you give me first place? Because that painting that I did is not abstract.' . . .

"She said, 'I liked it. That's all.' . . .

"I thought, 'That'll do.'" He laughed at the recollection. "It made me happy. So I'm real proud of that one—to get first place. The only thing is—of all the bees, there's one of them that don't have wings. That is the truth. It was an accident. I forgot to put wings on the one bee." He didn't realize his oversight until after the finished canvas was sold.

When he paints scenes of Florida wildlife, he relies on his lifelong observations; however, this subject required some research (see fig. 42). "I know about the bear, but I didn't know about the bee tree, how the bees have their honey laid in." So he visited Archbold Biological Station,[16] a research and educational facility in Lake Placid, Florida, to talk with an entomologist.

He explained the habitat and behavior of bees, and Guy learned "how the honey in the little cells is actually up at angles, kind of, so the honey stays in there just before they wax over the end." He also found out that, if possible, bees will choose to enter and exit the hive through the smallest possible opening because that gives them more control of their hive, and they will build honeycombs in big rows and lines that form a semicircle, pointing toward that opening.

Walking through the woods, he has encountered bee trees, but he has never delved into one. "I always stop, back up, and give it a wide berth. I do. I have something in my chemical makeup, apparently, that makes bees want to sting me. I'm not afraid of them, but if I'm standing there, and somebody's messing with bees and I'm a hundred feet away, they will come over and sting me . . . and they won't touch him."

Guy remembers watching his father remove honey from a hive in the eaves of a barrack on the Fort Lauderdale Naval Air Base. While another man used smoke to calm the bees, "my dad got up there with his pocketknife and was cutting out the honey and dropping it in this washtub. He got two washtub loads of honey out of that thing, and he got stung a couple of times, but . . . he was right there in the thick of them, so that's not bad." Afterward, Guy and his siblings chewed the honeycombs. "Trouble is, sometimes they had babies in them." He snickered at the undesirable image he had created. "You find out after you're chewing them. But they taste so sweet, it doesn't matter."

Although the canvas captures a single moment, he narrated the episode. "The bear rips a piece of the tree open and starts eating as fast as he can because the bees start attacking his nose, around his eyes, and everywhere. So he eats, and licks, and chews, and sucks that wax down, and gets it all down as fast as he can." Then the bear shakes off as many bees as possible before splashing into the water or wallowing in the mud to kill the rest. Guy said, "I've seen that on films, and the bears all seem to do the same thing."

One time, the LaBrees were riding in a car with some friends on the un-
paved roads east of Naples. "Way up ahead, it looked like two little boys fish-
ing, standing right side by side—one bent over and one standing up, and as
we got closer, we realized it was a black bear." When the bear saw the car, it
ran "into the swamp on the side of the road. So me and this other fellow got
out—I think his name was Mitch." The two followed the bear's tracks until
they spied the bear about fifty feet away.

"I am flat out afraid of bears—no two ways about it. So then I said, 'Let's
go on back to the car.' We got back to the car, and Patti said, 'I thought you
were afraid of bears.' I said, 'Yes, ma'am.' So she said, 'Why go on in there?'
And I said, ' 'Cause Mitch's fatter than me. I figured he'd get Mitch, and I
could outrun him.'" He chuckled before he added, "It didn't make Mitch real
happy to hear that."

Guy explained that he fears black bears because of their tremendous
strength. He gave two examples. "It's the same black bear as everywhere else
in the U.S., but they're smaller here in Florida, but they can still kill a Brahma
bull just by swatting him and breaking his neck. That's a lot of power." An-
other time, he watched what happened when a bear in a cage was given several
large Hayden mangos. "He just put his foot on one and shot the seed out of
that thing," He demonstrated the action as he spoke, by sliding one hand past
the other, his palms smacking as they met. "And then he ate the rest of it, skin
and all. That was amazing. Do you know how much power that takes?"

Perhaps the muse—or maybe an artist's temperament—inspired this can-
vas. "I think I got the idea in my head and the colors"—the oranges of honey
and the black of the bear—searching for a subject "in the deep woods." He
had just completed one scene of Seminole history and was about to start an-
other, and those subjects require research whereas a wildlife scene doesn't—
usually. "On this painting, I did research just about as much." The contradic-
tion caused him to laugh. "I didn't realize how many things I didn't know
about it."

No matter how involved the research, it is only a prelude to the work.
After picturing the background, "I had one honeycomb drawn out, and I put
that on there, to get the right angles," and then a sketch of the bear because
"he has to be a certain way, a certain size, and certain proportion." Details of
color came next, including the trees and leaves on the ground. "The last thing,
I painted bees for about three days. I don't know if it's true or not, but I think
it was about three days. . . . It's been a long time ago—seemed like it in my
memory—seemed like forever."

Afterword

ELGIN JUMPER

To be an artist is to believe in life.
HENRY MOORE (1898–1986)

There is only one artist I know of who has consistently captured on canvas the spirit of the Seminole, for Seminoles, and that artist is none other than Guy LaBree. For decades he has been a close friend of my father, Alan Jumper, and my family. He is one of the most prominent artists, if not *the* most prominent artist, producing Seminole-oriented paintings. The large body of work he has—along with his profound need to create art in a well-thought-out and skilled manner—is as vibrant today as the Florida sun.

His paintings *Genesis* and *Exodus* now hang in the Smithsonian National Museum of the American Indian in Washington, D.C., yet even before they were commissioned, connoisseurs of Seminole-related fine art had long been inundating the LaBrees with orders. Countless others—Seminole and non-Seminole alike—have been enchanted by the deep meaning and feeling evoked in paintings such as *Bridge to Eternity*, the sun-drenched intensity of *Battle of Okeechobee*, the heartfelt understanding of *Survival*, the brilliant creativity of *Sons of Thunder*, the thoroughly researched perceptions of *Plans of War*, and the emotions and overwhelming representations apparent in *"Oh, the Changes I Have Seen,"* a fine portrait, incidentally, of my late grandmother, Tommie Jumper, a personal favorite for obvious reasons.

Guy is a realistic painter, but he is not opposed to experimentation, and his approach to art has withstood, and will continue to hold up to, the crucial test of time. His quests for truth and accuracy in his work endure as the Seminole art scene moves into the twenty-first century. His presence is unmistakable.

Guy is respected and admired, and he has been or is close friends with many Seminoles—prominent or otherwise. His life has been remarkable, to say the least. Not only is he an established Florida artist, father, husband, and so on, but he is also a mentor and friend to emerging artists, Seminoles on the rise, and thus he is an art educator who is much looked up to and held in kindhearted reverence as well. He loves life, playing guitar, and the guitar wizardry of Stevie Ray Vaughan. After a journey to Australia, he camped with his family on wild land they bought in the 1970s near Arcadia, Florida, and later, they had a mobile home brought in, and he has lived there ever since. The tremendous strength of his art is only enhanced and elevated by his experiences to a prominence that never diminishes.

Guy has proven himself the preeminent artist of Seminole history, and he continues to treasure the remaining Florida wilderness, the traditional home and ally of the Seminoles. There is a sacred joy in painting and in art, and this is quite evident in the life and work of Guy LaBree. In his paintings, he is well-grounded truth personified. His knowledge, experiences, stories, anecdotes, and insights about the Seminoles of Florida are considerable, rich, and vivid.

I consider it the highest possible honor, as a writer and an artist, to be asked by Guy and Pat to write the afterword to this extraordinary book. I thank the LaBrees for the faith and belief they placed in me, for all they do on behalf of the Seminoles, for their overall vision and work, and for their invaluable friendship and assistance . . . and yet it remains a relationship not merely limited to art and writing, but to precious life as well. *Sho-na-bi-sha.*

Notes

Introduction

1. B. Jumper, *Legends of the Seminoles*.

2. Milani, "Area Artists Shine in Sarasota Exhibit," 1.

3. For a core list, see Kersey, *The Seminole and Miccosukee Tribes*; Sturtevant, *A Seminole Sourcebook*; Sturtevant, "Accomplishments and Opportunities in Florida Indian Ethnology"; and Sturtevant and Cattelino, "Florida Seminole and Miccosukee." For the difficulties of studying the Seminoles, see Sturtevant, "Mikasuki Seminole," 10–13, and "Chakaika," 36–37; and Capron, "Medicine Bundles," 159–60.

4. With few exceptions, Seminole children did not attend public schools until after World War II. "Segregation policies" are usually blamed, but tribal attitudes may be the more likely cause (Kersey, "Educating," 28–29; Kersey, "Private Societies," 309; Kersey, "Federal Schools," 171–72, 179; Kersey, *Florida Seminoles*, 144, 150).

5. In 1959, two years after the Seminole Tribe was given federal recognition, it created this tourist attraction, which included alligator-wrestling pits, a zoo, and a crafts building, as an income source (West, *The Enduring Seminoles*, 113; Covington, *Seminoles of Florida*, 246). For an assessment of its success, see Kersey, *Assumption of Sovereignty*, 98–99.

6. A Seminole "camp" is the "basic residential, social, and economic unit." It refers both to the location and the people who live there. "While the camp is usually named for some man, often the husband of the oldest woman, it actually is organized around this woman." Residents of the camp are related to her. (Fairbanks, *Florida Seminole People*, 61–66; Spoehr, "Camp, Clan, and Kin," 10–14). For a description and diagram of a camp, see Spoehr, "Florida Seminole Camp," 124–27.

7. Billie quoted in Kenny, "The Legend of Florida Artist Guy LaBree," 3.

8. Koven, *Florida through the Eyes of Guy LaBree*.

9. Hutchinson, "Painting among the Seminoles," 54–55.

Prologue: The Life of Guy LaBree

1. For information about the origin of the reservation and the establishment of the Seminole Indian Agency there, see Covington, "Dania Reservation," 137–44; Glenn, *My Work among the Florida Seminoles*, 10–11 n.7; and Nash, *Survey of the Seminole Indians*, 70–71. Relocated to Fort Myers in 1942, the Seminole agency headquarters returned to the Dania Reservation in 1950, when Guy was nine years old. In the 1960s, the name was changed to the Hollywood Reservation "to more accurately reflect its location in metropolitan south Florida" (Kersey, *Assumption of Sovereignty*, 18).

2. For discussions of the Seminole treatment of snakes, see Florida Writers' Project, *Seminole Indians in Florida*, 22–24; Ober, "Ten Days," 171; and W. Bartram, *"Travels" of William Bartram*, 164–66.

3. Billy Bowlegs III is the namesake of two Seminole leaders, and the Roman numerals following his name distinguish him from the others rather than identifying him as having the same name as his father and grandfather. Billy Bowlegs II fought in the Second and Third Seminole Wars, the latter of which is often called the Billy Bowlegs War. In 1858, he emigrated to Indian Territory—now the state of Oklahoma—where he supposedly died in 1859. However, Kenneth Porter believes that he also led the Seminoles loyal to the Union on their flight to Kansas and subsequently served as captain of Company A, First Indian Regiment, of the U.S. Army, dying of smallpox in 1864. A hereditary chief, he was named for another leader known as King Bowlegs (Billy Bowlegs I), who fought in the so-called Patriot War and whose town on the Suwannee River was one of Andrew Jackson's targets during the First Seminole War. The surname "Bowlegs" did not describe any physical deformity and may be a corruption of "Bowlecks," "Bolek," or "Bowles." Born near Lake Istokpoga in 1862, Billy Bowlegs III was counted in Clay MacCauley's 1880 census in family twenty-seven of the Fish Eating Creek Settlement. At age eleven, he killed his first buck, and he once shot fourteen deer in one day. He sold fresh meat to Kissimmee River steamboat captains and served as a broker of hides and as a hunting guide for many sportsmen. He learned to speak, read, and write some English, and he served as spokesman for the Seminoles so often that many people considered him a "chief." He was often asked to represent the Seminoles in parades, at festivals, and in ceremonies, and he had important friendships with James Willson and Minnie Moore-Willson, and later, Albert DeVane and Park DeVane. He died in 1965 at the age of 103 and is buried in Glades County, in the Ortona Cemetery, on State Road 78; at its intersection with U.S. 27, a historical marker commemorates him (Porter, "Billy Bowlegs in the Seminole Wars," 219–42; Porter, "Billy Bowlegs in the Civil War," 391–401; Boyd, *Florida Aflame*, 11–14; Boyd, "Events at Prospect Bluff," 71; Foreman, *Five Civilized*, 274 n. 11; Wright, *Creeks and Seminoles*, 61; Sturtevant, introduction to *Seminole Indians of Florida* by Clay MacCauley, xxxviii, xlviii; Moore-Willson, *Seminoles of Florida*, 155–62; "Dedication of Memorial"; P. DeVane, untitled presentation; Boone, 127–28).

4. Downs, *Art*, 19–22; Downs, "British Influences," 47–52; Warren, "Hamlet Rides," 48–50. One trader, James Innerarity, planned a colony of Scottish Highlanders on the Wakulla River, just south of Tallahassee. Although the War of 1812 thwarted his plans, eight years later another Scotsman, Neil McLendon, founded Euchee Village, a Scottish settlement, south of DeFuniak Springs. No one has traced the influence of this

settlement on the tribe for which it is named; however, members of the Euchee (Yuchi) Tribe fought with the Seminoles during the Second Seminole War (Wright, "Note on the First Seminole War," 571; Innerarity, "Letters," 134–36; Florida Writers' Project, *Florida*, 446; Smith, "Racial Strains," 27–28; Mahon, *Second Seminole War*, 6, 8, 212–14; McReynolds, *Seminoles*, 121). For the possible influence of the Highland costume on Seminole clothing, see chap. 2.

5. See an account of Bobby Henry thwarting an impending rainstorm in Gallagher, "Bobby Henry Cuts the Clouds," 31–33.

6. Seminole Communications, *Seminole Tribe of Florida*, i.

Chapter 1. Seminole Legends

1. This process is similar to one described in a folktale that explains how a medicine man learns chants in Capron, "Medicine Bundles," 166.

2. See origin myths in Greenlee, "Folktales," 141; Sturtevant, "Seminole Myths," 80–86; Glenn, *My Work among the Florida Seminoles*, 14; and Moore-Willson, *Seminoles of Florida*, 163. For the version attributed to Neamathla, explaining why the Seminoles declined the government's offer to educate their children, see McKenney and Hall, *Indian Tribes of North America*, 2: 266–69. For Creek versions of "The Origin of Races," see Swanton, *Myths and Tales*, 74–75.

3. Young men, vying in informal contests, burn their arms especially to create scars that will emit light for this crossing (Sturtevant, "Mikasuki Seminole," 356–59).

4. For patterns and procedures for making shirts, leggings, and moccasins, see Sturtevant, "Seminole Men's Clothing," 160–74.

5. Sturtevant, "Osceola's Coats?" 326.

6. See Greenlee, "Folktales," 138–39; Greenlee, "Ceremonial Practices," 28–29; and Sturtevant, "Mikasuki Seminole," 356–62.

7. For information about the supernatural beings known as "thunders," see Sturtevant, "Mikasuki Seminole," 424–26; and Urban and Jackson, "Mythology and Folklore," 715. In some versions of the tale "Lodge Boy and Thrown-Away," the two boys ultimately live in the sky as "Thunder and Lightning" (Greenlee, "Folktales," 141–43; Swanton, *Myths and Tales*, 2–7, 227–30).

8. Williams and Duedall, *Florida Hurricanes*, 32–33; Barnes, *Florida's Hurricane History*, 244–48.

9. Williams and Duedall, *Florida Hurricanes*, 32–33; Barnes, *Florida's Hurricane History*, 244–48.

10. The Coweta Indians, some of whom migrated to Florida and became Seminoles, used these shell vessels for their ceremonial drink, as did Florida Indians near the St. Johns River observed by the French in the sixteenth century and those living along Florida's east coast described by an Englishman in the seventeenth century (Sturtevant, "Medicine Bundles and Busks," 44; Weisman, *Unconquered People*, 8; White and LeMoyne, *The New World*, 73, 93, 115; Dickinson, *Journal*, 25).

11. As their trading post was in Pensacola, members of the Choctaw Tribe were in Florida as early as the First Seminole War, and their presence is noted at the end of the Second Seminole War (Boyd, "Events at Prospect Bluff," 76–80; Porter, "Negro Guides," 176; Sturtevant, "Chakaika," 39–40, 56; Neill, "Identity," 49–50, 53; Covington,

"Florida Seminoles in 1847," 52). See also the folktale "The Choctaw War," collected in the 1950s from the Brighton Reservation Seminoles (Evans, "Seminole Folktales," 473, 480–81).

12. A slit drum is created by hollowing out a log through a long slit down one side, leaving both ends solid. The instrument is common to many areas around the world, including Central Africa and Central America. An engraving entitled *Musical Instruments of the African Negroes* illustrating possible material culture from Fort Mosé shows two slit drums made of logs, so it is possible that escaped slaves or free blacks may have introduced such instruments to the Seminoles (Baines, *Musical Instruments*, 312; Deagan and MacMahon, *Fort Mosé*, 31).

13. For descriptions and photographs of the Big House, see Capron, "Medicine Bundles," 176 (fig. 7), plate 12 (caption on 209); and Sturtevant, "Medicine Bundles and Busks," 46 (fig. 1, photo B), 47.

14. B. Jumper, *Legends of the Seminoles*, 60.

15. Urban and Jackson note that the little people story is "widespread" in Southeastern Indian mythologies ("Mythology and Folklore," 715). See also Sturtevant, "Mikasuki Seminole," 426.

16. "The Seminole attitude toward crime is remarkably advanced. Briefly their attitude is this. It is to a man's advantage to belong to a social group, but he must pay for that advantage by conforming to the laws of that group. These laws are for the good of the group and therefore for the good of each individual of that group. And if a man breaks those laws he is acting against his own good. Therefore that man is not vicious— he is crazy" (Capron, "Medicine Bundles," 196).

17. B. Jumper, *Legends of the Seminoles*, 22–25. A summary of this portion of the tale is classified as a "Tale of Adventure" in Urban and Jackson, "Mythology and Folklore," 714–15. See also the five versions of the Creek and one version of the Hitchiti legend "The Man Who Became a Snake" in Swanton, *Myths and Tales*, 30–34, 97–98.

18. In a Seminole origin myth recorded by Louis Capron in the 1950s, the "Snake King" or "King Snake" has two horns like small deer horns ("Medicine Bundles," 168). A sacred object of the Seminole medicine bundles, this "snake horn" is also used as a hunting charm to attract deer (Sturtevant, "Medicine Bundles and Busks," 38–39; Sturtevant, "Mikasuki Seminole," 373–74; Urban and Jackson, "Mythology and Folklore," 715; Weisman, *Unconquered People*, 97). Capron notes that instead of the "Hunting Dance," the Seminoles he knows call it the "Snake Dance," which is a ritual to ensure success in hunting and to protect hunters from snakebite (Capron, "Notes," 67). In three of the five versions of the tale "The Man Who Became a Snake," the snake grows horns (Swanton, *Myths and Tales*, 32–34).

19. See Swanton, *Myths and Tales*, 154.

20. Kennedy, *Palmetto Country*, 149–50; Florida Writers' Project, *Seminole Indians*, 52.

21. Akerman, *Florida Cowman*, 1–36; Milanich, *Florida Indians*, 203; Hann and McEwan, *Apalachee Indians*, 101, 104–7, 148–50; W. Bartram, *"Travels" of William Bartram*, 117–21; MacCauley, *Seminole Indians of Florida*, 513; Jumper and West, *A Seminole Legend*, 36–37.

22. Covington, *Seminoles of Florida*, 212–13, 216–17, 246–48; Kersey, *Assumption of Sovereignty*, 15; Seminole Communications, "Grand Opening," 26.

Chapter 2. Seminole Life and Traditions

1. For the adaptation of the Seminole to the Everglades and other wilderness environments, see Goggin, "Cultural Traditions," 136–39; Freeman, introduction, ii–v; and MacCauley, *Seminole Indians of Florida*, 482–86, 499–505, 510–18. For information about the Seminoles' interaction with traders, see Kersey, *Pelts, Plumes, and Hides*.

2. For information on the Seminoles' participation in tourism, see West, *Enduring Seminoles*. On the formation of the reservations, see Covington, "Dania Reservation: 1911–1927"; and Kersey, "Private Societies." On the New Deal, see Kersey, *The Florida Seminoles and the New Deal*.

3. See Kersey, *Assumption of Sovereignty*; and Garbarino, *Big Cypress*.

4. Sturtevant, "Chakaika," 36–37; Sturtevant, "Seminole Personal Document," 69–70.

5. See prologue, note 1.

6. Sturtevant, "Creek into Seminole," 111–13; Sturtevant and Cattelino, "Florida Seminole and Miccosukee," 429. For a Mikasuki orthography, see Sturtevant, "Chakaika," 66–67; also reprinted in Neill, "Identity," 48.

7. Densmore, *Seminole Music*, 110–11.

8. Wickman, introduction to *Florida Place Names*, by William A. Read, xiii.

9. Captain Al Starts, who owned and operated the *Jungle Queen* sightseeing boat on the New River, asked Betty Mae and Moses Jumper Sr. to establish a small Seminole village that would feature alligator wrestling (West, *The Enduring Seminoles*, 23).

10. Coppinger's son, Henry Jr., has been credited with popularizing alligator wrestling. Several years before, in 1910, Warren Frazee, known as Alligator Joe, may have become the first "professional" alligator wrestler (West, *The Enduring Seminoles*, 11, 13).

11. M. Jumper Jr., *Echoes in the Wind*, 37.

12. Harry A. Kersey Jr. suggests that Seminole women created this hairstyle in response to picking crops for wages "to produce both a practical eye shade and an attractive arrangement" (*Florida Seminoles*, 119). In her introduction to the *The Seminole Indians of Florida* by the Florida Writers' Project, Ethel Cutler Freeman characterizes this style as an "adaptation to their environment" (iv–v). For instructions on how to create the coiffure, see Freeman, "We Live," 234. For a series of photographs illustrating the process, see Sturtevant and Cattelino, "Florida Seminole and Miccosukee," 440.

13. For a description of a Seminole woman donning her beads, see Densmore, *Seminole Music*, 19.

14. Abraham Clay may also be known as Abraham Lincoln, one of two Indian guides named in the first-person account of this trip by Allen H. Andrews (*Yank Pioneer*, 137–59).

15. Cory, *Hunting*, photos 4, 9; Skinner, "Across the Florida Everglades," photos 10–11; Skinner, "Florida Seminole," 156; Skinner, "Through Unknown Florida," photo 146; Kersey, *Pelts, Plumes, and Hides*, 63, 67; Densmore, *Seminole Music*, 8.

16. Betty Mae Jumper mentioned this incident in her memoir (Jumper and West, *A Seminole Legend*, 157), but Barbara Oeffner did not include it in her biography of James Billie, *Chief: Champion of the Everglades*.

17. "Some words, in both Muskogee and Mikasuki, have tonal accents; certain syllables within these words must be pronounced with a higher pitch, or else with a high pitch falling to a low one. Thus, when either Seminole language is spoken there is a sing-song effect, much less pronounced than in some Oriental languages but nevertheless audible" (Neill, *Story*, 110). See also Freeman, "Our Unique Indians," 18; and Church, "Dash through the Everglades," 26.

18. Spoehr, "Camp, Clan, and Kin," 14–16.

19. See MacCauley, *Seminole Indians of Florida*, 497; Sturtevant, "Mikasuki Seminole," 321–27; Spoehr, "Camp, Clan, and Kin," 12; Spoehr, "Florida Seminole Camp," 126; Snow and Stans, *Healing Plants*, 56–57; and Garbarino, *Big Cypress*, 69.

20. Spoehr, "Florida Seminole Camp," 126.

21. Sturtevant, "Seminole Men's Clothing," 171. Neill discounts the story that after the Seminole Wars, the women sewed ragged clothing together in decorative patterns (*Florida Seminoles*, 66). H. Davis theorizes that during World I, print material was unavailable, and the seamstress, accustomed to the patterns, designed her own ("History of Seminole Clothing," 977). Downs argues against the theory that patchwork is a modification of colonial quilting or African strip-sewing methods learned from the Seminole Maroons (*Art*, 88–89). In 1941, Deaconess Harriet M. Bedell suggested that the colorful banded liguus snails that live in the Everglades inspired the form of patchwork (Downs, *Art*, 82; H. Davis, "History of Seminole Clothing," 980). However, it may be that women were prompted to create patchwork designs by the strips of cloth sewn together for sewing machine demonstrations at the trading posts (Belland and Dyen quoted in Downs, *Art*, 89). For a chronology of patchwork designs, see Blackard, *Patchwork and Palmettos*, 45–55.

22. Kersey, *Pelts, Plumes, and Hides*, 54, 66, 137–38.

23. Seminole Indian Agency, *Seminole Indians*, 11.

24. H. Davis, "History of Seminole Clothing," 975–78; Blackard, *Patchwork and Palmettos*, 45, 50 (fig. 20). See also Densmore, *Seminole Music*, 33.

25. For details and diagrams of chickee construction, see Spoehr, "Florida Seminole Camp," 124–27.

26. The Belle Glade culture may have used such raised areas as sites for homes or gardens, in addition to other uses. However, some piles of rocks in the Everglades date from the second half of the nineteenth century, when the Seminoles first experimented in farming the flooded land (Milanich and Fairbanks, *Florida Archaeology*, 180–89; Weisman, *Unconquered People*, 77).

27. According to Nash, Guava Camp was named for the fruit grown there, and he noted the presence of other fruits "in season" (*Survey of the Seminole Indians*, 9). Clay MacCauley noted in 1880 that "the Seminole have around their houses at least a thousand banana plants. When it is remembered that a hundred bananas are not an overlarge yield for one plant, it is seen how well off, so far as this fruit is concerned, these Indians are" (*Seminole Indians of Florida*, 512). When the Seminoles lived in northern Florida, they planted sour orange trees near their house garden, so archaeologists look for this species to mark their villages (Weisman, *Unconquered People*, 108).

28. Neill, "Dugouts," 80.

29. Neill, "Sailing Vessels," 79–86; Sturtevant, "Spanish-Indian Relations," 73; Sturtevant, "Chakaika," 53; Buker, *Swamp Sailors*, 87–88; Goggin, "Seminole Negroes,"

203–4; Mulroy, "Seminole Maroons," 468. For photographs of sailing canoes by Ralph Middleton Munroe, see MacCauley, *Seminole Indians of Florida*, fig. 16; Parks, *Forgotten Frontier*, 161, 176; by Charles B. Cory, see Cory, *Hunting*, 26; and by Claude C. Matlock, see Downs, *Art*, 244 (fig. 11.5).

30. For descriptions of the variety, including painted canoes, see Densmore, *Seminole Music*, 30–32; Downs, *Art*, 243–46; and Covington, "Seminole Indians in 1908," 100. William Bartram reports dugout canoes, large enough for twenty to thirty men, that could travel to the Bahamas and Cuba (*"Travels" of William Bartram*, 143). See also Covington, "Trade Relations," 116–17; and Porter, "Negroes, 1817–1818," 277–78.

31. Weisman, *Unconquered People*, 21; Read, *Florida Place Names*, 30; Florida Cultural and Historical Programs Web site.

32. Flowers and Gallagher, "Pithlachocco."

33. In 1906, Smallwood first opened the trading post and store in his home, and later that year, he became postmaster and moved the post office there as well. The business outgrew his home in 1917, and he constructed a new building at the shoreline, and the next year, he dredged a channel to accommodate large vessels. When his rival in the region, Captain George W. Storter Jr., sold his trading post in Everglades in 1922, Smallwood's Store was truly "the major Indian trading post in Southwest Florida." Closed as a business in 1982, Smallwood's store is now a museum (Kersey, *Pelts, Plumes, and Hides*, 118–21; Ted Smallwood's Store, Inc., Web site).

34. Douglas, *Everglades*, 10–13; Read, *Florida Place Names*, 27–28.

35. Kersey, *Florida Seminoles*, 116; Stirling, *Report*, 1–2; Spoehr, "Camp, Clan, and Kin," 12–14. See also introduction, note 6 above.

36. Spoehr, "Camp, Clan, and Kin," 21–22; Tiger and Kersey, *Buffalo Tiger*, 25–27.

37. Sturtevant, "Medicine Bundles and Busks," 62.

38. Densmore, *Seminole Music*, 126–28, 162. See also Capron, "Medicine Bundles," 186–87; and Sturtevant, "Medicine Bundles and Busks," 61.

39. See Capron, "Medicine Bundles," 184–85; Sturtevant, "Medicine Bundles and Busks," 57 (fig. 3, photos A and B), 59; and Densmore, *Seminole Music*, 38–39, 45–46.

40. The "Indian Gallery" was a collection of portraits of Native Americans originally commissioned for and displayed at the War Department; they were later moved to the Smithsonian Institution. McKenney and Hall used the portraits to illustrate *Indian Tribes of North America*: opposite pp. 8, 202, 262, 320, 336, 394. The British began the practice of giving medals to leaders, distinguishing them as "Big Medal Chiefs" and "Small Medal Chiefs." The United States continued this tradition with the Seminoles, at least through the presidency of Millard Fillmore (1850–53) (J. Bartram, "Diary of a Journey," 35; Covington, "English Gifts," 72; Porter, "Founder," 376, 382; Porter, "Billy Bowlegs [Part I]," 240).

41. Sturtevant, "Seminole Men's Clothing," 170; Goggin, "Osceola," 186; Blackard, *Patchwork and Palmettos*, 36–37; W. Bartram, *"Travels" of William Bartram*, 319; Covington, "English Gifts," 72.

42. Goggin, "Osceola," 184; Coe, *Red Patriots*, 30; Downs, "British Influences," 60; Warren, "Hamlet Rides," 48–49; Wickman, *Osceola's Legacy*, 171–72. Unlike the Spanish colonies, the English settlements had to be self-supporting, so colonists pursued trading ostrich plumes and other items with the Indians as a means of gaining self-sufficiency (Boyd, "Diego Pena's Expedition," 1–2).

43. See Sturtevant, "Seminole Men's Clothing," 170.

44. For a description of this pole, see Sturtevant, "Medicine Bundles and Busks," 47; and Capron, "Medicine Bundles," 176 (fig. 7), 179 (fig. 8), 182.

45. See Capron, "Medicine Bundles," 182–83. For a photograph of sticks carved entirely of wood, including the leather lashings, see Sturtevant and Cattelino, "Florida Seminole and Miccosukee," 441 (fig. 7).

46. Neill, *Story*, 83–84, 123. For more details, see Sturtevant, "Mikasuki Seminole," 334–52; and Snow and Stans, *Healing Plants*, 59–60.

47. MacCauley, *Seminole Indians of Florida*, 520–21; Cory, *Hunting*, 11–12; Sturtevant, "Mikasuki Seminole," 338–46; Densmore, *Seminole Music*, 34–37.

48. Jumper and West, *A Seminole Legend*, 22–25. See also Skinner, "Notes on the Florida Seminole," 74; Densmore, *Seminole Music*, 10; Sturtevant, "Mikasuki Seminole," 352–54. For an account of the desecration of Tom Tiger's burial, see Moore-Willson, *Seminoles of Florida*, 151–54; Kersey, "Seminole 'Uprising' of 1907," 49–58. For the legend "Chief Tom Tiger," see Reaver, *Florida Folktales*, 53–54, 146.

49. See more on this concept in Sturtevant, "Seminole Medicine Maker," 525; and Sturtevant "Mikasuki Seminole," 110–15. See also Greenlee, "Medicine and Curing Practices," 319; Greenlee, "Ceremonial Practices," 28–29; and Capron, "Medicine Bundles," 174–75.

Chapter 3. Seminole History

1. Milanich, *Florida Indians*, 230–34. Fairbanks writes that the word *Seminoles* "derives from the Spanish *cimarrones*, applied to anything wild or untamed. The Spanish used it for the new Indian migrants to Florida because they had left their settled towns and had established themselves in wild, vacant lands" ("Ethno-Archeology" 171). On the tribes that formed the Seminole, Sturtevant writes, "The identification of the various bands present, and tracing their subsequent affiliations and movements, are major unsolved problems in Seminole history" ("Mikasuki Seminole" 69). See also Swanton, *Early History*, 398–414; Swanton, *Indian Tribes*, 139–43; Sturtevant and Cattelino, "Florida Seminole and Miccosukee," 429–32; Covington, "Migration of the Seminoles," 340–57; and Sturtevant, "Last of the South Florida Aborigines," 141–62.

2. Sturtevant, "Creek into Seminole," 111. Coker and Schafer render "Seminole" to mean "breakaways" or "pioneers" ("West Point Graduate," 450). Of the name "Seminole," Douglas writes: "The word was Muskogee to begin with; 'iste,' man, and 'semole,' free. In the poetic Indian fashion it meant 'people of distant fires.' At worst, to the contemptuous white man, it meant 'outlaw' or 'runaway.' But the people most accurately known as Seminole preferred to speak of themselves as 'Ikaniuksalgi,' 'the people of the peninsula'" (*Everglades*, 185). See also MacCauley, *Seminole Indians of Florida*, 509. Symptomatic of the dislike for the name is a poetic translation recorded by Ethel Cutler Freeman on a Big Cypress Reservation in 1942: "Men who love freedom as do the birds and deer. People who love nature, not cities" ("Our Unique Indians," 15). For a "synonymy," by Jack B. Martin, see Sturtevant and Cattelino, "Florida Seminole and Miccosukee," 448–49.

3. Florida State University, University Communications Web site.

4. Sturtevant, "Creek into Seminole," 93–98; Fairbanks, *Ethnohistorical Report*, 259–65; Kersey, *Assumption of Sovereignty*, 176; Swanton, *Indian Tribes*, 156–57. For a

classification of the linguistic groups of the Southeastern Indian tribes, see Swanton, *Early History*, 11.

5. MacCauley, *Seminole Indians of Florida*, 477–78; Covington, *Seminoles of Florida*, 156; Sturtevant, "Creek into Seminole," 113.

6. Porter, "Negroes, 1817–1818," 249–80; Porter, "Negroes, 1811–1813," 9–29; Peters, *Florida Wars*, 11–12, 18; Littlefield, *Africans and Seminoles*, 6–7; Rivers, *Slavery in Florida*, 189–92; Giddings, *Exiles of Florida*, 57; Sturtevant and Cattelino, "Florida Seminole and Miccosukee," 432. For the treatment of the three wars as a single conflict, see Peters, *Florida Wars*; Knetsch, *Florida's Seminole Wars*; and Missall and Missall, *Seminole Wars*.

7. Brown, "Race Relations," 299–304; Rivers, *Slavery in Florida*, 13, 203–5, 219; Porter, "Florida Slaves," 404; Porter, "John Caesar," 190–207; Porter, "Three Fighters," 56, 61–63; Mahon, *Second Seminole War*, 196; Sprague, *Origin, Progress*, 486; Giddings, *Exiles of Florida*, 314. Meltzer also identifies the greed for slaves and land as "the root of the conflict that led to America's longest, bloodiest, and most costly Indian war" (*Hunted Like a Wolf*, 40).

8. Porter, "Billy Bowlegs (Part I)," 230–40; Foreman, *Five Civilized Tribes*, 274–75; Covington, *Billy Bowlegs War*, 80; Mahon, *Second Seminole War*, 326; Stirling, *Report*, 3. Mahon writes: "The government itself rarely bothered to declare war on Indians: it simply moved militarily against them; nor did it usually take the trouble to conclude a war with a formal peace treaty. Treaties following combat were often instruments of land cession in which peace was only casually referred to" ("Indian–U.S. Military Situation, 1775–1848," 162).

9. Weisman, *Like Beads*, 164; MacMahon and Marquardt, *Calusa and Their Legacy*, 147; Mahon, *Second Seminole War*, 325–26.

10. At least as early as 1838, Florida governor Richard Keith Call suggested the establishment of military colonies as a way to defeat the Seminoles. Senator Thomas Benton of Missouri sponsored such a bill in 1839, and Congress debated it for three years before passing it in 1842: "Here was the precedent for homestead donations of public land, the direct forebear of the Homestead Act of twenty years later"(Mahon, *Second Seminole War*, 313–14). Knetsch notes that in July 1841, almost a year before the passage of the act, Colonel Worth promised "rations" to settlers driven from their land by the war who were willing to return to their former possessions or to establish new homesteads. He ordered his troops to assist the colonists by clearing land as well as building block houses or reclaiming abandoned forts as the center of their settlements (*Florida's Seminole Wars*, 134–40). Mahon, *Second Seminole War*, 321–27; Buker, *Swamp Sailors*, 138–39; Landreth, *Sherman*, 8.

11. Fairbanks, *Florida Seminole People*, 26.

12. Harris to Gibson, December 28, 1835, quoted in Boyd, *Florida Aflame*, 71–72.

13. Sprague, *Origin, Progress*, 225; Myer, "Indian Trails," foldout map insert in Bierer, *Indians and Artifacts*, between pages 338 and 339. For an account of building this road, see McCall, *Letters*, 183–99. In 1963, researchers hiked the old roadway that crosses and recrosses Route 301 from Tampa to Ocala. They concluded that the street called the Fort King Road, starting just west of Zephyrhills and proceeding north to Dade City, is not the historic highway (Goza, "The Fort King Road," 52–70).

14. See Ellis Hughes Papers, 1836–1861. The sketch is also reproduced in McIver, *Dreamers*, 161.

15. Also known as Arpeika, Abayaca, Apiaca, and Abiaka, Sam Jones was an elderly, white-haired medicine man. McCall notes that because he sold fish to the soldiers at Fort Brooke in 1823 before the war, the sutler nicknamed him Sam Jones, "as the embodiment of the myth celebrated at that time in New York in a low ballad." At first, he favored emigration from Florida, signing the Treaty of Payne's Landing in 1837, but after Coacoochee told of his capture and escape, Sam Jones opposed "removal" so much so that he did not believe in communicating with the U.S. Army and prevented others from so doing. He was with the warriors in the Battle of Okeechobee. Although he was an old man, he remained in Florida at the conclusion of the Third Seminole War in 1858. Willie Johns, a member of the Seminole Tribe, has characterized him as a symbol of "our successful struggle. . . . From beginning to end, Abiaca was the spiritual foundation of our resistance" (Sturtevant and Cattelino, "Florida Seminole and Miccosukee," 434; McCall, *Letters*, 412; Sprague, *Origin, Progress*, 74–76, 213, 219–20, 295, 512; Mahon, *Second Seminole War*, 127–28, 204, 227–28; Covington, *Billy Bowlegs War*, 16, 20, 82; Motte, *Journey into Wilderness*, 285–86, 310 n. 5, 312 n.6; Johns, "Reflections").

16. Mahon, *Second Seminole War*, 176; Motte, *Journey into Wilderness*, 226–29; Buker, *Swamp Sailors*, 29–31. For the first-person account of John W. B. Thompson, the assistant lighthouse keeper, see Brookfield, "Cape Florida Light," 5–12.

17. Potter, *War in Florida*, 41.

18. Laumer, *Massacre!* 6–7, 36, 136; Laumer, *Dade's Last Command*, 41, 55–57, 182–85.

19. Laumer, *Massacre!* 137–46, 141–46; Laumer, *Dade's Last Command*, 187–95.

20. Alligator was captured by soldiers in March 1838 and held at Fort Brooke before he was transported to the Indian Territory. During his confinement, he related through a translator an account of the preparation for and the Dade Battle itself to Second Lieutenant John T. Sprague, who first published Alligator's account in *The Florida War*. Although the paragraph about the celebration after the attack follows the story quoted from Alligator, it is not attributed to him. Sprague describes Alligator as about forty years old, a skilled hunter, with a "knowledge of the country" and talent for warfare that "made him a dangerous foe" and "the most shrewd, crafty, politic, and intelligent chief of the Seminole nation." Many historians credit Alligator, also known as Halpatter Tustenuggee, as the mastermind of the Dade Battle, who urged Micanopy, as the Seminole "chief," to fire the first shot, which may have killed Dade. Three days later at the Withlacoochee River, he fought with Osceola and 250 warriors against the forces under Generals Clinch and Call (see *Withlacoochee Surprise*, chap. 3). In 1838, he and John Horse surrendered, and he was transported to the Indian Territory. In 1841, he led a Seminole delegation that returned to Florida to convince other Seminoles to emigrate (Sprague, *Origin, Progress*, 90–93, 97–98, 204–6, 213, 330–31, 352–53; Mahon, *Second Seminole War*, 127, 227–28; Rivers and Brown, "Indispensable Man," 12–15; Foreman, *Indian Removal*, 378).

21. The Seminoles may have worn military clothing as "one expression of the warrior trophy complex, in which trophy scalps, heads, or other body parts or possessions of the enemy were displayed." Archaeologists have discovered military buttons in "Seminole burial and domestic contexts" dating from the Second Seminole War. "Although

the buttons may have originated as trade goods," more likely they are from military clothing valued and worn by the Seminoles (Weisman, "Archaeological Perspectives," 308–11).

22. Arguably one of the most famous Seminoles, Osceola is an enigma. Although researchers have worked diligently to document his life, the record contains many contradictions and omissions. Perhaps born in Alabama around 1804, he moved to Florida with his mother, a Creek woman who had previously been married to William Powell, a white trader. Osceola was often called by his stepfather's surname in contemporary documents; however, based on his experience with Native North Americans, George Catlin called him "a full-blooded and wild Indian." His adult Indian name is Osceola, an anglicization of Asiyaholi. Milanich writes: "Asi is likely from *assi*, the Creek word for 'black drink,' a sacred tea brewed from the leaves of the yaupon holly; *yaholi* is the name of a Creek deity intoned at the time black drink was served. Asiyaholi, or Osceola, might be translated as Black Drink Singer." Not a hereditary chief, Osceola urged the Seminoles to resist removal; consequently, he drew a large following of Seminole Maroons who also wanted to fight for their freedom. Indian Agent General Wiley Thompson once imprisoned Osceola for his impudence, and Thompson's murder was seen as Osceola's revenge. He also killed Charley Emathla, a Seminole chief who had agreed to removal, and he later liberated those gathered for removal near Fort Brooke who had signed the Treaty of Fort Dade in March 1837. (Osceola did not sign.) About six months later, he became a folk hero when he was captured, under a flag of truce, by General Jesup and confined with others in St. Augustine's Castillo de San Marcos, renamed Fort Marion. After some escaped, Osceola and others were transferred to Fort Moultrie, South Carolina, where he died of complications of malaria. The surgeon who attended Osceola made a death mask of his face and removed his head before the corpse was buried (Coe, *Red Patriots*, 29–30; Coe, "Parentage and Birthplace," 304–11; Boyd, "Asi-Yahola," 249–305; Porter, "Osceola and the Negroes," 235–39; Catlin, *Letters and Notes*, 219–20; Milanich, "Osceola's Head," 48–53; Ward, "Disappearance," 193–201). See also the "Osceola Double Number" of the *Florida Historical Quarterly*; and Wickman, *Osceola's Legacy*. Betty Mae Jumper told Guy that Osceola belonged to the Alligator Clan, and Sturtevant concurs ("Notes on Modern Seminole Traditions," 206–7).

23. When the U.S. Army—actually a group of surveyors—did locate Osceola's camp in 1837, it had been abandoned. One of those surveyors, Lieutenant Henry Prince, kept a diary, and descriptions of the location in his field notes helped archaeologists to discover the site in the 1980s (Prince, *Storm of Bullets*, 92–93; Weisman, *Like Beads*, 131–48). Osceola's town should not be confused with "a Negro village in the Panosufkee Swamp" where troops discovered Osceola in January 1837, nor the Seminole village near Fort King that may have been his mother's "camp" (Porter, "Osceola and the Negroes," 237; Neill, "The Site," 240–46).

24. Charles L. Norton, *A Handbook of Florida*, 232; Read, *Florida Place Names*, 41; Henderson, "Withlacoochee," 73–76.

25. Laumer, "Encounter," 322–27, 330–31; Mahon, *Second Seminole War*, 107–8; Sprague, *Origin, Progress*, 92; Bemrose, *Reminiscences*, 40–43; Cohen, *Notices of Florida*, 82–83; Cobb, "Florida Militia," 132–33.

26. Laumer, "Encounter," 327–30; Mahon, *Second Seminole War*, 109; Bemrose, *Reminiscences*, 48; Cobb, "Florida Militia," 134; Boyd, *Florida Aflame*, 82.

27. Laumer, "Encounter," 328–29; Mahon, *Second Seminole War*, 109; Bemrose, *Reminiscences*, 48–49.

28. Sprague, *Origin, Progress*, 93; Mark F. Boyd speculates that Osceola may have worn Dade's coat (*Florida Aflame*, 79, 104). The force under General Edmund P. Gaines that came to bury the victims of Dade's battle found many bodies undisturbed except for having been relieved of their guns and ammunition. McCall, who was with Gaines, noted that shirt and coat were missing from Dade's corpse (Laumer, "Encounter," 331 n. 25; McCall, *Letters*, 304).

29. Osceola's "death mask" is a plaster cast of his head and shoulders made after his death. Goggin, "Osceola," 168–79; Milanich, "Osceola's Head," 49–50; Wickman, *Osceola's Legacy*, 102, 154–62, 182–84.

30. Boyd, "Asi-Yaholo," 265–66; Goggin, "Osceola," 176–79; Coe, *Red Patriots*, 26–30; Motte, *Journey into Wilderness*, 140–41.

31. Colonel John H. Sherburne, "a self-styled secret agent," concocted a scheme that he claimed would quickly end the war. According to his plan, as the troops camped each evening, a balloonist could ascend and reconnoiter the Indian's position by tracking their fires. General Walker Keith Armistead rejected the scheme as impracticable (Schene, "Ballooning," 480–82; Mahon, *Second Seminole War*, 288–89).

32. During the War of 1812, Lieutenant Colonel Edward Nichols of the British Army built a fort on the east bank of the river, about thirty miles north of its mouth. After the Treaty of Ghent ended the war, the British abandoned the fortification to the African Americans and Native Americans who had served as British allies. In 1816, a lucky hot shot hit the powder magazine and destroyed the fort, killing or injuring all but two of 334 people inside (Giddings, *Exiles of Florida*, 32–45; Wright, "Note on the First Seminole War," 569–70; Boyd, "Events at Prospect Bluff," 71–81; Gadsen, "Defenses of the Floridas," 243–44; Coe, *Red Patriots*, 16–19; Porter, "Negroes, 1817–1818," 259–64).

33. Reduced from the voluminous manuscript, Monk's essay "Christmas Day in Florida, 1837" was published in *Tequesta* in 1978.

34. Cohen, *Notices of Florida*, 173n; Boyd and Latorre, "Spanish Interest," 94–95; Hammond, "Spanish Fisheries," 359; Buker, *Swamp Sailors*, 35–36.

35. Steele, *Battle of Okeechobee*, 42; A. DeVane, "A Letter"; Presley, "Most Decisive War."

36. Steele, *Battle of Okeechobee*, 17–18.

37. Ibid., 18–20; Sprague, *Origin, Progress*, 203–13; Mahon, *Second Seminole War*, 229–30. Knetsch explains that U.S. Army officers disliked the volunteers because they were "ill-trained and undisciplined," did not eat fixed rations, and supplied their own mounts and nonstandard equipment. "Militia forces cost on average about four times that of regular soldiers and were limited by law to only three months' service at any time" (*Florida's Seminole Wars*, 112).

38. Steele, *Battle of Okeechobee*, 18; Sprague, *Origin, Progress*, 213–14.

39. Johns, "Reflections."

40. Many of those who participated in the Florida War describe in detail conditions harmful to their health. Missall and Missall note that "during the summer, the Seminoles did not have to wage war upon the whites; the unhealthy Florida environment

killed more soldiers than Indian rifles ever could" (*Seminole Wars*, 115). Knetsch also notes that disease was "the greatest killer in Florida" (*Florida's Seminole Wars*, 113).

41. In his journal "Travels in Georgia and Florida," William Bartram noted that the Indians used oil-nut, *Pyrularia pubera*, to attract deer (141, 180). Densmore wrote that wild tobacco, *Nicotiana rustica*, was "carried by hunters to attract game" or "as a charm for success in hunting" (*Seminole Music*, 29, 31). See also chap. 1, n. 18; and the section "Hunting Magic" in Sturtevant, "Mikasuki Seminole," 371–75.

42. Created for San Francisco's 1915 Panama-Pacific International Exposition, the eighteen-foot plaster statue "received the exposition's gold medal for sculpture." Fraser hoped it would be cast in bronze and installed at Presidio Point on San Francisco Bay; however, his dream was lost in material shortages during World War I. In 1920, the city of Visalia, California, placed the statue in Mooney Park, where it remained until 1968, when it was acquired by the National Cowboy and Western Heritage Museum in Oklahoma City. The restored original plaster statue is now on display (National Cowboy and Western Heritage Museum Web site).

43. Johns, "Reflections."

44. For similar incidents, see Motte, *Journey into Wilderness*, 134; Sherman, *Memoirs*, 23–24; and Sprague, *Origin, Progress*, 293.

45. Heir of Cowkeeper, the Seminole Chief whom William Bartram encountered in 1774 on Payne's Prairie near Gainesville, Micanopy was honored by having a town, founded by white men, named for him in 1820. In 1823, he signed the Treaty of Fort Moultrie. Three years later, he joined a delegation of six other Seminole leaders on a trip to Washington, D.C., to request (among other items) additional reservation land. Two months later, Indian Agent Gad Humphreys convinced the Indians to hold an election to unite under a single leader, and Micanopy lost the election to John Hicks (Tukose Emathla), although after Hicks's death, Micanopy succeeded him. Various observers described Micanopy as middle-aged (thirty-five to fifty years), short, fat, lazy, and a "stupid fool," and his name supposedly means "Pond Governor" because he enjoyed watching his cattle drink in a pond. His indolence is credited for his reluctance to engage in war, although he claimed to be against removal. In 1837, his presence as a hostage was Article 10 of the capitulation or Treaty of Fort Dade in which the Seminoles agreed to removal from Florida; however, warriors liberated him and several hundred others encamped at Fort Brooke awaiting transport to Indian Territory. In December of that year, a Cherokee delegation escorted Micanopy and other Seminole leaders into Fort Mellon under a flag of truce to negotiate with General Jesup. He seized them, and they were held captive first in Fort Marion and then in Fort Moultrie, South Carolina. In 1838, Micanopy was transported to Indian Territory and died there ten years later (Porter, "Cowkeeper Dynasty," 341–49; Boyd, "Dexter," 67; Sprague, *Origin, Progress*, 20–22, 84–85, 97, 177–78; Mahon, *Second Seminole War*, 62–63, 75, 125–27, 204, 223; Foreman, *Indian Removal*, 328–29; Foreman, *Five Civilized Tribes*, 257; McCall, *Letters*, 148, 152–56; Pickell, "Journals," 162–63; Mulroy, *Freedom*, 47).

46. Goggin, "Osceola," 185; Catlin, *Letters and Notes*, 221.

47. Catlin, *Letters and Notes*, 220 and plate 300. Claiming Coacoochee as a member of her tribe in Oklahoma, Susan A. Miller acknowledges that her twenty-five years of research were inspired a story about Coacoochee, one of only two tales that her family

retains from the time before they were removed from Florida, and her uncle's saying that Coacoochee was related to her (ii, iv, xi).

48. Forry, "Letters," 89; Sprague, *Origin, Progress*, 324.

49. For accounts of the dance, see Forry, "Letters," 88–89; Motte, *Journey into Wilderness*, 282 n. 7; and Mahon, *Second Seminole War*, 225.

50. Sprague, *Origin, Progress*, 98, 219–21, 324–27; Motte, *Journey into Wilderness*, 134–35; Porter, "Seminole Flight," 113–33; Porter, *Black Seminoles*, 74, 84; Miller, *Coacoochee's Bones*, 196.

51. Faragher, *Daniel Boone*, 64; Sprague, *Origin, Progress*, 323.

52. Sewn of woolen cloth—red in most museum specimens—the pouches are generally square, decorated with fringe at the bottom, and closed with a triangular flap. They are suspended on nearly four-inch-wide sashes decorated with beaded embroidery, usually a repetition of a geometric design, and they are lobed or fringed where attached to the pouch. The sash is worn over the shoulder, crossing the chest and back, so the pouch is easily accessed by one hand (Goggin, "Beaded Shoulder Pouches," 49–63). According to Blackard, a majority "had designs differing on the front and back portion of the strap" (*Patchwork and Palmettos*, 32).

53. For the origin of this nickname, see the prologue.

54. Simmons, *Notices*, 77; Laxson, "Historic Seminole Burial," 113–17; Weisman, *Like Beads*, 85–92. See also *Last to Leave*, chap. 2.

55. McCall, *Letters*, 396.

56. Ibid., 380, 386.

57. For the evolution of the Seminole turban and its "unknown origins," see Sturtevant, "Seminole Men's Clothing," 165 (fig. 8), 170–71. For how the "bonnet" worn by Scottish Highlanders may have influenced the turban, see Downs, "British Influences," 60; and Warren, "Hamlet Rides," 48–49.

58. Cubberly, "Fort King," 152; Laumer, "Fort Dade," 10–11; Preble, "Canoe Expedition," 41, 43; "Recollections," 75, 79; Meek, "Journal," 316; Mahon, *Second Seminole War*, 160–61; Ott, "Fort King," 36–38; Neill, "Site," 245; Will, "Historians Locate."

59. Mahon, *Second Seminole War*, 249–51; Sprague, *Origin, Progress*, 227–28.

60. Ober, "Ten Days," 17. See also chap. 1, n. 18; and chap. 3, n. 41.

61. For one version of the name's origin, see Douglas, *Voice*, 190–91.

62. Inspired by Walter Lord's *A Time to Stand*, about the defenders of the Alamo, Frank Laumer wrote *Massacre!* about the Dade Battle, after five years of research (vii, ix). He continued his research, and twenty-five years later, he published *Dade's Last Command*, which John K. Mahon characterizes, in his foreword to the book, as "the definitive account of the march and annihilation of Maj. Francis Dade's column of 108 men in December 1835. . . . It embodies impeccable research, and as far as the historical record makes it possible, every detail of the action is perfectly accurate" (xi).

63. Motte, *Journey*, 145–46.

64. Although he could not identify the specific American and European models, Sturtevant notes that the early forms of clothing for both Seminole men and women are "paralleled not only elsewhere in the Southeast but also among such groups as the Winnebago and Menomini [Indian tribes in Wisconsin]—they must have copied the same frontier styles at the same period. But once adopted, these garments evolved independently among the Seminole until very recent years." Although the kind of cloth

available from traders changed through the years, and the sewing machine transformed some elements, the clothing style developed "without direct outside influence" until the 1920s, when Seminole men began wearing trousers ("Seminole Men's Clothing," 171).

65. Covington, *Seminoles of Florida*, 106; Foreman, *Indian Removal*, 383; Mahon, *Second Seminole War*, 243. Also, Wright notes: "Contemporary reports and folk tradition describe how Indian mothers smothered babies to keep them from disclosing their whereabouts" and includes an account from the August 19, 1838, issue of the *Mobile Daily Commercial Register* of soldiers finding Seminole children with mudgrass stuffed into their mouths and nostrils because they could not keep up with the fleeing Seminoles (*Creeks and Seminoles*, 259, 346 n. 29).

66. Simmons, *Notices*, 67. See also MacCauley, *Seminole Indians*, 491–92; Spoehr, "Camp, Clan, and Kin," 21. Weisman suggested that the quantity and quality of grave goods buried with children also reveal extraordinary parental affection (*Like Beads*, 89).

67. The article "Indian Murders: *Florida Herald*, May 29, 1840" is also reprinted in the April 1930 issue of the *Florida Historical Quarterly*.

68. Sprague, *Origin, Progress*, 259; Mahon, *Second Seminole War*, 285–86; Warren, "Hamlet Rides," 38, 44.

69. *Cyrano de Bergerac*; *Fire over England*.

70. Warren, "Hamlet Rides," 46–52.

71. Sprague, *Origin, Progress*, 259.

72. McCall, *Letters*, 163–65. See also the possible influence of this story on American folklore in Porter, "Davy Crockett and John Horse," 10–15. John Horse may also have been known as Peace Creek John (Rivers and Brown, "Indispensable Man," 5; Rivers, *Slavery*, 201; Porter, *Black Seminoles*, 76).

73. Porter, *Black Seminoles*, 138–39, 142–44; Porter, "Wild Cat's Death," 41–43; Miller, *Coacoochee's Bones*, 127, 139–43, 149.

74. Porter, *Black Seminoles*, 178, 196, 221–25; Porter, "Farewell to John Horse," 265–69; Goggin, "The Mexican Kickapoo," 238–41. For a brief biography of John Horse, see Porter, "Seminole Flight," 133 n. 7; Porter, "Thlonoto-sassa," 118.

75. Miller, *Coacoochee's Bones*, 193–97.

76. Sprague writes, "King Phillip, the father of Coacoochee or Wild Cat, was a good-natured, sensible Indian; his age, which was about sixty, and his royal blood, attached to him some importance" (*Origin, Progress*, 98). George Catlin painted his portrait (*Ee-mat-la, King Phillip*, plate 300) when the king was imprisoned in Fort Moultrie (*Letters and Notes*, 220).

77. Tillis was a veteran of the Second Seminole war, so revenge may have motivated the attack; other veterans were also targets (Covington, *Billy Bowlegs War*, 49–51; Covington, "An Episode in the Third Seminole War," 53–58; Tillis, "Original Narratives," 179–87). For Calvert Hamilton's recollection of the narrative of J. Dallas Tillis, Willoughby's son, see McKay, *Pioneer Florida*, 574–75.

78. See Porter, "Florida Slaves," 390–421; Porter, "Negroes, 1835–1842," 427–50; Mulroy, "Seminole Maroons," 465–77; Rivers, *Slavery in Florida*, 189–209; Rivers, "Troublesome Property," 114–27. For details of the lives of African Americans under Spanish rule, see Deagan and MacMahon, *Fort Mosé*; Landers, "Traditions," 17–41; Landers, "Spanish Sanctuary," 296–313; Landers, "Free and Slave," 167–82. For information about

blacks during the two decades of British government, see Schafer, "Yellow Silk Ferret," 71–103; and Wright, "Blacks in British," 425–42. For a discussion of terminology, see Coe, *Red Patriots*, 14–16; Mulroy, *Freedom*, 1–5; and Sturtevant, "Review," 916–17.

79. Simmons, *Notices*, 75; McReynolds, *The Seminoles*, 48; Porter, *Black Seminoles*, 5; Porter, "Florida Slaves," 390–97; Porter, "Negroes, 1835–1842," 427–35.

80. McCall, *Letters*, 160; Simmons, *Notices*, 76; Mulroy, "Seminole Maroons," 465. See also Porter, "Negroes, 1835–1842," 427–50; Porter, *Black Seminoles*, 6–7, 38–107; and Rivers, *Slavery*, 193–97.

81. Once a slave owned by Dr. Sierra in Pensacola, Abraham served Micanopy as an interpreter and was granted his freedom for his service to a Seminole delegation to Washington, D.C., in 1825–26. Seemingly in support of emigration, he interpreted for the Treaties of Payne's Landing and of Fort Gibson; however, as "sense-bearer" or "counselor" he influenced Micanopy to resist removal, secured gun powder, and encouraged St. Johns River plantation slaves to join the fight. Always open to negotiations, he wanted either a reservation in Florida or emigration with a guarantee that blacks would not be reenslaved. In 1837, at the Treaty of Fort Dade, General Jesup promised the Seminoles that "their negroes, their bona fide property, shall accompany them to the West." Later, he promised freedom to Abraham and his family—and threatened his life if he did not cooperate—so Abraham urged Micanopy and others to emigrate (Porter, "The Negro Abraham," 1–43).

82. Luis Pacheco said that he was born in 1800 on Francis Philip Fatio's plantation, thirty miles west of St. Augustine. Fluent in English, Spanish, and French, he also learned "Seminole" from a brother who lived with the Indians for twenty years. In 1824, he ran away from his young master, Lewis Fatio, to the Spanish fisheries on the Gulf coast. Found there, he was taken to Tampa, and—at his request—sold to Colonel Brooke, commanding officer of the fort named for him. Afterward, he was sold again, and again, and finally to Antonio Pacheco, who took him to Sarasota Bay. After Antonio's untimely death, his widow—living in Tampa—hired him to Colonel Belton as an interpreter, and he was sent with Dade's command from Fort Brooke to Fort King. Although not usually listed as one of the survivors of Dade's command, he outlived the others. Pacheco remained with the Seminoles, being removed with them west of the Mississippi, in 1841. Some say Jumper—others Coacoochee—claimed him as a slave, but he relates that the "agent of Indian affairs" in New Orleans told him he was free. For several years, he lived with the Seminoles in Indian Territory, and in 1849, he was purchased with other slaves by the agent of Indian affairs, who moved them first to Van Buren, Arkansas, and then in 1852, to Austin, Texas. He resided there for forty years. In 1892, he returned to Jacksonville, Florida, seeking asylum with Mrs. John L'Engle, (formerly Susan Philippa Fatio, daughter of his first master), who had taught him to read and write English (Porter, "Three Fighters," 65–72; Laumer, *Massacre!* 169–70; Laumer, *Dade's Last Command*, 241–43; Pacheco's account quoted in McKay, *Pioneer Florida*, 479–81; Boyd, *Florida Aflame*, 105–9).

83. Goggin, "Osceola," 182–83; see also Blackard, *Patchwork and Palmettos*, 25–30.

84. Turner, *Florida Railroads*, 12–32; MacCauley, *Seminole Indians*, 490.

85. Turner, *Florida Railroads*, 132, 137.

Chapter 4. Florida Wildlife

1. President Theodore Roosevelt designated, by executive order, three small Florida offshore islands as a "preserve and breeding grounds for native birds." Additional lands were also acquired (Florida State Parks Web site). In 1915, thanks to Florida Federated Woman's Clubs, Royal Palm State Park became Florida's first state park. During the Great Depression, the Civilian Conservation Corps developed many state parks (D. Nelson, "'Improving' Paradise," 96–97).

2. Covington, *Seminoles of Florida*, 216; Kersey, *Florida Seminoles*, 78–79, 85–86, 89–90, 95–96, 109–13; Tebeau, *They Lived in the Park*, 31–32; Robertson, *Everglades*, 83.

3. J. Davis, "Marjory Stoneman Douglas," 309. Florida's land acquisition programs include Environmentally Endangered Lands (EEL); Conservation and Recreational Lands (CARL); Save Our Coast (SOC); Save Our Rivers (SOR); Preservation 2000; and Florida Forever (Florida Department of Environmental Protection Web site).

4. Meindl, "Water, Water Everywhere," 129–32.

5. "This tiny crossroads community . . . eighteen miles west of Fort Lauderdale . . . got its start in 1947 as a coffee-serving shack. It grew slightly by adding a gas station, motel, restaurant and bars. In 1963, Andytown incorporated, but in 1979 was doomed to be bulldozed to make room for a freeway interchange. It no longer appears on maps" (Speck Publications, *Ghost Town*).

6. G. Nelson, *Trees of Florida*, 5.

7. Kennedy, *Palmetto Country*, 235–38; Florida Writers' Project, *Seminole Indians*, 72; Covington, *Seminoles of Florida*, 213–14.

8. Guy knows the route to Solomon's Castle in southwestern Hardee County because he often visits its creator, Howard Solomon, an artist, sculptor, and author. He fashioned the castle with "aluminum siding" created from offset printing plates discarded by a newspaper in nearby Wauchula, and much of his art is created from junk he has found or that people have given him. Decorated with eighty interpretive stained glass windows, the castle, Solomon's home, galleries, and workshops are open to the public (Grimes and Becnel, *Florida Curiosities*, 99–101).

9. Maehr and Kale, *Florida's Birds*, 54.

10. Beginning in a swamp in Georgia, the Aucilla creates the border between Jefferson and Taylor counties and a tidal marsh at the Gulf of Mexico, which is part of the St. Mark's National Wildlife Refuge (Shukovsky, "Aucilla," 63–66).

11. Ducks Unlimited Web site.

12. G. Nelson, *Ferns of Florida*, 127–28; Bell and Taylor, *Florida Wild Flowers*, 45–46.

13. Originating in Lake Hancock, the Peace River flows more than one hundred miles to Charlotte Harbor, through Polk, Hardee, DeSoto, and Charlotte counties. Perhaps as many as fifty thousand people canoe the river annually, probably without realizing that the phosphate industry has prospered by mining the riverbed and surrounding areas for more than a century. The beauty of its wooded banks is cleared in some places and replanted in citrus groves or cattle pasture (O'Donnell, "Peace," 51–54).

14. Color variations distinguish the Florida wild turkey, "found only on the peninsula of Florida," from the eastern wild turkey. "The wild turkeys in Southwest Florida are the

same species as those across America, but because of their regional differences, they are recognized as a separate subspecies: Osceola's wild turkey (*Meleagris gallopavo osceola*). The name was bestowed to honor the Seminole leader who adapted well enough in South Florida landscapes to successfully evade his enemies" (National Wild Turkey Federation Web site; Jackson, "Big Bird," 17).

15. In 1980, Peter Octave Caron (1939–2005) cofounded Octagon Wildlife Sanctuary and Rehabilitation Center, a nonprofit charitable organization. At first, he and his father saved animals native to Florida, but soon they began to rescue "lions, tigers, and bears." Now located in Charlotte County, the center's mission is "to create habitat—for abused, abandoned, injured and orphaned wildlife—resplendent with lush vegetation to produce a more comfortable environment for both the animal inhabitant and the visitor." Tours of the facility emphasize environmental education, prevention of animal cruelty, and conservation (Octagon Wildlife Center Web site).

16. Founded in 1941 by Richard Archbold, Archbold Biological Station had its own power and water plants and a main building with living quarters and seven work units. Although other structures, such as a garage, existed, Archbold added more, including several cottages. At first reserved for scientific research and tutorials by the staff of the American Museum of Natural History, to which Archbold belonged, the facility was opened to other researchers in 1944. Since then, the station has developed a scientific library, acquired additional land, and preserved extensive biological collections of insects, birds, and plants. The station hosts symposia, meetings, and workshops for scientists, as well as tours and educational programs for students and adults (Morse, *Archbold Biological Station*, 34–72).

Bibliography

Akerman, Joe A., Jr. *Florida Cowman: A History of Florida Cattle Raising*. Kissimmee, Fla.: Florida Cattlemen's Association, 1976.

Andrews, Allen H. *A Yank Pioneer in Florida: Recounting the Adventures of a City Chap Who Came to the Wilds of South Florida in the 1890's and Remained to Grow Up with the Country*. Jacksonville, Fla.: Douglas Printing, 1950.

Baines, Anthony. *The Oxford Companion to Musical Instruments*. New York: Oxford University Press, 1992.

Barnes, Jay. *Florida's Hurricane History*. Chapel Hill: University of North Carolina Press, 1998.

Bartram, John. "Diary of a Journey through the Carolinas, Georgia, and Florida, 1765–66." Annotated by Francis Harper. *Transactions of the American Philosophical Society*, n.s., 33, pt. 1. Philadelphia: American Philosophical Society, 1942.

Bartram, William. "Travels in Georgia and Florida 1773–74: A Report to Dr. John Fothergill." Annotated by Francis Harper. *Transactions of the American Philosophical Society*, n.s., 33, pt. 2. Philadelphia: American Philosophical Society, 1942.

———. *The "Travels" of William Bartram*. Naturalist's Edition. Edited with commentary and an annotated index by Francis Harper. Athens: University of Georgia Press, 1998.

Bell, C. Ritchie, and Bryan J. Taylor. *Florida Wild Flowers and Roadside Plants*. Chapel Hill, N.C.: Laurel Hill Press, 1982.

Bemrose, John. *Reminiscences of the Second Seminole War*. Edited with an introduction and postscript by John K. Mahon. Seminole Wars Historic Foundation Contribution No. 3. Tampa, Fla.: University of Tampa Press, 2001.

Bierer, Bert W. *Indians and Artifacts in the Southeast*. Columbia, S.C.: Bierer, 1980.

Blackard, David M. *Patchwork and Palmettos: Seminole-Miccosukee Folk Art since 1820: An Exhibition Sponsored by the Fort Lauderdale Historical Society*. Fort Lauderdale, Fla.: Fort Lauderdale Historical Society, 1990.

Boone, Floyd E. *Florida Historical Markers and Sites: A Guide to More Than 700 Historic Sites: Includes the Complete Text of Each Marker*. Houston, Tex.: Gulf, 1988.

Boyd, Mark F. "Asi-Yaholo or Osceola." *Florida Historical Quarterly* 33, nos. 3–4 (January–April 1955): 249–305.

———. "Diego Pena's Expedition to Apalachee and Apalachicolo in 1716." *Florida Historical Quarterly* 28, no. 1 (July 1949): 1–27.

———. "Events at Prospect Bluff on the Apalachicola River, 1808–1818: An Introduction to Twelve Letters of Edmund Doyle, Trader." *Florida Historical Quarterly* 16, no. 2 (October 1937): 55–96.

———. *Florida Aflame: The Background and Onset of the Seminole War, 1835*. Tallahassee: Florida Board of Parks and Historic Memorials, n.d. Reprinted from *Florida Historical Quarterly* 30, no. 1 (July 1951): 3–115.

———. "Horatio S. Dexter and Events Leading to the Treaty of Moultrie Creek with the Seminole Indians." *Florida Anthropologist* 11, no. 3 (September 1958): 65–95.

Boyd, Mark F., and Jose N. Latorre. "Spanish Interest in British Florida and in the Progress of the American Revolution." *Florida Historical Quarterly* 32, no. 2 (October 1953): 92–130.

Brookfield, Charles M. "Cape Florida Light." *Tequesta* 9 (1949): 5–12.

Brown, Canter, Jr. "Race Relations in Territorial Florida, 1821–1845." *Florida Historical Quarterly* 73, no. 3 (January 1995): 287–307.

Buker, George E. *Swamp Sailors in the Second Seminole War*. Gainesville: University Press of Florida, 1997.

Capron, Louis. "The Medicine Bundles of the Florida Seminole and the Green Corn Dance." Bureau of American Ethnology Bulletin No. 151. Washington, D.C.: Government Printing Office, 1953: 155–210. In Sturtevant, *Seminole Sourcebook*.

———. "Notes on the Hunting Dance of the Cow Creek Seminole." *Florida Anthropologist* 9 nos. 3–4 (December 1956): 67–78.

Catlin, George. *Letters and Notes on the Manners, Customs, and Conditions of the North American Indians*. Vol. 2. London, 1844. Reprint, New York: Dover, 1973.

Church, Alonzo. "A Dash through the Everglades." Edited with an introduction by Watt P. Marchman. *Tequesta* 9 (1949): 13–41.

Cobb, Samuel E. "The Florida Militia and the Affair at Withlacoochee." *Florida Historical Quarterly* 19, no. 2 (October 1940): 128–39.

Coe, Charles H. "The Parentage and Birthplace of Osceola." *Florida Historical Quarterly* 17, no. 4 (April 1939): 304–11. Edited as "The Parentage of Osceola" in *Florida Historical Quarterly* 33, nos. 3–4 (January–April 1955): 202–5.

———. *Red Patriots: The Story of the Seminoles*. Facsimile reproduction of the 1898 edition with an introduction by Charlton W. Tebeau. Bicentennial Floridiana Facsimile Series. Gainesville: University Presses of Florida, 1974.

Cohen, Myer M. *Notices of Florida and the Campaigns*. Facsimile reproduction of the 1836 edition with introduction by O. Z. Tyler Jr. Quadricentennial Edition of the Floridiana Facsimile and Reprint Series. Gainesville: University of Florida Press, 1964.

Coker, Edward C., and Daniel L. Schafer, eds. "A West Point Graduate in the Second Seminole War: William Warren Chapman and the View from Fort Foster." *Florida Historical Quarterly* 63, no. 1 (July 1964): 447–75.

Colburn, David R., and Jane L. Landers, eds. *The African American Heritage of Florida*. Gainesville: University Press of Florida, 1995.

Cory, Charles B. *Hunting and Fishing in Florida, Including a Key to the Water Birds Known to Occur in the State*, 2nd ed. Boston: Estes and Lauriat, 1896. See preface and "The Seminole Indians," 3–40. In Sturtevant, *Seminole Sourcebook*.

Covington, James W. *The Billy Bowlegs War: 1855–1858, The Final Stand of the Seminoles against the Whites*. Chuluota, Fla.: Mickler House, 1982.

———. "Dania Reservation: 1911–1927." *Florida Anthropologist* 29, no. 4 (December 1976): 137–44.

———. "English Gifts to the Indians: 1765–1766." *Florida Anthropologist* 13, nos. 2–3 (September 1960): 71–75.

———. "An Episode in the Third Seminole War." *Florida Historical Quarterly* 45, no. 1 (July 1966): 45–59.

———. "The Florida Seminoles in 1847." *Tequesta* 24 (1964): 49–57.

———. "Migration of the Seminoles into Florida, 1700–1820." *Florida Historical Quarterly* 46, no. 4 (April 1968): 340–57.

———. "The Seminole Indians in 1908." *Florida Anthropologist* 26, no. 3 (September 1973): 99–104.

———. *The Seminoles of Florida*. Gainesville: University Press of Florida, 1993.

———. "Trade Relations between Southwestern Florida and Cuba, 1600–1840." *Florida Historical Quarterly* 38, no. 2 (October 1959): 114–28.

Cubberly, Fred. "Fort King." *Florida Historical Quarterly* 5, no. 3 (January 1927): 139–52.

Cyrano de Bergerac. Movie based on the 1897 play by French poet Edmond Rostand. Directed by Michael Gordon. Starring José Ferrer, Mala Powers, and William Prince. United Artists, 1950.

Davis, Hilda J. "The History of Seminole Clothing and Its Multi-colored Designs." *American Anthropologist* 57 (1955): 974–80.

Davis, Jack E. "'Conservation Is Now a Dead Word': Marjory Stoneman Douglas and the Transformation of American Environmentalism." In J. Davis and Arsenault, *Paradise Lost?* 297–325.

Davis, Jack E., and Raymond Arsenault, eds. *Paradise Lost? The Environmental History of Florida*. Gainesville: University Press of Florida, 2005.

Deagan, Kathleen, and Darcie MacMahon. *Fort Mosé: Colonial America's Black Fortress of Freedom*. Gainesville: University Press of Florida/Florida Museum of Natural History, 1995.

"Dedication of Billy Bowlegs Memorial, Feb. 19, 1966." In Albert DeVane, *DeVane's Early Florida History*, n.p.

Densmore, Frances. *Seminole Music*. Bureau of American Ethnology Bulletin No. 161. Washington, D.C.: Government Printing Office, 1956. Reprint, New York: DeCapo Press, 1972.

DeVane, [George] Albert. *DeVane's Early Florida History*. Vol. 2. Sebring, Fla.: Sebring Historical Society, 1978.

———. "A Letter to Mr. J. Floyd Monk." N.d. In Albert DeVane, *DeVane's Early Florida History*, n.p.

DeVane, Park Trammel. Untitled presentation to the Peace River Valley Historical

Society, Zolfo Springs, February 1965. In Albert DeVane, *DeVane's Early Florida History*, n.p.

Dickinson, Jonathan. *Jonathan Dickinson's Journal or, God's Protecting Providence: Being the Narrative of a Journey from Port Royal in Jamaica to Philadelphia between Aug. 23, 1696 and Apr. 1, 1697.* Edited by Evangeline Walker Andrews and Charles McLean Andrews, with a foreword and new introduction by Leonard W. Labaree. Port Salerno, Fla.: Florida Classics Library, 1985.

Douglas, Marjory Stoneman. *The Everglades: River of Grass.* Illustrated by Robert Fink. Rivers of America series. New York: Rinehart, 1947.

———. *Voice of the River: An Autobiography by Marjory Stoneman Douglas.* With John Rothchild. Sarasota, Fla.: Pineapple Press, 1987.

Downs, Dorothy. *Art of the Florida Seminole and Miccosukee Indians.* Gainesville: University Press of Florida, 1995.

———. "British Influences on Creek and Seminole Men's Clothing, 1733–1858." *Florida Anthropologist* 33, no. 2 (June 1980): 46–65.

Ducks Unlimited. "Ducks Unlimited: Leader in Wetlands Conservation Fact Sheet." April 2006. www.ducks.org/aboutdu.

Evans, Hedvig Tetens, ed. "Seminole Folktales." *Florida Historical Quarterly* 56, no. 4 (April 1978): 473–94.

Fairbanks, Charles H. "The Ethno-Archeology of the Florida Seminole." In Milanich and Proctor, *Tacachale*, 163–93.

———. *Ethnohistorical Report on the Florida Indians.* Commission Findings, Indian Claims Commission. *Florida Indians III.* A Garland Series. American Indian Ethnohistory: Southern and Southeast Indians, compiled and edited by David Agee Horr. New York: Garland, 1974.

———. *The Florida Seminole People.* Phoenix, Ariz.: Indian Tribal Series, 1973.

Faragher, John Mack. *Daniel Boone: The Life and Legend of an American Pioneer.* New York: Henry Holt, 1992.

Fire over England. Movie based on a novel by A.E.W. Mason. Directed by William Howard and Alexander Korda. Starring Flora Robson, Raymond Massey, Leslie Banks, Laurence Olivier, Vivien Leigh. United Artists, 1937.

Florida Cultural and Historical Programs, Florida Department of State. "Newnan's Lake Canoes." http://dhr.dos.state.fl.us/archaeology/projects/canoes.

Florida Department of Environmental Protection. "State Lands Acquisition History." www.dep.state.fl.us/lands/acquisition/P2000/BACKGRND.htm.

Florida State Parks. "Matlacha Pass National Wildlife Refuge." www.stateparks.com/matlacha_pass.html.

Florida State University, University Communications. "The Florida State Seminoles: A Tradition of Tribute: A Seminole Timeline at Florida State University." http://unirel.fsu.edu/seminoles/pages/timeline.html.

Florida Writers' Project. *Florida: A Guide to the Southernmost State.* Compiled and written by the Federal Writers' Project of the Work Projects Administration for the State of Florida. The American Guide Series. New York: Oxford University Press, 1939.

———. *The Seminole Indians in Florida.* Compiled by workers of the Writers' Program

of the Works Project Administration in the State of Florida. Tallahassee: Florida State Department of Agriculture, 1941.

Flowers, Charles, and Peter B. Gallagher. "Pithlachocco: 'Extraordinary Find.'" *Seminole Tribune*, October 20, 2000. www.seminoletribe.com/tribune/canoe/find.shtml.

Fogelson, Raymond D., ed. *Southeast*. Vol. 14 of *Handbook of North American Indians*. Edited by William C. Sturtevant. Washington, D.C.: Smithsonian Institution, 2004.

Foreman, Grant. *The Five Civilized Tribes: Cherokee, Chickasaw, Choctaw, Creek, Seminole*. Introductory note by John R. Swanton. Norman: University of Oklahoma Press, 1934.

———. *Indian Removal: The Emigration of the Five Civilized Tribes of Indians*. 1932. Norman: University of Oklahoma Press, 1953.

Forry, Samuel. "Letters of Samuel Forry, Surgeon U.S. Army, 1837–1838. Part III." *Florida Historical Quarterly* 7, no. 1 (July 1928): 88–105.

Freeman, Ethel Cutler. Introduction to Florida Writers' Project, *The Seminole Indians of Florida*, i–viii.

———. "Our Unique Indians, the Seminoles of Florida." *American Indian* 2, no. 2 (Winter 1944–45): 14–28.

———. "We Live with the Seminoles." *Natural History* 49 (April 1942): 226–36.

Gadsden, James. "The Defenses of the Floridas: Report of Captain James Gadsden to General Jackson, 1818." Edited by Mark F. Boyd. *Florida Historical Quarterly* 25, no. 4 (April 1937): 242–49.

Gallagher, Peter B. "Bobby Henry Cuts the Clouds." *Forum: The Magazine of the Florida Humanities Council* 31, no. 1 (Spring 2007): 30–33.

Garbarino, Merwyn S. *Big Cypress: A Changing Seminole Community*. Prospect Heights, Ill.: Waveland Press, 1972.

Giddings, Joshua R. *The Exiles of Florida: or, the Crimes committed by our Government against the Maroons, who fled from South Carolina and other Slave States, seeking Protection under Spanish Laws*. Facsimile reproduction of the 1858 edition, with an introduction by Arthur W. Thompson. Quadricentennial Edition of the Floridiana Facsimile and Reprint Series. Gainesville: University of Florida Press, 1964.

Glenn, James Lafayette. *My Work among the Florida Seminoles*. Edited with an introduction by Harry A. Kersey Jr. Gainesville: University Presses of Florida, 1982.

Goggin, John M. "Beaded Shoulder Pouches of the Florida Seminole." *Florida Anthropologist* 4, nos. 1–2 (May 1951): 2–17. In Goggin, *Indian and Spanish Selected Writings*, 49–63.

———. "Cultural Traditions in Florida Prehistory." In Goggin, *Indian and Spanish Selected Writings*, 108–39.

———. *Indian and Spanish Selected Writings*. Coral Gables, Fla.: University of Miami Press, 1964.

———. "The Mexican Kickapoo Indians." *Southwestern Journal of Anthropology* 7, no. 3 (Autumn 1951): 314–27. In Goggin, *Indian and Spanish Selected Writings*, 238–52.

———. "Osceola: Portraits, Features, and Dress." *Florida Historical Quarterly* 33, nos. 3–4 (January–April 1955): 161–92.

———. "The Seminole Negroes of Andros Island, Bahamas." *Florida Historical Quarterly* 24, no. 3 (January 1946): 201–6.

Goza, William M. "The Fort King Road—1963." *Florida Historical Quarterly* 43, no. 1 (July 1964): 52–70.

Greenlee, Robert F. "Ceremonial Practices of the Modern Seminoles." *Tequesta* 1, no. 2 (August 1942): 25–33.

———. "Folktales of the Florida Seminole." *Journal of American Folklore* 58, no. 228 (April–June 1945): 138–44.

———. "Medicine and Curing Practices of the Modern Florida Seminoles." *American Anthropologist* n.s., 46 (1944): 317–28.

Grimes, David, and Tom Becnel. *Florida Curiosities: Quirky Characters, Roadside Oddities, and Other Offbeat Stuff.* Curiosities Series. Guilford, Conn.: Globe Pequot Press, 2003.

Hammond, E. A. "The Spanish Fisheries of Charlotte Harbor." *Florida Historical Quarterly* 51, no. 4 (April 1973): 355–80.

Hann, John H., and Bonnie G. McEwan. *The Apalachee Indians and Mission San Luis.* Gainesville: University Press of Florida, 1998.

Henderson, Rex. "Withlacoochee." In Marth and Marth, *Rivers of Florida*, 73–76.

Hughes, Ellis. Papers, 1836–61. Tampa Manuscript Collection. Special Collections, University of South Florida.

Hutchinson, James. "Painting among the Seminoles." *American Artist* 30, no. 4 (April 1966): 52–57, 77–81.

"Indian Murders: *Florida Herald*, May 29, 1840." *Florida Historical Quarterly* 8, no. 4 (April 1930): 200–203.

Innerarity, James. "Letters of James Innerarity: The War of 1812." *Florida Historical Quarterly* 10, no. 3 (January 1932): 134–38.

Jackson, Jerome A. "Bad Times for the Big Bird?" *WGCU Public Media Expressions* 7, no. 2 (November 2007): 17–18.

Johns, Willie. "Reflections: Reflections on the Battle of Okeechobee." In *The Battle of Okeechobee, Feb. 2nd and 3rd, 2008.* Commemorative edition program. n.p.

Jumper, Betty Mae. *Legends of the Seminoles as told by Betty Mae Jumper with Peter B. Gallagher.* Illustrated by Guy LaBree. Sarasota, Fla.: Pineapple Press, 1994.

Jumper, Betty Mae Tiger, and Patsy West. *A Seminole Legend: The Life of Betty Mae Tiger Jumper.* Gainesville: University Press of Florida, 2001.

Jumper, Moses, Jr. *Echoes in the Wind: Seminole Indian Poetry of Moses Jumper, Jr.* Boca Raton, Fla.: Boca Raton Printing, 1990.

Kennedy, Stetson. *Palmetto Country.* American Folkways. New York: Duell, Sloan, and Pearce, 1942.

Kenny, Colin. "The Legend of Florida Artist Guy LaBree: Painter of the Seminole." Special insert to the *Seminole Tribune*, January 19, 2001.

Kersey, Harry A., Jr. *An Assumption of Sovereignty: Social and Political Transformation among the Florida Seminoles, 1953–1979.* Lincoln: University of Nebraska Press, 1996.

———. "Educating the Seminole Indians of Florida, 1879–1970." *Florida Historical Quarterly* 49, no. 1 (July 1970): 16–35.

———. "Federal Schools and Acculturation among the Florida Seminoles, 1927–1954." *Florida Historical Quarterly* 59, no. 2 (October 1980): 165–81.

———. *The Florida Seminoles and the New Deal 1933–1942*. Boca Raton: Florida Atlantic University Press, 1989.

———. *Pelts, Plumes, and Hides: White Traders among the Seminole Indians, 1870–1930*. Gainesville: University Presses of Florida, 1975.

———. "Private Societies and the Maintenance of Seminole Tribal Integrity, 1899–1957." *Florida Historical Quarterly* 56, no. 3 (January 1978): 297–316.

———. *The Seminole and Miccosukee Tribes: A Critical Bibliography*. Bloomington: Indiana University Press, 1987.

———. "The Seminole 'Uprising' of 1907." *Florida Anthropologist* 27, no. 2 (June 1974): 49–58.

Knetsch, Joe. *Florida's Seminole Wars: 1817–1858*. The Making of America series. Charleston, S.C.: Arcadia, 2003.

Koven, Ellen. *Florida through the Eyes of Guy LaBree: July 8–Aug. 2*. Fine Arts Program pamphlet. DeLand, Fla.: Big Empire of America Federal Savings Bank, 1985.

Landers, Jane L. "Free and Slave." In *The New History of Florida*, edited by Michael Gannon, 167–82. Gainesville: University Press of Florida, 1996.

———. "Spanish Sanctuary: Fugitives in Florida, 1687–1790." *Florida Historical Quarterly* 62, no. 3 (January 1984): 296–313.

———. "Traditions of African American Freedom and Community in Spanish Colonial Florida." In Colburn and Landers, *African American Heritage*, 17–41.

Landreth, Marsha. *William T. Sherman*. Great American Generals series. New York: Gallery Books, 1990.

Laumer, Frank. *Dade's Last Command*. Foreword by John K. Mahon. Gainesville: University of Press of Florida, 1995.

———. "Encounter by the River." *Florida Historical Quarterly* 46, no. 4 (April 1968): 322–39.

———. *Massacre!* Gainesville: University of Florida Press, 1968.

———. "This Was Fort Dade." *Florida Historical Quarterly* 45, no. 1 (July 1966): 1–11.

Laxson, D. D. "A Historic Seminole Burial in a Hialeah Midden." *Florida Anthropologist* 7, no. 4 (December 1954): 110–18.

Littlefield, Daniel F., Jr. *Africans and Seminoles: From Removal to Emancipation*. Contributions in Afro-American and African Studies No. 32. Westport, Conn.: Greenwood Press, 1977.

MacCauley, Clay. *The Seminole Indians of Florida*. With an introduction by William C. Sturtevant. Southeastern Classics in Archaeology, Anthropology, and History. Gainesville: University Press of Florida, 2000.

MacMahon, Darcie A., and William H. Marquardt. *The Calusa and Their Legacy: South Florida People and Their Environments*. Gainesville: University Press of Florida, 2004.

Maehr, David S., and Herbert W. Kale II. *Florida's Birds: A Field Guide and Reference*. 2nd ed. Sarasota, Fla.: Pineapple Press, 2005.

Mahon, John K. *History of the Second Seminole War 1835–1842*. Rev. ed. Gainesville: University of Florida Press, 1985.

———. "Indian–United States Military Situation, 1775–1848." In *History of Indian-White Relations*, edited by Wilcomb E. Washburn, 144–62, vol. 4 of *Handbook*

of North American Indians, edited by William C. Sturtevant. Washington, D.C.: Smithsonian Institution, 1988.

Marth, Del, and Marty Marth, eds. *The Rivers of Florida*. Sarasota, Fla.: Pineapple Press, 1990.

McCall, George Archibald. *Letters from the Frontiers*. Facsimile reproduction of the 1868 edition with introduction and index by John K. Mahon. Bicentennial Floridiana Facsimile Series. Gainesville: University Presses of Florida, 1974.

McIver, Stuart B. *Dreamers, Schemers and Scalawags: The Florida Chronicles*. Vol. 1. Sarasota, Fla.: Pineapple Press, 1994.

McKay, D. B., ed. *Pioneer Florida*. Vol. 2. Tampa, Fla.: Southern, 1959.

McKenney, Thomas L., and James Hall. *The Indian Tribes of North America: With Biographical Sketches and Anecdotes of the Principal Chiefs*. Vol. 2. New edition edited by Frederick Webb Hodge and David I. Bushnell Jr. Edinburgh: John Grant, 1934.

McReynolds, Edwin C. *The Seminoles*. Norman: University of Oklahoma Press, 1957.

Meek, Alexander Beaufort. "The Journal of A. B. Meek and the Second Seminole War, 1836." Edited by John K. Mahon. *Florida Historical Quarterly* 38, no. 4 (April 1960): 302–18.

Meindl, Christopher F. "Water, Water Everywhere." In J. Davis and Arsenault, *Paradise Lost?* 113–37.

Meltzer, Milton. *Hunted Like a Wolf: The Story of the Seminole War*. Sarasota, Fla.: Pineapple Press, 1972.

Milani, Joanne. "Area Artists Shine in Sarasota Exhibit." *Sarasota Herald-Tribune*, "Bay Life" section, July 28, 1994.

Milanich, Jerald T. *Florida Indians and the Invasion from Europe*. Gainesville: University Press of Florida, 1995.

———. "Osceola's Head: Close Encounters with a Famed Seminole Chief." *Archaeology* 57, no. 1. (January–February 2004): 48–53.

Milanich, Jerald T., and Charles H. Fairbanks. *Florida Archaeology*. New York: Academic Press, 1980.

Milanich, Jerald T., and Samuel Proctor, eds. *Tacachale: Essays on the Indians of Florida and Southeastern Georgia during the Historic Period*. Gainesville: University Presses of Florida, 1978.

Miller, Susan A. *Coacoochee's Bones: A Seminole Saga*. Lawrence: University Press of Kansas, 2003.

Missall, John, and Mary Lou Missall. *The Seminole Wars: America's Longest Indian Conflict*. Gainesville: University Press of Florida, 2004.

Monk, J. Floyd. "Christmas Day in Florida, 1837." *Tequesta* 38 (1978): 5–38.

Moore-Willson, Minnie. *The Seminoles of Florida*. New York: Moffat, Yard, 1920.

Morse, Roger A. *Richard Archbold and the Archbold Biological Station*. Gainesville: University Press of Florida, 2000.

Motte, Jacob Rhett. *Journey into Wilderness: An Army Surgeon's Account of Life in Camp and Field during the Creek and Seminole Wars 1836–1838*. Edited by James F. Sunderman. Gainesville: University of Florida Press, 1963.

Mulroy, Kevin. *Freedom on the Border: The Seminole Maroons in Florida, the Indian Territory, Coahuila, and Texas*. Lubbock: Texas Tech University Press, 1993.

———. "Seminole Maroons." In Fogelson, *Southeast*, 14: 465–77.

Myer, William E. "Indian Trails of the Southeast." 1923. In *42nd Annual Report of the Bureau of American Ethnology to the Secretary of the Smithsonian, 1924–1925*. Washington, D.C.: Government Printing Office, 1928. Map reprinted in Bierer, *Indians and Artifacts in the Southeast*, between 338 and 339.

Nash, Roy. *Survey of the Seminole Indians of Florida*. 71st Cong., 3rd sess., S. Doc. 314 [Serial 9347], 1931. In Sturtevant, *Seminole Sourcebook*.

National Cowboy and Western Heritage Museum. "The End of the Trail." www.nationalcowboymuseum.org/g_trai.html.

National Wild Turkey Federation. "Florida Wild Turkey." www.nwtf.org/all_about_turkeys/history_florida_wild_turkey.html.

Neill, Wilfred T. "Dugouts of the Mikasuki Seminole." *Florida Anthropologist* 6, no. 3 (September 1953): 77–84.

———. "The Identity of Florida's 'Spanish Indians.'" *Florida Anthropologist* 8, no. 2 (June 1955): 43–57.

———. "Sailing Vessels of the Florida Seminole." *Florida Anthropologist* 9, nos. 3–4 (December 1956): 79–86.

———. "The Site of Osceola's Village in Marion County, Florida." *Florida Historical Quarterly* 33, nos. 3–4 (January–April 1955): 240–46.

———. *The Story of Florida's Seminole Indians*. 2nd ed. St. Petersburg, Fla.: Great Outdoors, 1976.

Nelson, Dave. "'Improving' Paradise: The Civilian Conservation Corps and Environmental Change in Florida." In J. Davis and Arsenault, *Paradise Lost?* 92–112.

Nelson, Gil. *The Ferns of Florida: A Reference and Field Guide*. Sarasota, Fla.: Pineapple Press, 2000.

———. *The Trees of Florida: A Reference and Field Guide*. Sarasota, Fla.: Pineapple Press, 1994.

Norton, Charles L. *A Handbook of Florida With Forty-Nine Maps and Illustrations*. 3rd ed., revised. New York, 1982. Quoted in Read, *Florida Place Names*.

Ober, Frederick A. "Ten Days with the Seminoles." *Appleton's Journal of Literature, Science and Art* 14 (July 31–August 7, 1875): 142–44, 171–73.

Octagon Wildlife Sanctuary and Rehabilitation Center. "History and Mission of Octagon." www.octagonwildlife.org.

O'Donnell, Brian. "Peace." In Marth and Marth, *Rivers of Florida*, 51–54.

Oeffner, Barbara. *Chief: Champion of the Everglades: A Biography of Seminole Chief James Billie*. Palm Beach, Fla.: Cape Cod Writers, 1995.

"Osceola Double Number." *Florida Historical Quarterly* 33, nos. 3–4 (January–April 1955).

Ott, Eloise R. "Fort King: A Brief History." *Florida Historical Quarterly* 46, no. 1 (July 1967): 29–38.

Parks, Arva Moore. *The Forgotten Frontier: Florida through the Lens of Ralph Middleton Munroe*. Rev. ed. Miami, Fla.: Centennial Press, 2004.

Peters, Virginia Bergman. *The Florida Wars*. Hamden, Conn.: Shoe String Press, 1979.

Pickell, John. "The Journals of Lieutenant John Pickell, 1836–37." Edited by Frank L. White Jr. *Florida Historical Quarterly* 38, no. 2 (October 1959): 142–71.

Porter, Kenneth W. "Billy Bowlegs (Holata Micco) in the Seminole Wars (Part I)." *Florida Historical Quarterly* 45, no. 3 (January 1967): 219–42.

———. "Billy Bowlegs (Holata Micco) in the Civil War (Part II). *Florida Historical Quarterly* 45, no. 4 (April 1967): 391–401.

———. *The Black Seminoles: History of a Freedom-Seeking People*. Revised and edited by Alcione M. Amos and Thomas P. Senter. Gainesville: University Press of Florida, 1996.

———. "The Cowkeeper Dynasty of the Seminole Nation." *Florida Historical Quarterly* 30, no. 4 (April 1952): 341–49.

———. "Davy Crockett and John Horse: A Possible Origin of the Coonskin Story." *American Literature* 15, no. 1 (March 1943): 10–15.

———. "Farewell to John Horse: An Episode of Seminole Negro Folk History." *Phylon* 8, no. 3 (3rd quarter 1947): 265–73.

———. "Florida Slaves and Free Negroes in the Seminole War, 1835–1842." *Journal of Negro History* 28, no. 4 (October 1943): 390–421.

———. "The Founder of the 'Seminole Nation' Secoffee or Cowkeeper." *Florida Historical Quarterly* 27, no. 4 (April 1949): 362–84.

———. "John Caesar: Seminole Negro Partisan." *Journal of Negro History* 31, no. 2 (April 1946): 190–207.

———. "The Negro Abraham." *Florida History Quarterly* 25, no. 1 (July 1946): 1–43.

———. "Negro Guides and Interpreters in the Early Stages of the Seminole War, Dec. 28, 1835–Mar. 6, 1837." *Journal of Negro History* 35, no. 2 (April 1950): 174–82.

———. "Negroes and the East Florida Annexation Plot, 1811–1813." *Journal of Negro History* 30, no. 1 (January 1945): 9–29.

———. "Negroes and the Seminole War, 1817–1818." *Journal of Negro History* 36, no. 3 (July 1951): 249–80.

———. "Negroes and the Seminole War, 1835–1842." *Journal of Southern History* 30, no. 4 (November 1964): 427–50.

———. "Osceola and the Negroes." *Florida Historical Quarterly* 33, nos. 3–4 (January–April 1955): 235–39.

———. "Seminole Flight from Fort Marion." *Florida Historical Quarterly* 22, no. 3 (January 1944): 113–33.

———. "Thlonoto-sassa: A Note on an Obscure Seminole Village of the Early 1820s." *Florida Anthropologist* 13, no. 4 (December 1960): 115–19.

———. "Three Fighters for Freedom." *Journal of Negro History* 28, no. 1 (January 1943): 51–72.

———. "Wild Cat's Death and Burial." *Chronicles of Oklahoma* 21 (1943): 141–43.

Porter, Woodburne. *The War in Florida*. March of America Facsimile series. Ann Arbor, Mich.: University Microfilms International, 1966.

Preble, George Henry. "A Canoe Expedition into the Everglades in 1842." Reprinted from *United Service: A Quarterly Review of Military and Naval Affairs* (April 1883): 358–76, in *Tequesta* 5 (January 1946): 30–51.

Presley, Bill. "Most Decisive War Fought on Banks of Okeechobee." *Okeechobee (Fla.) News*, June 8, 1962. In DeVane, *DeVane's Early Florida History*, n.p.

Prince, Henry. *Amidst a Storm of Bullets: The Diary of Lt. Henry Prince in Florida,*

1836–1842. Edited by Frank Laumer. Foreword by John K. Mahon. Tampa, Fla.: University of Tampa Press, 1998.

Read, William A. *Florida Place Names of Indian Origin and Seminole Personal Names*. Baton Rouge: Louisiana State University Press, 1934. Reprinted with introduction by Patricia Riles Wickman. Tuscaloosa: University of Alabama Press, 2004.

Reaver, J. Russell, ed. *Florida Folktales*. Gainesville: University of Florida Press, 1987.

"Recollections of a Campaign in Florida." *Yale Literary Magazine* 11 (December 1845–January 1846): 72–80, 130–37.

Rivers, Larry Eugene. *Slavery in Florida: Territorial Days to Emancipation*. Gainesville: University Press of Florida, 2000.

———. "A Troublesome Property: Master-Slave Relations in Florida, 1821–1865." In Colburn and Landers, *African American Heritage*, 114–27.

Rivers, Larry E., and Canter Brown Jr. "'The Indispensable Man': John Horse and Florida's Second Seminole War." *Journal of the Georgia Association of Historians* 18 (1997): 1–23.

Robertson, William B., Jr. *Everglades—The Park Story*. Coral Gables, Fla.: University of Miami Press, 1959.

Schafer, Daniel L. "'Yellow Silk Ferret Tied Round Their Wrists': African Americans in British East Florida, 1763–1784." In Colburn and Landers, *African American Heritage*, 71–103.

Schene, Michael G. "Ballooning in the Second Seminole War." *Florida Historical Quarterly* 55, no. 4 (April 1977): 480–83.

Seminole Communications. "Grand Opening of the Seminole Hard Rock Hotel and Casino." Commemorative issue of the *Seminole Tribune*, May 4, 2004.

———. *Seminole Tribe of Florida Celebrating 50 Years, 1957–2007, of the Signing of Our Constitution and Corporate Charter*. Edited by Virginia Mitchell. Hollywood, Fla.: Seminole Communications, 2007.

Seminole Indian Agency. *The Seminole Indians of Florida*. United States Indian Service "Indian Life Reader." Fort Myers, Fla.: Seminole Indian Agency, 1948.

Sherman, William Tecumseh. *Memoirs of General W. T. Sherman*. 1875. New York: Library of America, 1990.

Shukovsky, Paul. "Aucilla." In Marth and Marth, *Rivers of Florida*, 63–66.

Simmons, William Hayne. *Notices of East Florida*. Facsimile reproduction of the 1822 edition, with introduction and index by George E. Buker. Bicentennial Floridiana Facsimile Series. Gainesville: University of Florida Press, 1973.

Skinner, Alanson B. "Across the Florida Everglades." *Agwi Steamship News* 7, no. 10 (October 1915): 5–11. In Sturtevant, *Seminole Sourcebook*.

———. "The Florida Seminole." *Southern Workman* 40 (1911): 154–63. In Sturtevant, *Seminole Sourcebook*.

———. "Notes on the Florida Seminole." *American Anthropologist* 15 (1913): 63–77. In Sturtevant, *Seminole Sourcebook*.

———. "Through Unknown Florida." *Harvard Illustrated Magazine* 12 (1911): 141–46. In Sturtevant, *Seminole Sourcebook*.

Smith, Rhea M. "Racial Strains in Florida." *Florida Historical Quarterly* 11, no. 1 (July 1932): 16–32.

Snow, Alice Micco, and Susan Enns Stans. *Healing Plants: Medicine of the Florida Seminole Indians*. Gainesville: University Press of Florida, 2001.

Speck, Gary B., Publications. *Ghost Town USA's Guide to the Ghost Towns of Florida, "The Sunshine State."* http://freepages.history.rootsweb.ancestry.com/~gtusa/usa/fl.htm.

Spoehr, Alexander. "Camp, Clan, and Kin among the Cow Creek Seminole of Florida." *Anthropological Series, Field Museum of Natural History* 33, no. 1 (August 2, 1941): 7–27. In Sturtevant, *Seminole Sourcebook*.

———. "The Florida Seminole Camp." *Anthropological Series, Field Museum of Natural History* 33, no. 3 (December 25, 1944): 117–50. In *Publications of Field Museum of Natural History*, Anthropological Series No. 33. Chicago: Kraus Reprint Company, 1976.

Sprague, John T. *The Origin, Progress, and Conclusion of the Florida War*. Facsimile reproduction of the 1848 edition with introduction by John K. Mahon. Quadricentennial Edition of the Floridiana Facsimile and Reprint Series. Gainesville: University of Florida Press, 1964.

Steele, Willard. *The Battle of Okeechobee*. Edited by Robert S. Carr. Archaeology and Historical Conservancy. Miami, Fla.: Florida Heritage Press, 1987.

Stirling, Gene. *Report on the Seminole Indians of Florida*. Washington, D.C.: Office of Indian Affairs, Applied Anthropological Unit, 1936. In Sturtevant, *Seminole Sourcebook*.

Sturtevant, William C. "Accomplishments and Opportunities in Florida Indian Ethnology." In *Florida Anthropology*, edited by Charles H. Fairbanks, 15–55. Florida Anthropological Society Publications No. 5. Florida State University, Department of Anthropology, *Notes in Anthropology*, vol. 2. Tallahassee, 1958.

———. "Chakaika and the 'Spanish Indians': Documentary Sources Compared with Seminole Tradition." *Tequesta* 13 (1953): 35–73.

———. "Creek into Seminole." In *North American Indians in Historical Perspective*, edited by Eleanor Burke Leacock and Nancy Oestreich Lurie, 92–128. New York: Random House, 1971.

———. "The Last of the South Florida Aborigines." In Milanich and Proctor, *Tacachale*, 141–62.

———. "The Medicine Bundles and Busks of the Florida Seminole." *Florida Anthropologist* 7, no. 2 (June 1954): 31–70. In Sturtevant, *Seminole Sourcebook*.

———. "The Mikasuki Seminole: Medical Beliefs and Practices." Ph.D. diss., Yale University, 1954. Facsimile by University Microfilms International, Ann Arbor, Mich., 1984.

———. "Notes on Modern Seminole Traditions of Osceola." *Florida Historical Quarterly* 33, nos. 3–4 (January–April 1955): 206–17.

———. "Osceola's Coats?" *Florida Historical Quarterly* 34, no. 4 (April 1956): 315–28.

———. Review of *Africans and Seminoles: From Removal to Emancipation*, by Daniel F. Littlefield Jr. *American Anthropologist*, n.s., 81, no. 4 (December 1979): 916–17.

———. "A Seminole Medicine Maker." In *In the Company of Man: Twenty Portraits of Anthropological Informants*, edited by Joseph B. Casagrande, 505–32. New York: Harper Torchbooks, 1960.

———. "Seminole Men's Clothing." *Proceedings of the 1966 Annual Spring Meeting of*

the *American Ethnological Society*, 160–74. Seattle: University of Washington Press, 1967. In Sturtevant, *Seminole Sourcebook*.

———. "Seminole Myths of the Origin of Races." *Ethnohistory* 10, no. 1 (Winter 1963): 80–86.

———. "A Seminole Personal Document." *Tequesta* 16 (1956): 55–75.

———. "Spanish-Indian Relations in Southeastern North America." *Ethnohistory* 9, no. 1 (Winter 1962): 41–94.

———, ed. Introduction to 2000 edition of *The Seminole Indians of Florida* by Clay MacCauley.

———, ed. *A Seminole Sourcebook*. New York: Garland, 1985.

Sturtevant, William C., and Jessica R. Cattelino. "Florida Seminole and Miccosukee." In Fogelson, *Southeast*, 14: 429–49.

Swanton, John R. *Early History of the Creek Indians and Their Neighbors*. Bureau of American Ethnology Bulletin No. 73. Washington, D.C.: Government Printing Office, 1922.

———. *Indian Tribes of North America*. Bureau of American Ethnology Bulletin No. 145. Washington, D.C.: Government Printing Office, 1952. Reprinted in Bierer, *Indians and Artifacts in the Southeast*, 398–567.

———. *Myths and Tales of the Southeastern Indians*. Bureau of American Ethnology Bulletin No. 88. Washington, D.C.: Government Printing Office, 1929. Reprint, with an introduction by George E. Lankford. Norman: University of Oklahoma Press, 1995.

Tebeau, Charlton W. *They Lived in the Park: The Story of Man in the Everglades National Park*. Copeland Studies in Florida History No. 3. Miami, Fla.: Everglades Natural History Association/University of Miami Press, 1963.

Ted Smallwood's Store, Inc. "Historic Smallwood Store: Old Indian Trading Post and Museum, Chokoloskee, Florida." www.florida-everglades.com/chokol/smallw.htm.

Tiger, Buffalo, and Harry A. Kersey Jr. *Buffalo Tiger: A Life in the Everglades*. Lincoln: University of Nebraska Press, 2002.

Tillis, James Dallas. "Original Narratives of Indian Attacks in Florida: An Indian Attack of 1856 On the Home of Willoughby Tillis." *Florida Historical Quarterly* 8, no. 4 (April 1930): 179–87.

Turner, Gregg. *A Short History of Florida Railroads*. The Making of America series. Charleston, S.C.: Arcadia, 2003.

Urban, Greg, and Jason Baird Jackson. "Mythology and Folklore." In Fogelson, *Southeast*, 14: 707–19.

Ward, May McNeer. "The Disappearance of the Head of Osceola." *Florida Historical Quarterly* 33, nos. 3–4 (January–April 1955): 193–201.

Warren, Robin O. "Hamlet Rides among the Seminoles." *Southern Cultures* 7, no. 4 (Winter 2001): 31–63.

Weisman, Brent Richards. "Archaeological Perspectives on Florida Seminole Ethnogenesis." In *Indians of the Greater Southeast: Historical Archaeology and Ethnohistory*, edited by Bonnie G. McEwan. Gainesville: University Press of Florida, 2000.

———. *Like Beads on a String: A Cultural History of the Seminole Indians in Northern Peninsular Florida*. Tuscaloosa: University of Alabama Press, 1989.

———. *Unconquered People: Florida's Seminole and Miccosukee Indians*. Native Peoples,

Cultures, and Places of the Southeast U.S. series. Gainesville: University Press of Florida, 1999.

West, Patsy. *The Enduring Seminoles: From Alligator Wrestling to Ecotourism*. Gainesville: University Press of Florida, 1998.

White, John, and Jacques LeMoyne. *The New World: The First Pictures of America: With Contemporary Narratives of the Huguenot Settlement in Florida 1562–1565 and the Virginia Colony 1585–1590*. Engraved by Theodore DeBry. Edited and annotated by Stefan Lorant. New York: Duell, Sloan, and Pearce, 1946.

Wickman, Patricia Riles. Introduction to the 2004 edition of *Florida Place Names of Indian Origin and Seminole Personal Names*, by William A. Read.

———. *Osceola's Legacy*. A Dan Josselyn Memorial Publication. Tuscaloosa: University of Alabama Press, 1991.

Will, Lawrence E. "Historians Locate Old Seminole War Fort Sites." *Belle Glade (Fla.) Herald*, July 14, 1966. In DeVane, *DeVane's Early Florida History*, n.p.

Williams, John M., and Iver W. Duedall. *Florida Hurricanes and Tropical Storms*. Rev. ed. Gainesville: University Press of Florida, 2002.

Wright, J. Leitch, Jr. "Blacks in British East Florida." *Florida Historical Quarterly* 54, no. 4 (April 1976): 425–42.

———. *Creeks and Seminoles: The Destruction and Regeneration of the Muscogulge People*. Lincoln: University of Nebraska Press, 1986.

———. "A Note on the First Seminole War as Seen by the Indians, Negroes, and Their British Advisers." *Journal of Southern History* 34, no. 4 (November 1968): 565–75.

Index

Page numbers in *italics* indicate a photograph

Abiaka (Sam Jones), 84, 146n15

A Bosh Che—Will A Tee Chee (LaBree's Seminole nickname), xix, 14

Abraham (interpreter), 114, 152n81

Accuracy of paintings. *See* Authenticity of LaBree's paintings

African Americans in the Seminole Wars, 113–14. *See also* Seminole Maroons

Afterlife, 23–25

Ah-Tah-Thi-Ki Museum, xviii, 63, 74, 100

Alligator (Seminole leader), 86–87, 89, 146n20

"Alligator Joe" (Frazee, Warren), 141n10

Alligators, 42–43, 103, 105, 111–12

Alligator wrestling, xvii, 5, 43–47, 137n5, 141n9, 141n10

Almost Hog Heaven, 120, 122–24

American Museum of Natural History, 154n16

Andytown, 12, 153n5

Animal Land, 45–46

Apache Indians, 112

Arcadia, the LaBrees' home in, xix, 10, 12, 16, 136

Archaeological and Historical Conservancy, 91

Archbold, Richard, 154n16

Archbold Biological Station, 133, 154n16

Armed Occupation Act of 1842, 80

Arrows, 95

Art critics on LaBree, xviii

Articles on LaBree, xvii, 12

Artist's block, 125

Asiyaholi. *See* Osceola, Seminole Warrior

Assimilation of Seminoles, 28, 50, 77, 118

Aucilla River, 128, 153n10

Australia, emigration of LaBree family to, 9–10

Authenticity of LaBree's paintings: Elgin Jumper on, 135–36; Ellen Koven on, xviii; from experience on the Reservations, 41, 42, 53–54; from extensive research, xiv, xviii, 40, 81–82, 96, 120, 133–34; Joanne Milani on, xiv; from keen observation of nature, 27–28, 64–68, 81, 83, 119, 133; in *Mikasuki Seamstress*, 39; rare mistake in, 73–74; recognized by curator of the Whitney Museum, xviii; respect for requests not to depict some subjects, 39; revisions to paintings to ensure accuracy, 19–23, 40; understanding of Seminole traditions and customs, 39, 87, 135–36. *See also* Friendships with Seminoles, LaBree's lifelong

Barefoot Artist, LaBree as, xvii, xix, 14, 100
"Barefoot Man" (Ralph Billie), xix
Bartram, William, 143n30, 149n41, 149n45
Basinger, William Elon, 86
Battle of Okeechobee (painting), xiv, 81, 91–94, 135
The Battle of Okeechobee (Steele), 12, 91
Battle of Okeechobee Reenactment, xix, 91
Beads, Seminole, 48, 52, 141n13
Bear Clan, 51
Bears, 131–34
Bees and beehives, 133–34
Benton, Thomas, 145n10
Big Cypress National Preserve, 105
Big Cypress Reservation, 4, 13, 20–21, 35–36, 114. *See also* Ah-Tah-Thi-Ki Museum; *A Visit to Big Cypress*
Big Cypress Swamp, 13, 77, 102, 121
"Big House" in Green Corn Dance, 29
Billie, Henry John, 26, 62
Billie, Ingraham, Jr., 95
Billie, James: alligator wrestling, xvii, 40; birth at Chimpanzee Farm, 38; on the bridge to eternity and the afterlife, 23–25; canoe made by, 63; endorses use of Seminole name for FSU team, 78; gives Seminole patchwork jacket to LaBree, 57; on LaBree and his paintings, vii–viii; LaBree inspired by stories told by, 26; as patron of LaBree's work, 13, 40, 87; saves ancient canoes, 63
Billie, Ralph, xix
Billie, Sonny, 15–16, 20–23, 70
Billie, Susie, 55
Billie Swamp Safari, 13, 47
Bingo hall, original on Dania Reservation, 4
Bird Clan, 22, 23
Birds: feathers and plumes of, 66, 72, 99, 143n42; in LaBree's paintings, 72, 74, 91, 122, 128–31; preservation of native, 153n1. *See also* Eagles; Egrets; Hawks; Owls; Wood duck
Blackard, Dave, 55–56
Black Seminoles, 79, 113–14. *See also* Seminole Maroons
Boars. *See Almost Hog Heaven*
Bobcats, sightings of, 120, 126, 130, 131
Boca Museum of Art, xviii
Boone, Daniel, 99
Bowers, Bill, 35

Bowers, Carrie, 35
Bowers, Dan, *xvi*, 41, 64
Bowers, Eugene "Tank," *xvi*
Bowers, Paul, 36
Bowers, Richard, 36
Bowlegs, Billy I, 138n3
Bowlegs, Billy II, 138n3
Bowlegs, Billy III, 8–9, 93, 138n3
Bows, 95
Breakfast Time, 39, 53–54
The Bridge to Eternity, viii, ix, 19, 23–25, 24, 135
Brighton Reservation, xix, 35, 58–59, 79
Bromeliads, 129
Brown, Jane, 54
The Buck Stops Here, 126
Buffalo Tiger, 6
Busks, 70

Cabbage palms, 52, 56, 74, 83, 102
California, the LaBrees' time in, 11
Call, Richard Keith, 88, 89, 145n10
Canoes, 62–64, 66–69, 95, 143n30
Careers. *See* Jobs held by LaBree
Caron, Peter Octave, 132, 154n15
Carr, Robert, 91
Carrady, Andy, 4
Casey, John C., 97
Cash, Johnny, 116–17
Catlin, George, 89, 97, 147n22
Cattle in Florida, 35
Cattle program of the Seminoles, 35, 79
Chants and songs, Seminole, 26, 29
Chickees: in camp settings, 51, 54; for childbirth, 51; components shown in a painting, 56; construction of, 41–42, 48–49, 56, 142n25; for cooking, 53–54; LaBree's childhood experiences in, xvii, 49; in *Mikasuki Seamstress*, 55–57; in *"Oh, the Changes I've Seen,"* 48–49, 51; older Seminoles' preference for, 49; sewing in, 55; thatching of, 56; village of, built for tourists, 57
Children of the LaBrees, 8, 10, 47
Chimpanzee Farm, 5, 38, 43, 44, 57
Choctaw Tribe, 139–40n11
Civil Air Patrol, 6
Clans, ix, 22, 23, 51, 60, 69–70, 73
Clark, Guy, 116–17
Clay, Abraham, 48
Clinch, Duncan Lamont, 85, 88, 145n20
Clothing, traditional Seminole: calico with

appliqué designs, 100; in *Danger Zone*,
103–4; expert on, 56; feathers and plumes,
72, 99–100, 143n42; jackets given to
LaBree, 57; lack of knowledge about
first Indians' apparel, 108; leggings and
breechcloths, 95, 97, 105, 115; in *Mikasuki
Seamstress*, 54–57; moccasins, 23–24; in
"*Oh, the Changes I've Seen*," 47–53; origin
of patchwork designs, 142n21; parallels
among the Winnebago and Menomini,
150–51n64; patterns and procedures for,
139n4; pouches, 34, 100, 101, 105, 150n52;
publication about, 55–56; sashes, 72,
97, 100, 103, 104, 110, 115, 150n52; shirts,
23–24, 92–93, 100; ties and garters (rib-
bons, sashes, bandanas), 97, 100, 104, 115;
turbans, 72, 99–100, 103–4, 150n57; in
the vanishing ceremony, 28–29; worn by
warriors, 92–93, 95, 100, 105, 115, 146n21.
See also Beads, Seminole; Religion of the
Seminoles; Seminole way of life
Clouds, LaBree's portrayal of, 67
Coacoochee (the Red Warrior): death of, 112;
enjoyment of the Forbes Company cos-
tumes, 109–11; escape from Fort Marion,
99, 146n15; family tales about, 149–50n47;
father of, 97, 151n76; as a fighter, 99–113;
Mexican government welcomes, 112;
Pacheo as slave of, 152n82; portrait of, 81,
97–98; reputation, 98–99, 113
Collectors of LaBree's paintings: David
Cypress, 17; the Elett family, xix, 13; James
Billie, xvii, 13, 21, 40, 87
Collier County Museum, 87
Comanche Indians, 112
Commissions, LaBree's research for. *See*
Research for paintings
Cooley, Brad, 12, 128
Coppinger, Henry, 44
Coppinger, Henry, Jr., 44, 141n10
Corkscrew Swamp, 65
Cornered, 124
"Cowboy and Indian All-Kid Rodeo," 4
Cowboys, Indian, 4, 34–36
Cow Creek Seminoles, 78
Coweta Indians, 139n10
Cowkeeper, 149n45
Creek (language). *See* Muskogee (Creek)
(language)
Creek Confederacy, 78

Creek people, 77–79, 147n22
Crider, Dale, 63
Cuba, relocation of native populations to, 77
Cubans, trade with the Seminoles, 92
Cultural and Historical Programs of the
State of Florida, 63
Curtis, Robert John, 89
Cypress, Billy L., xviii, 20, 21, 23
Cypress, David, xix, 17
Cypress, Mitchell, xix, 34–35, 52–53
Cypress trees, 61–62, 102, 122–23

Dade, Francis L., 82, 85, 146n20, 150n62
Dade Battle, 81, 85, 89, 106, 146n20, 148n28,
150n62
Dade Massacre. *See* Dade Battle
Dade's Last Command (Laumer), 150n62
Danger Zone, 81, 101–4
Dania, Florida, xvi, 1–2, 4–6, 8, 17, 42–43,
61, 116
Dania Elementary School, xvi, 4, 36
Dania Reservation (Hollywood Reserva-
tion), xv–xvii, 1, 4, 38, 40, 50, 138n1
Dayton, Bill, 84
Deep Cypress Engagement, 81, 104–6
Deer, 121–22
Deer, in paintings, 60, 61, 94–96, 126–27, 130
Deerskin used by Seminoles, 24, 66
Densmore, Frances, 41, 71
DeSoto County, the LaBree home in, xiii, 10,
72, 126–27, 129–31
Devine, Dennis, 11
Discover Native American Festival, xvii–xviii
Discrimination against Seminoles, 4–5, 40,
51, 137n4. *See also* Distrust of outsiders by
Seminoles
Diseases introduced from Europeans, 77
Distrust of outsiders by Seminoles, xvi, 2–3,
38, 40, 101. *See also* Discrimination against
Seminoles
Dittmer, Patricia. *See* LaBree, Pat
Dogs: for managing cattle, 35–36; in Semi-
nole camps, 58–59; with U.S. Army, 82
Douglas, Marjory Stoneman, 105
Dredging of the Everglades, 38, 121
Drums, 29, 140n12
Ducks, wood, 128–29
Ducks Unlimited, 120, 128–29
Duckweed, 102
Dugout Apprentice, 39, 61–65

Eagles, 35, 68

"East Florida Annexation Plot," 79

Echoes in the Wind: Seminole Indian Poetry of Moses Jumper, Jr., 46

Eckerd College, xvii

Ecology of Florida, 119

Egrets, 66, 72, 99, 122

Elett family, xix, 13

Emathla, Tukose (John Hicks), 71, 149n45

End of Message, 81, 82–85

End of the Trail (Fraser), 96, 149n42

Engines, steam locomotives, 116–18

Enslavement of native inhabitants, 77

Euchee (Yuchi) Tribe, 138–39n4

Everglades: burial site in, 75; climate of, 49; dredging of, by white people, 38, 121; ecological changes in, 65–66, 121; fires in, 121–22; LaBree hunts snakes in, 6–7; nighttime glow in, 28; origin of name, 68; piles of rocks in, 142n26; Seminoles' adaptation to, 38, 49, 141n1; Seminoles' reverence for, 104; Seminoles' seclusion in, 77, 104, 119, 136

Everglades National Park, 119

The Everglades: River of Grass (Douglas), 105

Exhibitions of paintings: Boca Museum of Art, xviii; Discover Native American Festival, xvii–xviii; first one-man show, xvii; Florida Capitol Building, xviii, 13; John and Mable Ringling Museum of Art, xviii; Museum of Florida History, xviii; Native Village, 13; partial list of, 17–18; Seminole Cultural Museum, xviii; St. Petersburg Museum of History, xvii, 42

Exotic plants and creatures, invasion of, 120

Fairbanks, Charles H., 81

Fanning, Alexander, 89

Fifties Fun, 5

Fireflies, 30, 31

Fire Peril, 120–22

Fires in the Everglades, 120–22

First Seminole War, 79, 139n11

Fish, 27–28, 131–32

Florida: Capitol Building of, xviii, 13; changes brought by Second Seminole War, 80; ecology of, 119; original inhabitants, 77; preservation of distinctive nature, 119; wilderness, dramatic changes to, 120. *See also* Everglades; Seminole Wars

Florida Fish and Wildlife Conservation Commission, 127

Florida Folk Festival, 11

Florida Herald and Southern Democrat (1840), 109

Florida Seminole Heritage Map, 68

Florida State University mascot, 78

Florida Volunteers, 80, 88, 148n37

Foods, traditional Seminole, 51–52, 57–60, 69

Forbes Company, fate of its costumes, 109–11

Forry, Samuel, 98

Fort Blount (Negro Fort), 91, 148n32

Fort Brooke (Tampa), 82–83, 152n82

Fort Brooke Cemetery, 101

Fort King (Ocala), 82–83, 85–86

Fort Marion (Castillo de San Marcos), 98–99, 147n22

Fort Meade, 113

Fort Mose, 140n12

Fraser, James Earle, 96

Frazee, Warren ("Alligator Joe"), 141n10

Freeman, Ethel Cutler, 141n12, 144n2

Friendships with Seminoles, LaBree's life-long, xv–xvii, xix, 1–6, 8, 81, 87, 99, 135–36

Fry, Jack, 59

Fry bread, 52

Funerals and burials, 74–76

Game, stick ball, 73

Gar, 131–32

Gardiner, George Washington, 85–87

Geldzahler, Henry, xiv

Genesis and *Exodus*, 19, 20–23, 135

Gentry, Richard, 93–94

Gibson, George, 83

Giddings, Joshua, 79

Giron, Ray, 92

Girtman, James D., 55

Glory pole, 86–87

Goal, LaBree's, in his paintings, xix, 20, 30, 36, 64

Goodhue, Tom, 95

Gorgets, 71–72

Government recognition of Miccosukee Tribe, 41

Government recognition of Seminole Tribe, 38

Grass, saw, 68, 105, 121, 131

Great Barrier Reef, 10

Green Corn Dance, 29, 70–71, 73
Griffith, John, 114–15
Guitars, xiii, 5, 17
Guns of the Palmetto Plains (Rick Tonyan), 12
"Guy LaBree Holding Cayman" (photo), 43
"Guy LaBree Wrestling an Alligator" (photo), 46

Hairstyles, traditional Seminole, 48, 55, 141n12
Hall, Curtis, 50
Hammocks, 54, 66, 105
Handbook of Florida (1892), 88
Handbook of North American Indians, xviii
Hard Rock Hotel and Casino, Seminole, xiii, 14, 17, 118
Harris, Joseph W., 83
Hawks, 122, 130
Health problems, LaBree's ongoing, xii, xix–xx, 15, 124
Henry, Bobby, 14–15, 30, 32, 34, 58, 139n5 (prologue)
Heritage Gallery of the R.A. Gray Building, xviii
Hialeah, 101
Hicks, John (Tukose Emathla), 71, 149n5
Hill, Buster, 36
Hinata, 41
Historical Society of St. Augustine, 109
Hitchcock, Ethan Allen, 108
Hitchiti (language), 41
Hogs. *See Almost Hog Heaven*
Hollywood Reservation. *See* Dania Reservation (Hollywood Reservation)
Holmes, James, 2
Homes, Seminole. *See* Chickees
Homestead Act, 145n10
Homework, 39, 57–60
Horse, John, 112–13, 146n20, 151n72
Horse, John (Gopher John), 109
Hounds. *See* Dogs
Hughes, Ellis, 84
Humor in LaBree's paintings, 31
Hunter in the Grass, 39, 60–61
Hunting: of hogs, by LaBree, 123–24; *Hunter in the Grass*, 39, 60–61; Seminole clothing worn while, 95; by the Seminoles, 94–96, 140n18, 149n41; "Snake Dance" ritual in preparation for, 140n18; the "Two Hunters" story, 32–33

Hurricane David chanted away, 26
Hurricanes, as the "sons of thunder," 25–26
Hutchinson, James, xviii–xix

"Ikaniuksalgi," 144n2
Illustrations, LaBree's, for other books, xviii, 12
Imaginary worlds, LaBree's talent for depicting, 19
Implements, kitchen, 53–54
Indian Removal Act of 1830, 79
Indians as preferred term of Florida Seminoles, 78
Indian Territory (now Oklahoma), 58, 79–80, 86, 99, 112
Infanticide, 81–82, 106–8, 151n65
Influence on Seminole life by whites. *See* Discrimination against Seminoles; Distrust of outsiders by Seminoles; Seminole Wars; Transition from the old ways to modern lifestyles
Integrity of LaBree's work. *See* Authenticity of LaBree's paintings
Intruder on the Land, 82, 116–18
"Invisible people," in *Vanishing Ceremony*, 20, 28–30

Jackson, Andrew, 79
Jeopardy, 120, 126–27
Jesup, Thomas Sidney, 79, 99, 152n81
Jiggers, 123
Jobs held by LaBree, xiv, xvii, 6–10
John and Mable Ringling Museum of Art, xiv, xviii
Johns, Mary, 58, 73–74
Johns, Stanlo, 4
Johns, Willie, 94, 96–97, 146n15
Jones, Sam (Abiaka), 84, 146n15
Jumper, Alan, 66; as alligator wrestler, 5, 43–47, 50, 111; birth in a chickee, 51; describes clothes worn by warriors, 92–93; expertise with an ax, 62; family camp of, xviii; guitar gift to LaBree, xiii; LaBree's lifelong friendship with, xvii, xix, 1, 8, 39, 81, 99, 135; LaBree's son named after, 8; language preference, 51; suggests that LaBree paint the Seminoles, xvii, 10; suggests that LaBree paint Tommie Jumper, 48; tells LaBree the story for *Time to Go Home*, 32; vehicle accident, 50; visit to LaBrees' new acreage, 10–11

Jumper, Alana, 8–9

Jumper, Betty Mae: enforcer of attendance at school, 51; establishes village with husband, 141n9; on her grandfather's burial, 75; as storyteller, xviii, 19; and the "Two Hunters" story, 33

Jumper, David, 1

Jumper, Eva, 10–11

Jumper, Harry, 41–42

Jumper, Jimmy, 1, 5, 41, 43–44, 50

Jumper, Joe, 62

Jumper, Moses, Jr., xix, 46

Jumper, Moses, Sr., 9, 141n9

Jumper, Tommie, 39, 47–53, 135

Jumper family camp, xvii, 2–3, 39

Jungle Queen (tourist attraction), 44, 141n9

Kennedy, Stetson, 123

Kersey, Harry, 103, 141n12

Kickapoo Tribe, 112, 113

King, Horace, 96

King Phillip, 97, 151n76

Kirsch, Fred, 76

Kissimmee River Legend, 20, 32–34

Kitchens, Seminole, 53–54

Knives: homemade, 55; as weapons, 83–84

Koven, Ellen, on LaBree and his paintings, xviii

LaBree, Cynthia, 8

LaBree, Edgar, 2

LaBree, Guy Thomas ("Shorty"), 8, 47

LaBree, Helen Taylor, 2

LaBree, Pat: as business manager, xi, 12, 16, 132; close relationships with tribal friends, 17, 136; contribution to interviews, xv, 2, 16, 23, 49, 55, 66, 79, 92, 101, 125, 129; courtship with Guy LaBree, xiv, 7; judge of contests on the reservations, 16; keeper of scrapbooks about Guy, xv; knowledge of Seminole legends, 21, 41, 98; knowledge of Seminole traditions, 69, 74, 78, 80–81; namer of paintings, 20, 66; participation in research for paintings, xviii, 82; photo of, *xiii*; selection of paintings for the book, xv; writer of brochures, 7

LaBree, Shorty, 8, 47

LaBree, William Alan, 8

Lake Istokpoga, 64

Lake Istokpoga Village, 12

Lake Okeechobee, 33–34

Lake Pithlachucco (Newnan's Lake), 63

La Navaja, 112

Languages of the Seminoles. *See* Mikasuki (language); Muskogee (Creek) (language)

Largo Folk Festival, 11

Last to Leave, 39, 74–76

Laumer, Frank, 106, 150n62

"The Legend of Florida Artist Guy LaBree: Painter of the Seminole," xvii

Legends, Seminole: *Bridge to Eternity*, 23–25; *Genesis* and *Exodus*, 19–23; *Kissimmee River Legend*, 32–34; morals in, 27; *Sons of Thunder*, 20, 25–27; *Water Lily Lovers*, 20, 27–28. *See also* "Little people"

Legends of the Seminoles (Jumper), 19, 32, 140n17

Lifestyle, Seminole. *See* Seminole way of life

Light a Distant Fire (Robson), 12

Lighthouse keeper (Cape Florida Light), 84

Lightning bugs, 30

Lightning strike, as sign of little people in a tree, 32

Lincoln, Abraham (Seminole), 141n14. *See also* Clay, Abraham

"Little people," 20, 30–32, 98, 140n15

Loomis, Gustavus, 80

MacCauley, Clay, 116, 138n3

Magic, protective, 93, 107

Make It Count, 81, 94–96

Malaria, 95, 99

Mallett, Harry, *xiii*

"The Man with No Shoes" (Moses Jumper, Jr.), xix

Mascot of Florida State University, 78

Massacre! (Laumer), 106

Matrilocality of Seminole camps, 69, 137n6

McCall, George Archibald, 101–2, 148n28

McClellan, Bill, 43–44

Medals used by Seminoles, 71, 110, 143n40

Medicine, invisibility, 93

Medicine bundle, in the Green Corn Dance, 70

Medicine men and women: Abiaka (Sam Jones), 84, 146n15; Bobby Henry, 14–15, 30; chants of, 139n1; colors of, 28, 60; components of ritual dress, 71–72; Sonny

Billie, xviii, 15–16, 20–23, 70; and the vanishing ceremony, 28

Menomini Tribe, clothing of, 150–51n64

Mexican government, 112

Micanopy, 97, 146n20, 149n45, 152n81

Miccosukee (tribe), 41, 78

Mikasuki (language), 41, 51, 55, 77–78, 141n6, 142n17

Mikasuki Seamstress, 39, 54–57

Milani, Joanne, xiv

Milanich, Jerald, 77

Miller, Susan A., 97, 113, 149–50n47

Missouri Volunteers, 93–94, 148n37

The Mocker, 81, 85–87

Monk, J. Floyd, 91–92

Mortar and pestle, 57–58

Mosquito nets in chickees, 49

Motlow, Nancy, 33

Mulberry, red, 95

Murray, Andrew, 36

Museum of Florida History, xviii

Music, LaBree's lifelong interest in, xiii, 5, 17, 136

Muskogee (Creek) (language), 41, 77–78, 142n17

Myths of the Seminoles. *See* Legends, Seminole

Nacimiento, 112, 113

National Cowboy and Western Heritage Museum, 149n42

National Rifle Association, 6

Native Americans. *See Indians* as preferred term of Florida Seminoles

Native inhabitants of Florida, original, 77

Native Village, 24, 26, 47

Nature in LaBree's paintings. *See* Authenticity of LaBree's paintings

Negro Fort (Fort Blount), 91, 148n32

New Deal, work relief programs of, 38

Newnan's Lake (Lake Pithlachucco), 63

Nichols, Edward, 148n32

Nickname of LaBree in Seminole, xix, 14

Ochese Creek Indians, 78

Octagon Wildlife Sanctuary and Rehabilitation Center, 132, 154n15

"*Oh, the Changes I've Seen*," 39, 47–53, 135

Okeechobee, Battle of, 91–94. *See also Battle of Okeechobee* (painting); *The Battle of Okeechobee* (Steele)

Oklahoma, Seminoles relocated to "Indian Territory" in, 58, 77, 112, 138n3, 146n20, 149n45

Oral traditions of the Seminoles, 19, 81, 82, 90, 92–93, 95, 105–6, 108. *See also* Legends, Seminole

Osceola, Billy, Reverend, 9

Osceola, Cory: powwow honoring, 13

Osceola, Eloise, 34

Osceola, Jacob (Jake), ix–x, 60, 82

Osceola, Jimmy O'Toole, 24, 29, 87

Osceola, Judybill, *xvi*, 40, 51, 106

Osceola, Laura Mae, 78

Osceola, O. B., 54

Osceola, Seminole Warrior: camp of, 88; capture of, 89; clothing of, 97; death mask, 147n22, 148n29; death of, 147n22; kills General Thompson, 86; life record unclear, 147n22; possessions of, 100

Osceola's Deathbed, 74

Osceola turkeys, 130, 153–54n14

Ostrich plumes, 72, 99, 143n42

Outdoors, LaBree's love of, xiv. *See also* Authenticity of LaBree's paintings; Snakes; Trees

Outsiders, Seminole distrust of, xvi, 2–3, 38, 40, 101

Owls: screech, 72; as spirit of a deceased person, 74

Pacheco, Luis, 114, 152n82

Paintbrushes, LaBree's, 64–65

Painting, mystery in, 83

Painting career, 10, 12

Paintings: of alligator wrestling, 47; on book covers, 12; as book illustrations, xviii, 12; featured in documentary, xviii; glazing in, 29, 60; LaBree describes ability to visualize, 64, 125; LaBree on symbols in, 72–73; light in, 64, 83, 87, 121, 127, 130; mural, 12; nature in, 27–28, 64–68, 81, 83, 90–91, 119–20; prizes for, 132–33; of the Seminole Wars, 80–81; storytelling as goal of, xix, 20, 30, 64. *See also illustrations of individual paintings*; Authenticity of LaBree's paintings; Seminole perspective in LaBree's paintings

Palmettos, 52, 83

Panther Clan, ix, 22, 51, 60

Panthers: diet of, 127; fear of, 126; LaBree's sightings of, 61, 120, 124–25; in paintings, 51, 60, 120, 124–25

"Parade of Natives," xviii

Patchwork and Palmettos: Seminole-Miccosukee Folk Art Since 1820 (Blackard), 55–56

Patchwork clothing of the Seminole. *See* Clothing, traditional Seminole

"Patriot War," 79, 138n3

Peace River, 130, 153n13

People, "little." *See* "Little people"

Phillip, King, 97, 151n76

Phillips, Lisa, xviii

Picolata, 109

Pierce, Mary, 2

Plans of War, 82, 113–16, 135

Plants, invasion of exotic, 120

Plumes, for ladies' hats, 66

Plumes, ostrich, 72, 99, 143n42

The Plunderer, 131

Poaching on the reservation by whites, 122

Pond flag, 29, 102

Porter, Kenneth, 138n3

Prince, Henry, 147n23

Races, origins of in Seminole myth, 22

Racial awareness, 3, 5. *See also* Discrimination against Seminoles

Railroads, first ones in Florida, 116–18

Rainmaking, 14–15

Rattlesnake Ridge, 42

Rattlesnakes. *See* Snakes

Red Patriots, 97

Religion of the Seminoles, 14, 29, 70. *See also* Legends, Seminole

Removal of Seminoles, 58, 77, 79, 86

Repeat Offender, 120, 132–34

Reptiles. *See* Alligators; Alligator wrestling; Snakes

Research for paintings, xiv, xviii, 40, 80–82, 90, 96, 120, 133–34

Restful Shade, 120, 124–26

Rivers, Larry, 79

Rodeos, 4

Roosevelt, Theodore, 153n1

"Root, hog, or die!" 123

Saw grass, 34, 68, 93, 105, 121, 131

Scalping, 86–87

Schuler, Gene, 126

Scottish Highlanders, 72, 138–39n4

Screech Owl Dance, 39, 70–74

"The Sea Serpent of Cape Sable," 34

Second Seminole War: Andrew Jackson's participation in, 79; artifacts from, 100–101; the Dade Battle, 81, 85, 89, 106, 146n20, 150n62; military buttons from, 146–47n21; primary source material from, 84; profound changes brought to Florida by, 80; reenactment of, 20; sailing canoes in, 62–63; Sherman's experience from, 80; strategies of the U.S. Army during, 90, 104, 107; tales told about, 40; and the vanishing ceremony, 28; Zachary Taylor's construction during, 83

Seminole, derivation and meaning of, 77–78, 144n1, 144n2

Seminole Arts and Crafts Enterprise Gift Shop, xvi, 40

Seminole beliefs, 6, 29, 39, 74. *See also* Legends, Seminole; *Screech Owl Dance*

Seminole chants and songs, 29, 71

Seminole Cultural Museum, permanent exhibit of LaBree's work at, xviii

Seminole Hard Rock Hotel and Casino, xiii, 14, 17, 118

Seminole Indian Agency, 138n1

Seminole languages. *See* Mikasuki (language); Muskogee (Creek) (language)

Seminole legends. *See* Legends, Seminole

Seminole Maroons: and African strip-sewing, 142n21; depiction in LaBree's paintings, 115; in the First Seminole War, 79; followers of Osceola, 147n22; history, 113–14; leader of (John Horse), 113. *See also* Slaves

Seminole Music (Densmore), 41, 71

Seminole Negro Indian Scouts, 113

Seminole new year, rituals of, 70–74

Seminole Okalee Indian Village, xvi, 8, 40, 137n5

Seminole perspective in LaBree's paintings: and LaBree's goal in his work, xix, 20, 30, 64; LaBree's research, xiv, xviii, 40–41, 80–82, 90, 96, 120, 133–34; revisions to paintings to ensure accuracy, 19–23,

40. *See also* Authenticity of LaBree's paintings; Friendships with Seminoles, LaBree's lifelong

Seminoles, discrimination against, 4–5, 40, 51, 137n4

Seminoles, distrust of outsiders, xvi, 2–3, 38, 40, 101

Seminoles cattle program, 35, 79

Seminoles' high regard for LaBree, 40, 135–36

Seminole Tribe, federal recognition of, 38

Seminole Tribe of Florida Celebrating 50 Years, 17

Seminole Tribune: article on ancient Seminole canoes, 63; articles on Guy LaBree, xvii, xix, 12; Mitchell Cypress' comments about LaBree's painting, 52–53

"The Seminole Village" (Tampa), 14–15

Seminole Wars: caused by greed for land and escaped slaves, 79, 145n7; Coacoochee's attack on theatrical troupe, 109–13; decimation of the Seminole population, 77; Indian attack on the Russell homestead, 113–14; lack of peace treaty, 80, 96; little physical evidence of remaining, 104; loss of cattle herds, 35; participation of Seminole Maroons, 113–14; as phases of one forty-year conflict, 79; source of distrust of strangers, 40; strategies of the Seminoles, 82–85, 104, 106–7; waged by the U.S. government, 58, 79, 82; way of life since, 38. *See also* First Seminole War; Removal of Seminoles; Second Seminole War; Third Seminole War

Seminole way of life, 49; after the Seminole Wars, 38–39; camp settings, x, xvii, 39, 49, 51, 56–59, 69–70, 137n6; cattle in, 35–36; in the chickees, 47–57; clan relationships and responsibilities, 51, 60, 69–70; education of children in public schools, xvi, 137n4; farming, 38, 59, 64, 142n26, 142n27; funerals and burials, 74–76; hairstyles, 48, 55, 74, 141n12; hunting, 94–96; kitchen items and customs, 53–54, 57–60; LaBree's understanding of, 39, 136; leggings and breechcloths, 95, 115; love for their children, 108–9, 151n66; matrilocal marriage, 69, 137n6; oxcarts, 49–50; sense of humor, 40–41, 109–10; spirits in, 74–75; trading,

66, 92; traditional clothes, 24, 47–48, 54–57; traditional foods, 51–52, 57–60, 69; *See also* Chickees; Clans; Clothing, traditional Seminole; Transition from the old ways to modern lifestyles

Sewing machines, 54–55, 142n21, 150–51n64

Shanley, Lois, xvi–xvii

Shepard, Harriet, 131

Sherburne, John H., 148n31

Sherman, William T., 80

Slaves, 79, 112, 114, 145n7. *See also* Seminole Maroons

Smallwood, C. S. "Ted," 66, 143n33

"Smith's Museum." *See* Smithsonian National Museum of the American Indian

Smithsonian National Museum of the American Indian, xi, xviii, 20

Snack Gar, 120, 131–32

Snake Clan, 23, 73

Snake Dance, 71, 140n18

Snakes: coral snakes in paintings, 126; flying (in a painting), 20, 25; in the *Kissimmee River Legend*, 33–34; LaBree's collection of in Australia, 10; LaBree's experience with, xiv, 2, 6–7, 66; Seminole beliefs about, 6, 33, 138n2; symbol (in a painting), 73

Sofkee (cornmeal mush), 57–60, 69

Solomon, Howard, 153n8

Sons of Thunder, 20, 25–27, 135

South Broward High School, xvii

Spanish moss, 93, 105, 129

Spirits of the departed, 74

Sponsors of exhibitions. *See* Exhibitions of paintings

Sprague, John T., 81, 146n20, 151n76

Starts, Al, 141n9

State of Florida, Cultural and Historical Programs of, 63

St. Augustine, 98, 109–10, 114, 147n22, 152n82

Steam engines, locomotive, 116–18

Steele, Willard (Bill), 91, 93–94

Stick ball game, 73

St. Johns River, 79, 109, 114, 139n10, 152n81

The Story of Florida's Seminole Indians (Neill), 12

Storytelling, Seminole. *See* Oral traditions of the Seminoles

Storytelling as goal of paintings, xix, 20, 30, 64

The Storyteller/Sunset Recollection, 39, 40–42, 78
St. Petersburg Museum of History, xvii
Stranahan, Ivy, 54
Streamliners (trains), 116–17
Studio, LaBree's painting, xiii
Sturtevant, William C., 24, 77, 150–51n64
Summerville, Slim, 5
Sunup Turkey Feast, 120, 129–31
Supernatural beings, 139n7
Survival, ix, 82, 106–9, 135
Suspect Foul Play, 82, 109–13
Suspicion, 81, 99–101
Swamp cabbage, 52

Tamiami Trail, 48, 54
Tamiami Trail Reservation, 30
Taylor, Tommy, 47
Taylor, Zachary, 83, 93–94, 104
Third Seminole War, 80, 113
Thomas, Ann, xix, 11
Thomas, Frank, xix, 7, 11
Thompson, Wiley, 86, 147n22
Tiger, "Captain" Tom, 75
Tillis, Willoughby, 113
Time to Go Home, 20, 30–32
Tommie, Mittie, 32
Tommie, Sam, 32
Trading, Seminole, 66, 72, 92, 97, 143n33, 143n42, 146–47n21, 150–51n64
Traditions, Seminole. See Seminole way of life
Tragedy of War, ix–x
Trains, 116–18
Transition from the old ways to modern life- styles, ix–x; adoption of modern lifestyles, 39; camping, old style and new, 10–11, 14; changes to clothing, 36, 47–48, 54–55; influence of the sewing machine, 54–55, 142n21, 150–52n64; LaBree sees last of original ways, xvii; necessity of assimila- tion, 28, 50, 77, 118; work in the tourism economy, 38, 141n2
Travelog, 39, 65–67
Treaties, 80, 96, 145n8, 147n22, 149n45, 152n81
Trees, 61–62, 64–65, 90–91, 102, 122–23
Treibwasser, Orville, 65
Tribal Fair, annual, 118
Trubey, Dr. (LaBree's teacher), 110
Turkeys, wild, 129–31, 153–54n14

Tustenuggee, Halpatter, 86–87, 89, 146n20
Twins' Legend, ix

Underhill, Thomas, 113
Uniforms, army, 92, 99, 102–3
USA Today, xviii

Vanishing Ceremony, 20, 28–30
A Visit to Big Cypress, 39, 68–70
Volunteers, Florida, 80, 88, 148n37
Volunteers, Missouri, 93–94, 148n37

Waiting for Mom, 120, 128–29
Water, LaBree describes his portrayal of, 67, 130
Water lilies, 27, 69, 102, 131
Water Lily Lovers, 20, 27–28
Weaponry during the Seminole Wars, 83–84, 90, 92, 95, 100, 105
Web site www.guylabree.com, 11
Weed, Frank, 7, 124–25
Weisman, Brent, 80
When I Grow Up, 39, 42–47
When the Time Comes, 20, 34–37
Whites, influence on Seminoles by. See Dis- trust of outsiders by Seminoles; Seminole Wars; Transition from the old ways to modern lifestyles
Whitman, Barney, 113
Whitney Museum of American Art, xviii
Wild Animal Retirement Village, 126
Wild Cat, Red Warrior, 81, 96–99
Wilderness, Florida, 120–21. See also Au- thenticity of LaBree's paintings; Ever- glades
Wildlife at LaBrees' Acadia acreage, 16, 126
Wind Clan, 22, 26
Winnebago Tribe, clothing of, 150–51n64
Withlacoochee, Cove of, 88
Withlacoochee River, 88–91, 146n20
Withlacoochee Surprise, 81, 88–91
Wolf Clan, 72
Wood duck, 128–29
Worth, William Jenkins, 80, 145n10

Young, Scarlet Jumper, 28

Zepeda, Brian, 66, 95
Zepeda, Pedro, 95

Carol Mahler has served as humanities scholar, discussion leader, and project director for programs funded by the Florida Humanities Council focusing on Florida literature, history, and oral history. Her poems and articles have been published in magazines; her children's book, *Adventures in the Charlotte Harbor Watershed*, was published by the Charlotte Harbor National Estuary Program; and she has taught writing and literature classes in schools, colleges, churches, recreation centers, libraries, parks, and a prison. A professional storyteller and singer-songwriter, she shares music every week with a circle of friends that includes Guy LaBree.